DAVID P. SILCOX is an art historian, author, and cultural administrator. He is the managing director of Sotheby's, Canada; a Senior Fellow at Massey College (University of Toronto); the chairman and chief executive officer of the Canadian Artists and Producers Professional Relations Tribunal; and the former director of the University of Toronto Art Centre.

He has held cultural portfolios at all levels of government and has served on the boards of numerous cultural and educational organizations.

The author of the definitive biography of the artist David Milne, Silcox has also co-authored books on Tom Thomson, Christopher Pratt, Jack Bush, and other artists. He has written numerous exhibition catalogues as well, and his many articles on Canadian art and artists have appeared in national and international periodicals.

THE GROUP OF SEVEN AND TOM THOMSON

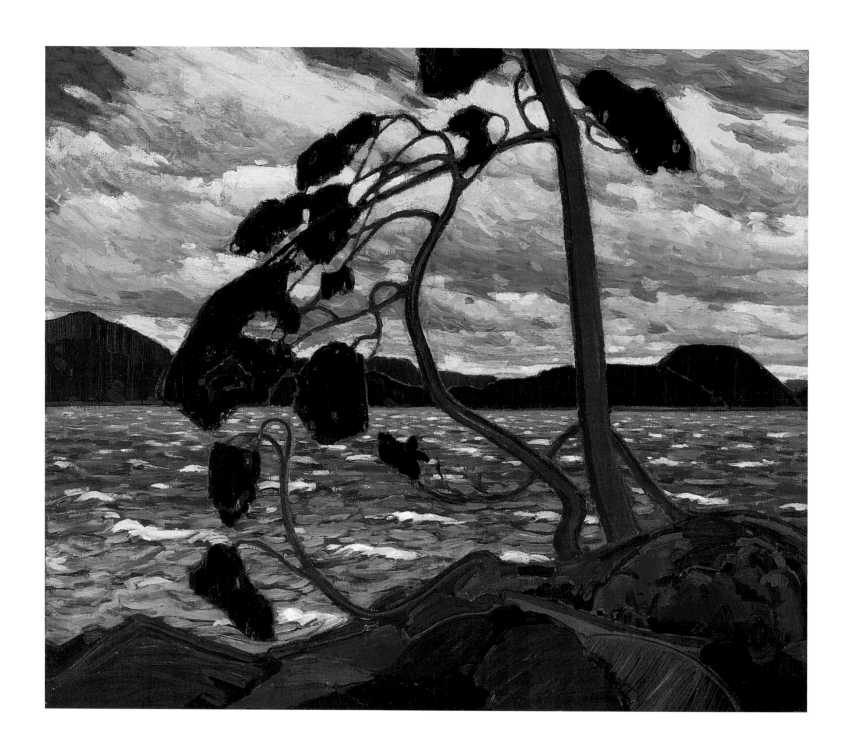

Tom Thomson *The West Wind* 1916–1917

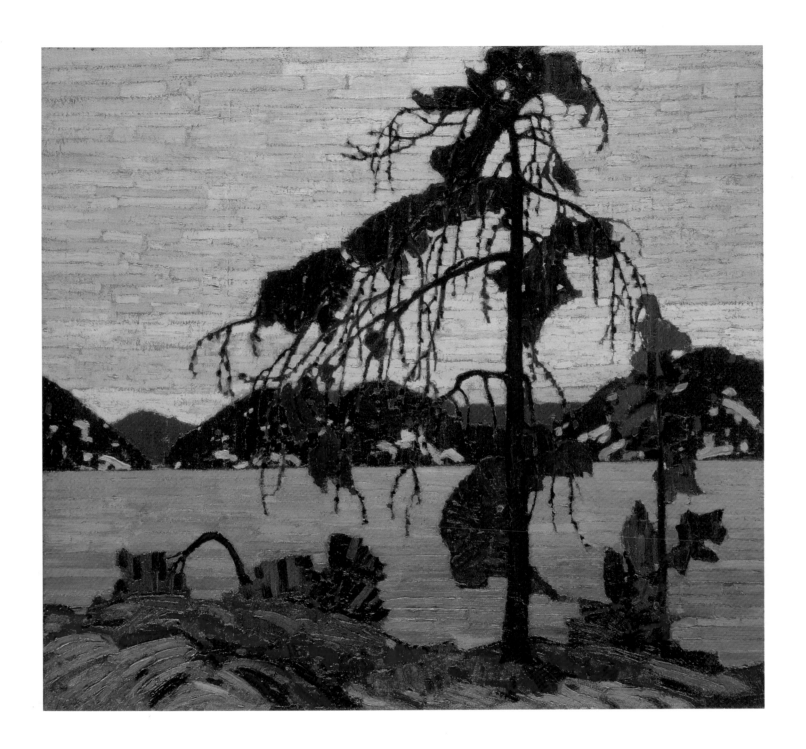

Tom Thomson *The Jack Pine* 1916–1917

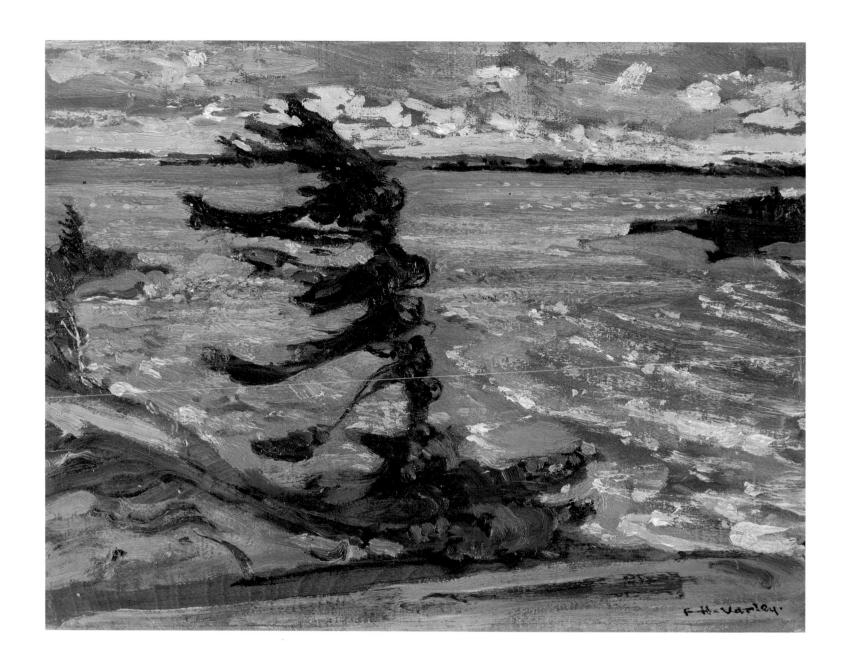

F.H. Varley *Squally Weather, Georgian Bay* 1920

THE GROUP OF SEVEN
and TOM THOMSON

Tom Thomson

Lawren Harris

J.E.H. MacDonald

A.Y. Jackson

Arthur Lismer

F.H. Varley

Frank Carmichael

Frank Johnston

A.J. Casson

Edwin Holgate

LeMoine FitzGerald

David P. Silcox

Firefly Books

A FIREFLY BOOK

Published by Firefly Books Ltd. 2003

First printing

National Library of Canada Cataloguing in Publication Data

Silcox, David P., 1937–

 The Group of Seven and Tom Thomson / David Silcox.

Includes bibliographical references and index.

ISBN 1-55297-605-X

 1. Group of Seven (Group of artists)

2. Painting, Canadian – 20th century. I. Title.

N6545.5.S4S55 2003 759.11 C2003-901470-3

Published in Canada in 2003 by
Firefly Books Ltd.
3680 Victoria Park Avenue
Toronto, Ontario, M2H 3K1

Publisher Cataloging-in-Publication Data (U.S.)
(Library of Congress Standards)

Silcox, David.

 The group of seven and Tom Thomson/ David Silcox. – 1st ed.

[444] p. : col. ill. ; cm.

Includes bibliographical references and index.

Summary: A major retrospective of the famous Canadian art movement
and their contemporaries. Features 400 works of art organized by the
subject of the painting, plus introductory text.

ISBN 1-55297-605-X

1. Art, Canadian – 20th century. 2. Art, Modern – 20th century – Canada.

3. Group of Seven (Group of artists). I. Title.

759.11 21 N6545.5.S4.S55 2003

Published in the United States in 2003 by
Firefly Books (U.S.) Inc.
P.O. Box 1338, Ellicott Station
Buffalo, New York 14205

Design: Counterpunch / Linda Gustafson
Project Manager and Photo Editor: Jennifer Pinfold

Printed in Canada
Printed on acid-free paper by Friesens, Altona, Manitoba

The Publisher acknowledges the financial support of the Government of Canada
through the Book Publishing Industry Development Program for its publishing activities.

To my wife, Linda Intaschi

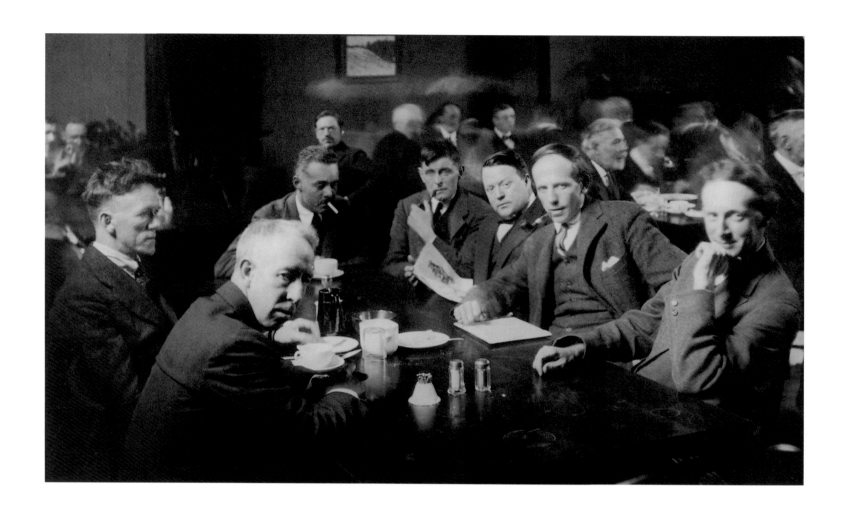

Founding members of the Group of Seven at the Arts and Letters Club, Toronto, c. 1920.
Left to right: F.H. Varley, A.Y. Jackson, Lawren Harris, art critic Barker Fairley, Frank Johnston,
Arthur Lismer, J.E.H. MacDonald. Absent, Frank Carmichael.

CONTENTS

Tom Thomson

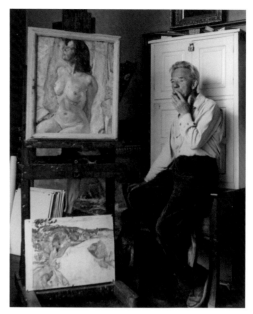

F.H. Varley

Lawren Harris

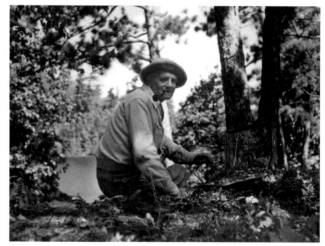

Arthur Lismer

A.Y. Jackson

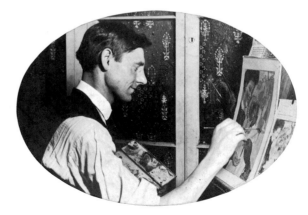

J.E.H. MacDonald

Preface

This book is the story, told primarily in pictures, of the Group of Seven and Tom Thomson. Lawren Harris, in his *The Story of the Group of Seven*, was firm about Thomson's inclusion: he was 'part of the movement before we pinned a label on it.' A.Y. Jackson emphasized the same point in his autobiography, *A Painter's Country*. Two of Thomson's iconoclastic paintings, *The West Wind* (p. 2) and *The Jack Pine* (p. 3), are the Group's major progenitors. They defined the spirit of Canada as 'Northern.' With Thomson, the Group of Seven would have been eight; as it was, three more members were added over the years. These eleven artists moulded our way of looking at our land.

Their pictures, reproduced here, capture the eye, provoke the mind, stir the memory, and feed the heart. These are the images that helped Canada to discover its identity almost a hundred years ago, and that described the country as it was then and as much of it is today.

Everyone's favourite paintings are here, mostly, along with others that deserve to be better known and many that have seldom or never been published before. In my search for images for this book, I scoured public and private collections across the country, reread books on the Group and on that period in the history of Canadian art, and reviewed dozens of old exhibition and auction catalogues. In the process I must have looked at well over five thousand images. I was drawn, as many are, to the Group's small oil sketches and on-the-spot watercolours, which in reproduction are closer in scale to the originals and thus give much greater immediacy than reproductions of some of the large canvases the artists painted from them later in their studios. Despite their activities as teachers, designers, writers, illustrators, and family men, these artists were incredibly productive throughout their lives. And how many hundreds of their paintings are still unpublished?

This book is organized to begin with a sort of 'fanfare' of major paintings – great icons – for Tom Thomson and each of the ten artists who, at one time or other, were members of the Group of Seven proper. Some, like Thomson and Harris, created many memorable works, some just a few. Some focused on landscape to the exclusion of all else, some preferred an urban, rural, or domestic setting, some painted all over this vast country, some never went east, some

Edwin Holgate

Frank Carmichael

LeMoine FitzGerald

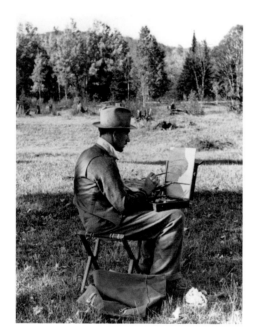

A.J. Casson

Frank Johnston

never went west, some never went to the far north. But all of them, collectively, created paintings that reflect a thousand different aspects of the physical environment, life, and spirit of Canada. They bequeathed to Canada an enduring legacy, which this book celebrates.

The 'fanfare' is followed by a section on gardens, still lifes, and portraits. The Group was criticized in some quarters for portraying a land in which no or few people were to be seen. Landscapes are landscapes, one might point out, and by definition usually do not have people in them, except incidentally to give a sense of scale. Often, however, members of the Group did include figures in their landscapes. Moreover, domestic and intimate subjects were a significant part of these artists' worlds and therefore of their achievements.

Then follows work the Group did in the cities, towns, and rural villages of Canada. When the Group was formed in 1920, eighty percent of Canadians lived in small rural communities or on farms, so the emphasis on 'country' is not surprising. Nevertheless, Toronto was the Group's headquarters, and the city naturally found a significant place in their work. This section is followed by paintings done for the Canadian War Memorials during the First World War. Only Arthur Lismer, A.Y. Jackson, F.H. Varley, and Frank Johnston (briefly) were part of this program, and only Jackson and Varley went overseas to the battlefields. Neither Harris nor Edwin Holgate painted officially during their military service.

The rest of the book is a tour of Canada, beginning in the East, with Newfoundland and Labrador, the Maritime provinces, and the Gaspé; then moving up the St Lawrence River to Quebec City and the Laurentians; on to Bon Echo, Algonquin Park, Georgian Bay, and La Cloche; and then further north in Ontario to Algoma and Lake Superior. The Prairies, seldom depicted by the Group, the Alberta foothills, and the Rockies through to the West Coast are next. The book concludes with paintings done in the territories, including the Arctic.

This visual tour of Canada may proceed at whatever pace you choose as a viewer, from awesome power to small delights, from wild rivers to domestic fields, from autumn forests to city gardens, from the warm portraits of patrons, friends, and visitors to the stark landscape of the Arctic. My choice was made by how paintings 'work' together as reproductions on paper, and by how their sequence tells a story.

The major books on the Group of Seven in the past thirty years (by Peter Mellen, Dennis Reid, Roald Nasgaard, and Charles Hill) have given us the documented narrative of how these

artists gave Canada a national artistic identity. Each has contributed much to our historical knowledge through diligent research and detailed accounts of the development of this historic movement. The work by Charles Hill is particularly comprehensive and well presented. The Selected Bibliography refers readers to these indispensable sources and to other references on and by the Group, its individual members, and Tom Thomson.

To experience the variety and vitality of the Group's images, even in reproduction, is to know oneself and Canada better. My hope in publishing this collection, therefore, is that it will contribute to an appreciation of the role that artists have in creating our identity, and emphasize the importance of art in our lives. For today's artists are defining who we are now, as surely as the Group of Seven and their colleagues did only a few generations ago.

David P. Silcox

Toronto

Acknowledgements

Many people helped me in the preparation of this book, and I am deeply indebted to them all. The owners of the paintings, whether private collectors or public institutions, were all cooperative in supplying access, photography, or permission; in particular, I would like to thank Ken Thomson. Many paintings that deserve to be known are now published because of their generosity. Next, my thanks are extended to the estates of those artists that gave permission for reproduction, especially Stewart Sheppard of the Lawren Harris Estate and Anna Brennan of the A.Y. Jackson Estate. The idea of this book, a place where a large collection of works by all members of the Group of Seven and Tom Thomson could be seen, was that of Lionel Koffler, publisher of Firefly Books. His staff, led by Michael Worek, helped in every way to make the book a reality. Jennifer Pinfold assembled the daunting mass of transparencies, handled permissions, asked questions, and insisted on answers that made the book better. Dan Liebman edited the text with careful precision, while Karen Worek assembled the complex indexes. The bibliography, the most comprehensive now available, was meticulously compiled by Elizabeth Driver. Fred and Beverly Schaeffer helped with advice and by lending their copy of the Rous and Mann portfolio of drawings.

I would also like to thank all those who have written on the Group of Seven before. I am indebted to Peter Mellen, Dennis Reid, and Charles Hill particularly, but must also acknowledge Marjorie Bridges, Donald Buchanan, Anne Davis, Nancy Dillow, Naomi Jackson Groves, Russell Harper, Robert Hubbard, Alan Jarvis, Peter Larisey, Joan Murray, Doris Shadbolt, Peter Varley, Joyce Zemans, and many others.

The actual production of the book required the talents of outstanding photographers, who made transparencies of many works for the first time: Nancy Rahija, Christine Guest, Trevor Mills, Peter Ure, Michael Cullen, and J. Randy Harquail primarily; I also wish to thank those who had already made transparencies for private collectors or public institutions and the photographic staffs at the National Gallery of Canada, the Art Gallery of Ontario, the McMichael Canadian Art Collection, and all the other public galleries that contributed works to this publication. Heather McMichael at the Thomson Collection, Toronto, was a great help, as was Conrad Graham at the McCord Museum in Montreal. Laura Brendan, curator at the Canadian War Museum, helped me find two remarkable paintings not reproduced in more than eighty years. Transparencies were also supplied by the auction houses Sotheby's and Joyner's for works now in private hands but untraceable. Dealers and curators all had suggestions to make, and I would like to thank Charles Hill, Dennis Reid, Rod Green, Eric and Alan Klinkhoff, Catharine M. Mastin, Liz Wylie, and Christopher Varley. John O'Brian read the introduction and raised several points I am glad to have corrected.

For photographic material about the Group of Seven and of the artists themselves, I would like to thank the staff of the Art Gallery of Toronto; Scott James and Margaret McBurney at the Arts and Letters Club, Toronto; Barbara Carroll and the Carroll Family Archives for an enchanting photograph of A.Y. Jackson in the Studio Building; and David Rittenhouse, for an equally wonderful photograph of Edwin Holgate, as well as access to an unknown Holgate painting.

The design of the book was entrusted to Linda Gustafson, with whom I had many exciting meetings as we laid out the book, section by section, and page by page. The shape and appearance of the book are due to her talents, and the veracity of the reproductions is the result of her stubborn insistence on the highest quality that was achievable. Her choice of Carl Dair's Cartier typeface would have delighted the artists.

INTRODUCTION

THE GROUP OF SEVEN was formed one evening in March 1920, at Lawren Harris's elegant mansion, 63 Queen's Park (now Queen's Park Crescent), Toronto, where St Michael's College, University of Toronto, stands today, and next door, but one, to his friend (and co-heir to the Massey-Harris Company) Vincent Massey, then Dean of Residence at Victoria College and already a significant arts patron. The artists present were Harris, J.E.H. MacDonald, Arthur Lismer, F.H. Varley, Frank Carmichael, and Frank Johnston. A.Y. Jackson was away painting in Georgian Bay, but was considered to be present by proxy. The *Memorial Exhibition of Paintings* by Tom Thomson at the Art Gallery of Toronto had just closed.

No one knows why these seven men were chosen (originally it was going to be nine) from among artists who shared their ambitions and beliefs. Someone decided whom to invite to that historic meeting, and probably Harris, or Harris after conferring with MacDonald, was responsible. Three of the seven were English (if one includes MacDonald, who spent his boyhood there), three were from Ontario, and one was from Montreal. Lawren Stewart Harris (1885–1970) was an heir to his family's farm implement–manufacturing company, Massey-Harris. He was born in Brantford, Ontario, and moved to Toronto at the age of nine, when his father died. After attending the University of Toronto briefly, he went to study art in Berlin. He had already painted extensively around Toronto, in the Laurentians, Muskoka, Haliburton, Algonquin Park, and Algoma, and elsewhere. The Studio Building, built for himself and his artist friends in 1913–14, was but one of his practical contributions to their serious purpose. Harris served in the army during the First World War. Unlike the others, he had only a brief experience as a commercial artist, having neither the interest nor the need to become one.

Harris was certainly a key instigator of the Group, although it did not have a leader, *per se*. 'The Group had no formal organization,' Jackson wrote later. 'We had no officers, and as we had no money we did not need a treasurer.'[1] But it was Harris who always had the energy and means to take initiatives. When Harris moved to the United States in 1934 (to side-step the stigma of a divorce), Jackson wrote that 'we were bereft ... he provided the stimulus; it was he who encouraged us always to take the bolder course, to find new trails.'[2]

James Edward Hervey MacDonald (1873–1932), usually called 'Jim' by his colleagues, was born in Durham, England. His Canadian father brought his family back to Canada when MacDonald was fourteen. After his commercial art training and apprenticeship in Canada, he returned to England from 1901 to 1903. By the time he met Harris in 1911, MacDonald was a leading commercial artist in Toronto, an excellent writer, and a poet. He was a keen admirer and follower of the transcendental American writers Ralph Waldo Emerson and Henry David Thoreau, after whom he named his son. When Harris saw MacDonald's paintings at a little exhibition at Toronto's Arts and Letters Club, he thought that he had finally discovered the work of someone who saw Canada in an original and truthful way. Harris and MacDonald sketched together frequently after they met and, in January 1913, travelled to Buffalo, New York, to see the *Exhibition of Contemporary Scandinavian Art* at the Albright Art Gallery. From the way the artists of Finland, Sweden, and Norway (particularly Edvard Munch, J.F. Willumsen, Prince Eugen, and Harald Sohlberg) depicted their countries, Harris and MacDonald were able to give shape and conviction to their then vague feelings about how to paint Canada. MacDonald wrote later: 'We felt "This is what we want to do with Canada."'[3] The northern light, the patterns of snow, the profiles of conifer trees, and a sense of the mystery embedded in the rawness of nature all touched a nerve for Harris and MacDonald. Certainly the correlation of the landscapes of Canada with those of Scandinavia was greater than with Italy, Holland, or England. The trip to Buffalo, which began in curiosity, profoundly influenced the work of all their artist friends thereafter.

Alexander Young Jackson (1882–1974), usually called 'Alex' by his friends, was born and grew up in Montreal. After working for various lithography firms there and in Chicago, he travelled in France and later studied under Jean-Paul Laurens at the Académie Julian in Paris. He had gone to Toronto in 1913, fed up with Montreal's negative attitudes toward Canadian art and artists, the indifference of its collectors to his own and other artists' work, and a lack of adequate exhibition opportunities. His early painting *The Edge of the Maple Wood* (p. 187) had enchanted Harris, MacDonald, Tom Thomson, and Arthur Lismer, when they saw it in 1911, and so had his powerful *Terre Sauvage* of 1913 (p. 381), a canvas developed from his trip to Georgian Bay that spring. He had served as a private in the war, then as a war artist in the Canadian War Memorials program. Although he was technically absent on that historic night, his wry humour and combative nature were as reliable as if he had been there.

Arthur Lismer (1885–1969) was born in Sheffield, England, and received his training there and in Antwerp before emigrating to Canada in 1911. A gifted writer and educator who had early established his own design business in Sheffield, he brought the sense of the pioneer with him to Canada, where he sensed the opportunity for unlimited creation and the possibility of Utopian ideals. By 1920 Lismer had made a considerable mark as a teacher and educator, and his paintings, strongly influenced by Impressionism, had gained wide admiration. He had also contributed major works to the Canadian War Memorials domestic program.

Lismer persuaded his fellow Yorkshireman, Frederick Horsman Varley (1881–1969), to come to Canada in 1912. Varley had made a promising start as an artist after two years at art school in Antwerp, and then faced a lack of opportunity to advance quickly in England. Toronto, as a hub of activity for commercial design and printing, could easily absorb men with a talent for drawing and illustrating. Varley was, in some ways, always the odd man out among the Group members. His one emblematic landscape painting, *Squally Weather, Georgian Bay* (p. 4), was, in truth, not typical of Varley's own spiritual quest, which took him along a path, travelled by none of his Group associates, to paint mostly people and landscapes in a different key altogether. By the time the Group was formed, Varley was a leading portrait painter whose War Memorial work had also been much admired.

Franklin Carmichael (1890–1945) was the youngest of those present at the Group's founding meeting. Born in Orillia, Ontario, and trained in his father's carriage business, he started work as a commercial artist with Rous and Mann in Toronto in 1911, and studied art formally in Antwerp in 1913 (following in the footsteps of Lismer and Varley). He shared a studio with Tom Thomson upon his return in 1914, his study plans curtailed by the war. He was known to the others through his clever work as a commercial artist, as an enthusiastic weekend painter, and as another potential transcendentalist in his views on art and the spirit.

And finally, Francis Hans Johnston (1888–1949), known as Frank but soon to change his name to Franz, was a Torontonian, a gifted and versatile artist whose ability to work quickly and to create attractive designs was much admired. He had served briefly in the Canadian War Memorials program at home, with startling and large paintings of airplanes. He would leave the Group shortly after the initial exhibition to head the School of Art in Winnipeg, Manitoba. Soon he was highly critical of the Group and against most 'modern' art in any form. He organized exhibitions of his work, two or three hundred canvases at a time, at commercial

venues like department stores and, unlike his colleagues, sold extremely well, a point that irked Jackson and others who believed that he had sold out by casting aside the desire to develop a strong and vibrant aesthetic.

Missing from the gathering, and much missed, was Tom Thomson (Thomas John Thomson, 1877–1917), who would have been, with MacDonald, one of the two eldest members. His was certainly the unseen presence. Like all the others (except Harris), Thomson had been a commercial artist and had joined their weekend sketching trips. In about 1911–12 he had become more ambitious about his painting and had emerged as a major talent. His attachment to the lakes, rocks, and forests of Algonquin Park, where he went for the first time in 1912, was infectious, and soon he and his friends were camping and travelling throughout Algonquin. In Toronto, Thomson shared a room in the Studio Building with Jackson and then Carmichael before settling into his own less expensive studio in a shack behind it. Thomson had been the inspiration of all the artists gathered at Harris's before his untimely drowning in Canoe Lake, Algonquin Park, only thirty-two months earlier. Later, in *The Story of the Group of Seven*, Harris wrote of him:

> *I have, in my story of the Group, included Tom Thomson as a working member, although the name of the group did not originate until after his death. Tom Thomson was, nevertheless, as vital to the movement, as much a part of its formation and development, as any other member.*[4]

Thomson learned an enormous amount from Harris and MacDonald and Jackson, and then they learned an enormous amount from him – a classic case of the student becoming the teacher. The artist David Milne offered his assessment of Thomson in a letter to H.O. McCurry of the National Gallery of Canada in 1930, shortly before the Group announced its dissolution: 'Your Canadian art apparently, for now at least, went down in Canoe Lake. Tom Thomson still stands as *the* Canadian painter, harsh, brilliant, brittle, uncouth, not only most Canadian but most creative. How the few things of his stick in one's mind.'[5]

■

THE MEMBERS OF the Group of Seven were already well-respected figures in the Canadian art world on that night in 1920. Their work had been purchased by governments, some had been War Artists, nearly all reviews of their exhibited work had been extremely positive and people were ready to accept, for various reasons, their ambitious renditions of the Canadian landscape. Moreover, officials at the National Gallery of Canada, especially the director Eric Brown, had supported the work of these men since Brown's arrival in Canada in 1910 and helped to win approval for them. The gallery had purchased a good number of their paintings, as had other public galleries and institutions. Only the paucity of individual collectors meant that sales were not sufficient to allow all the artists to make their living solely by painting, and they nearly all had families to support. Consequently, Carmichael stuck to his job as a commercial artist, MacDonald and Lismer taught at art schools or ran education programs at public galleries, Varley taught and sought out portrait commissions wherever he could; only Harris, privately wealthy, and Jackson, a bachelor, managed to paint full time. At a critical juncture, Thomson and Jackson each got financial support from Dr James MacCallum, a Toronto ophthalmologist, to give them time to paint, but they also earned their way with sales of pictures. While none was rich, other than Harris, neither were any of them poor, including Thomson, another bachelor, who was able to sell several of his large paintings; and certainly none of the Group lacked for materials, a studio, or enough income on which to get by. That changed somewhat for several of the Group in the 1930s, but in 1920 times were expansionary and good.

The formal creation and naming of the Group of Seven occurred right in the middle of the twenty-five-year period during which these artists were most active and influential. As early as 1908, some of them had started to gather regularly to share their ideas and ambitions for Canadian art. They had worked together as commercial artists at Grip Limited, then at Rous and Mann, and at other design firms in Toronto. On weekends they had gone on sketching trips together to Lake Simcoe, Lake Scugog, Haliburton, and Muskoka, expanding their artistic vocabulary and stretching their imaginations. By 1920 they were all long-standing members of the Arts and Letters Club, where they met almost daily for lunch and where they contributed to the club's publication, *LAMPS* (which stood for Literature, Art, Music, Painting, and Sculpture). They also helped to adorn the building acquired for the club that year with

murals and they arranged its exhibition program. MacDonald called the club 'a blessed centre for me in this grey town.'[6] The men were, on average, approaching forty years of age, 'young Turks' no longer, but all fervid art enthusiasts. They believed in a distinct Canadian art and planned ways to promote a Canadian approach to art and design.

In the year or so before the First World War, Thomson, Harris, MacDonald, Jackson, Lismer, Varley, and Carmichael had become known informally in art circles as the 'Algonquin School' for their bravura paintings of 'The North.' Hung among the group shows of the various art societies they belonged to, their works stood out from the academic and European subjects produced by others. These painters of 'The North' were riding the wave of patriotism that accompanied Prime Minister Wilfrid Laurier's huge expansion of Canada in the century's first decade. With Laurier, the Group's members believed that the twentieth century belonged to Canada. They were ready to shuck off what Harris called 'the gloom of a colonial attitude.'[7] The First World War had given a strong impetus to the search for a Canadian identity. The groundwork was laid and the basic intention was clear. What was needed was a plan to make a major statement and convert Canadians to an awareness of their own land through a made-in-Canada aesthetic. So when they met on that night in 1920, the artists saw that the omens for a major crusade were propitious.

This movement was planted in ground that was already fertile. The Toronto artists Paul Kane (although born in Ireland, he grew up in Toronto) and Frederick Verner (born in Sheridan, Ontario) had earlier traversed the continent to record the native cultures before their anticipated disappearance, and to depict the scenery; later, the Canadian Pacific Railway had commissioned photographers William Notman and Alexander Henderson and artists such as William Brymner, John Fraser, Lucius O'Brien, C.W. Jefferys, and J.W. Beatty to capture the western landscape – especially the Rockies – on canvas. And as the future members of the Group of Seven were becoming acquainted with one another, Curtis Williamson, Fred Brigden, J.W. Beatty, C.W. Jefferys and others were already staking claims that were similar to the Group's, while a Canadian form of expression was being promoted by the short-lived Canadian Art Club in 1907. Other artists, according to Newton MacTavish in his 1925 book *The Fine Arts in Canada,* 'began to paint Canadian subjects with the vigour and breadth that is characteristic of the country.'[8] Emily Carr (1871–1945), a brilliant painter from Victoria, British

Columbia, had certainly flown her unmistakable colours early on, but then retreated into inactivity, discouraged by the indifference she received for tackling Canadian subjects in a new way. In Montreal, Prudence Heward and Anne Savage were also making headway with Canadian expression against the entrenched attitudes that had so exasperated Jackson earlier. Several capable artists, theoretically, could have become members of the Group, insofar as shared objectives were concerned, but gender, the politics of art, and the differences between generations and personalities doubtless played a role in excluding various artists from receiving an invitation to Harris's house on that decisive night.

Members of the future Group had already seen and painted a lot of geography by 1920. Their weekend painting trips to areas within easy reach of Toronto set a pattern for exploration. Harris had painted in Haliburton and the Laurentians, and MacDonald had visited Georgian Bay, Algonquin Park, Mattawa, and Magnetawan by 1910. Over the next few years the spark of possibility developed into a blaze of confident and intense activity, as the arrival in Toronto of Carmichael and Lismer in 1911 and of Varley in 1912, the sudden explosion of work from Tom Thomson beginning in 1912, and then the arrival of Jackson in 1913 all added energy to the fledgling movement.

In the fall of 1914 Thomson, Jackson, Lismer, and Varley were all painting together in Algonquin Park – the largest number of the friends to go on a painting trip together, except for once in Algoma, when again four members were together.

Then, just as the conditions for a breakthrough arrived, and the momentum for a vigorous movement reached a critical point, war broke out in the autumn of 1914 and put everything that might have happened on hold. 'Had it not been for the war, the Group would have been formed several years earlier,' Jackson wrote, 'and it would have included Thomson.'[9] Not until after everyone had begun to recover from the war and from the dispiriting death of Tom Thomson in 1917, did the band of friends rearticulate their ambitions for Canada and Canadian art.

■

LAWREN HARRIS

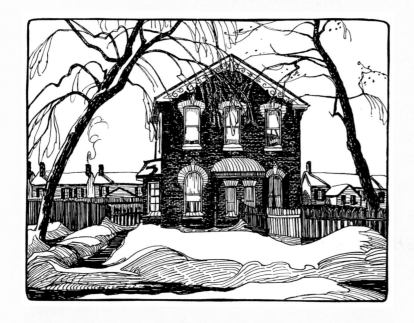

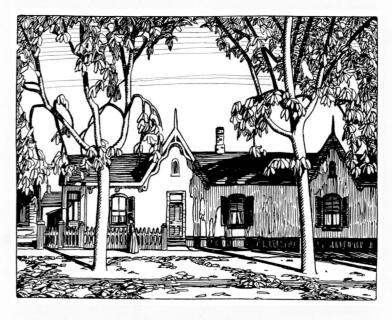

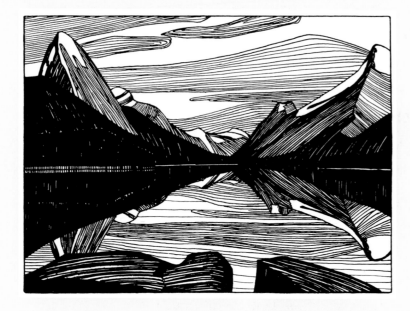

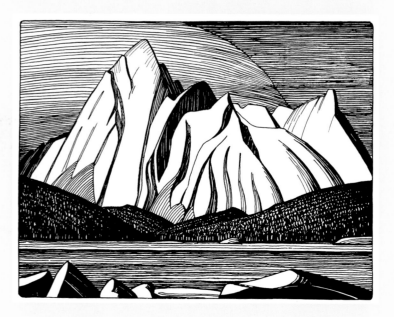

Winter in the City

Maligne Lake, Jasper Park

House, St. Patrick Street

Mount Samson, Jasper Park

LIKE MISSIONARIES, the Group wanted to convert skeptics into believers. The text of their sermon was that the artistic salvation of Canada required art that was all-Canadian. They believed that European subjects produced by Canadian academic artists, and even Canadian subjects produced by artists in a European style, were not fit for a young country that wanted to express its own identity. In a typically Canadian way, they made no frontal attack on the Royal Canadian Academy or on other conservative bodies. They held the door open to other artists with like views, and they were socially responsible, serious, fervent, egalitarian, and sensitive to the concerns of ordinary working people. They believed that Canada should develop its own distinct approach to art education, to industrial design, and to the interaction among the various arts. Theirs was 'not a secession'; no violent revolution, no insult to tradition. Nor did their campaign bring in unwelcome foreign propaganda – forms of expression imported to bring Canada up to date – as the explosive Armory Show of avant-garde European art had done in New York in 1913. Rather, the Group of Seven relied mostly on art forms that were already in use commercially, and on their record of more than a decade of painting 'the spirit of the North.' They proposed progress, advancement, and development, not revolt, rebellion, and revolution. They painted, they exhibited, they wrote, they published, they illustrated, they lectured and talked, they persuaded curators and critics, and they inspired children. They were deep in a process which Harris called 'finding our emotional bearings'[10] as artists and as a nation. Something was being created and improved; nothing was being destroyed or taken away.

Two aspects of the Group contributed to their success then, and the same factors continue to keep their reputations alive now: their identification of 'The North' as a touchstone for Canadian sensibilities – 'the true north, strong and free'; and the conviction that their appeal to ordinary-thinking Canadians would be acceptable and accepted.

With respect to the idea of 'North,' its boundary changed as time went by. At first, the 'North' was not much farther away than Lake Simcoe and Orillia, a short distance from Toronto. Then, in the years before the First World War, the threshold of the 'North' moved to the more distant tracts of Algonquin Park and Georgian Bay, where many people had cottages and spent their summers, often with well-developed services and modern facilities. To paint

this landscape was to pick an easy target, as David Milne pointed out in a letter to Donald
Buchanan at the National Gallery in 1930:

> *Very few people are interested in painting aside from representation ... Tom Thomson isn't*
> *popular for what aesthetic qualities he showed, but because his work is close enough to*
> *representation to get by the average man; besides his subjects were ones that have pleasant*
> *associations for most of us, holidays, rest, recreation. Pleasant associations, beautiful sub-*
> *ject; beautiful subject, good painting! Then in Canada we like our heroes made to order*
> *and in our own image. They mustn't be too good and above all, not too difficult.*[11]

As the war was concluding, and two years before the Group was formally created,
the 'North' shifted again, first to the more remote Algoma district, north of Sault Ste Marie
at the east end of Lake Superior, which Harris first scouted with James MacCallum in 1918, and
then to the north shore of Lake Superior – all this still in Ontario. The East Coast – the Gaspé,
Newfoundland, and Labrador – were tackled by Harris and Jackson in 1921. The Canadian West
with its vast plains and rugged mountains was on the agenda in the mid-1920s. And a few
years later in 1930, when Harris and Jackson went to the Arctic, the whole country had been
appropriated by their painted vision of a northern nation, embracing a vast geography and a
terrain that was spread from coast to coast to coast; a vision that defined Canada as different
from anywhere else.

In his writing Harris was the most articulate and persistent exponent of this idea of
Canada as 'a northern nation.' 'We live on the fringe of the great North across the whole
continent,' he wrote in *The McGill News,* 'and its spiritual flow, its clarity, its replenishing power
passes through us to the teeming people south of us.'[12] Harris claimed that Canadians were
'cleansed by the pristine and replenishing air which sweeps out of [the North].'[13] Further, he
believed that this power influenced Canadian art: 'This emphasis of the north in the Canadian
character that is born of the spirit of the north and reflects it, has profoundly affected its art,
and its art in turn, clarifies and enhances the quality of Canadian consciousness.'[14] The idea
was provocative, yet Harris made it an appeal to national pride:

> *Through our own creative experience we [the Group] came to know that the real tradition*
> *in art is not housed only in museums and art galleries and in great works of art; it is innate*
> *in us and can be galvanized into activity by the power of creative endeavour in our own*

day, and in our own country, by our own creative individuals in the arts. We also came to realize that we in Canada cannot truly understand the great cultures of the past and of other peoples until we ourselves commence our own creative life in the arts. Until we do so, we are looking at these from the outside.[15]

Another dominant strain in the philosophy of the Group's members was spiritualism. All were admirers of the transcendentalist writings of Americans Ralph Waldo Emerson and Henry David Thoreau, and all found that their attraction to the natural world gave rise to profound ideas about the basis of life and, especially, to the spiritual dimensions of human life. The urge to find the extraordinary, or to treat the ordinary in an extraordinary fashion, and to push past the superficial or decorative to the deeper meaning of nature was a compelling idea among them. To catch and convey both spirit and shape of a subject was a tantalizing challenge. In an allied vein, the ideas of theosophy were studied, particularly by Harris, but also by Lismer, MacDonald, Carmichael, and Varley. Thomson was a keen reader of poetry and doubtless Harris gave him essays and books on theosophy to pore over. The Russian spiritualist Madame Blavatsky, a founder of the Theosophical Society in New York, which promoted the study of eastern religions, a universal brotherhood, and the release of the latent potential in human energy, was also read avidly by the members.

All these ideas and attitudes drew members of the Group into a wider circle of American artists such as Arthur Dove, Georgia O'Keeffe, and Marsden Hartley; Northern European symbolists such as Wassily Kandinsky (Russia) and Ferdinand Hodler (Switzerland); Scandinavian painters such as Edvard Munch, J.F. Willumsen, Karl Nordstrom, and Helmer Osslund; and Piet Mondrian from Holland. The spiritual aspect of the Group's thinking re-ignited the banked fires of Emily Carr's ambitions and inspired her to return to painting after a long hiatus. This remarkable painter had studied in San Francisco and in France, and then, after painting the native villages of the northwest coast in a bold and contemporary fauve style, had given up her professional life, in despair at the isolation and lack of recognition. She regained her pride as an artist in 1927 when she travelled to Toronto and Ottawa and met Harris, Lismer, Jackson, and MacDonald, and had her work exhibited by the National Gallery of Canada. Her enchantment with Harris's paintings, and the encouraging letters he wrote to her over the next few years, prompted her exploration of theosophy (although she preferred

A.Y. JACKSON

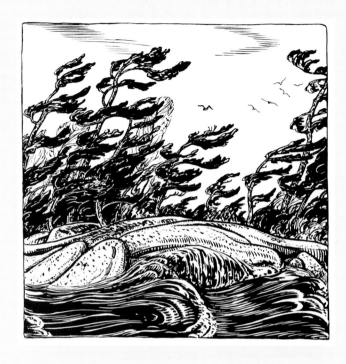

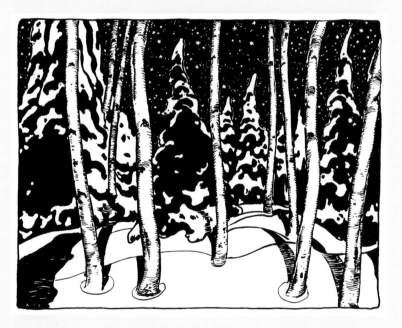

Pine Island

Lake Superior

Winter in Quebec

Winter Night

the transcendentalism of Thoreau and Walt Whitman) and triggered a change in her painting to work that was more powerful in its forms and aesthetic organization.

The priesthood that the Group became was deliberate and responsible. Artists had their role and their obligations to their congregations, as Harris explained:

> *No man can roam or inhabit the Canadian North without it affecting him, and the artist, because of his constant habit of awareness and his discipline in expression, is perhaps more understanding of its moods and spirit than others are. He is thus better equipped to interpret it to others, and then, when he has become one with its spirit, to create living works in their own right, by using forms, colours, rhythms, and moods, to make a harmonious home for the imaginative and spiritual meaning it has evoked in him.*[16]

'The whole environment of the artist in Canada was different from the environment of the artist in England and in Europe,' Harris wrote, looking retrospectively at what the Group had collectively achieved, and why. He noted that 'in Canada, there were no great collections of old or modern masterpieces to study as a guide to creative adventure; and the art which was then accepted and valued by our wealthy patrons and connoisseurs – for there were such – was all of it imported, but none of it notable: Dutch windmills, canals, and peasant house interiors, Barbizon leftovers, and tidy, circumspect English pictures.'[17] In this near-vacuum, the Canadian artist turned, perforce, to 'the power and clarity and rugged elemental beauty of our own land'[18] for inspiration, guidance, and subject matter.

This is the point at which the commendable and honest idea of 'North' began to melt into the fog of propaganda. Members of the Group, and they were nearly all guilty of it, claimed that their wellspring and the forms of their art came not from art but from the land itself. Not only was a European style inappropriate for depicting the Canadian landscape but, so the Group's mantra ran, the landscape dictated its own style, unaffected by the forms of art learned or inherited from history or elsewhere. Thus they were able to claim that Thomson was completely innocent of 'outside' influences, a 'natural,' an 'original' talent, uncorrupted by Europe and therefore totally Canadian. Harris again:

> *The source of our art then is not in the achievements of other artists in other days and lands, although it has learned a great deal from these. Our art is founded on a long and growing love and understanding of the North in an ever clearer experience of oneness with*

the informing spirit of the whole land and a strange brooding sense of Mother Nature

fostering a new race and a new age ... So the Canadian artist was drawn north.[19]

The next step in this argument, describing an art that not only was indigenous but which had little or nothing to do with European or other sources of art, was the most misleading, and it was one in which all members of the Group indulged. Jackson described the first MacDonald painting he saw as one that 'showed an artist with no knowledge of any school,'[20] which, although meant as a compliment, set MacDonald's extensive education and experience at little worth. Each member of the Group, and Jackson most especially, owed a great deal to European styles. Yet European training, so they frequently preached, meant a European technique usually applied to a European subject, none of which was apt for a young, new, and distinctly different Canada. That Canadian collectors, few as there were, would buy European paintings was, therefore, a natural consequence of the colonial prison in which they lived. What was needed was Canadian training, a Canadian technique, and a Canadian subject. The Group was convinced that if Canada was depicted by Canadians for Canadians, collectors of Canadian paintings, public and private, would emerge. They were right, of course, but wrong only in estimating how long it would take for the practice to catch on sufficiently to allow talented artists to make a reasonable living.

The question posed by the Group of Seven, therefore, was whether Canada would recognize its own character and identity and develop a form of artistic expression suitable to the country and its people. An allied argument, which put them directly in touch with a large segment of the population, was that the amateur artist was important because, rather than learning and following academic rules, he or she was moved rather by passion and creative instinct, inspired by love of country, nature, and spirit.

The tactics of the Group's campaign to bring their art to the people were brilliantly exe-cuted. They created travelling exhibitions that went into communities across the country and into the United States. While the Royal Canadian Academy, which believed itself to be the only authority to select exhibitions, complained to the government that it was given insufficient funds to do so, the Group of Seven dug into their own pockets, hustled support from their friends, and developed warm relations with librarians, community leaders, and teachers so that their work could find a place and an audience in cities, towns, and villages all across the

country. Moreover, they openly promoted the idea of purchasing new Canadian art for public institutions. Hart House at the University of Toronto, where Harris and other eminent artists acted as advisors to the Art Committee, began its collection in 1922 with a 1921 canvas by A.Y. Jackson (*Georgian Bay, November,* p. 288). Tentatively but bravely, libraries, schools, and community museums began to follow suit.

The Group of Seven wanted their work to be accessible and it became more so, beginning in 1928, when the National Gallery published reproductions of some of their paintings and sent them to practically every school in Canada. These prints were accompanied by material written by Arthur Lismer for primary and secondary school teachers. Postcard-size versions were also included, so that each student could collect Canadian art for a few pennies. In the 1940s, the National Gallery again took the lead by engaging the printing firm of Sampson-Matthews to make larger silkscreen reproductions for factories, barracks, government and military offices, and so on, to inspire those engaged in the war effort. Later the project was extended so that schools, offices, and homes could all have Canadian landscapes by Canadian artists, most of them by the Group of Seven and Tom Thomson. The Group of Seven's vision of Canada, therefore, is what several generations of Canadians grew up with. The most active members in this many-faceted campaign were Harris, Lismer, Jackson, and MacDonald.

All the members of the Group drew prolifically and constantly in pencil and ink. Some of them (Varley, Carmichael, Casson, FitzGerald, and Johnston) were exceptionally adept at watercolour, a difficult medium. Many of them were expert at woodblock and linoleum prints, and familiar with printing methods from their work in commercial art. These less expensive forms of art extended the reach of their images into many areas that were impossible, for practical reasons, for oil paintings. The graphic clarity of their drawings made MacDonald, Carmichael, Harris, Lismer, and Varley superb as book or magazine illustrators.

The Group of Seven also wanted to have an impact on commercial art, industrial design, education, and publishing. They believed that an artistic sensibility was one that had an association with music, theatre, and literature, as their involvement with poets, musicians, actors, and writers at the Arts and Letters Club had proved. This interrelationship could have an impact on a whole society, giving everyone a sense of belonging, identity, and worth.

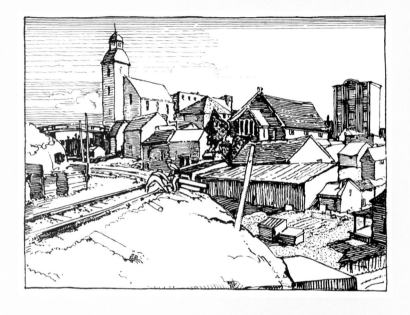

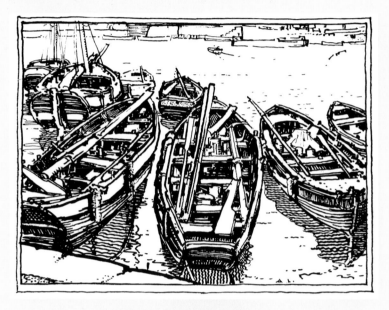

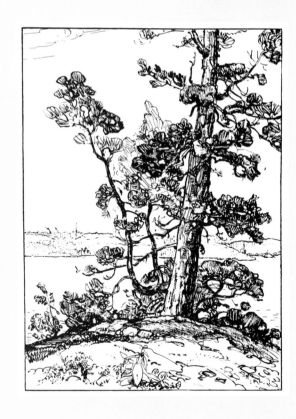

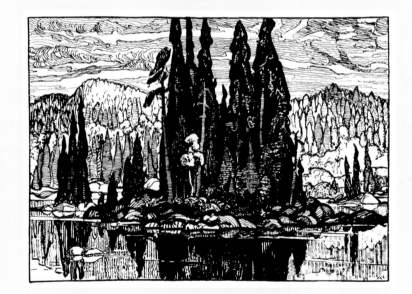

A Northern Town

Pine

Small Craft

Islands of Spruce

Their aim was to put their art, and the arts, at the centre of Canadian life. To that end, Harris, Jackson, MacDonald, and Lismer all designed productions for director Roy Mitchell at the Hart House theatre after it opened in 1919; MacDonald led his associates to assist with the mural decoration of St Anne's Church in Toronto; and nearly all members of the Group illustrated books by Canadian authors. Many of the members contributed to *Canadian Forum,* an influential publication of the political left, either with polemical or patriotic articles or with drawings and illustrations. They had a natural alliance with working people as well as with white-collar professionals. In one striking example, Lawren Harris drew a powerful ink drawing of a Glace Bay, Nova Scotia, miner's wife and child suffering from poverty, insecurity, and fear; his paintings of the miners' houses (pp. 172–5), like some of his earlier paintings of 'The Ward' in Toronto, are disturbing reminders of the inequalities in society. Most of the paintings of the Group, however, were not overtly political in their orientation; the general strike of 1919 in Winnipeg, for example, went unrecorded by the Group.

Despite their somewhat mischievous claim (usually Jackson when he was in a belligerent mood) that they were the first to discover much of the land (despite the work of Kane, Verner, and Krieghoff), the first to paint it in a truly Canadian way (despite the work of Jefferys, Brymner, O'Brien, Maurice Cullen, and J.W. Morrice), and the first to create a national school of art (and to do so without the knowledge, help, or influence of any foreign art traditions), the Group was at the same time finely tuned to the history of the country, even though their emphasis was on the present and the future. Jackson did acknowledge that J.W. Beatty had painted the North, 'but his academic training restrained him. The atmospheric approach was not effective.'[21] Beatty's style, Jackson was saying, was doomed to failure because it was European in origin.

■

ALTHOUGH THE Group's aims were lofty and the means by which they tried to achieve them clever and practical, the immediate purpose of the meeting at Lawren Harris's that March night in 1920, and the primary reason for their formation into a Group, was to exhibit their paintings together (ten each) in order to make a coherent statement about art and its place

and purpose in Canada. In the large annual shows of the Royal Canadian Academy or the Ontario Society of Artists, their paintings were scattered randomly and did not make the impact they wanted. Their purpose certainly was not new, since these men had known each other for more than ten years in some cases and during that time had already shared ideas, techniques, philosophies, and their lives as artists. The proposed exhibition, instead, was a culmination of a collective thrust that had been checked by the advent of the First World War and was now overdue. Their missionary goal was to convince Canadians to accept 'Canada painted in her own spirit,' as Harris had said about MacDonald's work when he first saw it a decade earlier.

The Group of Seven showed together eight times at the newly expanded Art Museum of Toronto (now the Art Gallery of Ontario) between May 1920 and December 1931. With one exception, they always invited other artists to contribute to their shows – as many as seventeen and twenty-five colleagues, respectively, in their last two exhibitions in 1930 and 1931. The Group's number diminished to six in 1920, when Frank Johnston left after the first show, then went up to seven again in 1926 with the addition of A.J. Casson, then to eight in 1929, when Edwin Holgate joined, and finally to nine when an invitation was extended to Winnipeg's LeMoine FitzGerald in 1932. The Group disbanded in 1933, having embraced a total of ten members (and in their hearts Tom Thomson) in its fourteen years. Their eldest member, MacDonald, had been born in 1873; the last living member, Casson, died in 1992, giving the Group a total span of nearly 120 years.

The first exhibition by the Group of Seven was held in one room of the Art Museum of Toronto – the planned seventy canvases having turned into fifty-four canvases, sixteen pastels, and forty-four sketches by the seven members, plus seven works invited from Randolph Hewton, Robert Pilot, and Albert Robinson, all Montreal friends of Jackson, who were sympathetic to the Group's views. A brochure and exhibition list, which sold for ten cents and was probably designed by Carmichael, laid out some of the reasons why the artists had banded together and presented their aims for Canadian art. 'The group of seven artists whose pictures are here exhibited have for several years held a like vision concerning Art in Canada,' the text read. 'They are all imbued with the idea that an Art must grow and flower in the land before the country will be a real home for its people.' They paraphrased John Ruskin (without

credit) to the effect that 'the greatness of a country depends upon three things: "its Words, its Deeds, and its Art."' They did not continue the quote: 'And the most important of these is Art.' The little brochure also extended an invitation: 'The artists invite adverse criticism. Indifference is the the greatest evil they have to contend with.'

The show was of portraits, urban scenes, gardens, Nova Scotia fishing villages, and war paintings. A few were of Algoma, which had recently been a prime painting ground, and Jackson showed his *Terre Sauvage* (p. 381) of 1913, 'perhaps the most radical painting in the show,' in his opinion.[22] Six paintings were sold – the prices ranging from $25 (for a sketch by MacDonald) to $1000 (for a canvas by Harris). It was not a cataclysmic or even controversial exhibition, but it was an unequivocal statement about Canadian art that had not been made in such a concentrated form before.

The second exhibition, a year later, was really a 'Group of Six,' for it was without Johnston or guests. The National Gallery of Canada bought four works. The accompanying list of works had a short word of advice: 'The pictures must speak for themselves. Unfortunately, pictures are not always allowed to speak for themselves. The spectator frequently brings with him a preconceived notion of what a picture should be like. This means that he talks to the pictures instead of letting them talk to him.'

For the third exhibition in 1922, Percy Robinson, an amateur painter and a professor at the University of Toronto, was invited as a guest. The ten-cent handout was defensive: 'It is as impossible to depict the autumn pageantry of our northern woods with a lead pencil as it is to bind our young art with the conventions and methods of other climates and other ages … Artistic expression is a spirit, not a method, a pursuit, not a settled goal, an instinct, not a body of rules. … Art must take to the road and risk all for the glory of a great adventure.' There were no sales, but the exhibition travelled to Sarnia, Fort William (now part of Thunder Bay), Brandon, Moose Jaw, Calgary, Edmonton, Vancouver, and Victoria, and then went on to centres in the United States, including Kansas City, Milwaukee, and Brooklyn.

The next two years were occupied with preparations for London's British Empire Exhibitions of 1924 and 1925, better known as the Wembley Exhibitions after their London location. The Canadian section, organized by the National Gallery of Canada, was to be ambitious and the choice, in the opinion of Eric Brown, had to reflect the new art of Canada. For

J.E.H. MacDonald

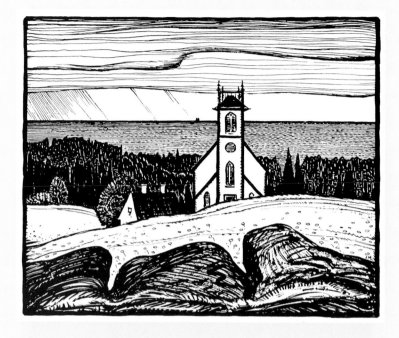
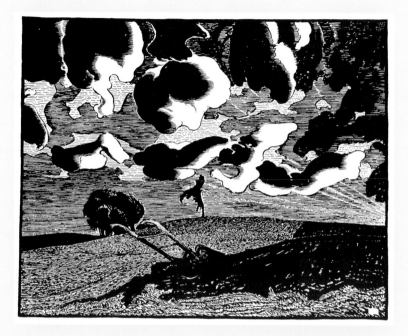
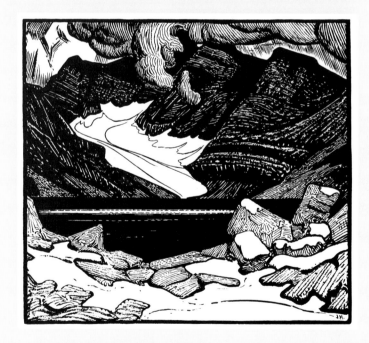
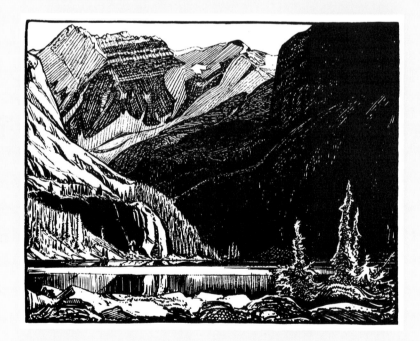

Church by the Sea, N.S.

A Glacial Lake, Rocky Mountains

Autumn Sunset

Lake O'Hara, Rocky Mountains

the 1924 show, however, the jury of members of the Royal Canadian Academy chose only twenty paintings by the members of the Group of Seven and Tom Thomson, out of more than a hundred works, and the same jury chose almost the same proportion of work for the sequel exhibition in 1925. Despite this handicap, it was the paintings of Thomson and the Group which stole both shows and were hailed by the British critics. The Tate Gallery purchased Jackson's *The Entrance to Halifax Harbour* (p. 111) for its permanent collection, thus vindicating the Group's sense of justice and anointing them in the eyes of Canadians.

The fourth Group of Seven exhibition was in 1925, three years after the third, when Albert Robinson was invited again. This exhibition had the distinction of showing drawings, as well as paintings, and a portfolio of reproductions of drawings, published by Rous and Mann in a limited edition of one hundred, by five of the members (Carmichael had no work in it). Each portfolio reproduced four drawings, one to a sheet, for each member, and sold for $12, giving concrete evidence of the Group's determination to make their work accessible to a larger public. The twenty works in the portfolio are reproduced here together for the first time since 1925 (pp. 24, 28, 32, 36, and 40).

In 1926, for the fifth exhibition, nine guest artists were invited to contribute. One of them was Alfred Joseph Casson (1898–1992), a young and affable commercial artist from Toronto, who was invited to become a member to replace Johnston. He was working as Carmichael's assistant at Rous and Mann and was in awe of the much older men. Casson certainly did not add novelty or controversy to the Group; one reviewer claimed that 'his canvases will form resting places for those visitors to the present show who cannot understand Lawren Harris.'[23]

The sixth exhibition, in 1928, had fifty-seven paintings by Group members and thirty-seven by seventeen invitees. In March of the following year Edwin Headley Holgate (1892–1977), a Montreal painter, was invited to become a member, the ninth. Holgate, who had served in the military, had been instrumental in forming the Beaver Hall Group (it had nineteen members initially) in Montreal in 1921, in emulation of the Group of Seven.

Exhibition seven, in 1930, at what was by then the Art Gallery of Toronto, integrated the work of thirteen invitees with that of what was now eight members. Emily Carr in distant Victoria was one of the invited guests; nearby, David Milne, living obscurely in Weston, a sub-

urb of Toronto, had not contacted Harris, MacDonald, or Jackson, as Harry McCurry of the National Gallery had suggested he do, and thus remained uninvited.

The final show opened on 4 December 1931 with twenty-five invited artists showing with the eight members. In May 1932, Lionel LeMoine FitzGerald (1890–1956), a painter and teacher at the School of Art in Winnipeg, was invited to be a member, thus becoming the tenth and last person to join the Group of Seven. FitzGerald was born and raised in Winnipeg and spent his entire professional life there. Later that year MacDonald, not yet sixty, died, depriving the Group of its most versatile talent, its chief polemicist (although they were all adept in that department), and its most poetic spirit. Earlier that year MacDonald had, at last, at age fifty-eight, been elevated from associate to full membership in the Royal Canadian Academy, although the honour had been meanly diminished by the refusal of the Academy to accept any of his paintings as his formal deposit or 'Diploma Work.' Nothwithstanding this myopia on the part of the Academy, all the members of the Group of Seven, except for Harris (and Tom Thomson), became members of the Academy, since it was still considered by them an honour, however uneasy they may have been about the Academy's ultra-conservative policies. Jackson, however, resigned in 1933, the year the Group disbanded, because he was 'not in sympathy with the Academy's policies.'[24] By this time their average age was over fifty.

The Group of Seven had been a potent force for nearly a quarter of a century when they decided to disband in 1933. By the time the formal creation of the Group had taken place in 1920, all the 'revolution' that we associate with the Group of Seven had already occurred. The direction had been set in the decade before, the goal was already within sight, the aesthetic parameters had been worked out, the subject matter had been defined, the techniques had been practised, and the polemical battle had been joined and, for the most part, won. After the first exhibition there was a last trip to Algoma, and then only the Far West and the Arctic remained to be committed to canvas. When they dissolved their association, the Group of Seven (as it still called itself, despite the fluctuation in membership) wanted to make way for a broader range of expression, a more democratic system of exhibiting, and greater opportunities for younger artists. This was to be undertaken by the Canadian Group of Painters, a much larger coalition of artists who generally espoused the views of the Group of Seven. Of the Canadian Group, many had been invitees at earlier shows – Carl Schaefer, Pegi Nicol

MacLeod, Will Ogilvie, George Pepper, Paraskeva Clark, Yvonne McKague Housser, Charles Comfort, W.P. Weston, Prudence Heward, Isabel McLaughlin, E.J. Hughes, and Kathleen Daly, among numerous others. The history of the Group of Seven had already been written by F.B. Housser in his adulatory book *A Canadian Art Movement* of 1925, published just after the members' paintings had been widely celebrated at the great Wembley exhibitions in England. Further, writers like Bertram Brooker were pointing out that 'the Group of Seven has become an orthodoxy and now, I suppose, the public will start buying their pictures.' He went further in reviewing the 1930 exhibition:

> *The present show at Toronto rings the deathknell of the Group of Seven as a unified and dominant influence in Canadian painting ... They have themselves ceased to experiment. Moreover, they are much less productive ... Jackson and Harris, the only two of the Group who have much time for painting, are represented mostly by smaller paintings than usual, all landscapes, and of a type that one has come to expect. The experimentation is over, the old aggressiveness has declined.*[25]

■

THE MYTHOLOGY surrounding the Group of Seven has a powerful way of surviving, as the legends around them are burnished by successive generations: how they battled hostile critics, collectors, and curators; how they painted such a wild, unsettled Canada that some politicians (and critics) thought they would discourage immigration; how they developed special skills in the bush and discovered Canada by travelling into the virgin territories of the North, the West, and the East; how they painted in an original style, uninfluenced by European models and traditions, and so on. None of these things is entirely true. Besides, the Group of Seven does not need the trappings of mythology to sustain their place in our history and in our hearts. As we searched for our national identity through the last half of the twentieth century, we seemed to need the mythology more than they.

Much has been made of the criticism that the Group of Seven received, but most of it has been exaggerated and taken out of the context of their largely positive reception. The 'conservative stock response,' as Northrop Frye called it, came largely from the critic Hector

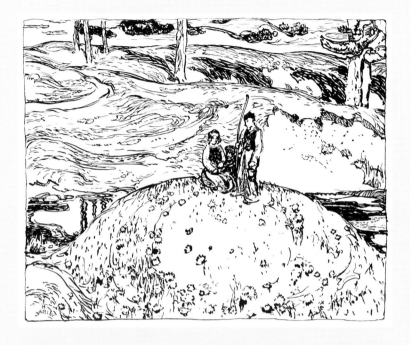

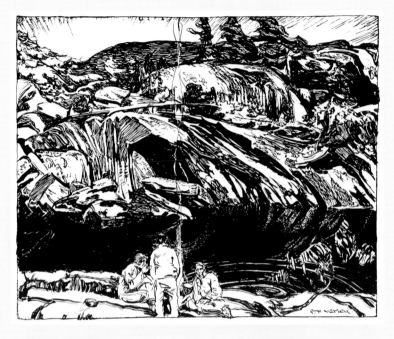

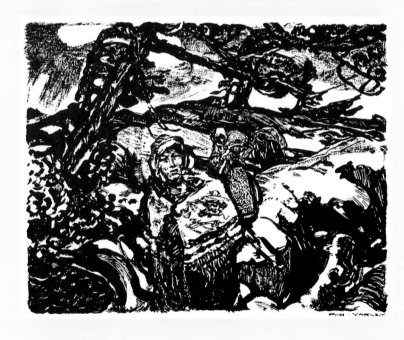

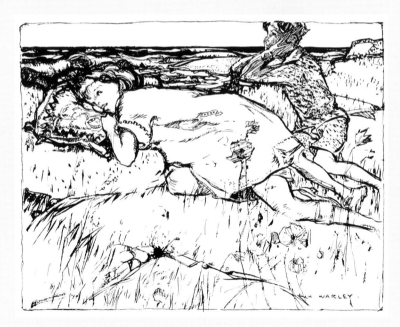

Summer Time

A Wind-Swept Shore

Georgian Bay

Children

Charlesworth in *Saturday Night,* who had at first been a strong supporter but then abruptly changed his mind. Once he went so far as to suggest that the Group could no more 'excuse their vagaries' as artists by claiming to be one hundred per cent Canadian than the Ku Klux Klan could by claiming to be one hundred percent American.[26] The other rabid and not-well-informed critic was Samuel Morgan-Powell in Montreal, who was opposed to any form of modern expression whatever, starting with the Impressionists. A journalist at the *Toronto Daily Star* coined the phrase 'hot mush school,' but this was in a humorous and satiric column, not meant as art criticism. Yet even these were isolated and rare attacks. The usually reliable art historian Russell Harper referred to 'reams of bitter denunciation and invective,' and an 'incredible flood of adverse publicity,'[27] although nothing like this can be found in the substantial documentation of the time. Nothing resembling the solid phalanx of criticism aimed at the work of van Gogh, Gauguin, Cézanne, Matisse, Picasso, and Duchamp in the New York Armory Show of 1913 assailed the Group of Seven. What they faced was mild compared with what it might have been, and the reason is that the paintings were not difficult to understand nor radical in their aesthetic premise. Just before the first Group exhibition, Peter Donovan, writing in his satirical column 'Conosoor' in *Saturday Night,* welcomed their innovations: 'These modern chaps always keep three jumps ahead of our comprehension – but we like their daring and enterprise.'[28] Here is a sample by Fred Jacob in the *Toronto Mail and Empire* of 10 May 1919 that is typical of many of the reviews:

> In their work the spirit of young Canada has found itself ... It is not commercial and it is purposed for pure love. It is not ostentatious. It is highly intellectual and poetic and without any debasing appeal to the senses. It is neither gross nor vulgar. It possesses the charm of out-of-doors and the grandeur and dignity of nature remote and supreme.[29]

Dr Salem Bland, the charismatic preacher painted by Harris in 1925 (p. 95), wrote that 'the Group of Seven and the United Church of Canada seem to me to be the two most original and distinctively Canadian things Canada has so far produced.'[30] In describing the Group's paintings, Bland thought that they conveyed 'the Canadian soul ... in these strong and solemn and lonely landscapes ... I felt as if the Canadian soul were unveiling to me something secret and high and beautiful which I had never guessed – a strength and self-reliance and depth and a mysticism I had not suspected. I saw as I had never seen before the part the wilderness is destined to play in moulding the ultimate Canadian.'[31]

Jackson had a nose for publicity and a sharp and often sarcastic pen, as indeed most of the Group did, and was ready to answer the least criticism:

> If [our critics] asked of us more heroic things worthy of a vast and thrilling country – great forests, swirling rivers and endless stretches of hills and plains, and the seasons working their marvellous changes of colour over all – then we could frankly admit that we have accomplished little. But these hardy Canadians look at a painting of a pine or a spruce tree and run all the way home to write to the press about the shock they have received.[32]

Jackson also was particularly protective of the Group's turf later in his life and was vigilant about any incursions that might distract from its place in Canadian art. He was critical of Douglas Duncan, the influential Toronto art dealer and collector, active from 1938 to 1968, mostly because he was jealous of Duncan's concentration on David Milne and other artists, such as Paul-Emile Borduas, Harold Town, and Paraskeva Clark. Jackson was conscious of the politics of art and the coverage of exhibitions by the critics, and he especially noticed when the staff of the National Gallery gave too much attention to non-Group artists.

Where the Group of Seven's real battle lay, however, was not with the public, the press, institutions, or young artists. Rather, it was with the Royal Canadian Academy, which saw in the Group a challenge to its own hegemony in the control of art purchases and exhibitions. The Academy had been instrumental in agitating for the creation of the National Gallery in the latter part of the nineteenth century, and when the Gallery was opened for business in 1880, the Academy expected to control its two essential functions, acquisitions and exhibition selection, which it did for several decades. When the staff of the National Gallery under Eric Brown (director, 1910–39) decided independently on these matters, or worse, favoured members of the Group, as Brown had tried to do with some success for the Wembley exhibitions, the Academicians became incensed. Its members fought back to maintain a grip that their livelihoods, to a degree, depended upon, as did those of the Group of Seven. Members of Parliament were solicited, letters were written, and meetings were held. In the year that the Group of Seven disbanded, 1933, the Academy launched a bitter and tenacious dogfight over the National Gallery's support of the Group, threatening the director by calling for his dismissal. The retrospective view of the Group of Seven's being under attack stems most of all from this confrontation, which dealt with the crucial issues of which artists get into the

national collection, who represents Canada in national exhibitions, who represents Canada abroad, and who gets into the history books. In this scrap the members of the Group of Seven, and Canada, were the winners.

The Group's members were no armchair aesthetes. They moved into the wilderness to confront the elements and the still-unexploited land directly. Lismer caught this urge when he wrote:

> *The typical qualities of such places as the Georgian Bay, Lake Superior, the Laurentians, the Northwest prairies, Rocky Mountains, and the foothills: what grand pictures these call to mind, and what a background for the elemental forces of nature to sport in. The aspects of winter and the fall; the green riot of spring, storm and sunshine, against and on such a setting, are truly of epic grandeur – no timid play of subtleties, but bold and massive design.[33]*

The Group also moved into every corner of society to proselytize, argue, sell, or persuade anyone they could about the importance of art and of their particular vision of its importance to Canada.

The Group of Seven nearly always asked fellow artists to exhibit with them and eventually dissolved the Group in favour of a much larger assembly of artists from across Canada. As they rose in prominence the Group pulled their friends along with them. The influence they wielded, by virtue of their intense activity and their patriotic stance, had a remarkable impact on the policies of the National Gallery of Canada and other art galleries and museums across Canada. They also had powerful friends, such as Eric Brown and his successive Board chairmen, Sir Edmund Walker and H.S. Southam, both of whom realized that the professional staff, not the Royal Canadian Academy, should be responsible for the activities of the gallery. Vincent Massey, who would later become the first Canadian-born Governor General, and other collectors were also supportive of the Group, and they recruited their friends and the organizations with which they were associated, such as the universities and private clubs. The attention the Group received in the United States and at the Commonwealth exhibitions at Wembley in 1924 and 1925 was turned to good account in advancing their cause for living Canadian artists.

The egalitarian approach to art that the Group espoused philosophically did not extend to women artists. Although Jackson was admiring of the women artists in Montreal who formed the core of the Beaver Hall Group there, no women were invited to become members

of the Group of Seven. In later years Jackson would say that Prudence Heward was as good a painter as any of the members, and so she was. Although she, Sarah Robertson, Marion Scott, Anne Savage, and others were, at least, invited to display their work in the Group's exhibitions, they were never considered as equals with the men. One positive thing that can be said about the Group is that they supported the recognition and acceptance of women artists within the prevailing *mores* of the day. Emily Carr, in particular, was re-invigorated by her 1927 visit with the Group in Toronto, and especially by Harris's vision for art in Canada, and returned home, launched anew on what proved to be the most momentous period of her career. Still, the Group would have honoured itself and her by making her, rather than Casson, Holgate, or FitzGerald, a member.

Given the various backgrounds from which the members of the Group came, it is no surprise to find in their work a broad mix of aesthetic ideas that were current in Canada early in the twentieth century: impressionism, by that time nearly fifty years old, which had come chiefly through Jackson; art nouveau and the English arts and crafts equivalent, with their stylized botanical forms and flat decorative imperatives (MacDonald); academic realism; advertising art, with its brash and sometimes crass commercialism, in which all of the Group (save Harris) and their colleagues were either trained or on which they depended for their livelihood; and a faint whiff of an aromatic blend of fauvism, futurism, and cubism that wafted in from Paris or New York through magazines and distant exhibitions. By the time the Group of Seven had its first exhibition in 1920, Europe and the United States had experienced the emergence of fauvism, cubism, futurism, suprematism, and a host of other revolutionary forms of expression; reconciling the history of Canadian art to the history of contemporary art elsewhere is a task that requires a thoughtful gaze into the middle distance and some sleight of hand. 'It rather surprises me,' wrote Bertram Brooker in 1929, 'that our own "moderns" … are not more in sympathy with what "moderns" are doing elsewhere.'[34] To look at art in Canada in the 1920s, one would hardly imagine that Matisse, Picasso, Kandinsky, or even Whistler had ever lived. The Group of Seven style owed a heavy debt to impressionism, to art nouveau, and to some aspects of modernism without being too modernist itself.

Nevertheless, Harris, the most progressive and open-minded of the Group, was not quite

as provincial or ignorant of modern movements as might appear. He formed a connection to the influential Société Anonyme in New York, and in 1927 arranged for its founder, Katherine Drier, to lecture in Toronto on modern art. Harris was a constant explorer, like Kandinsky and Cézanne, and sought out new ideas and new forms of expression throughout his long life. His colleagues settled into predictable routines as painters after 1930; MacDonald, who shared Harris's openness, died in 1932. Harris's paintings after the mid-1930s, however, were non-representational; they are not included in this book since they did not make the impact that his earlier work did. Carmichael, who had left commercial work in 1933 to teach at the Ontario College of Art, also made a tentative foray into abstraction just before he died in 1945 at the early age of fifty-five. FitzGerald too turned to abstractionism, in the early 1950s.

The quarter-century high tide of activity by the Group of Seven that depicted and redefined the people and the geography of Canada, whatever one may think of the aesthetic mix of their work, was spectacular. Their productivity was staggering. They provided the historic anchor that has tied Canada to its past, to its various regions, to its sense of northernness, and to its soul. David Milne, who analyzed their work from his sophisticated perch of two and a half decades in New York – he participated in the Armory Show of 1913, associated with The Eight and other modernists in New York, and had a wide knowledge of art history – was sharply critical of some of the art and artistic practices of the Group of Seven, but even so he readily acknowledged their importance to their society: 'Whatever the value of the Group of Seven in Art, there is no doubt about their value to Canada. Mr Bennett [the prime minister] could very nicely vote the seven a million dollars each, and the country would still be in their debt.'[35] As it has turned out, Milne's was not an extravagant opinion.

Moreover, the Group's paintings imbedded themselves into the country's self-image in ways that were unrelated to the images themselves. In the United States and abroad, the Group of Seven's masterworks became the signature for the land that everyone who had never been here imagined Canada to be like. Canadian children learned about their country and their place in the world through the Group's paintings. When Lismer asked a group of children at the National Gallery if they knew the names of any of the Group of Seven, an enthusiastic boy answered, 'Jack Pine.' Numerous people collected one oil sketch by each of the members; and Carmichael, whose work was hardest to find, became more expensive for

a time because of it. Younger artists trying to make their way in the late 1930s were at first annoyed to find the Group blocking their path, but after the Second World War the Group of Seven became part of history and were admired by their successors for having put Canadian art and artists on the map. Their prices rose, as Bertram Brooker had predicted, and have now reached tentatively into the millions of dollars, a posthumous fulfilment of Milne's appraisal of their worth.

Whether the art of the Group of Seven changed the way Canadians looked at their country during the Group's early ascendancy, or whether the Group was celebrated because that is the way Canadians wanted to look at their country, matters little now. The fact of their historical achievement is unassailable, and their contribution to our sense of nationhood is a matter of record. Although we like to spin stories about their skirmishes with art critics, their intrepid voyages, and their enduring devotion to the landscape, the Group of Seven are not in need of mythologies. Their work stands firmly on its own – powerful, varied, resonant, uplifting, inspiring, and moving. In 1964 Harris summed up their 'great adventure':

> *We lived in a continuous blaze of enthusiasm. We were at times very serious and concerned, and at other times, hilarious and carefree. Above all, we loved this country and loved exploring and painting it.*[36]

■

Notes

1. A.Y. Jackson, *A Painter's Country* (Toronto: Clarke, Irwin, 1958), 116.

2. Ibid., 117.

3. J.E.H. MacDonald, 'Scandinavian Art,' *Northward Journal* 18/19: 9–35; quoted in Charles C. Hill, *The Group of Seven* (Toronto: McClelland and Stewart, 1995), 48.

4. Lawren S. Harris, *The Story of the Group of Seven* (Toronto: Rous and Mann Press, 1964), 7.

5. [c. December 1930], draft, in Milne Family Papers.

6. J.E.H. MacDonald, addressing the annual meeting of the Arts and Letters Club in 1929, quoted in *The Group of Seven: Why Not Eight or Nine or Ten?* Arts and Letters Club of Toronto [1995], 23.

7. Harris, *Story*, 10.

8. Newton MacTavish, *The Fine Arts in Canada* (Toronto: Macmillan of Canada, 1925), 222.

9. Jackson, *A Painter's Country*, 53–4.

10. Harris, *Story*, 8.

11. David Milne, Letter to Donald Buchanan [c. 16 June 1936], draft, 2–4, National Gallery of Canada.

12. Harris, 'Creative Art and Canada,' in *Yearbook of the Arts in Canada, 1928–1929* (Toronto: Macmillan of Canada, 1929), 182; reprinted from *McGill News* 10, No. 1 (Dec. 1928).

13. Harris, *Story*, 11.

14. Harris, 'Creative Art and Canada,' 182.

15. Harris, *Story*, 24.

16. Harris, 'Revelation of Art in Canada,' *Canadian Theosophist* 7, No. 5 (15 July 1926), 86.

17. Harris, *Story*, 10.

18. Ibid., 10.

19. Harris, 'Creative Art and Canada,' 185.

20. Jackson, *A Painter's Country*, 22.

21. Jackson, Foreword in Blodwen Davies, *Tom Thomson* (Vancouver: Mitchell Press, 1967), 2.

22. Jackson, *A Painter's Country*, 54.

23. Quoted in Hill, *The Group of Seven*, 199.

24. Jackson, *A Painter's Country*, 118.

25. Bertram Brooker, 'The Seven Arts,' *Ottawa Citizen*, 19 April 1930, quoted in Hill, *The Group of Seven*, 264.

26. Hector Charlesworth, 'Toronto and Montreal Painters,' *Saturday Night* 41, No. 27 (22 May 1926), 3.

27. J. Russell Harper, *Painting in Canada: A History* (Toronto: University of Toronto Press, 1966), 263.

28. Peter Donovan, 'Conosoor,' *Saturday Night* 29, No. 26 (8 April 1919), 5.

29. Quoted in Hill, *The Group of Seven*, 83.

30. Salem Bland, 'F.B. Housser's Story of the Group of Seven,' *Toronto Daily Star*, 11 Feb. 1927, 6, signed 'The Observer,' quoted in Hill, *The Group of Seven*, 169.

31. Salem Bland, 'The Group of Seven and the Canadian Soul,' *Toronto Daily Star*, 31 Jan. 1925, signed 'The Observer,' quoted in Hill, *The Group of Seven*, 158.

32. Jackson, 'Those Pictures: More Opinions,' letter to the editor, *Ottawa Journal*, 20 March 1926, quoted in Hill, *The Group of Seven*, 233.

33. Arthur Lismer, 'Canadian Art,' *Canadian Theosophist* 5, No. 12 (Feb. 1925), 179.

34. Bertram Brooker, 'The Seven Arts,' *Ottawa Citizen*, 1 Feb. 1930, quoted in Hill, *The Group of Seven*, 259.

35. Letter to H.O. McCurry, 7 Jan. 1932, at National Gallery of Canada and copy at University of Toronto Archives. Additional comments by Milne about the members of the Group and the works exhibited in 1929–31 are quoted in David P. Silcox, *Painting Place: The Life and Work of David B. Milne* (Toronto: University of Toronto Press, 1996).

36. Harris, *Story*, 16.

Icons: Images of Canada

WE DEFINE ourselves as citizens and as a country by the images we think of when we describe our place in the world – what we call 'here.' Although there are no towering firs on the prairies, no majestic mountains in Nova Scotia, no forbidding icebergs in Vancouver, and no tidal flats in Ontario, we relate to the iconic paintings of these natural aspects of our country as being part of who we are as Canadians. We are mostly an urban people now, yet we continue to think of ourselves in terms of our geography.

Equally, we respond to specific manufactured images: houses, factories, churches, totem poles, streets, stores, villages, barns, and all the architecture of our built environment. Despite the eclectic imports we have brought to Canada from all over the world, some adaptations of other forms of expression are distinctively ours, adapted to our climate and geography by our imaginations.

The natural regional features we each grow up with have a special allure, of course, for these are the characteristics of what we call home. But Canadians have a double sense, both of their immediate locale and of the country's vast and magnificent variety – mountains, plains, tundra, three oceans, mighty cataracts, long rivers, forests and farms, and cities and towns, all spread across a huge part of the globe.

The images created by the Group of Seven represent a Canadian sensibility, which means that they contain in the choice of their subject, and in the means of expressing it, an essential reflection of who we are as individuals brought up in this particular part of the world. These images, which were created by Tom Thomson and the members of the Group of Seven in the early twentieth century, have been adopted by us as signifying the country when we imagine it.

At a certain point, if images are strong enough and profound enough, and if they are sufficiently broad in their appeal, they achieve the status of a symbol. That is, they come to stand for something more complex and comprehensive than what they simply describe or depict, and they evoke emotions and responses that are powerful. National anthems are musical examples. Thomson's great paintings *The West Wind* (p. 2) and *The Jack Pine* (p. 3)

are the visual equivalent of a national anthem, for they have come to represent the spirit of the whole country, nothwithstanding the fact that vast tracts of Canada have no pine trees.

And while Algonquin Park and Georgian Bay were soon abandoned for more distant parts, the seed of the idea that was born there was transplanted over the ensuing decades to all parts of the country. The idea of 'North' was the Group's mantra as it tried to find or create images fit for a young country in a new century. This impulse tended to overshadow equally valid images of urban and domestic subjects, although we now appreciate how strong many of these were.

While Tom Thomson's *The Jack Pine* and *The West Wind* and images of similar subjects are the most widely disseminated, others like Lawren Harris's *Isolation Peak,* Arthur Lismer's *Isles of Spruce,* Edwin Holgate's *Totem Poles, Gitsegiuklas,* and A.J. Casson's *Old Store at Salem* all show aspects of the country that are valid and trustworthy images of the world outside Algonquin Park or Georgian Bay. Thomson also commemorates the intimate side of nature in his luscious painting *Moccasin Flower (Orchid, Algonquin Park),* as LeMoine FitzGerald does in his delicate and contemplative painting *The Pool.* Frank Johnston's *Fire-swept, Algoma* brings vividly to our attention the terrible power of natural phenomena, which surround us so closely and which intrude frequently in our lives.

Some paintings, such as Carmichael's *Grace Lake,* show the mystery and the austerity of the natural world not far from our urban doorstep. Another, like Lismer's impressionistic *The Guide's Home, Algonquin,* appears to revel in the light and colour of the natural world. Many works show the seasons in their transitional mode, most often the autumn with its blazing colours, which Jackson caught so intimately in *The Red Maple,* J.E.H. MacDonald dramatized in his majestic *October Shower Gleam,* and Carmichael portrayed in *Autumn Hillside.* F.H. Varley immortalizes one of the loves of his life in *Vera,* and in *Open Window* invites us to gaze out upon the Pacific. And Holgate reminds us of family and youth in his portrait, *Ludivine.*

Even the First World War, for the short time Canadian artists were engaged by the Canadian War Memorials program, produced several powerful works. Johnston's *Beamsville,* of airplanes over one of the Canadian flight-training bases in Ontario, is one of the earliest views of Canada from the air, captured less than a decade after an airplane first flew over Toronto.

The storehouse of images produced by the Group of Seven and Thomson also reflects

the history of the society we have created and the human environment we have built. The strong domestic and personal icons they created include Harris's *Return from Church,* FitzGerald's *Doc Snyder's House,* MacDonald's *The Tangled Garden,* Jackson's *The Winter Road;* and portraits of people and portraits of cities and houses, like Casson's *House Tops in the Ward.*

The legacy of the Group of Seven and Tom Thomson contains a spectrum of subjects, ideas, styles, moods, conditions, attitudes, scales, sizes, and colours wide enough and varied enough to stock any country's image bank. The character of the country is defined by all of these, which were brought to life by imaginations that were ambitious, energetic, zealous, and most of all, profoundly attuned to the spirit of an emerging nation.

■

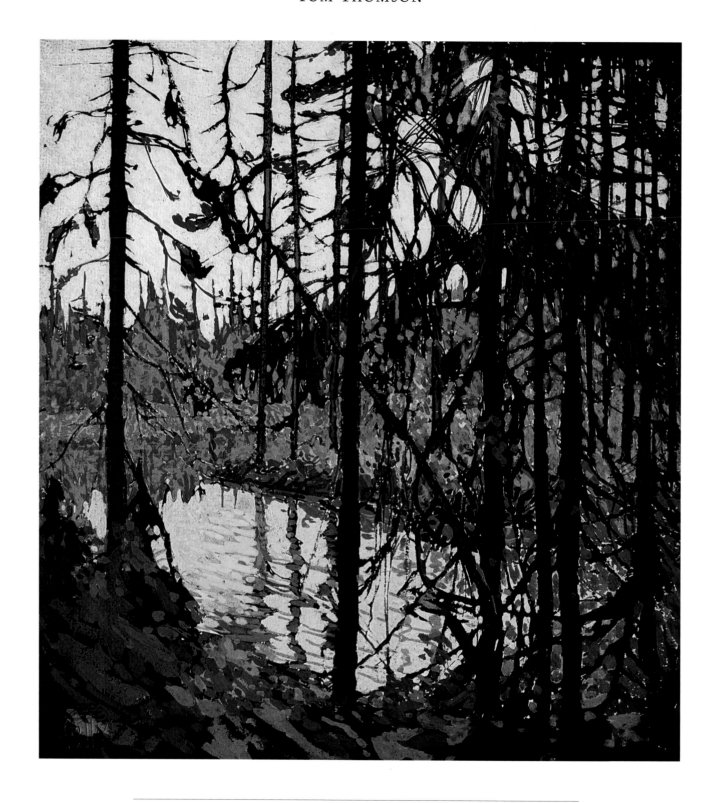

Study for Northern River 1914–1915

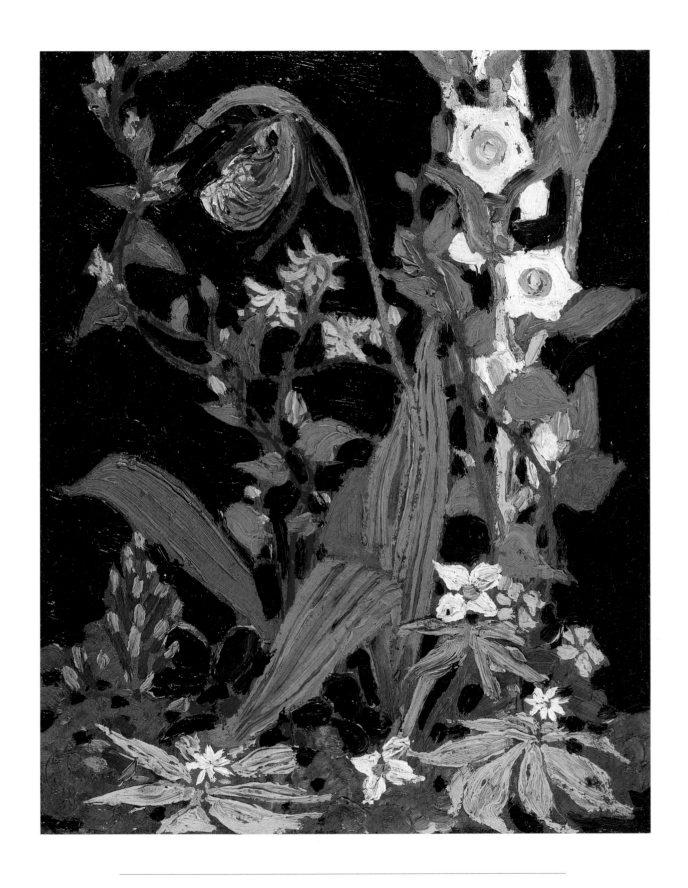

Moccasin Flower (Orchid, Algonquin Park) c. 1915

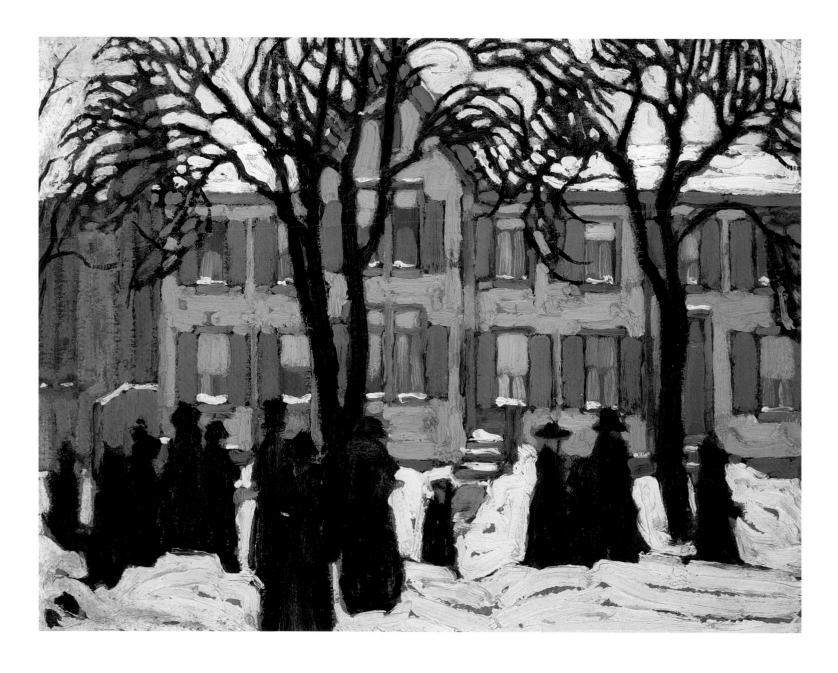

Return from Church c. 1919

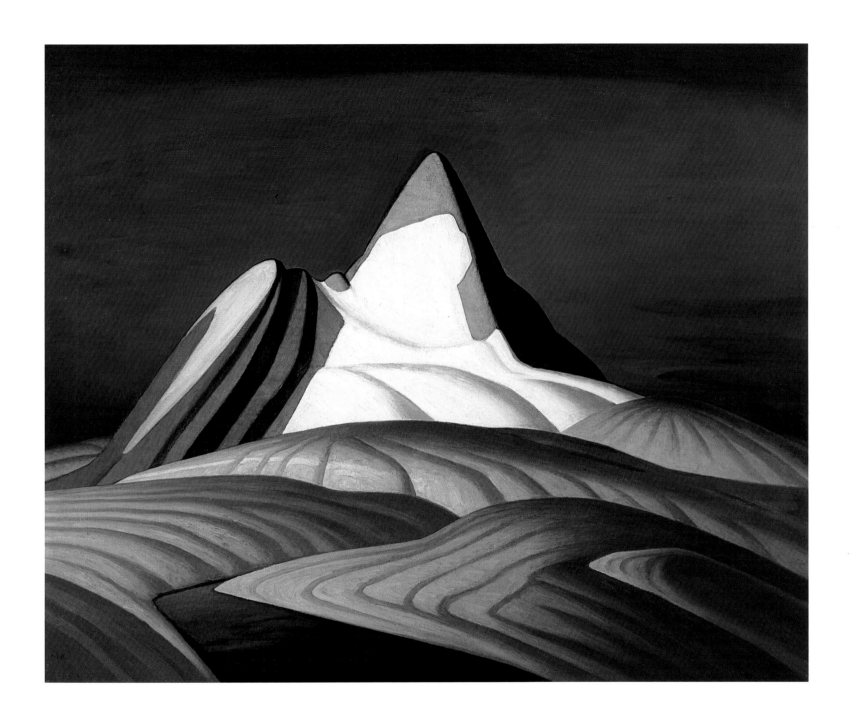

Isolation Peak c. 1930

A.Y. Jackson

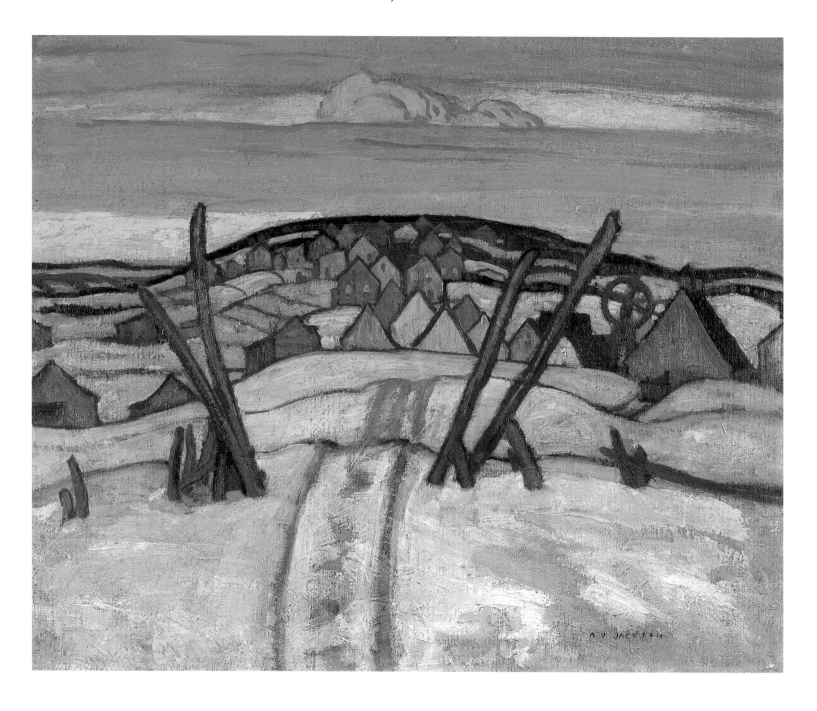

The Winter Road 1921

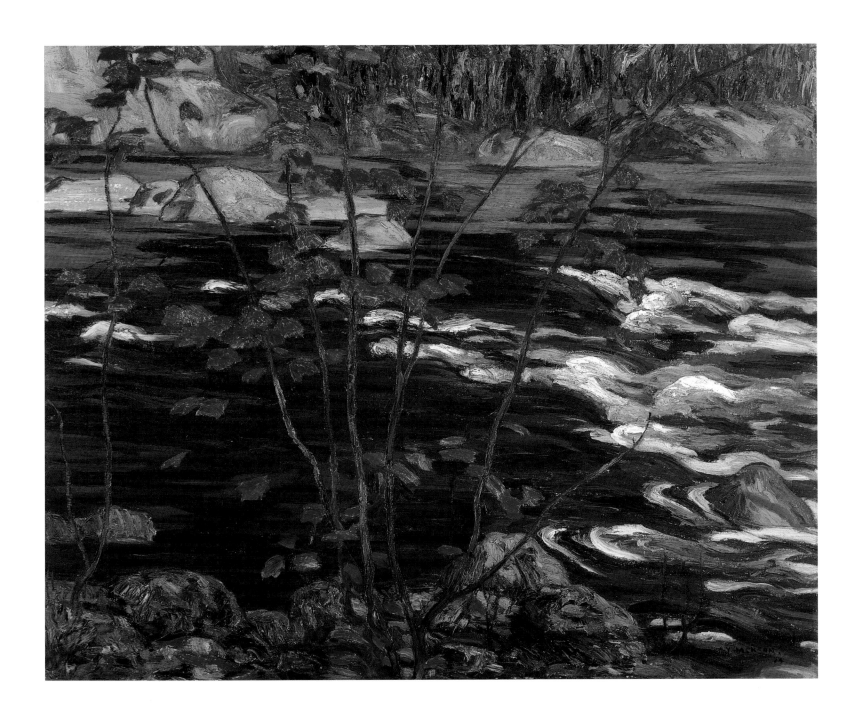

The Red Maple 1914

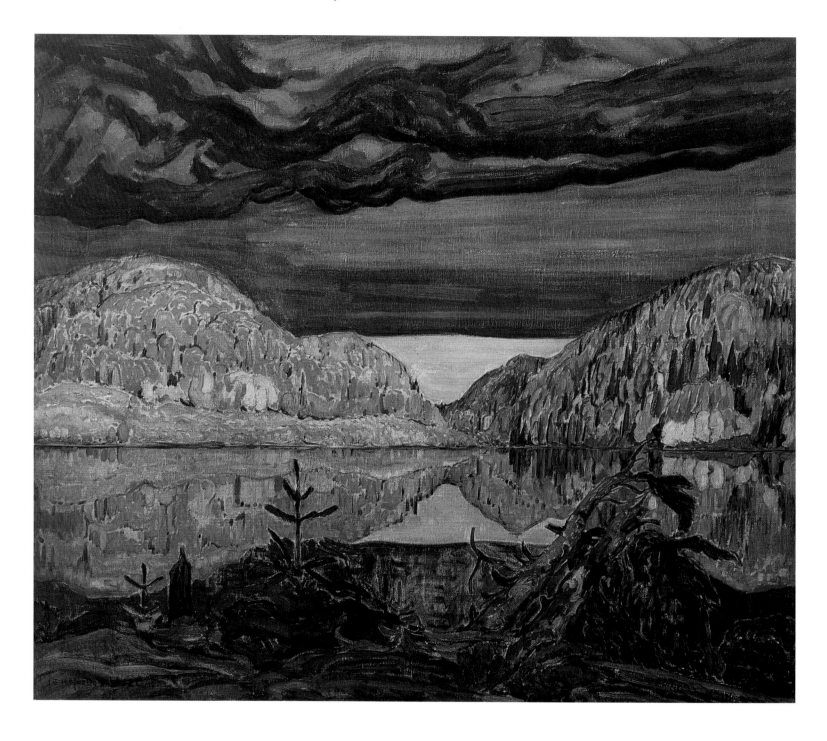

October Shower Gleam 1922

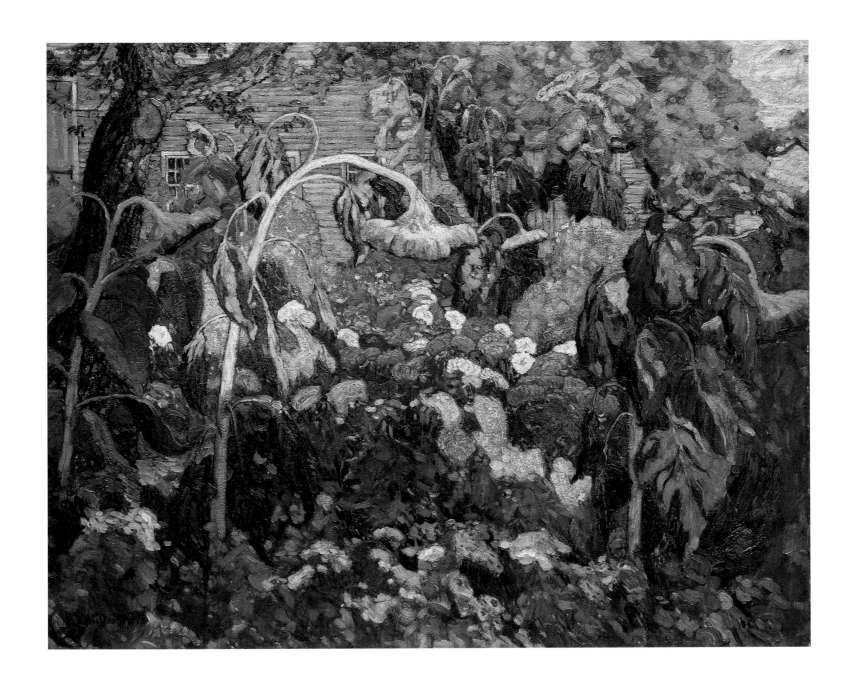

The Tangled Garden 1916

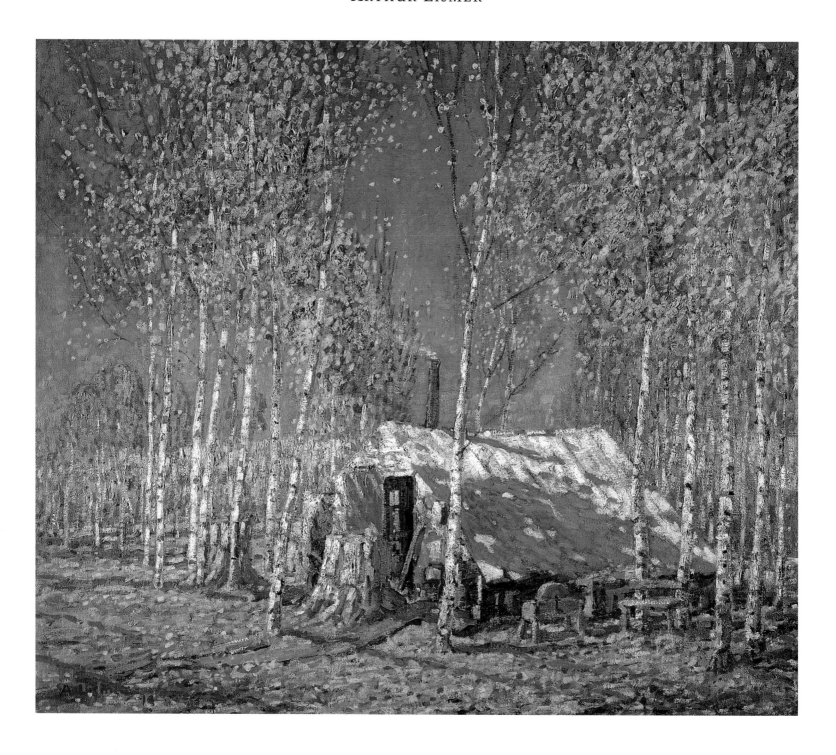

The Guide's Home, Algonquin 1914

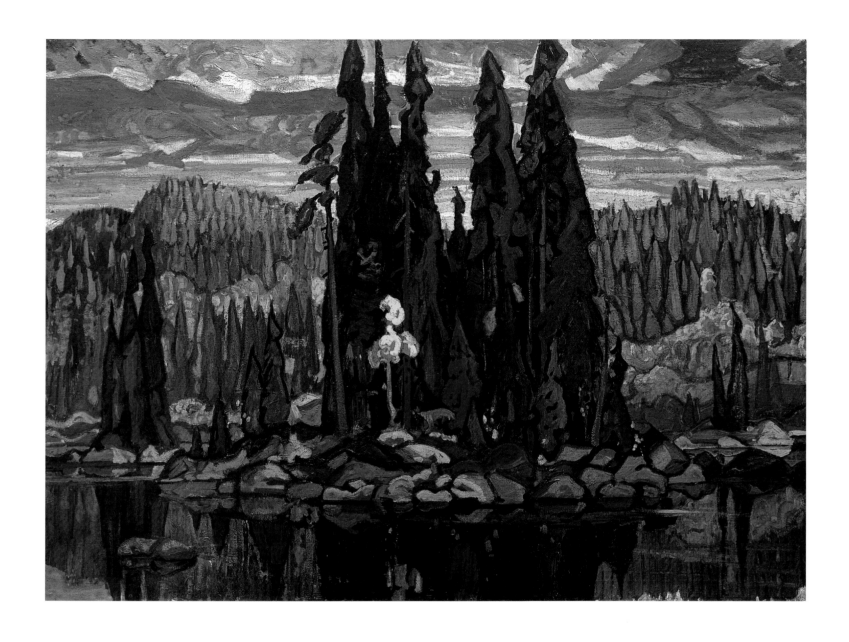

Isles of Spruce 1922

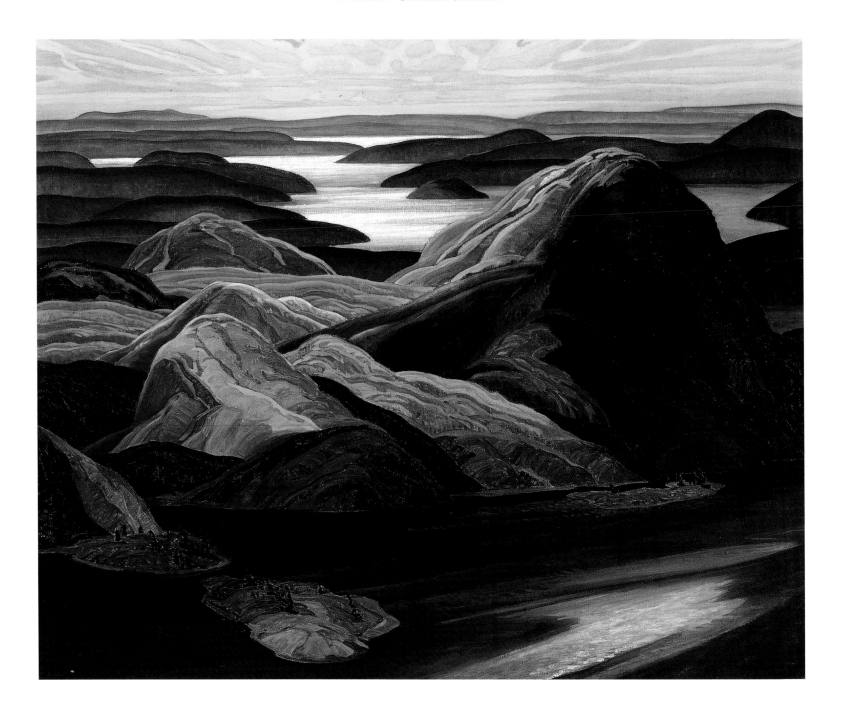

Grace Lake 1931

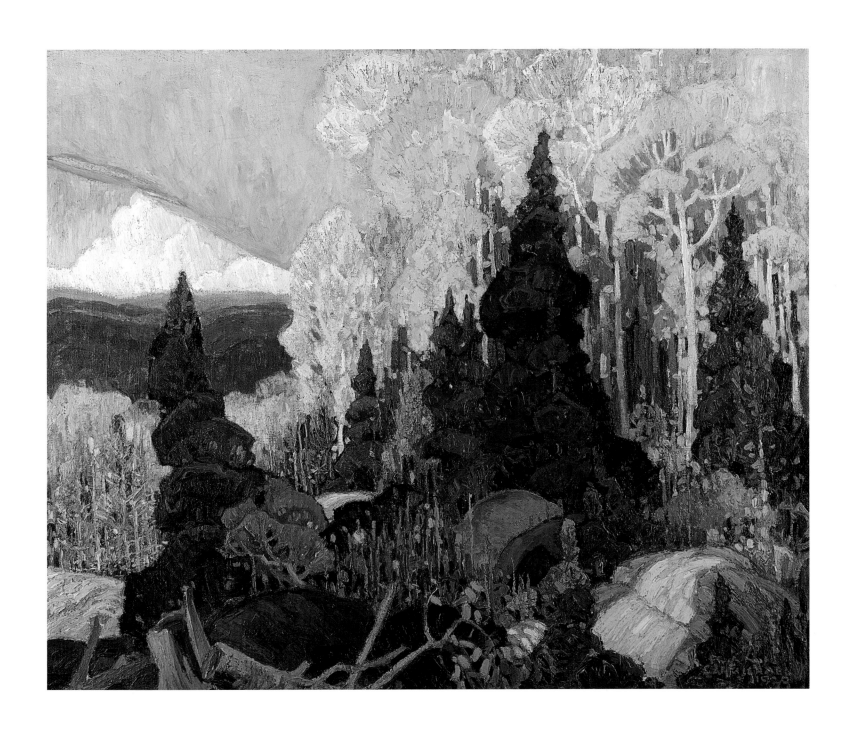

Autumn Hillside 1920

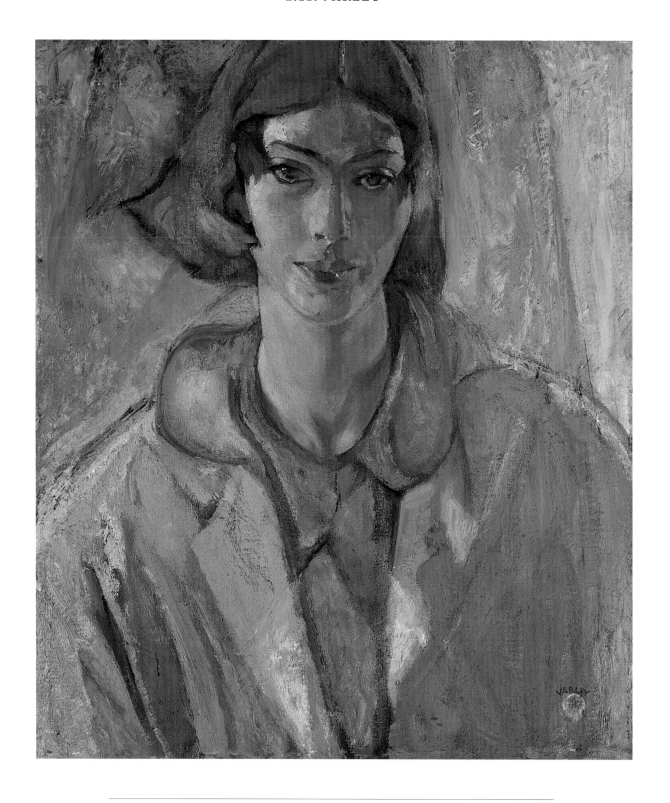

Vera 1931

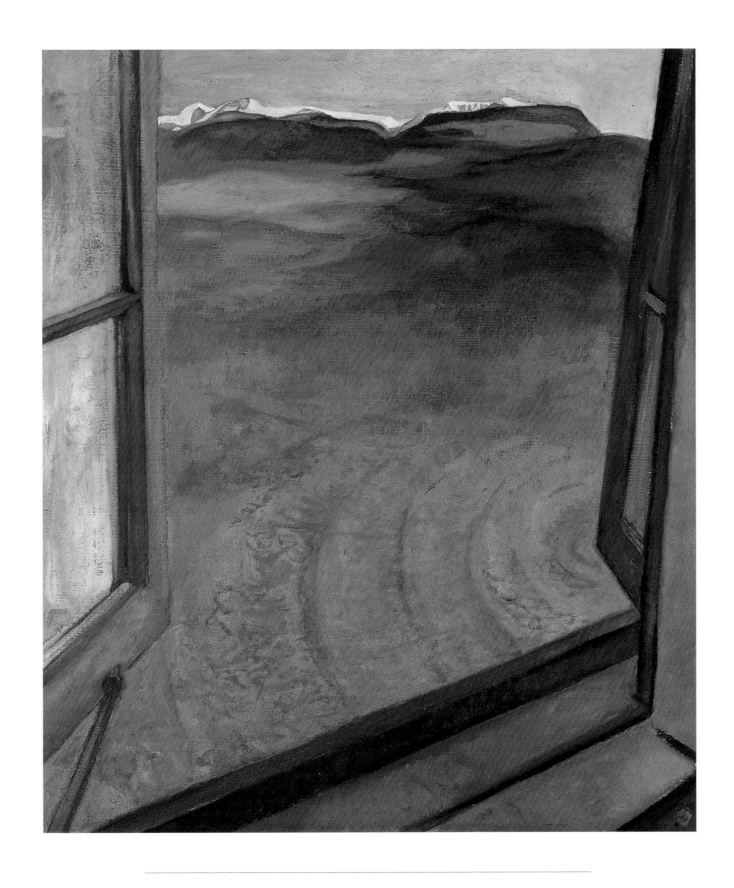

Open Window c. 1933

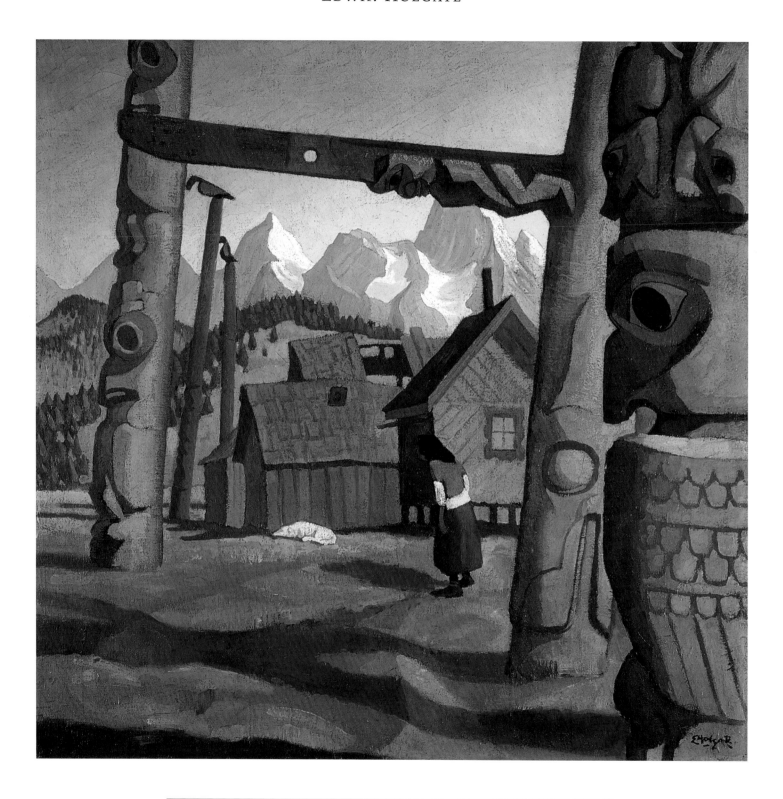

Totem Poles, Gitsegiuklas 1927

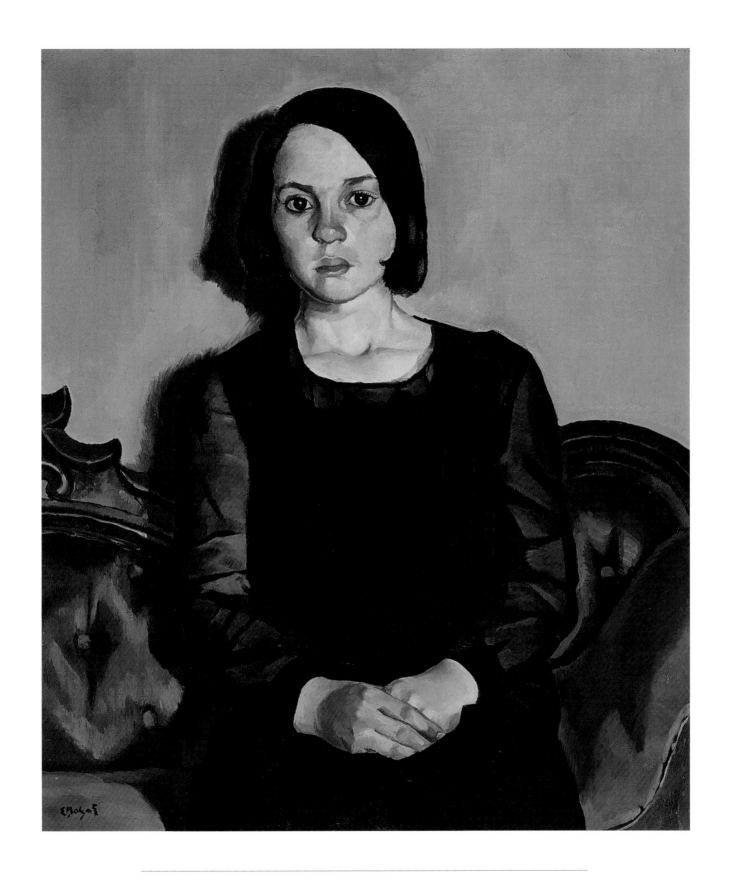

Ludivine 1930

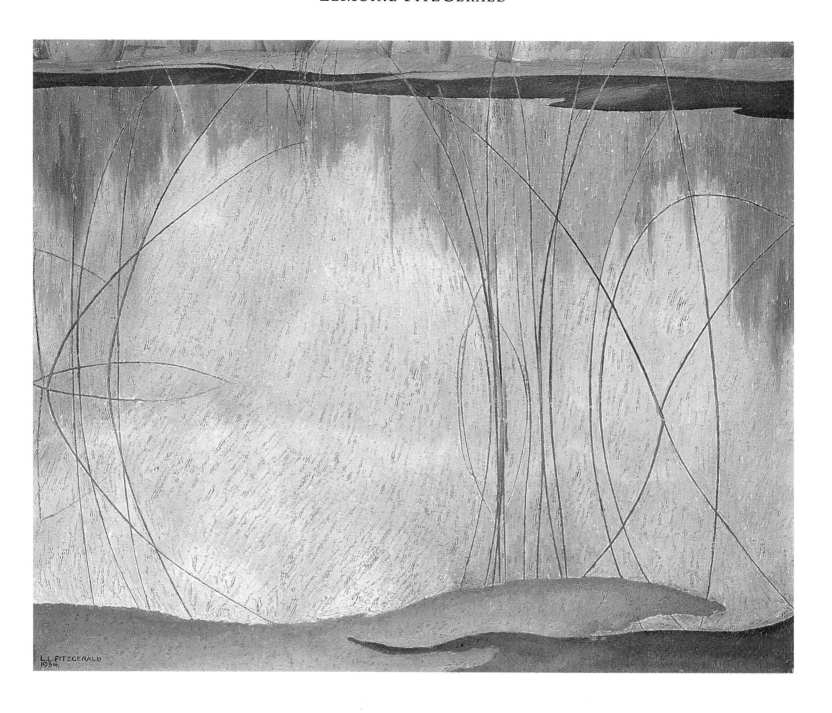

The Pool 1934

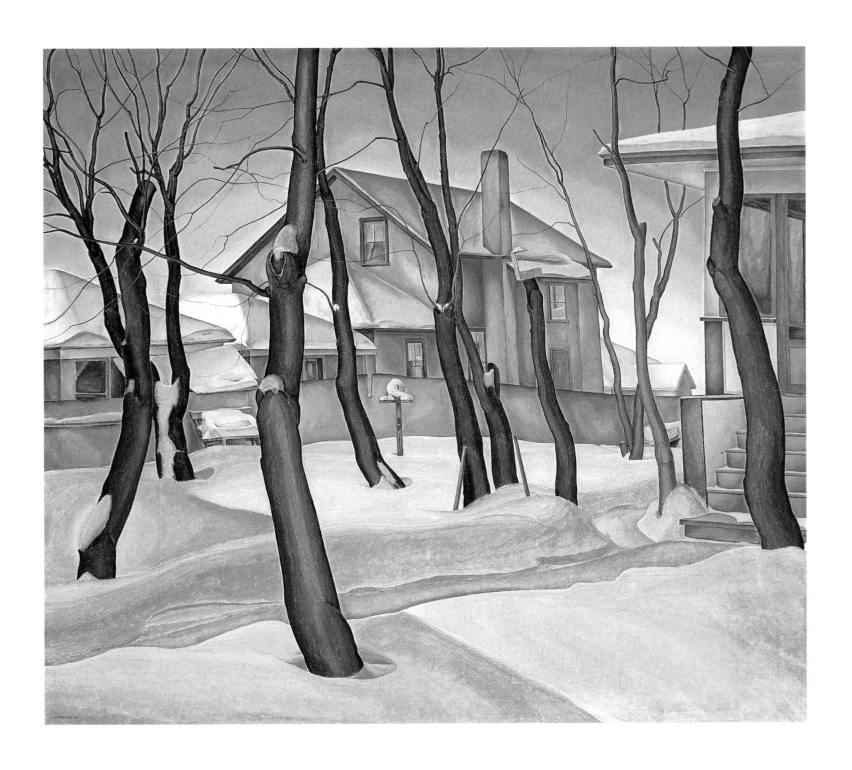

Doc Snyder's House 1931

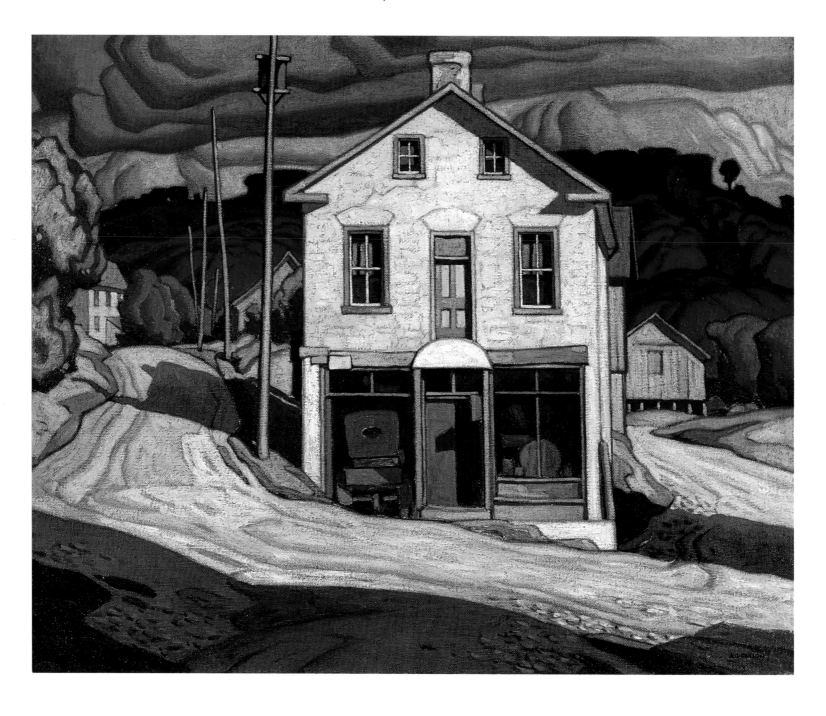

Old Store at Salem 1931

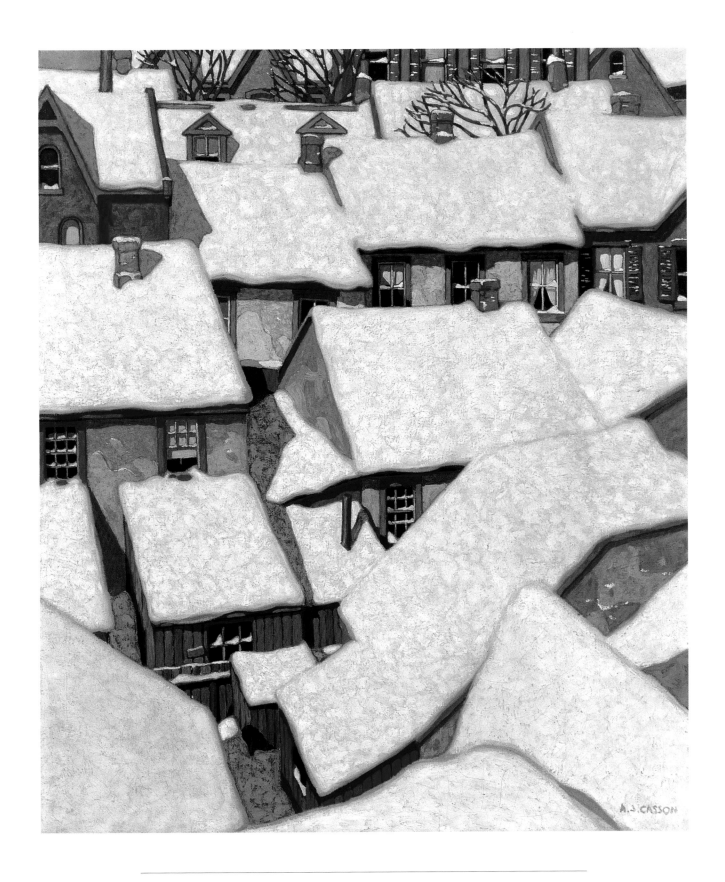

House Tops in the Ward 1924

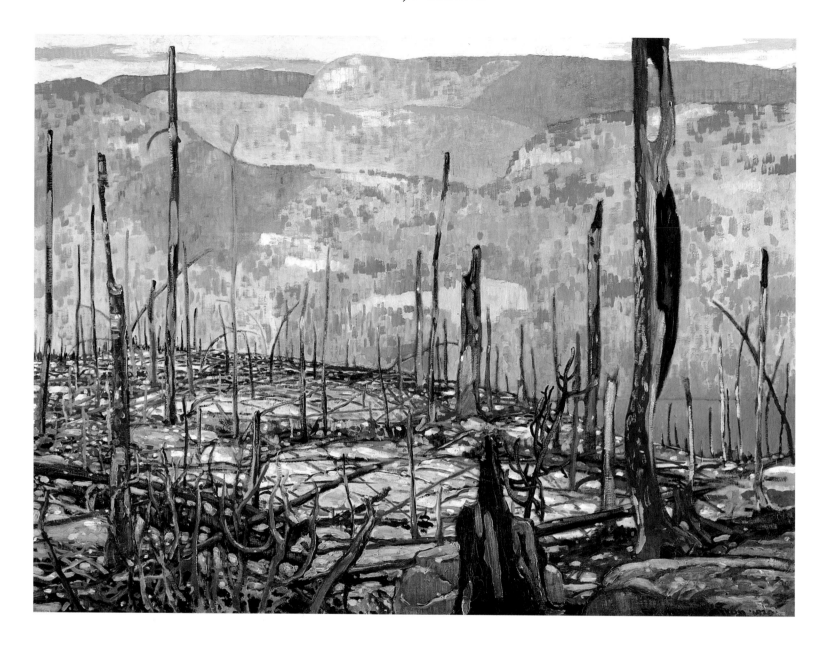

Fire-swept, Algoma 1920

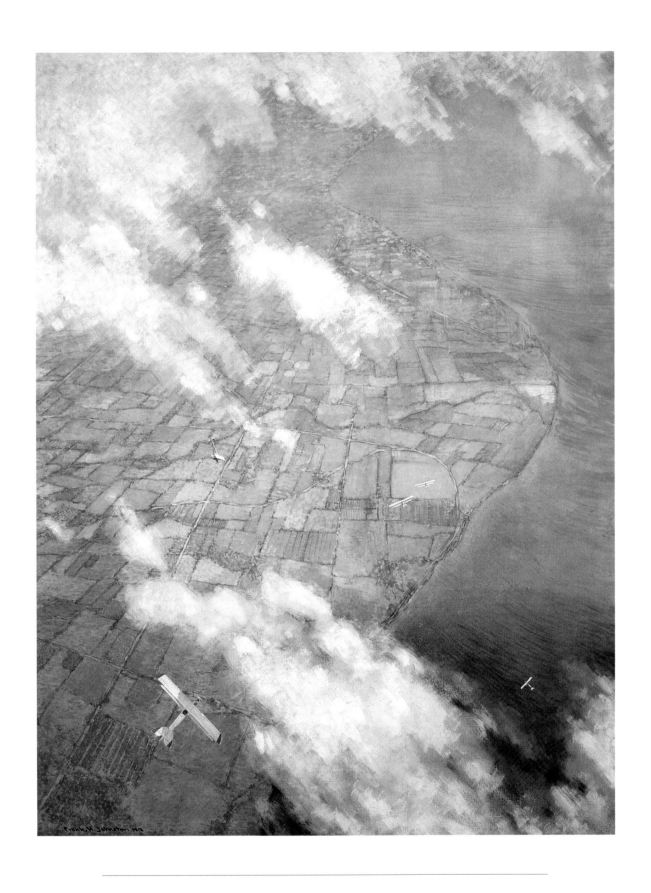

Beamsville 1918–1919

GARDENS, STILL LIFES, AND PORTRAITS

ARTISTS WORK within the traditions of art. Even artistic rebels, whose primary aim is to destroy existing conventions, know intimately and exactly what it is they are trying to replace with their new images. The painters of the Group of Seven and Tom Thomson, like previous generations of artists, first learned the basics of their art at school, imitated older artists, developed techniques, learned what worked and what did not, and then stretched their minds and imaginations to find their own forms of expression – forms that were authentically reflective of their time and place.

Still lifes and portraits were a staple of painting in the early twentieth century. Still lifes were primarily of flowers, to which nearly every artist turns at some point. A.Y. Jackson's *Blue Gentians* (p. 77) leads off a remarkable assortment of flower paintings, followed by powerful examples by Tom Thomson (*Marguerites, Wood Lilies and Vetch,* p. 83; *Wild Flowers,* p. 82), J.E.H. MacDonald (*Asters and Apples,* p. 80), and Arthur Lismer (*Lilies and Apples,* p. 81), in particular.

Lawren Harris seems to have resisted the allure of moccasin flowers, lilies, and blue gentians, but LeMoine FitzGerald's *The Little Plant* (p. 85) and Frank Carmichael's *Wild Cherry Blossoms* (p. 79) are strong contributions to this genre. A.J. Casson did stylized flowers and once received a commission from a lumber company to make prints of trilliums and other flowers silkscreened on cedar veneer. Varley was taken by trees, as in *The Wonder Tree,* also known as *Magic Tree* (p. 149), as well as flowers, and some of his studies seem as much loving portraits as landscapes; his charming portrait of a little girl with sunflowers (p. 93) deftly combines both.

Although Jackson did not produce many still lifes, he taught still life classes at the Ontario College of Art during the 1924–5 year, which he recalled in his autobiography:

> *Inevitably, the students hated still life. I found it fun and tried to communicate some of this feeling to my students. At Eaton's Gift Shop I had them save broken pottery and glass for me. Each morning, as I walked to school, I would pick up apples, pears, egg plants, and other exciting things at the grocery stores.*

Portraiture and figure painting are not usually associated with the Group; indeed, one of the enduring criticisms is that the Group's depictions of Canada left people out of landscapes, and thus, according to worried politicians, discouraged immigration. Yet figures show up in the landscapes much more often than one might expect. Jackson's numerous paintings of Quebec's tiny villages, mostly in winter, nearly always include a sleigh or someone stacking wood or doing some other chore. Holgate frequently painted the female figure and made the nude an integral part of the Canadian landscape. He also painted portraits, often cataloguing different trades: a lumberman, a forester, a skier, and so on. Lismer deftly captured people at meetings and other gatherings, and his hundreds of drawings are mostly of people. Among his paintings, however, the early and sweetly impressionistic portraits of his wife (*Severn River*, p. 104; *My Wife, Sackville River, Nova Scotia*, p. 104) stand almost alone.

Harris's early Toronto paintings nearly all had people in them, and he did several exceptional portraits. The one of Bess Housser (p. 94), with whom he later fell in love and married in 1934, was shown in the first Group exhibition in 1920. Also in the 1920 exhibition was the handsome *Mrs. Oscar Taylor* (p. 96), a Christian Scientist whom Harris would have met through his numerous theosophical friends. Harris painted few portraits thereafter, but he believed that both people and landscapes were part of what constituted the character of the country. His portrait of Dr Salem Bland (p. 95), a vocal supporter of the Group and a riveting preacher, is a great example of 'Canadian Gothic.' The sole portrait by Carmichael, of an unidentified woman (*Woman in a Black Hat*, p. 96), makes one wish that he had tackled more.

F.H. Varley, who later flirted with cubism, was certainly the member of the Group whose primary interest was people, faces, and figures. He tried to make part of his living as a portrait painter – alas, not successful from a financial point of view. His portraits of Vera Weatherbie, Jess Crosby, Evelyn Ely, Alice and Vincent Massey, and many others show another aspect of the Group's pursuit of nation-making, one that was nearly overwhelmed by the vast landscape. Varley was the only member of the Group to make two penetrating self-portraits (pp. 88 and 89), each following a world war, when Varley had to look hard at himself to decide that the world was still worth living in.

In these gardens, still lifes, and portraits, a sympathy with the subjects and an understanding of early twentieth-century society emerge clearly.

■

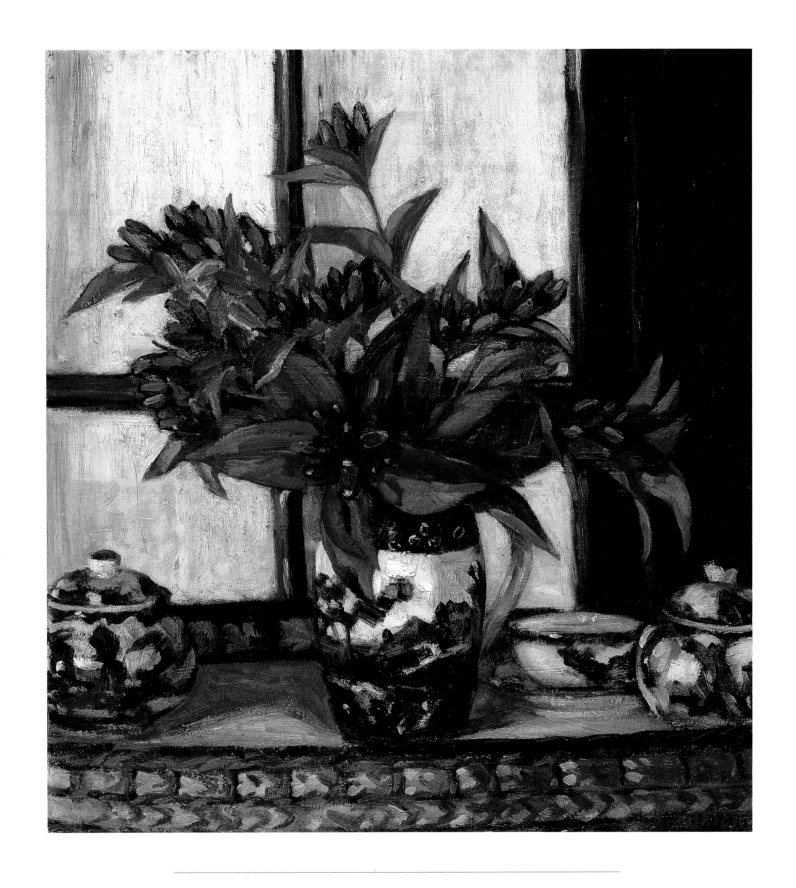

A.Y. Jackson *Blue Gentians* 1913

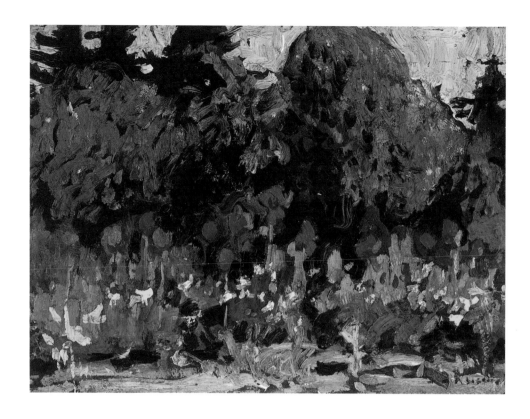

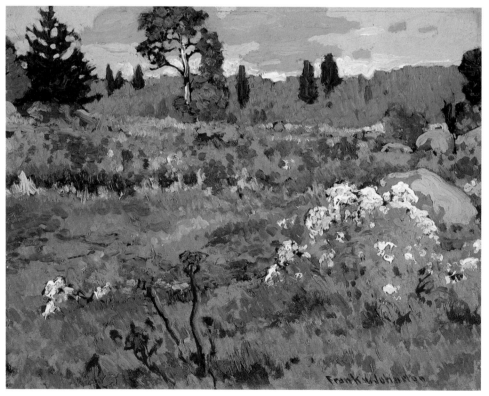

Arthur Lismer *Poppies, Bedford Park Avenue* 1924

Frank Johnston *Near the Berry Patch* c. 1920

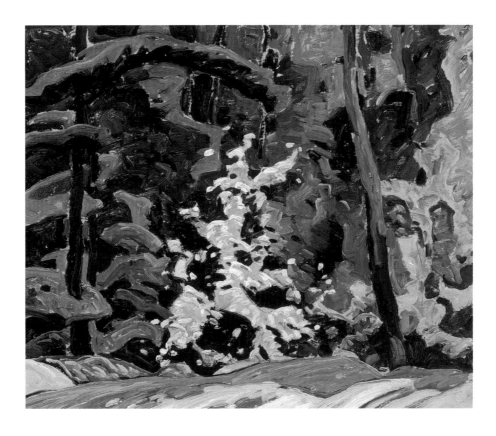

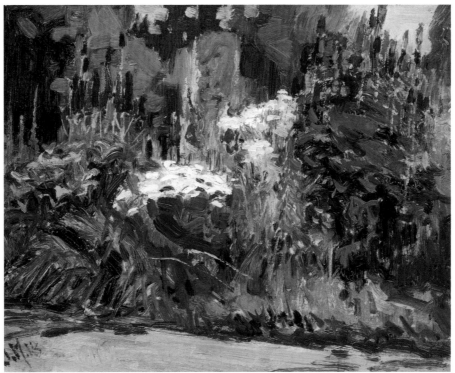

Frank Carmichael *Wild Cherry Blossoms* c. 1932

J.E.H. MacDonald *Flower Border, Usher's Farm, York Mills* 1918

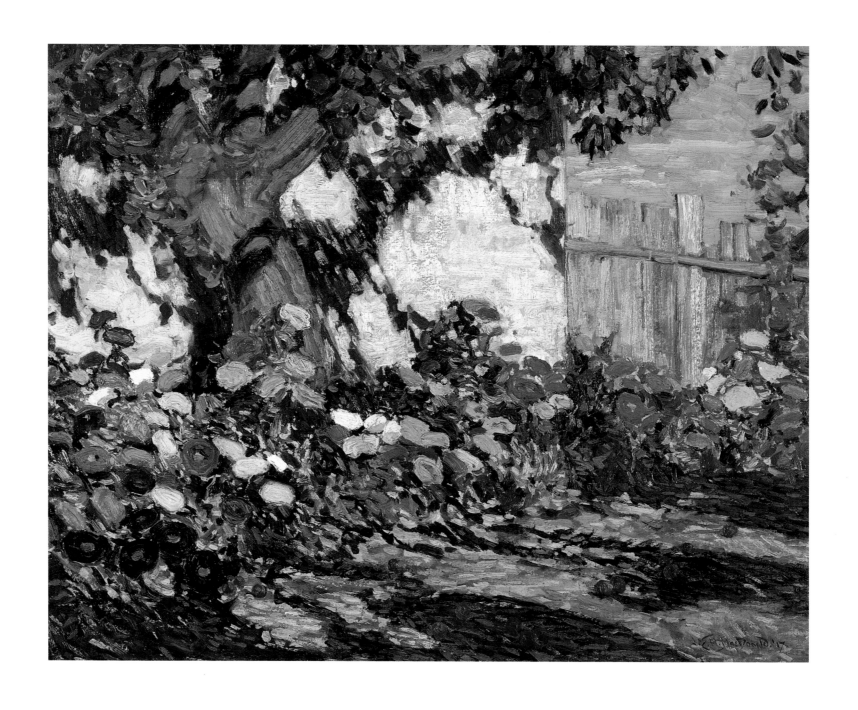

J.E.H. MacDonald *Asters and Apples* 1917

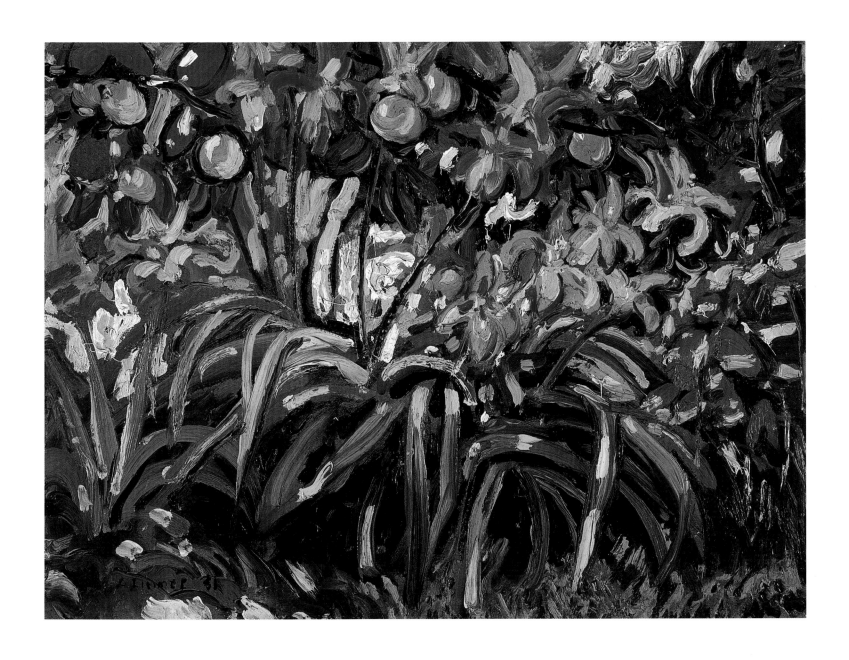

Arthur Lismer *Lilies and Apples* 1931

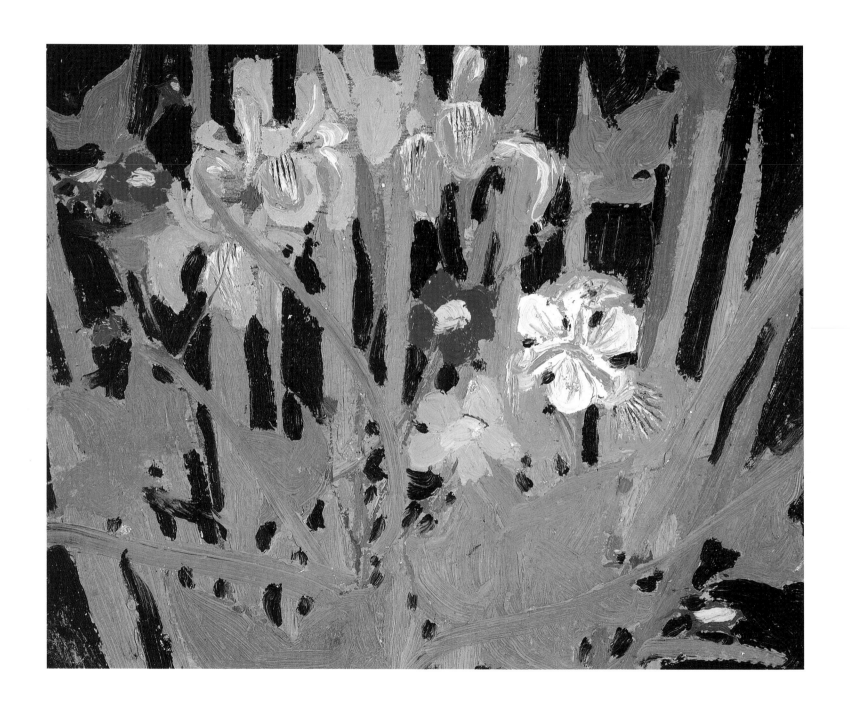

Tom Thomson *Wild Flowers* 1916

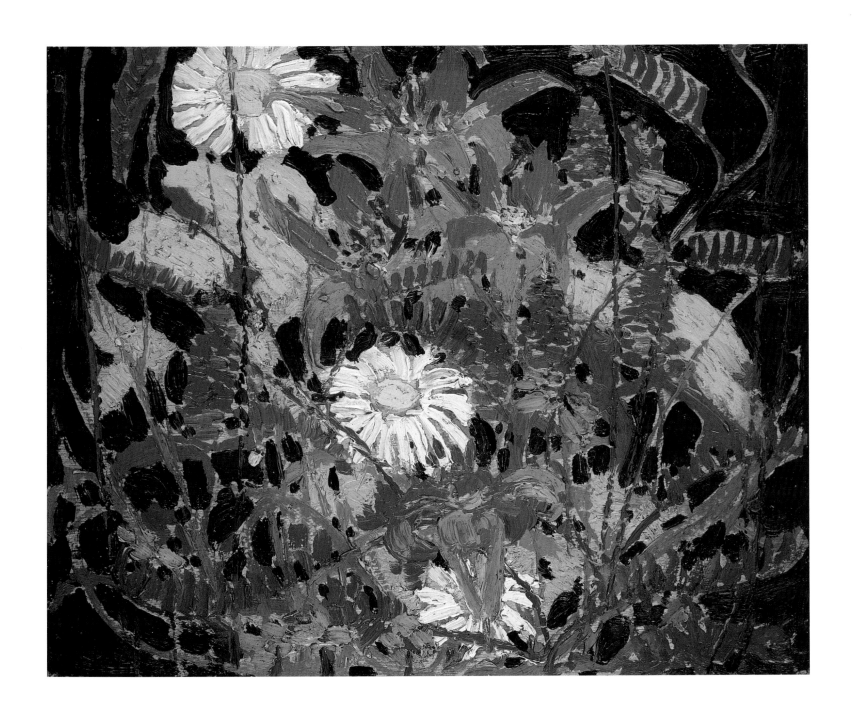

Tom Thomson *Marguerites, Wood Lilies and Vetch* 1915

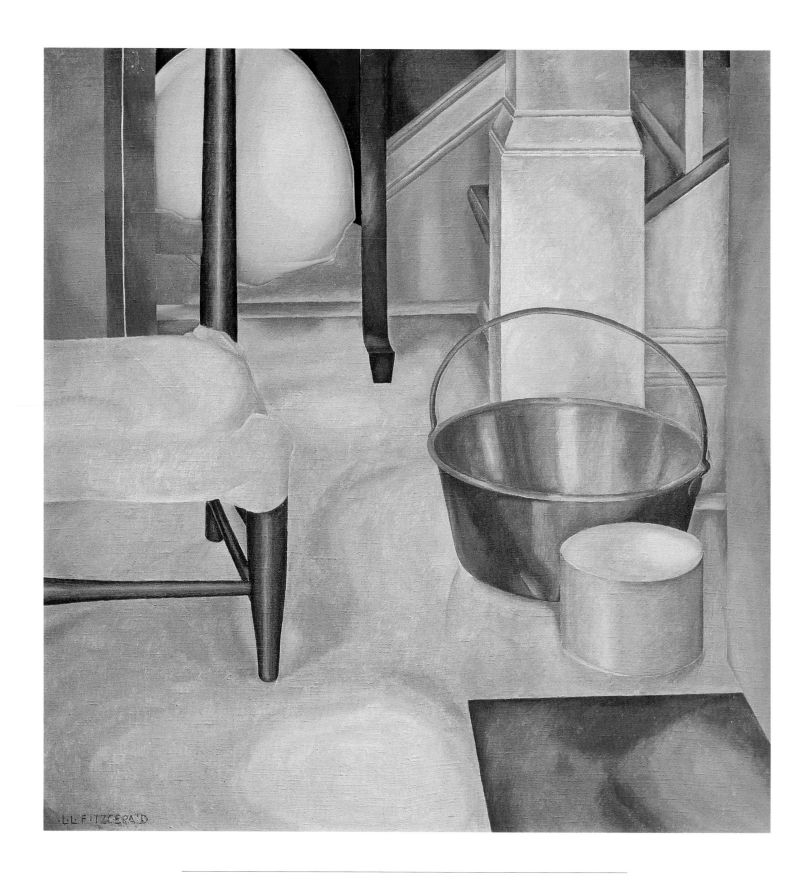

LeMoine FitzGerald *Interior* c. 1948

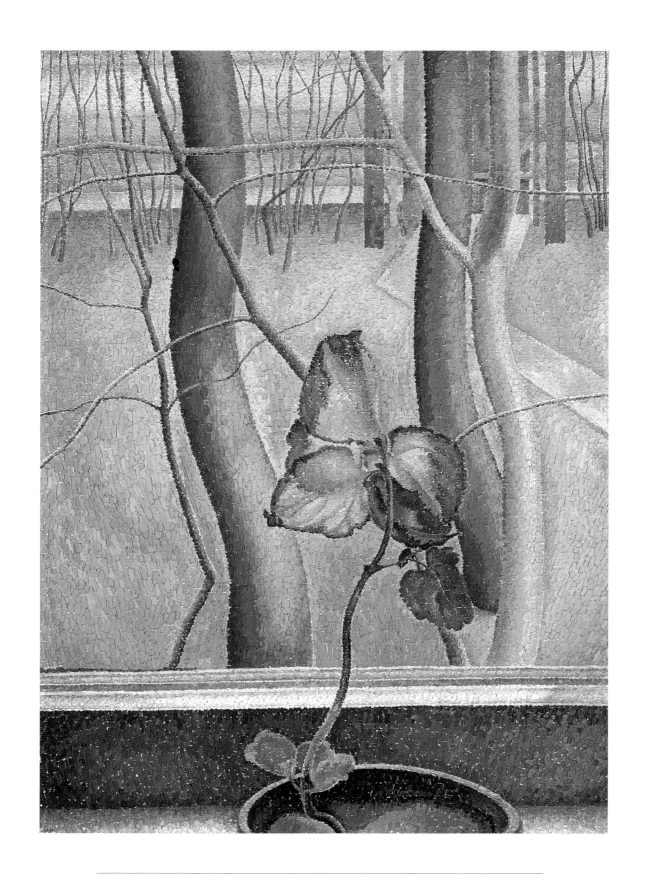

LeMoine FitzGerald *The Little Plant* 1947

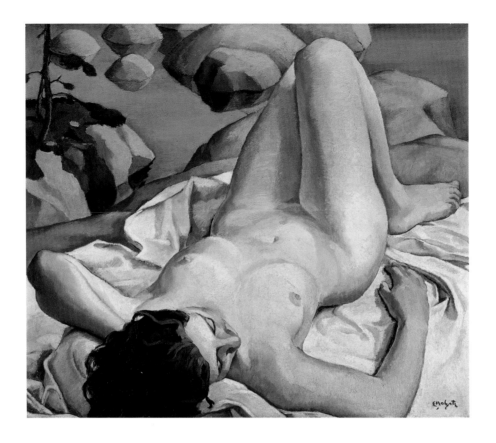

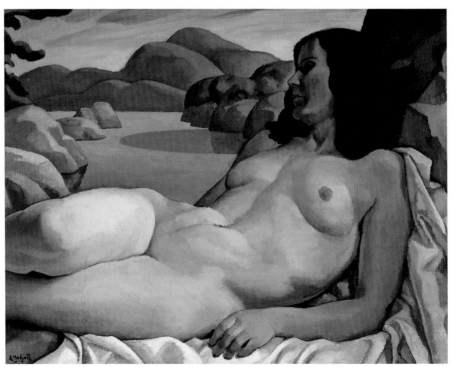

Edwin Holgate *Nude* 1930

Edwin Holgate *Nude in a Landscape* c. 1930

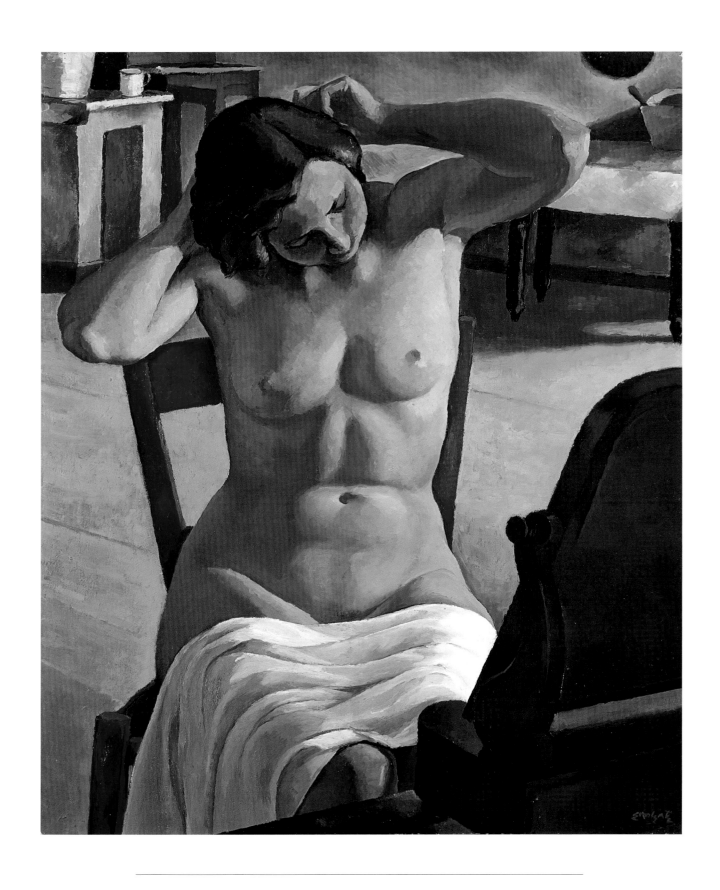

Edwin Holgate *Interior* c. 1933

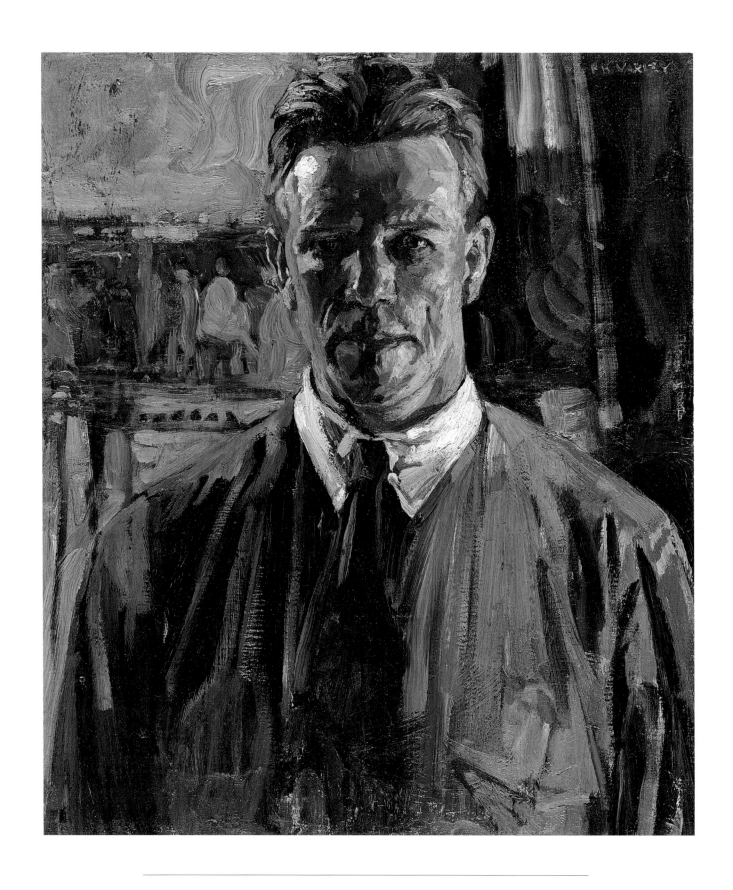

F.H. Varley *Self-portrait* 1919

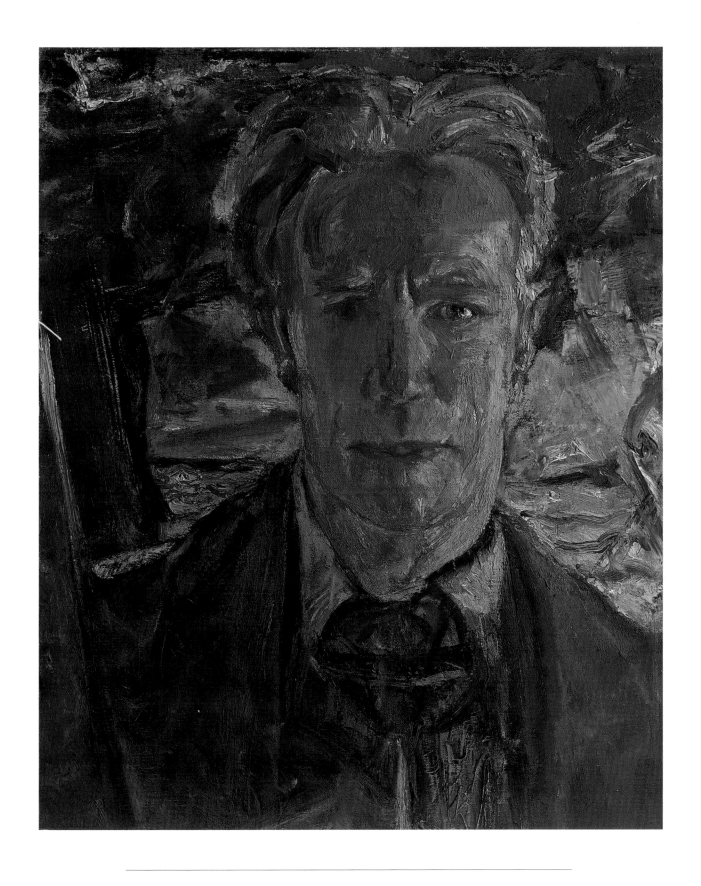

F.H. Varley *Self-portrait* 1945

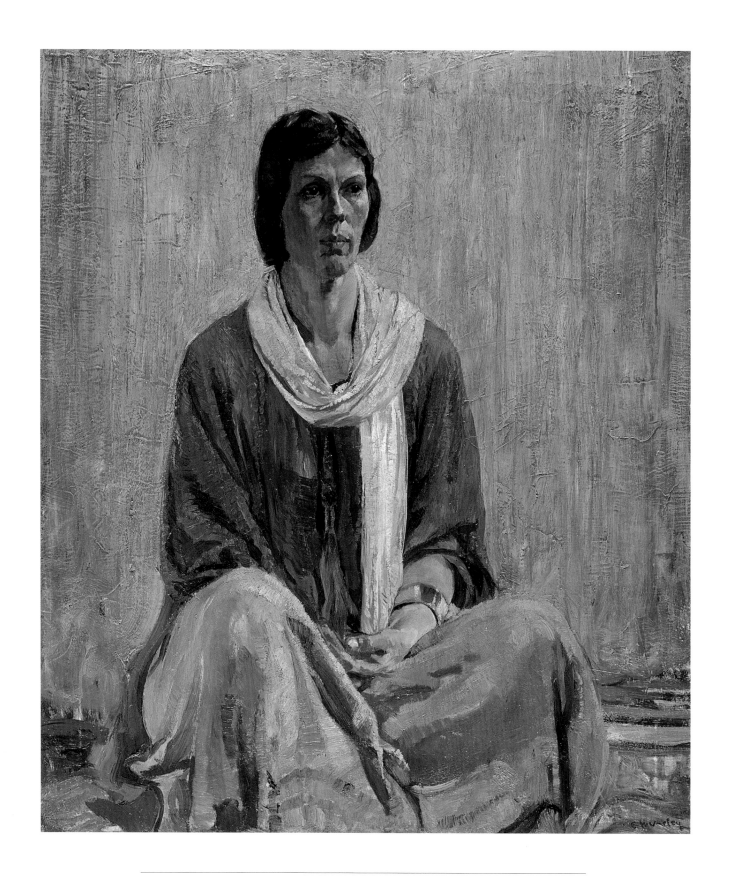

F.H. Varley *Mrs. E.* 1921

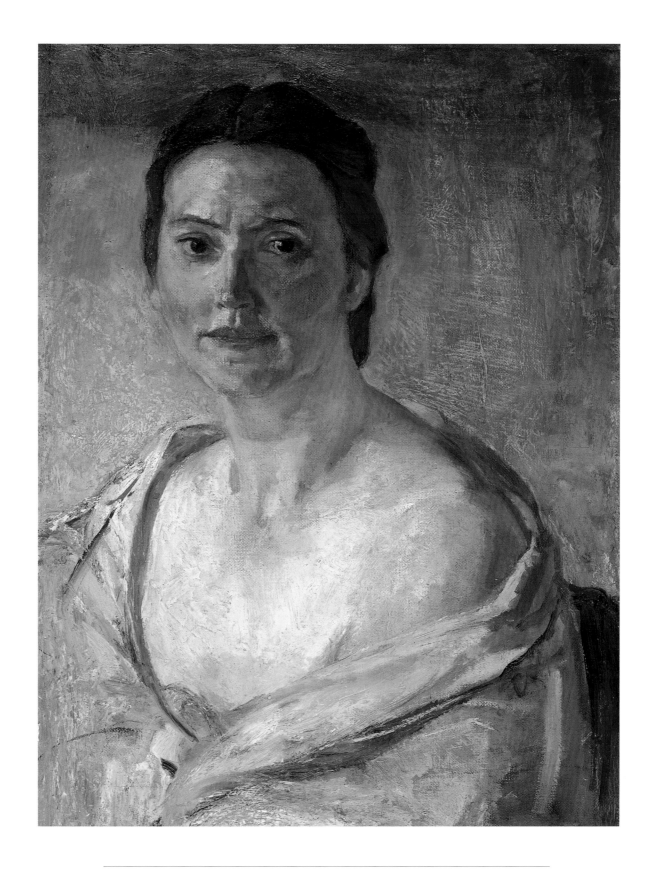

F.H. Varley *Jess* 1950

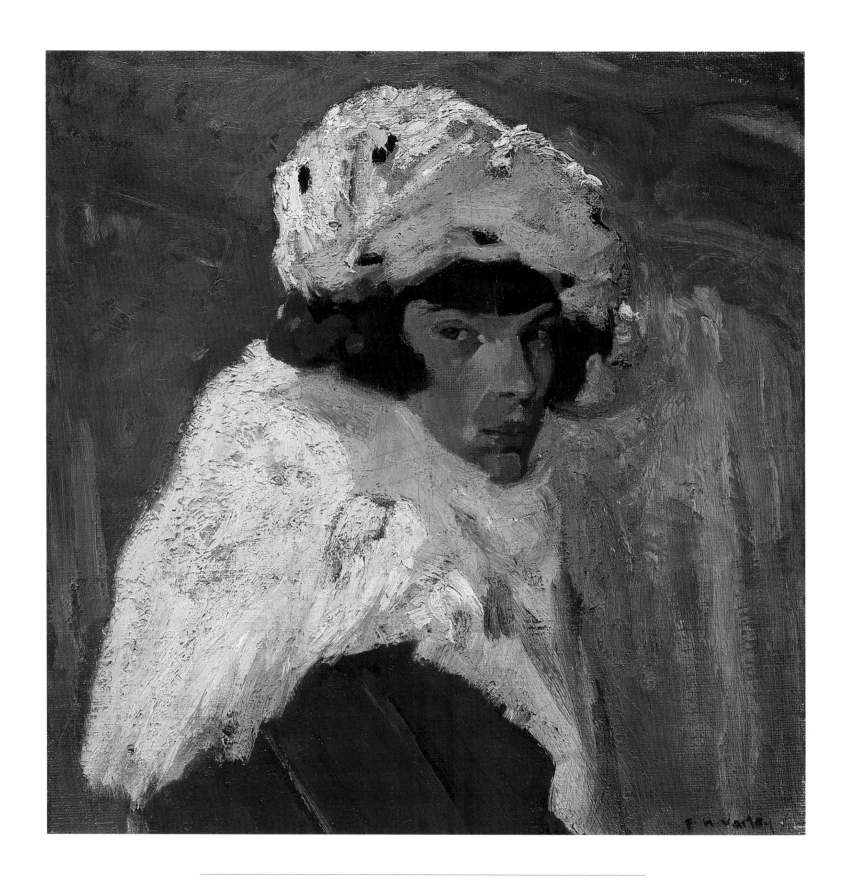

F.H. Varley *Girl in Red* c. 1921

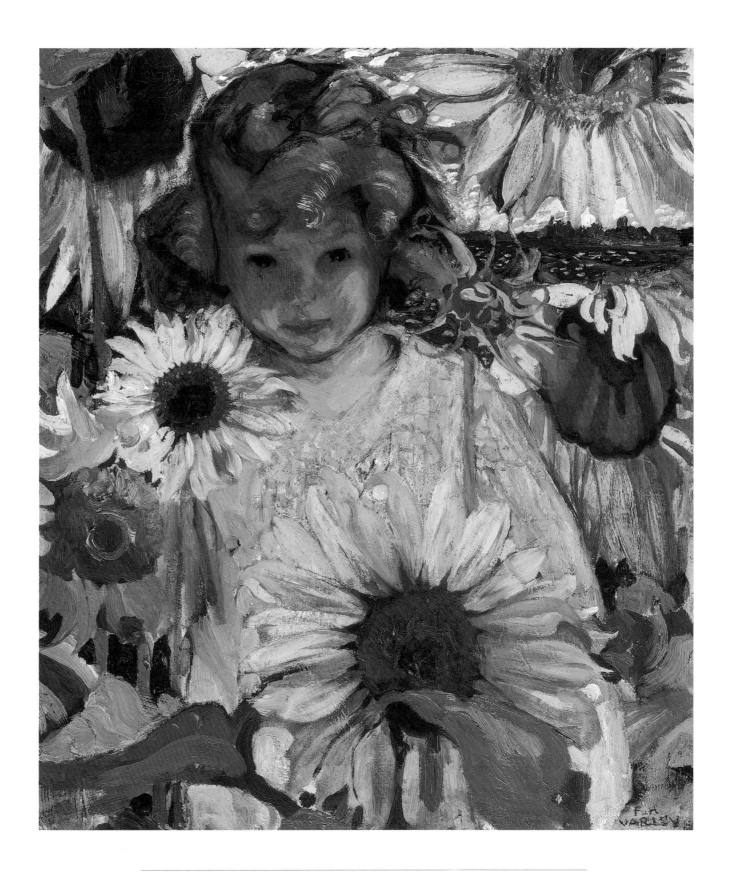

F.H. Varley *Sunflowers* c. 1921

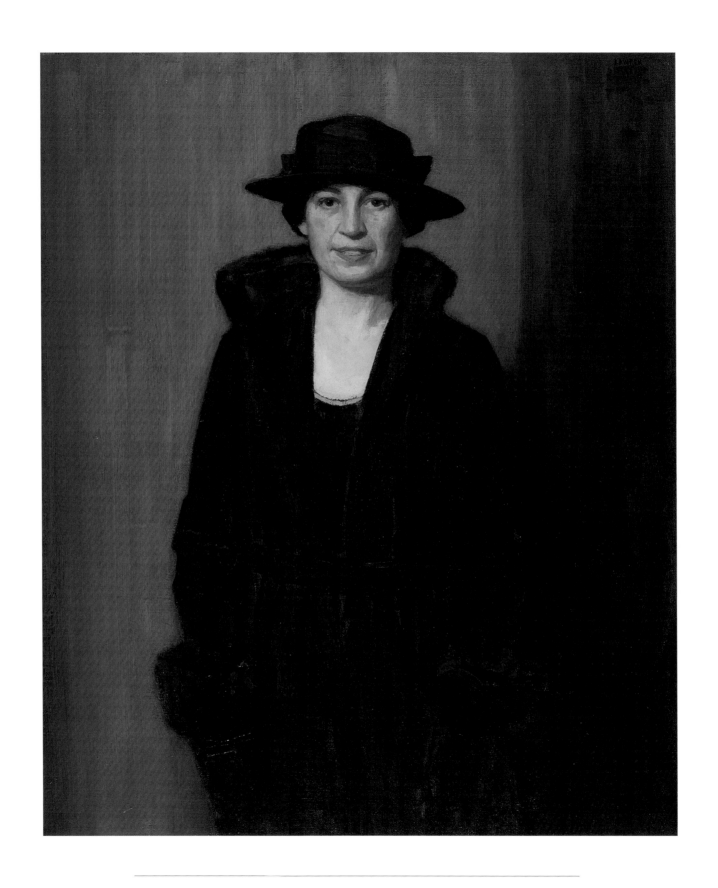

Lawren Harris *Bess* 1920

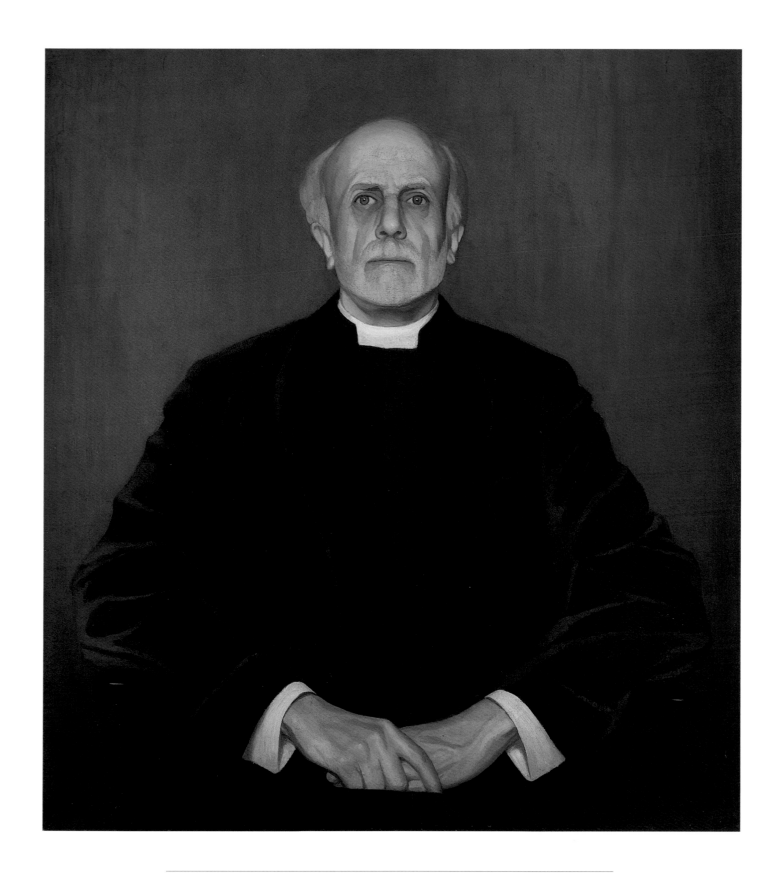

Lawren Harris *Dr. Salem Bland* 1925

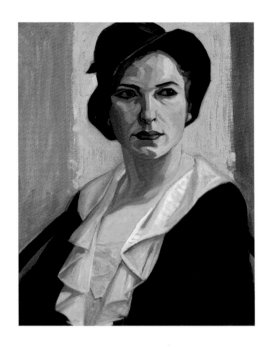

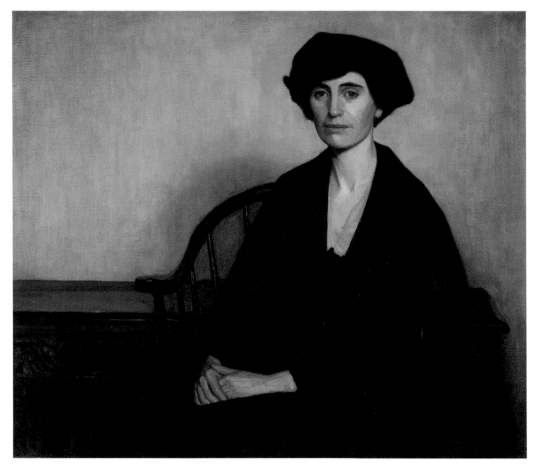

Frank Carmichael *Woman in a Black Hat* 1939

Lawren Harris *Mrs. Oscar Taylor* 1920

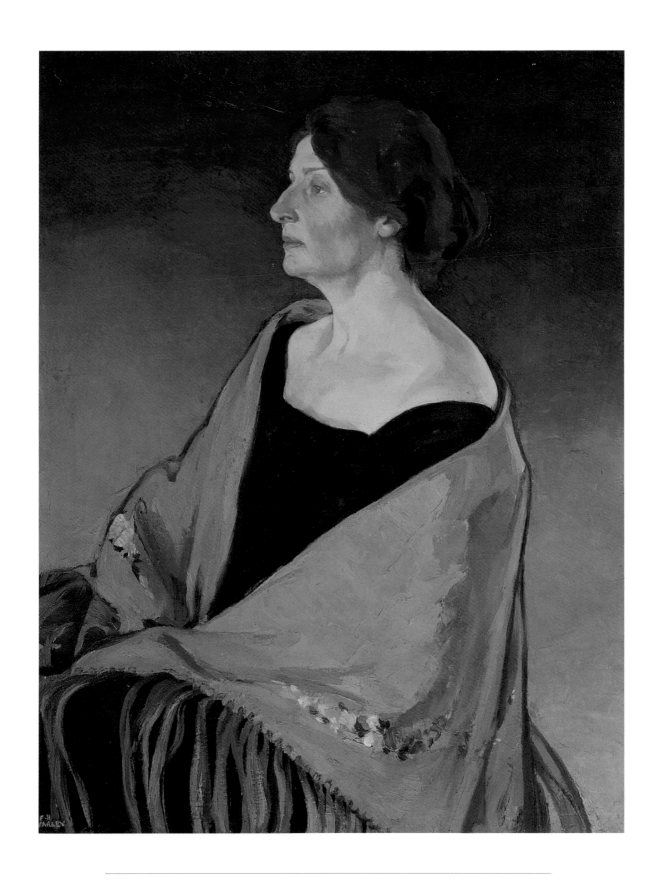

F.H. Varley *Alice Massey* c. 1924–1925

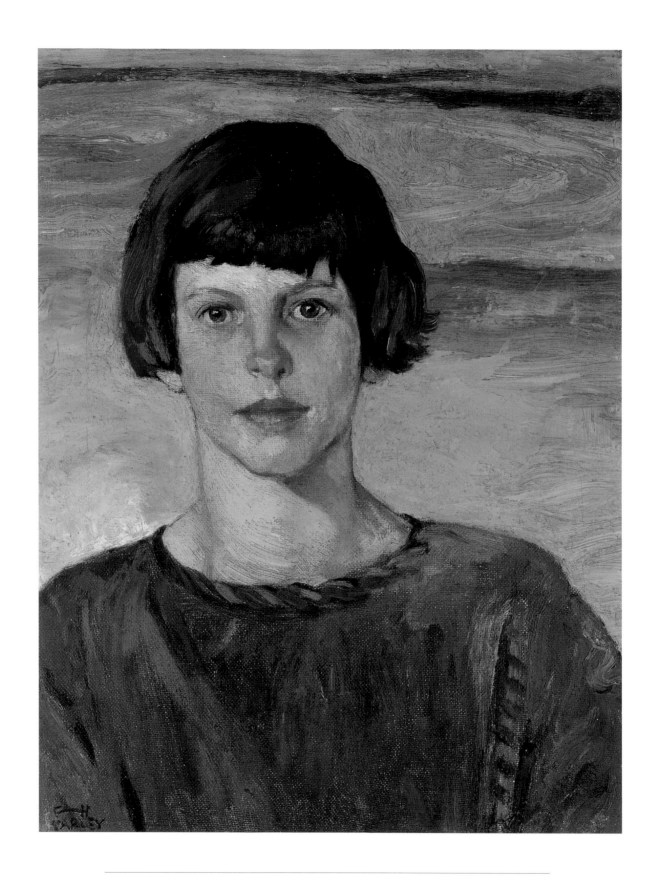

F.H. Varley *Study of Joan (Fairley)* c. 1923

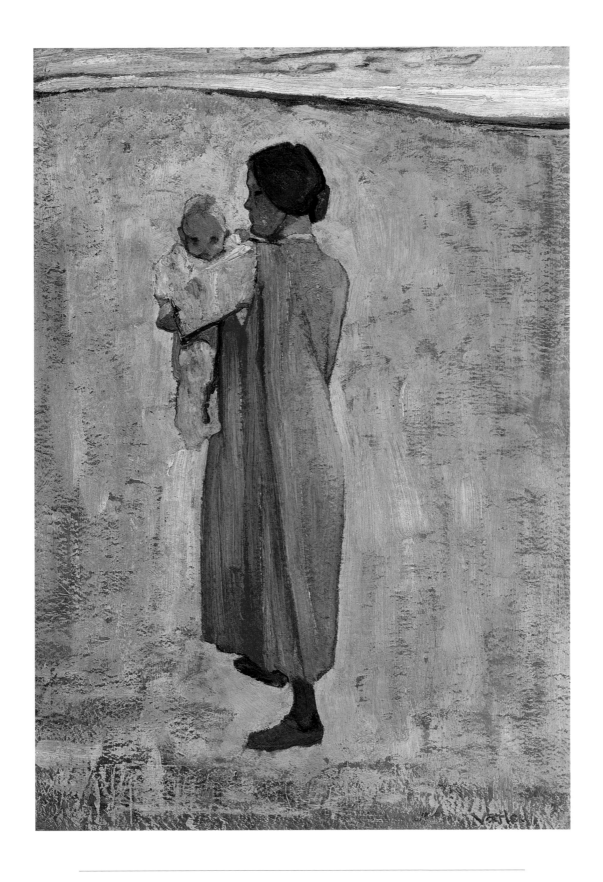

F.H. Varley *Rocky Shore* 1921

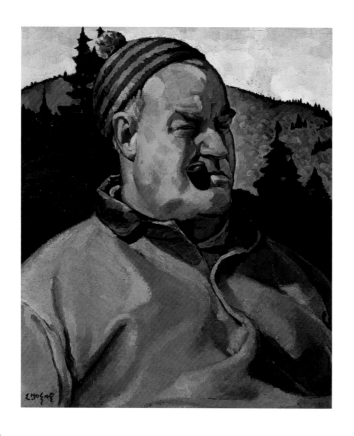

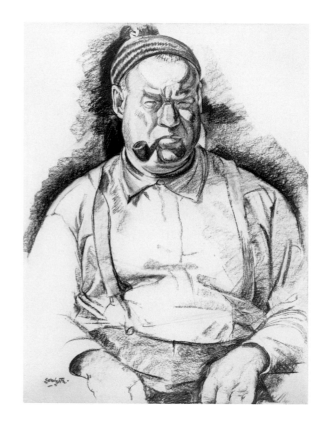

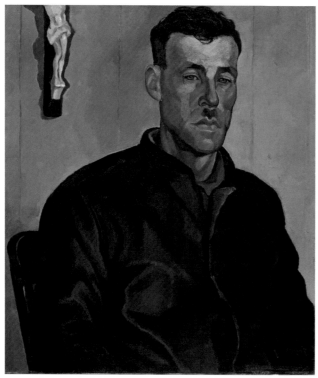

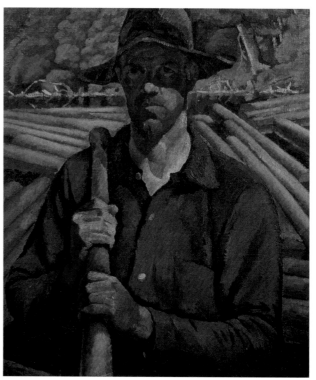

Edwin Holgate *Fire Ranger* 1925–1926

Edwin Holgate *Paul, Trapper* c. 1929

Edwin Holgate *Forest Ranger* c. 1926

Edwin Holgate *The Lumberjack* 1924

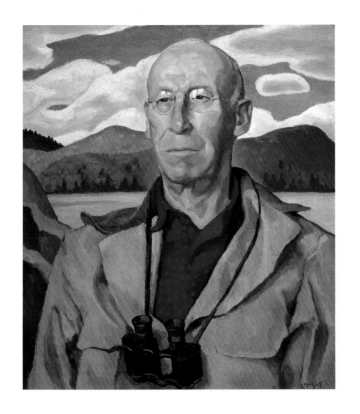

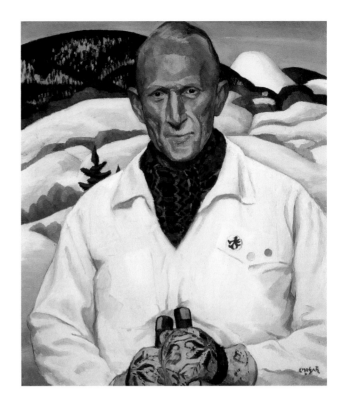

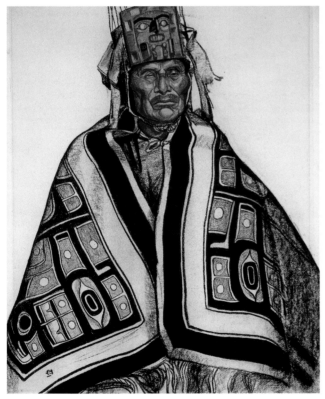

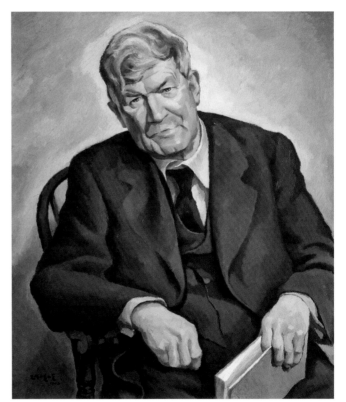

Edwin Holgate *The Naturalist* 1941

Edwin Holgate *Chief Tsimshian Jim Larahnitz* 1926

Edwin Holgate *The Skier (Portrait of Herman "Jackrabbit" Johannsen)* c. 1935

Edwin Holgate *Portrait of Stephen Leacock* 1943

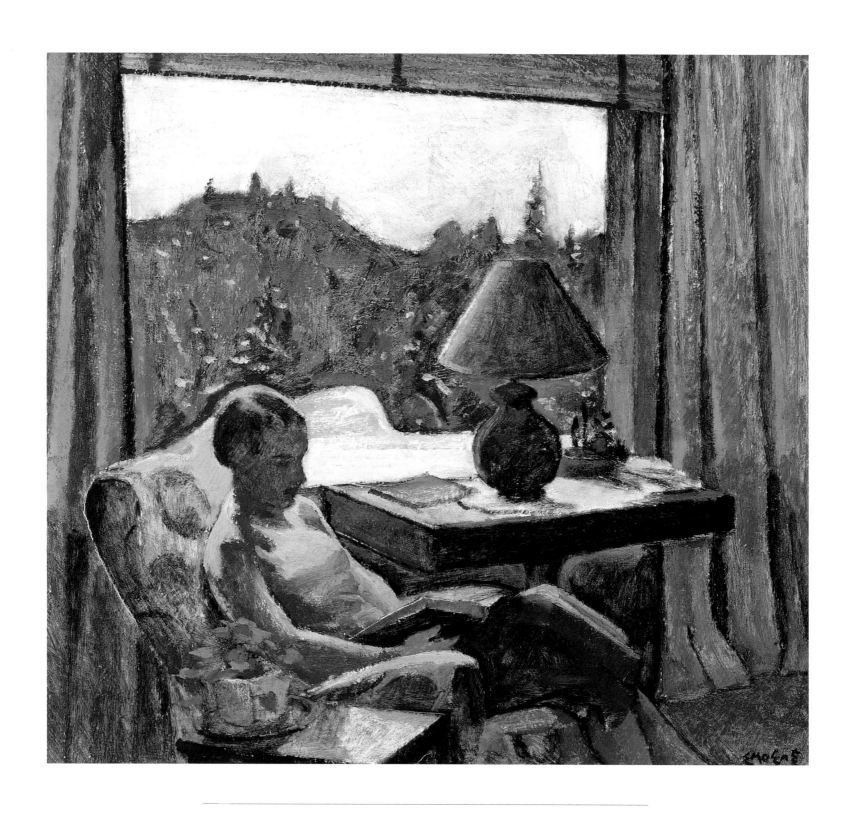

Edwin Holgate *Lady by the Window* c. 1946

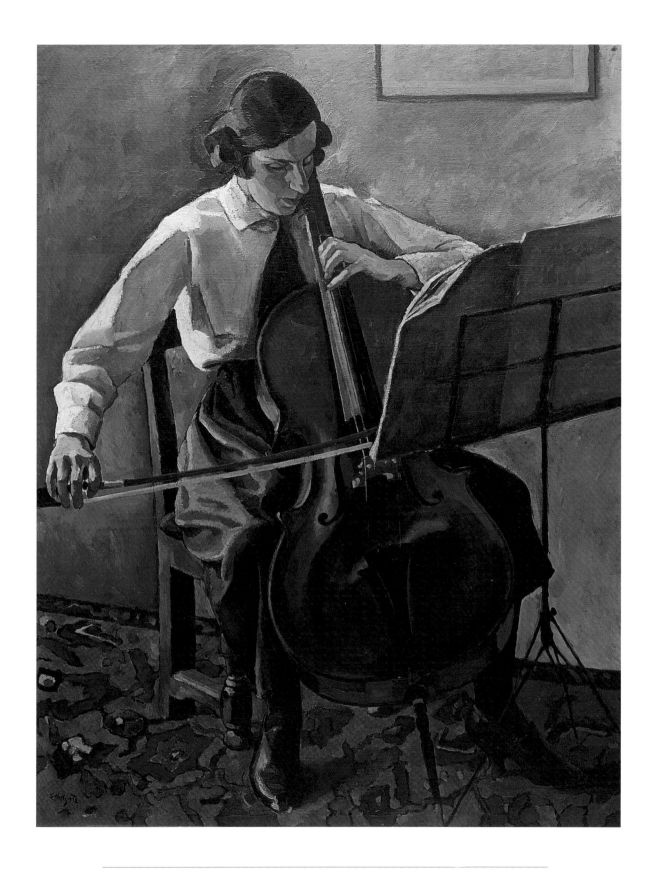

Edwin Holgate *The Cellist* 1923

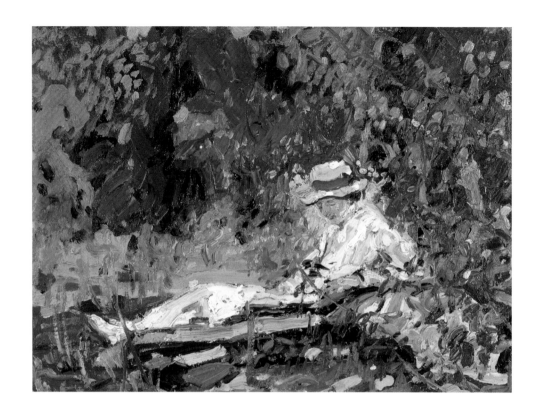

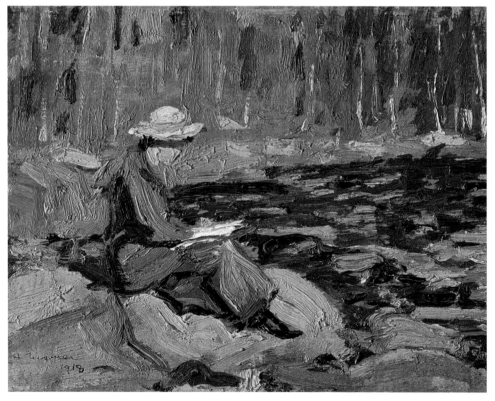

Arthur Lismer *Severn River* 1925

Arthur Lismer *My Wife, Sackville River, Nova Scotia* 1918

THE FIRST WORLD WAR

IN EUROPE IN 1914, the First World War broke like a summer thunderstorm, just as, in Canada, the momentum toward the creation of an artistic collective was reaching a crucial point among the individuals who later formed the Group of Seven. The war changed the lives of everyone. The atmosphere for art and artists altered abruptly. With the war came a nasty conscription crisis that pitted Quebec against the rest of Canada, and a growing awareness that Canada's ties to Britain were not inviolate. Canada's identity was bound to be redefined.

Core members of the Group had by this time been together for a good five years or more as friends, colleagues at work, and members of the Arts and Letters Club. A.Y. Jackson had just moved from Montreal to be with them, and they were all creating some of the most important work of their careers. But for the war, the Group of Seven surely would have emerged sooner, perhaps accomplished even more; and it would undoubtedly have included Tom Thomson, their spiritual guide and greatest natural talent.

What happened instead was that in 1918 Jackson (the only member who fought at the front – and was wounded) and F.H. Varley were engaged to paint as part of the Canadian War Memorials program in Europe, where they experienced the horrors of the slaughter of young men and the mutilation of the countryside. Lawren Harris joined the army in 1915 and trained soldiers at Camp Borden, but painted little during his service. After his only brother, Howard, died in the trenches, he suffered a nervous breakdown and was discharged early in 1918. Arthur Lismer was engaged, late in the war, by the domestic program of the Canadian War Memorials and painted the naval operations in Halifax. Frank Johnston, similarly, painted at the flight-training bases at Beamsville and Camp Borden in Ontario. J.E.H. MacDonald worked on propaganda posters, then suffered a stroke in 1917, when he was forty-four, from which he only slowly recovered.

And then came the worst news of all for the Group, and not from the front lines of the war at all, but from Algonquin Park: Tom Thomson, not yet forty, had drowned in a canoeing accident in Canoe Lake on 8 July 1917. This loss to the small circle of artists was devastating. Thomson had tried to enlist (as he had for the Boer War earlier), but was found

unfit because of his health and probably his age. His death dashed the hopes all his friends had for him and for Canadian art. His loss was so acutely felt that speculation arose that he was murdered. Confusion was compounded by uncertainty about where his body was – it had been buried at Canoe Lake and then exhumed shortly after and re-interred in the family churchyard at Leith, near Owen Sound. The war did not delay MacDonald and J.W. Beatty from immediately erecting a cairn to his memory at Canoe Lake. The mythology of the Group of Seven had begun.

■

THE CANADIAN WAR MEMORIALS program was the brainchild of Lords Beaverbrook and Rothermere, well-to-do art patrons with extensive social connections, and it was based on a similar British program. Being something of an art collector, Beaverbrook extended his initial Canadian War Records program of photographic propaganda of Canadian war action, produced mostly for newspapers he owned, to include paintings. Beaverbrook and Rothermere expected the cost to be recovered from subsequent exhibition admissions, a condition that made the idea palatable to the military, which had to administer it. At first only British artists were engaged to record the contribution of Canadians to the war effort. And then, at the suggestion of his advisor, the art critic Paul Konody, Beaverbrook also invited Canadian artists, among them Maurice Cullen, J.W. Morrice, and David Milne. The National Gallery in Ottawa launched a complementary program on the home front in Canada.

A grand commemorative building to house all these works was planned to be built in Ottawa. Improbably, it was to be a replica of the Panthéon in Paris. Beaverbrook's mistaken belief that the Canadian government would pay for its construction led to a contretemps with Arthur Meighen, the new prime minister, and the lasting memorial was never built. The large-scale creations of many of the artists, such as Varley and particularly Johnston, and their determination to produce huge 'academy-like' set-pieces, were dictated in part by the innocent expectation that the 'Panthéon' of Canadian war art would need grand works for the permanent display. The Memorials program, nevertheless, was immensely successful and was

resurrected for the Second World War, although the only artist among the Group who served both times was Lismer.

Canadian losses in the First World War were horrific: sixty thousand dead and twice that number wounded. Toronto alone lost ten thousand men in a population of less than 400,000, a staggering number and a high proportion of the male population. Most of the casualties were in their late teens or early twenties. To walk along the rows and rows of crosses in the acres of cemeteries near Vimy Ridge, France, and to see how many young Canadians died is an almost unbearable experience. Many of those who survived the trenches were unable to pick up the threads of their lives or to lead a normal existence thereafter. Varley and Jackson found new depths of artistic purpose in having to deal with the grimness of the battlefields. Varley wrote home to Lismer: 'I tell you, Arthur, your wildest nightmares pale before reality.'

The paintings by Jackson and Varley are moving testimonials. Varley posed a profound question with his painting *For What?* (p. 118). Was the loss of life necessary? Had the sacrifice been worthwhile? The origin of the painting, a dispatch photograph, showed the reality of the horror vividly enough, but the painting raises the level of our emotional awareness to a higher pitch. The same is true of Varley's *Burnt-out Tank* (p. 120) and *The Sunken Road* (p. 119). Jackson's *Springtime in Picardy* (p. 117) is troubling and provocative, its powerful juxtaposition of wrecked buildings and flowering fruit trees conveying an acute sense of what is at once bitter yet life-affirming. The electric blue and vivid tangerine colours add to the irony and unreality of the image.

On the home front, Lismer was in Halifax just after the great explosion of 1917, when a munitions ship rammed another ship in the harbour, killing many people and destroying a large part of the city. He recorded naval activities: training, defence work, target practice, and the assembly of convoys in Bedford Basin. His paintings of ships entering and leaving Halifax harbour, or sweeping the harbour approaches for mines, are among some of his best work. Shortly after the war he was joined by Jackson, who also painted the still-camouflaged ships returning Canadian troops home.

Despite the searing memories and the enormous loss of life, Canada emerged from the crucible of the European war ready to develop a new sense of national and artistic identity, as MacDonald had thought it might. The experience of being abroad doubtless

made a difference for those who returned. Peace brought the country to a new level of maturity and a clearer determination to achieve greater independence from Britain. There was resolve and even buoyancy in the air in the years following 11 November 1918. The artists, who were back together in Toronto, had resumed their circle of friendship at the Arts and Letters Club. More importantly, they had decided to rededicate themselves to their mission to create a national art equal to the greatness they thought Canada deserved, having just proved herself on the battlefields of Europe. The first thing they set about to arrange was a memorial exhibition of the works of Tom Thomson.

■

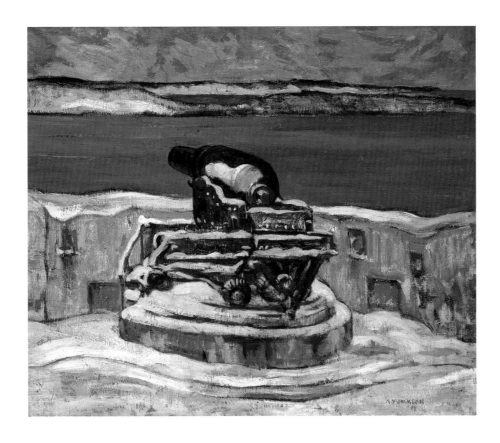

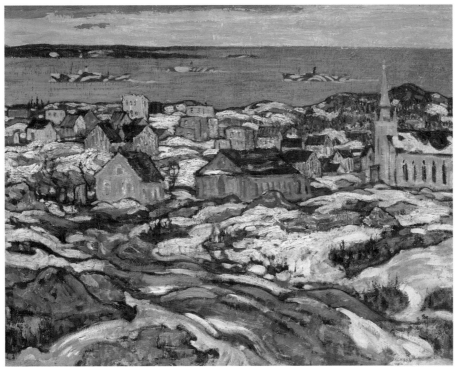

A.Y. Jackson *The Old Gun, Halifax* 1919

A.Y. Jackson *The Entrance to Halifax Harbour* 1919

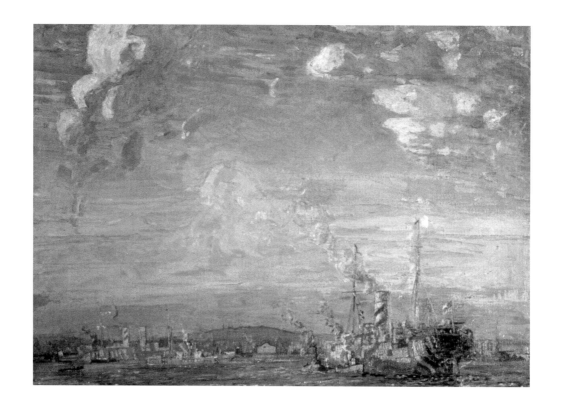

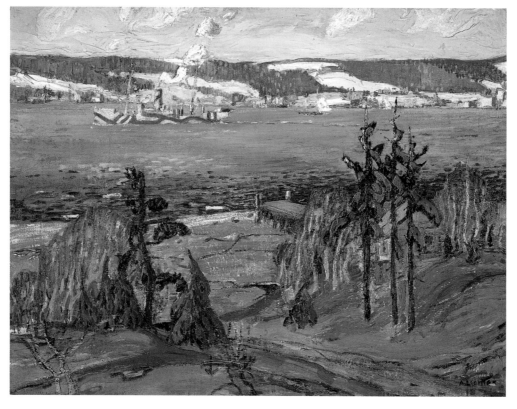

Arthur Lismer *Halifax Harbour, Time of War* 1918
Arthur Lismer *Winter Camouflage* 1918

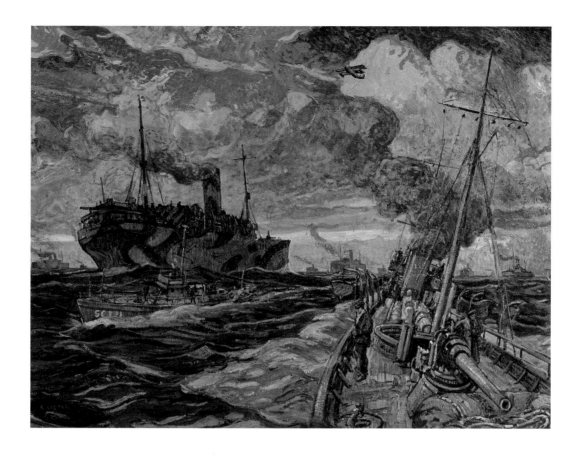

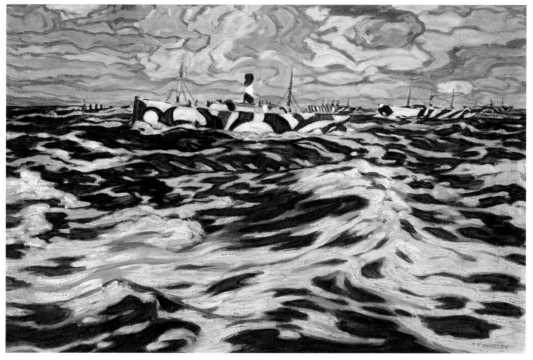

Arthur Lismer *Convoy at Sea* 1920

A.Y. Jackson *The Convoy* 1919

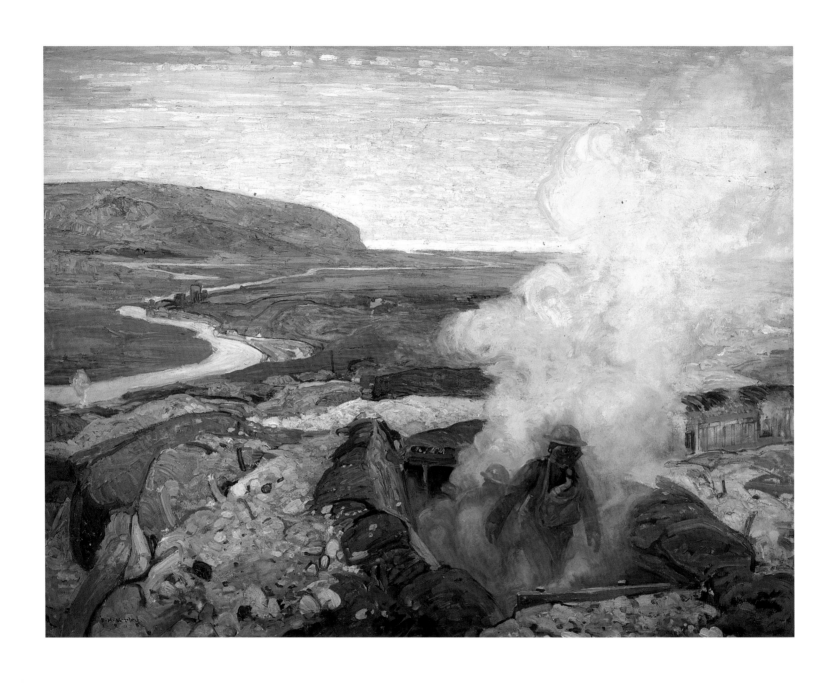

F.H. Varley *Gas Chamber at Seaford* 1918

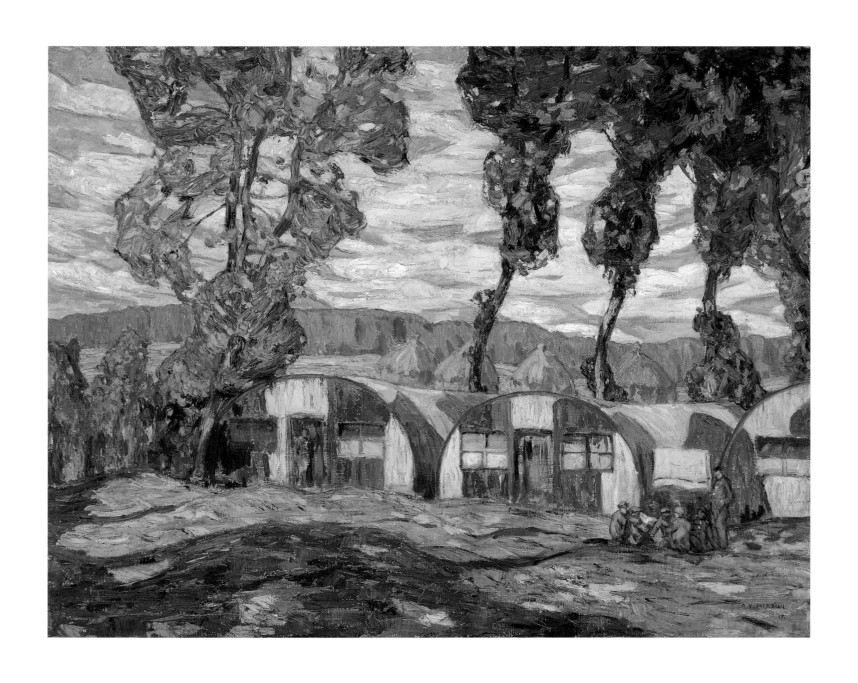

A.Y. Jackson *Camouflaged Huts, Villers-au-Bois* 1917

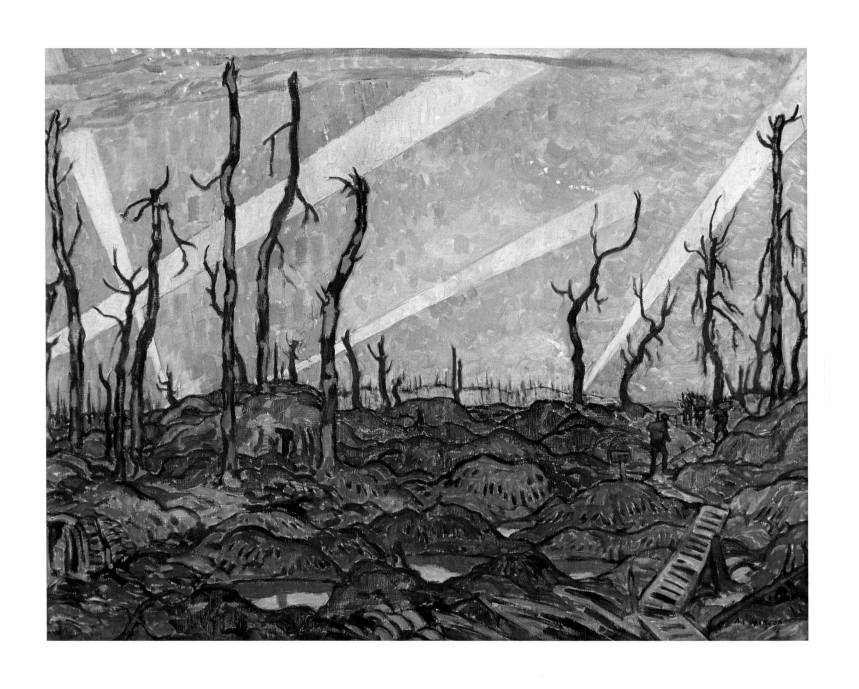

A.Y. Jackson *A Copse, Evening* 1918

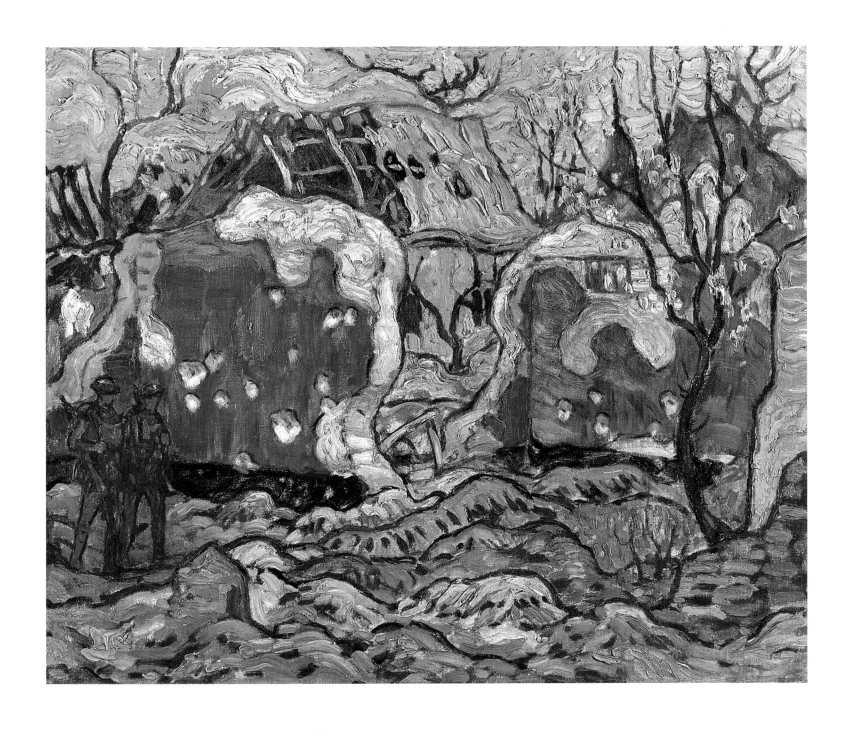

A.Y. Jackson *Springtime in Picardy* 1919

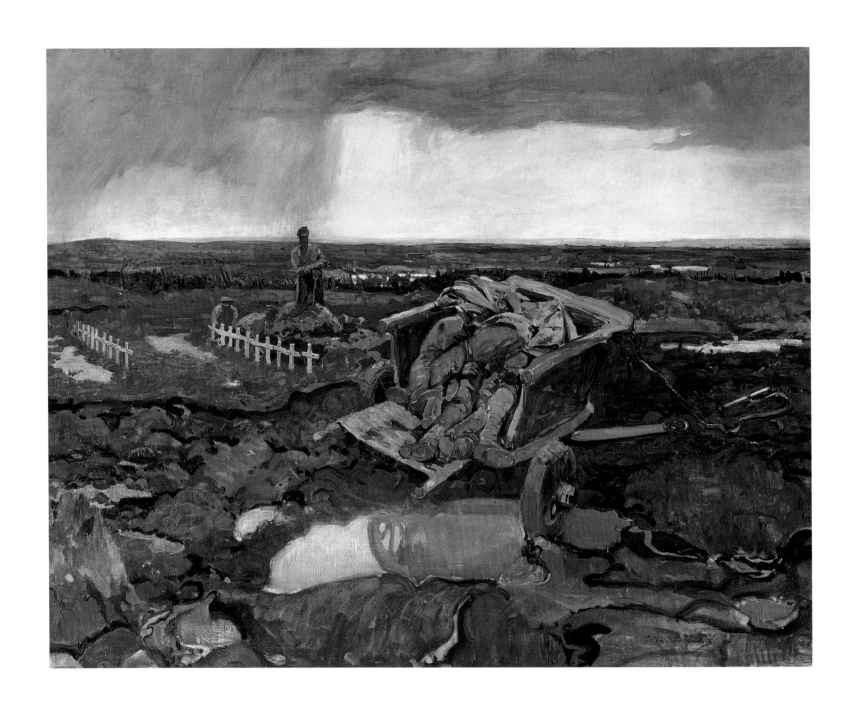

F.H. Varley *For What?* 1918

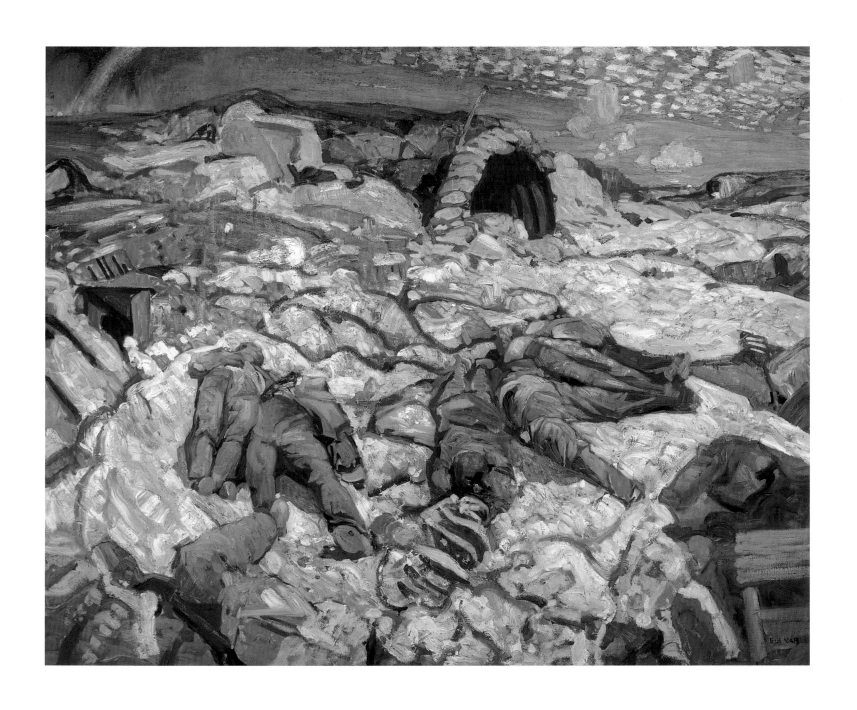

F.H. Varley *The Sunken Road* 1918

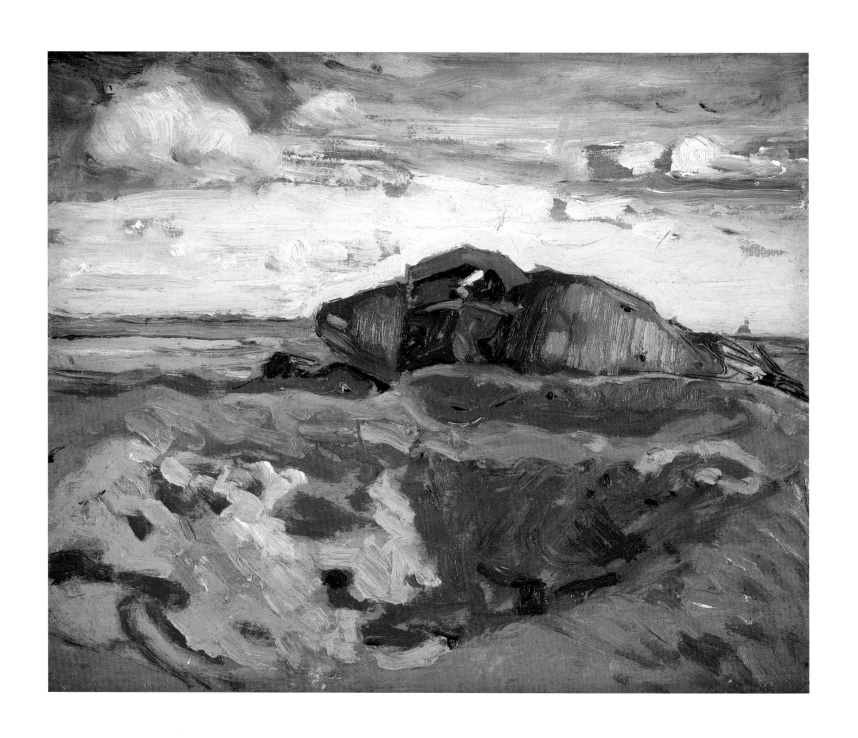

F.H. Varley *Burnt-out Tank* 1918

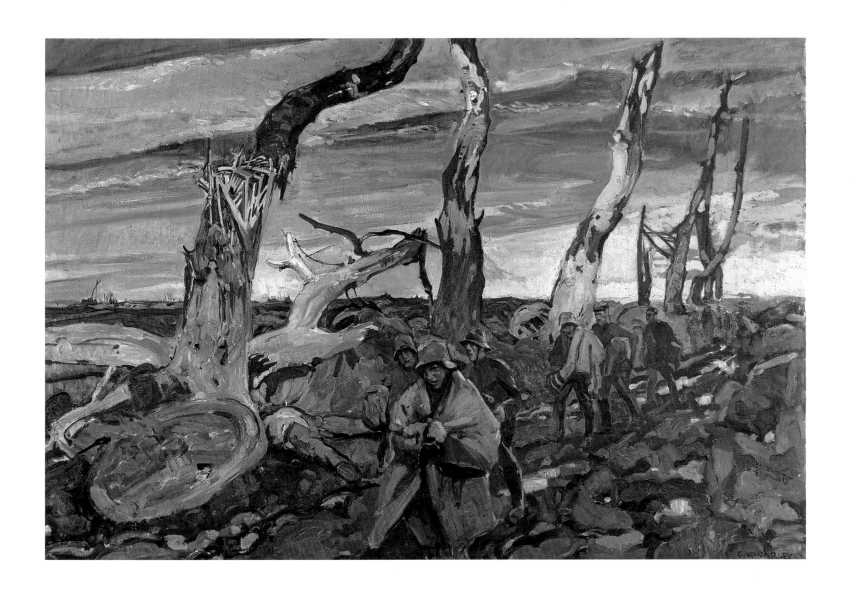

F.H. Varley *German Prisoners* 1918

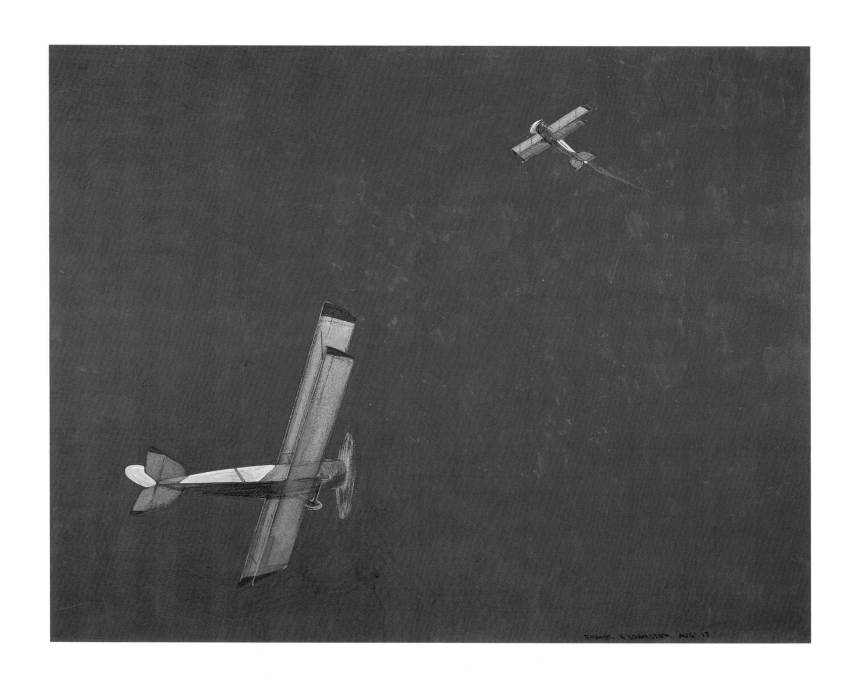

Frank Johnston *Looking into the Blue* 1919

Cities, Towns, and Villages

When the members of the Group of Seven and Tom Thomson were first beginning to get to know one another, in the early part of the twentieth century, Toronto was still a small, provincial, and colonial city with a population of just over 350,000. Canada's whole population was only 6,625,000. By 1920, when the Group finally was formed, Toronto had well over half a million souls and Canada over 8,500,000; by 1931, when the Group held its last exhibition, Toronto had grown to a thriving city of 712,880 people and Canada's population had reached 10,633,000. This was a period of rapid growth for Canada, despite the devastation of the First World War in Europe and the disruption of Canada's economic expansion.

Toronto, not the wilderness, was the place in which the Group of Seven spent most of their time together. The Group really was a Toronto regional school and the city was their centre and their place of work. All the explorations of the country, when seldom more than three or four of them were ever together at one time, were subject-gathering trips – inspirational to be sure, but raw material for the real work, which happened in their studios in Toronto. Even so, the first subject to attract Lawren Harris, after his academic training as an artist in Germany, was the city itself. Although Toronto was not inherently beautiful, something about the place was attractive to painters. Harris painted it often when it was laden with snow, with its industrial, residential, and natural features: the huge gas tanks, the factories, sheds, parks, shops, and houses – both grand and small.

Harris, a productive artist and therefore a hard worker, was also conscious that the largest part of artists' lives are spent in their studios. In 1913, seeing the need in Toronto for proper studios for serious artists (at the time he shared a studio-room over a bank at Yonge and Cumberland streets with A.Y. Jackson), Harris joined with his friend Dr James MacCallum, an ophthalmologist, to construct a building at 25 Severn Street in the Rosedale ravine. The Studio Building, as it was called, was a three-storey brick affair, which housed six spacious north-facing studios with fourteen-foot ceilings. The three eastern studios had fireplaces and bathrooms. The western studios had a sink and a toilet off the service stair. All had windows across most of their width and all of their height (except for the low steam radiators) and a

small mezzanine for sleeping, with rack storage for paintings underneath. These quarters were soon occupied by Harris, Jackson, J.E.H. MacDonald, Tom Thomson, and Frank Carmichael, as well as J.W. Beatty, Arthur Heming, and Curtis Williamson. 'About all that Williamson, Heming and Beatty had in common,' Jackson commented in his autobiography, 'was a hearty dislike of one another.' The Studio Building and the Arts and Letters Club were the places where the future members of the Group most often met to see one another's work, to talk about art, and to discuss their plans for the future of art in Canada.

When Harris painted in Toronto's 'Ward' district, as it was called – an eight-acre, ramshackle quarter of the city north of City Hall and Osgoode Hall, bordered by University Avenue and College, Yonge, and Queen streets, where the poor, immigrant population of Toronto mostly lived until they were evicted in 1913 to make way for the Toronto General Hospital and the Armoury – he was painting what was then regarded as a distasteful and improper subject. Yet to him this was an integral part of the country and the society he wanted to record. He made the Ward look warm and social, and he populated his paintings with citizens going about their lives, going to church, shopping, even being serenaded by an organ grinder in *Hurdy-Gurdy* (p. 147). The Eaton factory building Number 4, built in 1909 (p. 132), was north of Queen Street behind what is now Old City Hall and housed garment workers, the largest work force of Eastern European Jewish labour in Canada. In 1912 Harris and MacDonald sketched together at the foot of Bathurst Street in Toronto, Harris producing *The Gas Works* (p. 131) and MacDonald, *Tracks and Traffic* (p. 130). Harris's simple row houses on Wellington and Richmond streets (pp. 137 and 139) and other ordinary urban subjects are depicted to make us see them as if through a prism of bright light: rich handling of paint, dappled shade and sunlight, a sense of a moment caught in the life of a person, a family, a city, a society. There seems always to be a subtle moral aspect to Harris's work, an implied lesson or observation that is seldom overt or propagandistic.

MacDonald painted in High Park, around the city, and on nearby farms. He lived in the farming community of Thornhill, some thirty kilometres north of Toronto, for much of his life. Toronto then was built barely as far north as St Clair Avenue; and the urban belt through which Highway 401 now ploughs its way was all forest and field. Although we do not know where his painting *Cattle by the Creek* (p. 155) was done, it probably was relatively close to what

is now downtown Toronto, for dairy farms at that time were within a short radius of the city. *Pump and Pumpkins* (p. 157), similarly, could have been anywhere south of what is now Eglinton Avenue. The flowers at Usher's Farm (p. 79) were painted in the rural village of York Mills, now part of Toronto.

Although all Thomson's large canvases were painted in his Toronto studio, and the city itself was one of Thomson's favourite places – where he worked, attended concerts, went to the theatre, used the library, and visited with his friends – it was rarely his subject. Once he painted the Rosedale ravine at night, just outside the Studio Building, a now-missing picture. Thomson shared space in the Studio Building with Jackson (they moved into studio 1 on the ground floor in January 1914, while construction was being finished, and split the $22 rent), and then with Carmichael. Since Thomson was in Algonquin Park from April to November starting in 1914, Harris had an old shack at the back of the building fixed up for $176.02 and rented it to him for one dollar a month, starting in late 1914 or early 1915. Thomson built his own bunk and work spaces. Harris described his nocturnal ramblings there in *The Story of The Group of Seven:*

> When he was in Toronto, Tom rarely left the shack in the daytime and then only when it was absolutely necessary. He took his exercise at night. He would put on his snowshoes and tramp the length of the Rosedale ravine and out into the country, and return before dawn.

Lismer, Varley, Carmichael, and Jackson did not find the inspiration in city forms that Harris did. Casson, who later caught some of Harris's love of houses and the city, was an exception, as his *House Tops in the Ward* (p. 71) eloquently attests. LeMoine FitzGerald often painted city subjects – views from his Winnipeg house window in winter, such as *Williamson's Garage* (p. 142), which display a personal style of subtle tonality, a tight range of colour, careful execution, and painstaking attention to structure. So accurate is his sense of place and light that it is hard not to see FitzGerald paintings whenever you drive down some of Winnipeg's older residential streets.

The attachment to the small towns and villages of Canada, however, was something that tugged at the heartstrings of all the Group's members, except for Thomson and Varley. Holgate, Harris, Lismer, MacDonald, and, particularly, Jackson painted the picturesque villages of Quebec perched along the shores of the St Lawrence River or nestled in the valleys of the

Laurentians or the Charlevoix. They immortalized the little farming villages of Ontario, with their grist mills, lumber sheds, and simple frame homes with the winter wood stacked along the side.

The same attraction to the human environment is evident in the paintings by Harris, MacDonald, Casson, and others of summer cottages at Lake Simcoe, Lake Ontario, Algonquin Park, or Georgian Bay. Harris's *Summer Houses, Grimsby* (p. 159) elevates an undistinguished row of buildings into a startling and powerful image. In these locales the conveniences of urban life are reconstituted for summer holidays, when Canadians repair to the wilderness without necessarily forsaking city comforts. This was the first expression of 'The North,' a terrain of lakes, rivers, forests, and rock in Muskoka, Haliburton, Madawaska, Bon Echo, and the Rideau lakes, all areas in what was then called Northern Ontario. Today Lake Scugog is considered part of southern Ontario; Haliburton, Madawaska, and Muskoka are the 'Near North'; and the Rideau lakes are an easy drive from Kingston and Ottawa. For us, Northern Ontario, which was then New Ontario, now begins at North Bay.

The English, Scottish, and Irish farming communities of Ontario came from a different architectural tradition than those in Quebec. Their sturdy, utilitarian, and durable buildings were just as attractive to painters, and Casson's quick eye was able to catch their appealing qualities and to give them a touch of nostalgic romance, as he has done with *Mill Houses* (p. 153) and *Hillside Village* (p. 151). And each community, whether in Ontario, Quebec, or the Maritime provinces, had at least one church, and it, too, was often the subject of the Group's record, as seen in the sections on the East Coast and on the St Lawrence River and Quebec, and in Casson's *Anglican Church at Magnetawan* (p. 152).

The city and its environs (Toronto for all except FitzGerald in Winnipeg, and Jackson and Holgate in Montreal), while providing the amenities of places like the Arts and Letters Club, the Studio Building, the Art Gallery of Toronto, and other necessities for artists, nevertheless ceased to be a subject for the Group after the 1920s, when most of their attention was focused on the landscape of the more distant parts of Canada. This change in focus occurred in tandem with the growth of the Group's own ideas and philosophies.

■

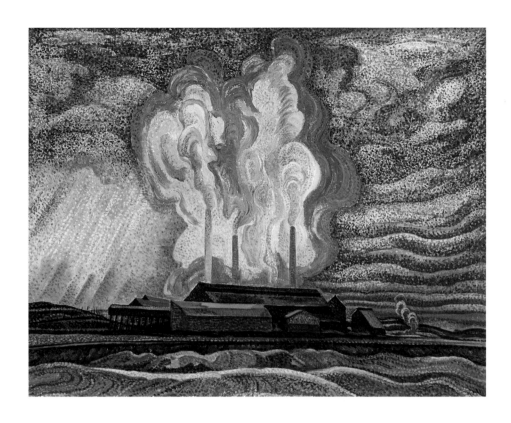

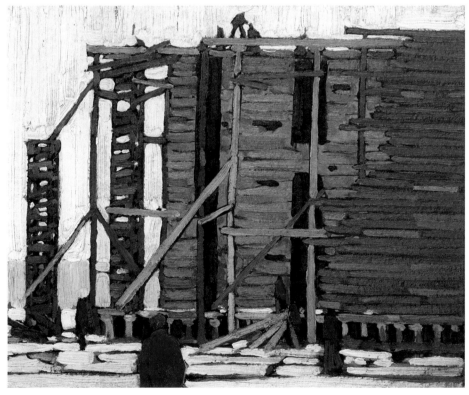

A.Y. Jackson *Smoke Fantasy* 1932

Lawren Harris *Building the Ice House, Hamilton* c. 1912

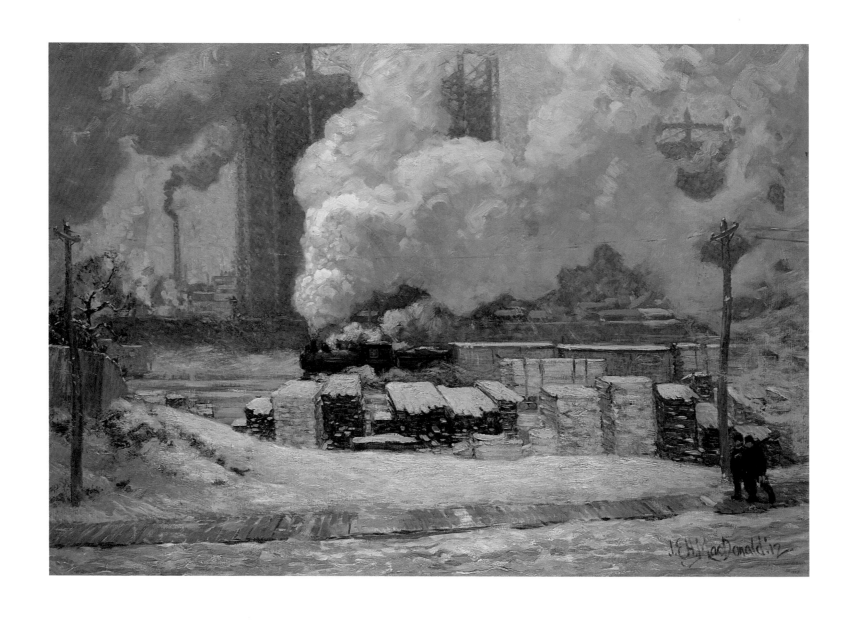

J.E.H. MacDonald *Tracks and Traffic* 1912

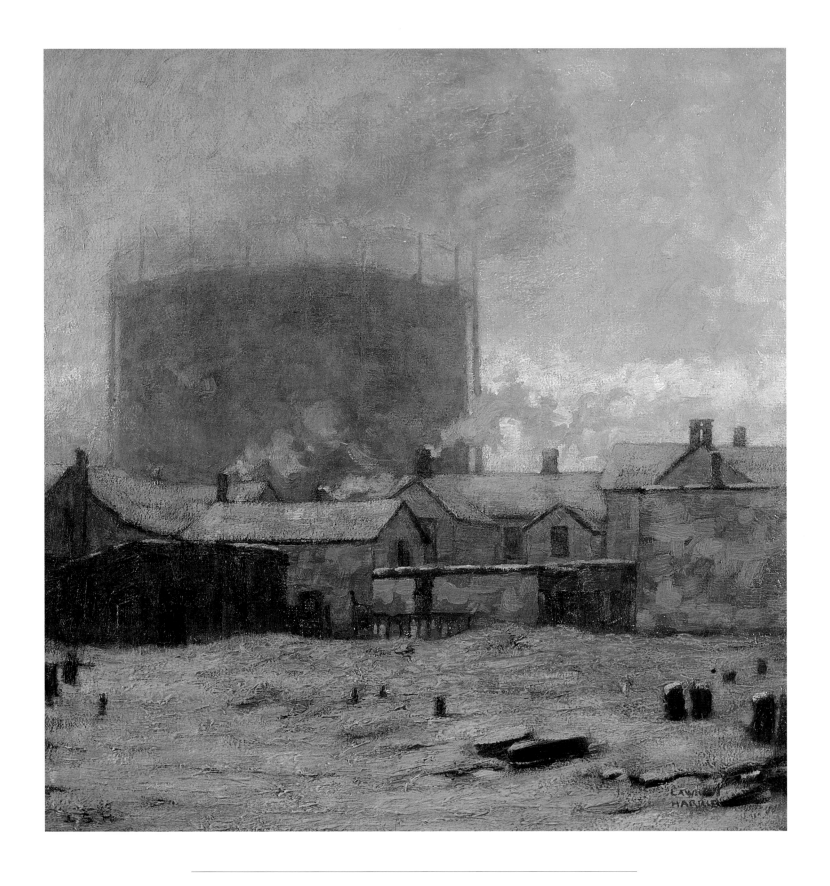

Lawren Harris *The Gas Works* 1911–1912

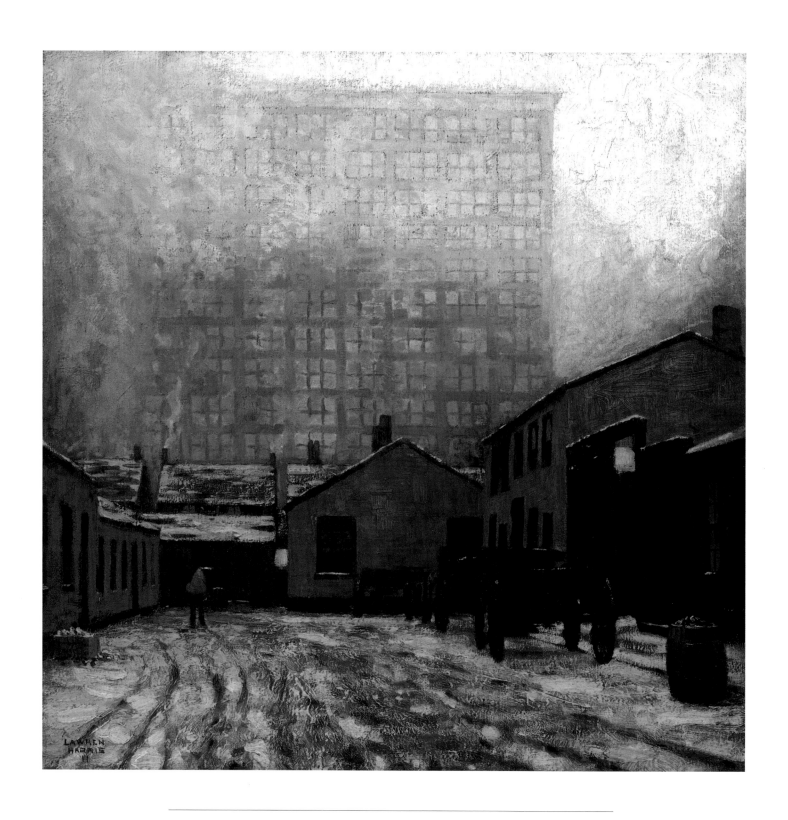

Lawren Harris *The Eaton Manufacturing Building* 1911

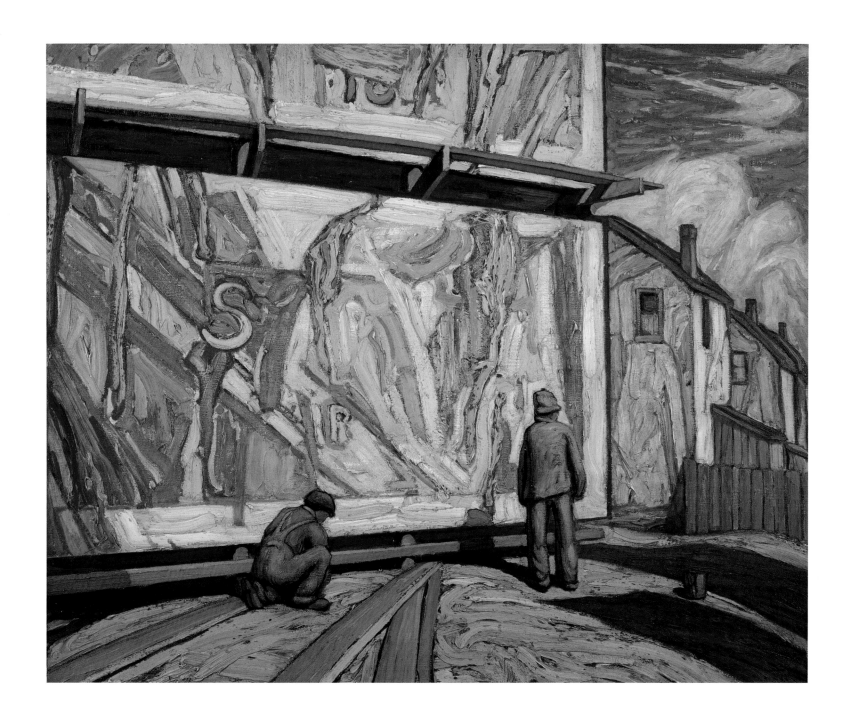

Lawren Harris *Billboard (Jazz)* 1920

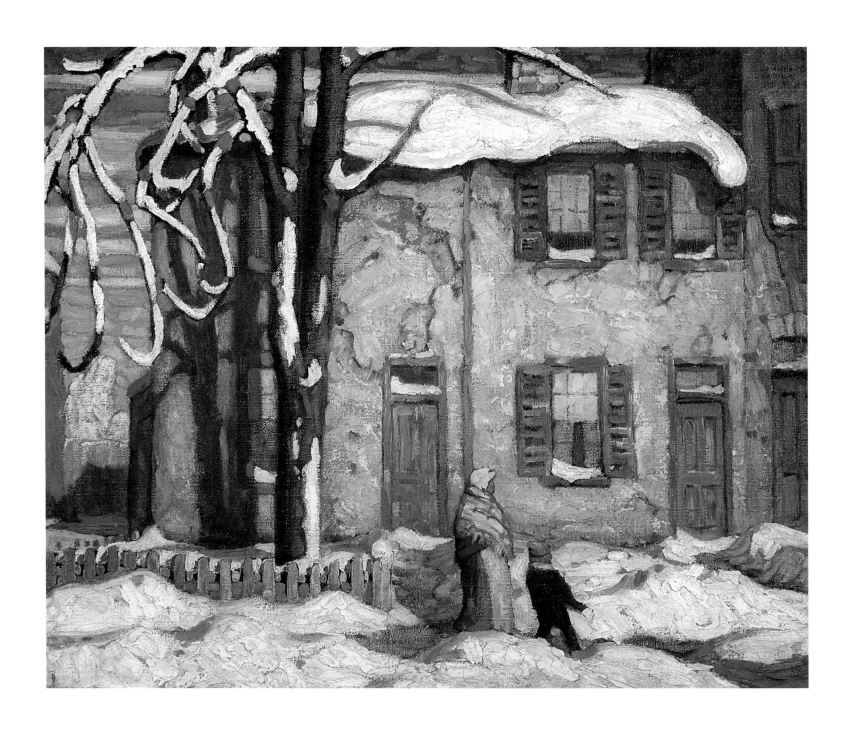

Lawren Harris *Old Houses, Toronto, Winter* 1919

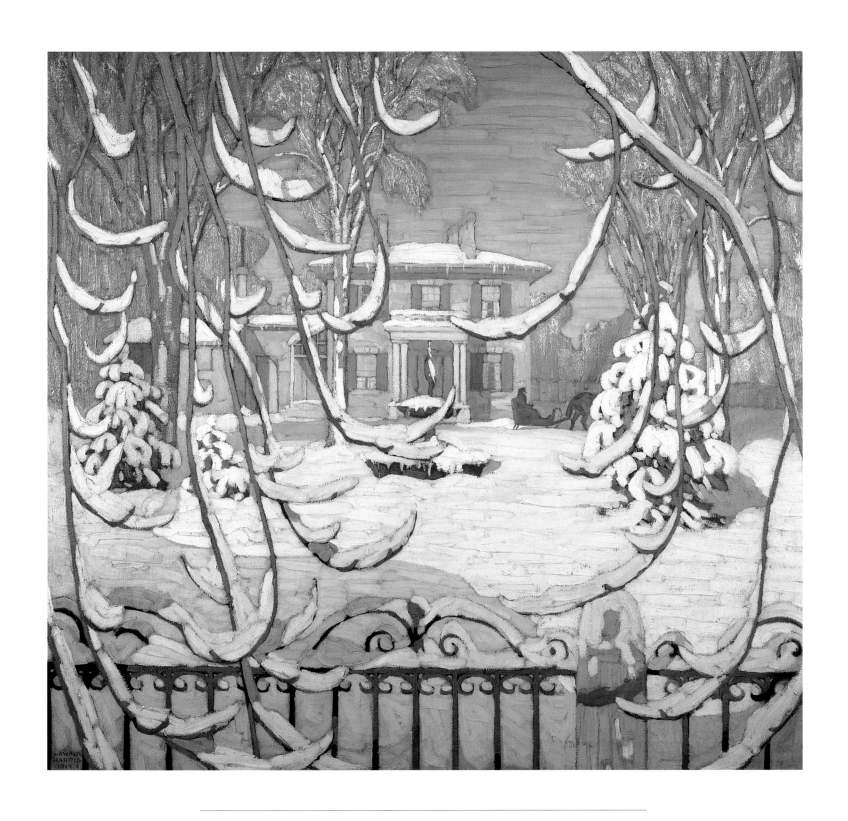

Lawren Harris *Red Sleigh, House, Winter* 1919

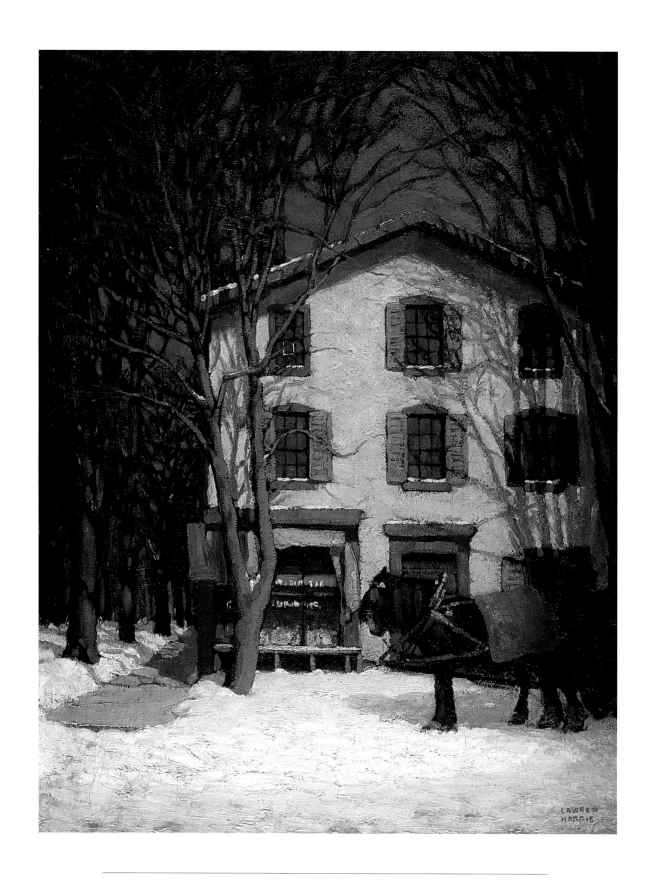

Lawren Harris *The Corner Store* 1912

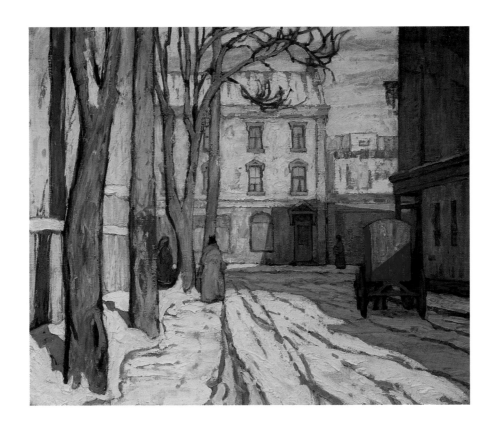

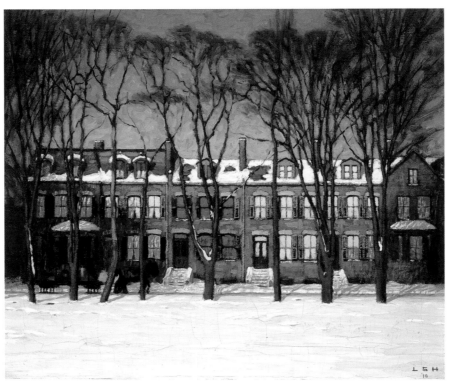

Lawren Harris *Toronto Street, Winter Morning* 1920

Lawren Harris *Houses on Wellington Street* 1910

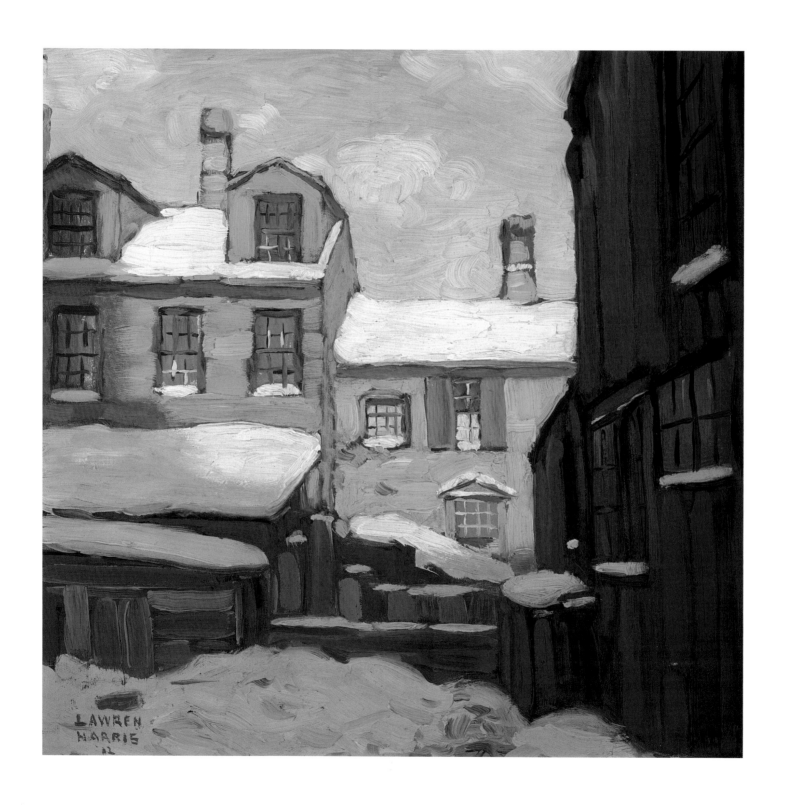

Lawren Harris *Toronto, Old Houses* 1911

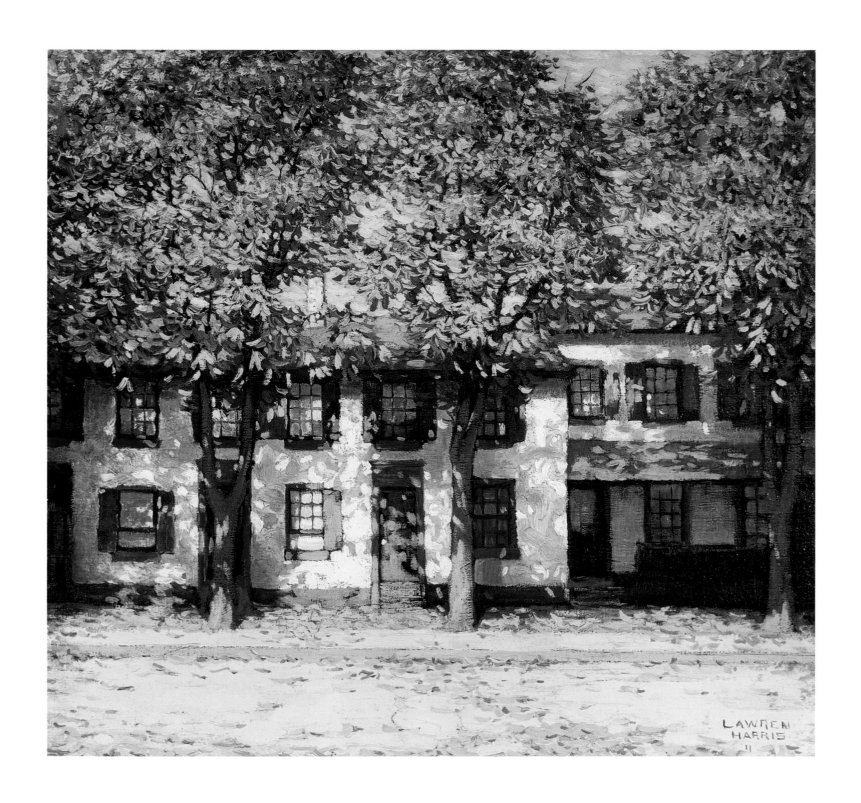

Lawren Harris *Houses, Richmond Street* 1911

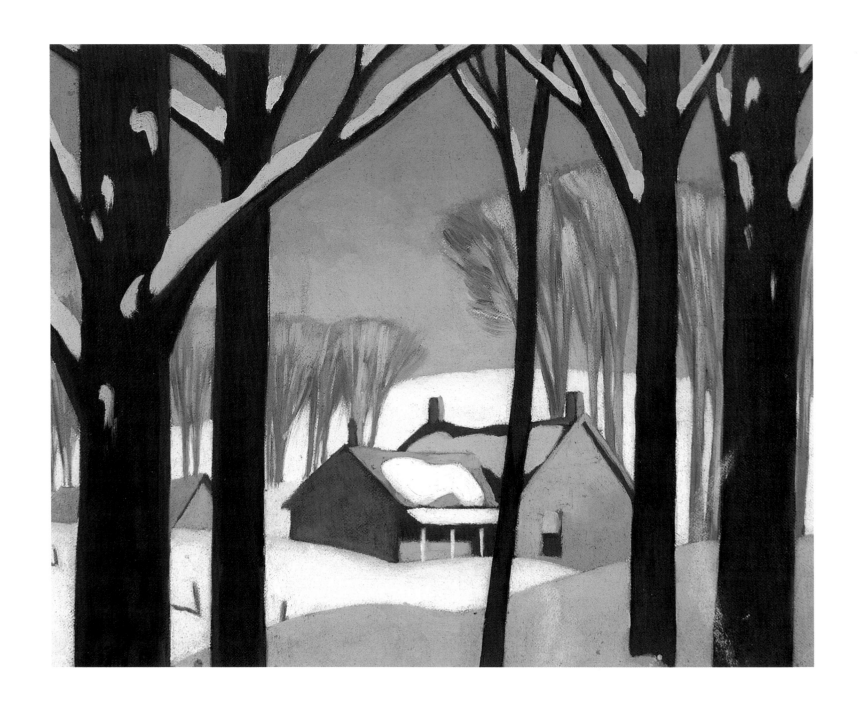

A. J. Casson *Winter House* c. 1942

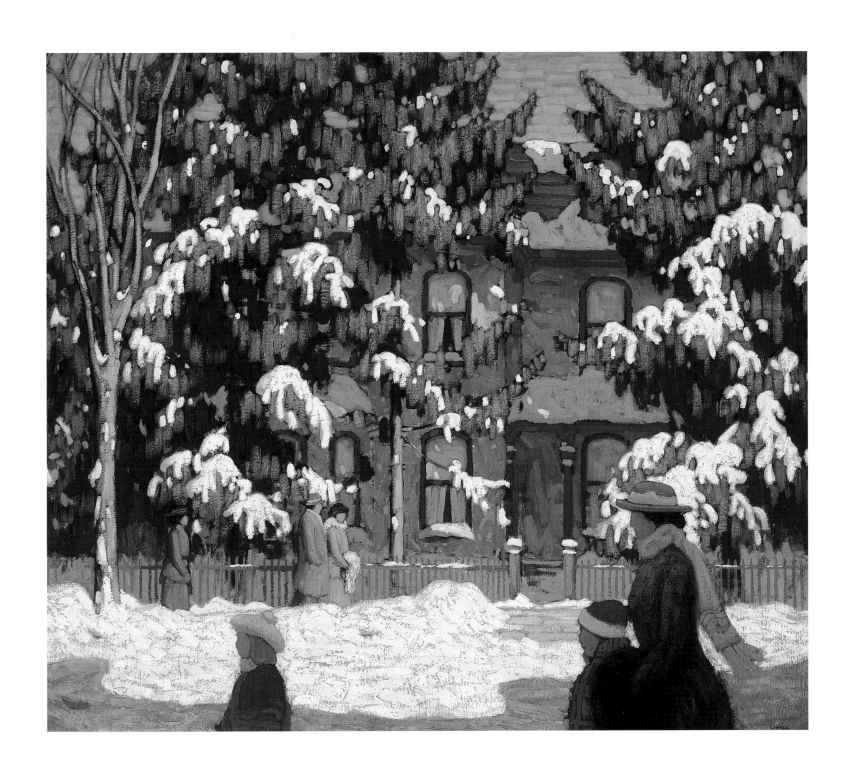

Lawren Harris *Winter Afternoon, City Street, Toronto* 1918

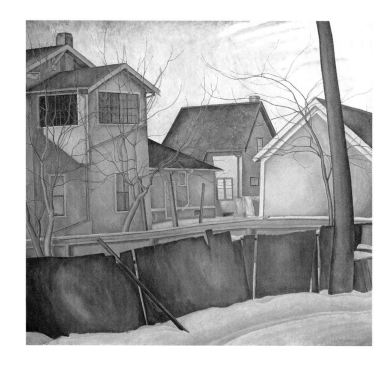

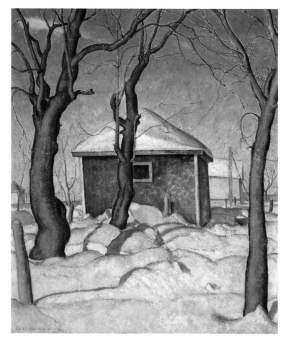

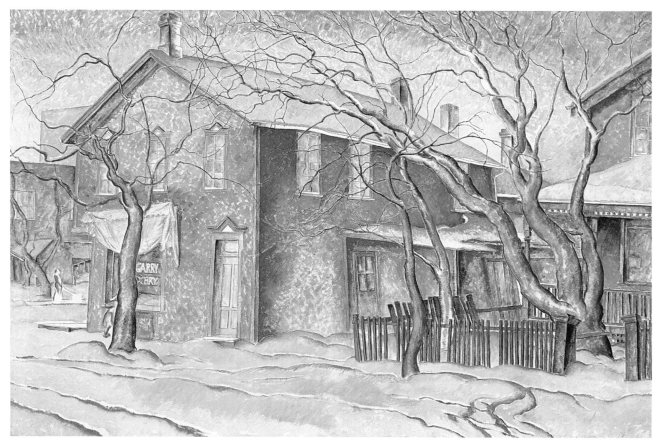

LeMoine FitzGerald *Pritchard's Fence* c. 1928 and *Williamson's Garage* 1927

LeMoine FitzGerald *Fort Garry Store* c. 1929

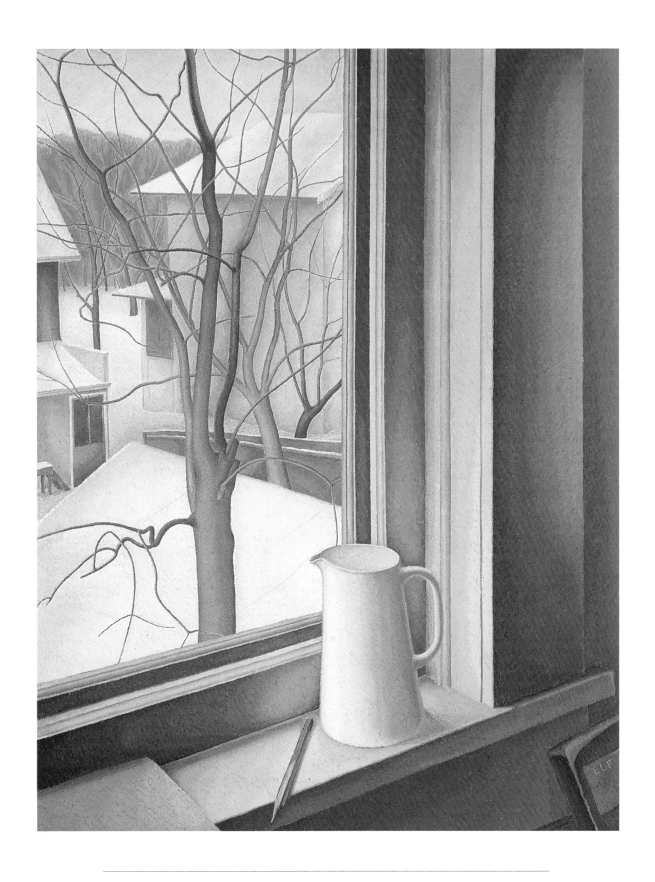

LeMoine FitzGerald *From an Upstairs Window, Winter* c. 1950–1951

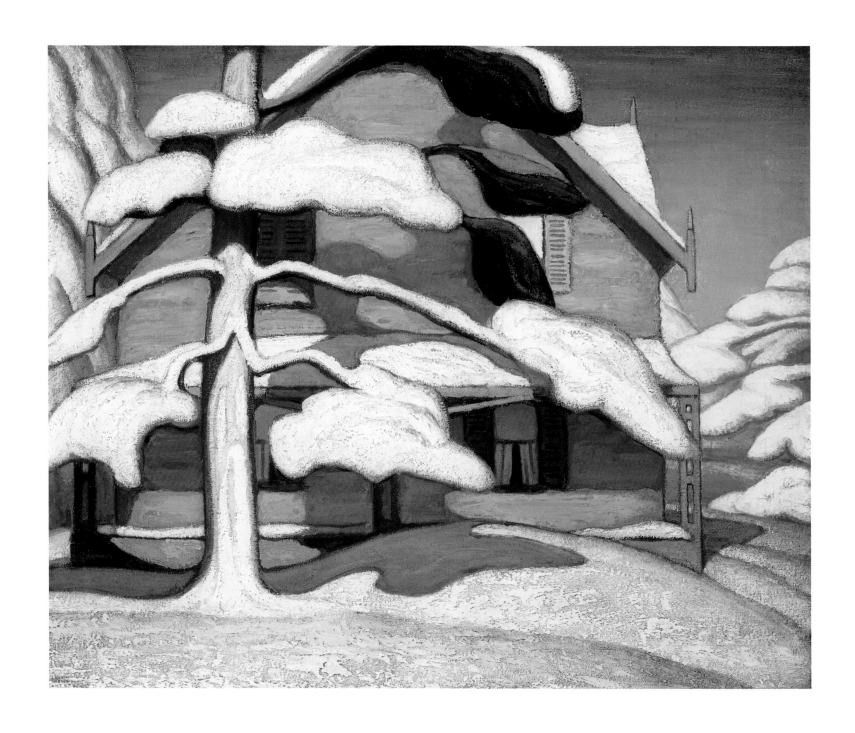

Lawren Harris *Pine Tree and Red House* c. 1920

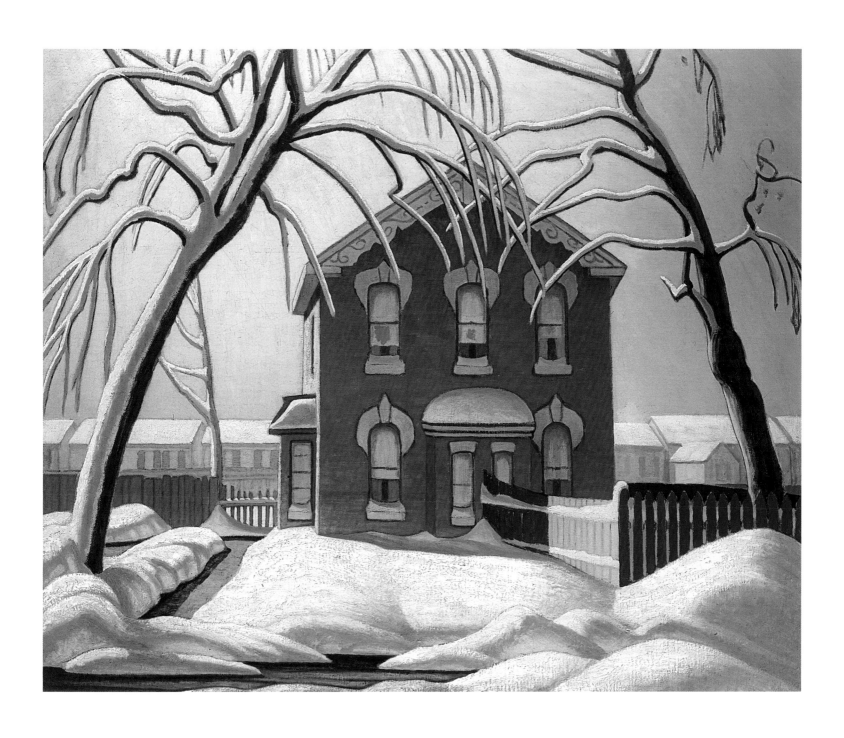

Lawren Harris *Red House, Winter* c. 1925

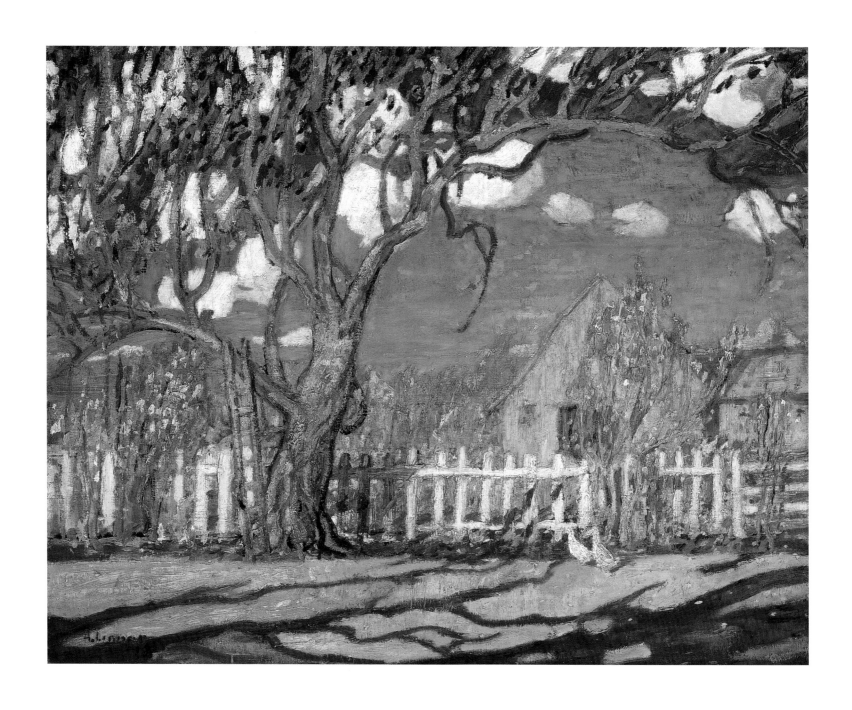

Arthur Lismer *Springtime on the Farm* 1917

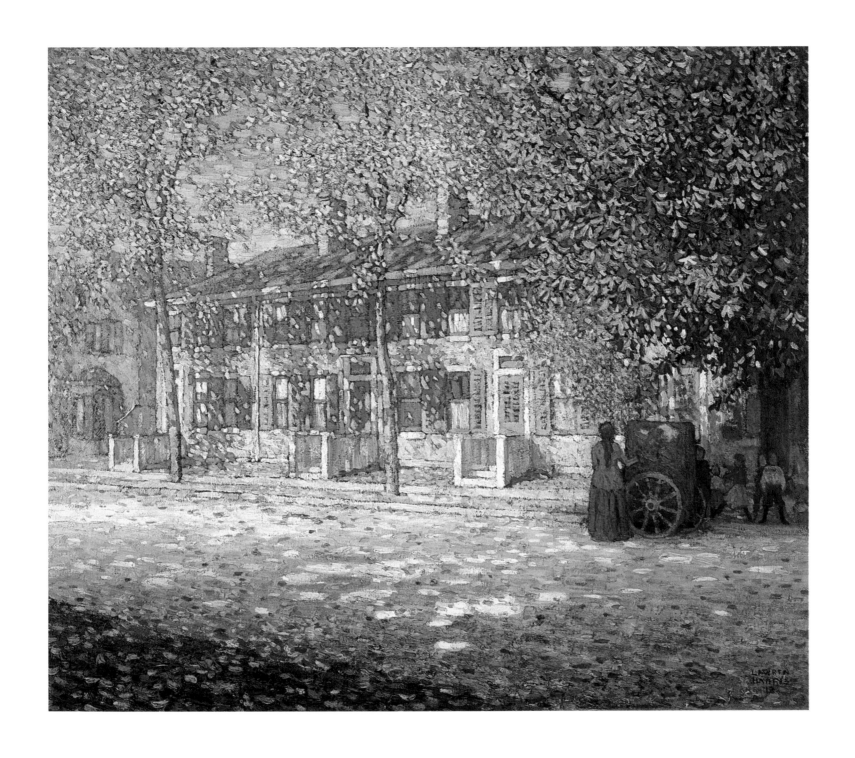

Lawren Harris *Hurdy Gurdy* 1913

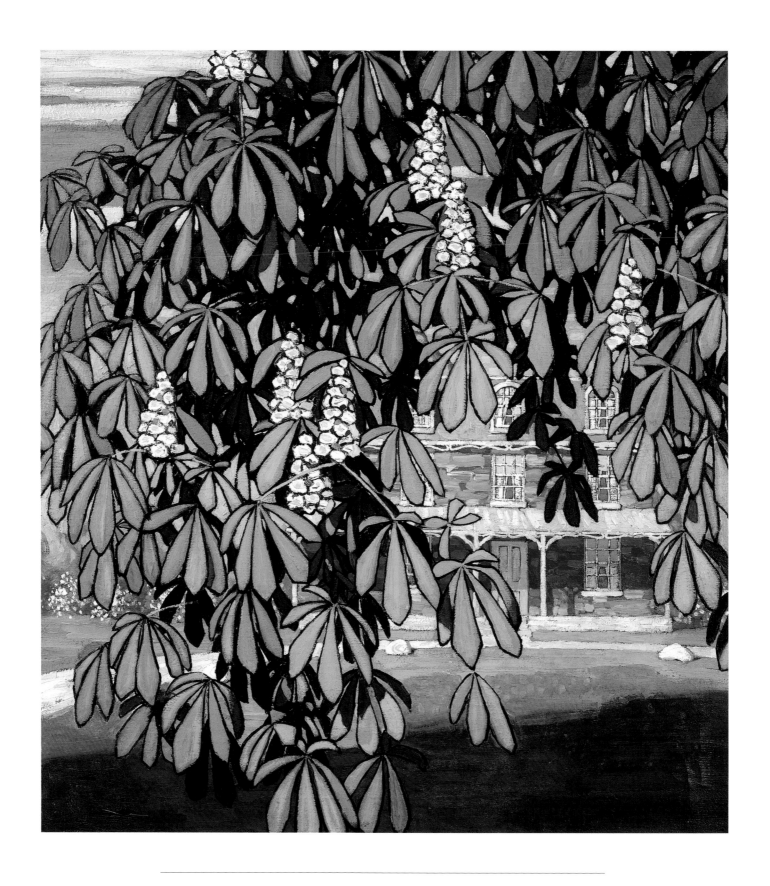

Lawren Harris *Chestnut Tree, House, Barrie* 1916–1917

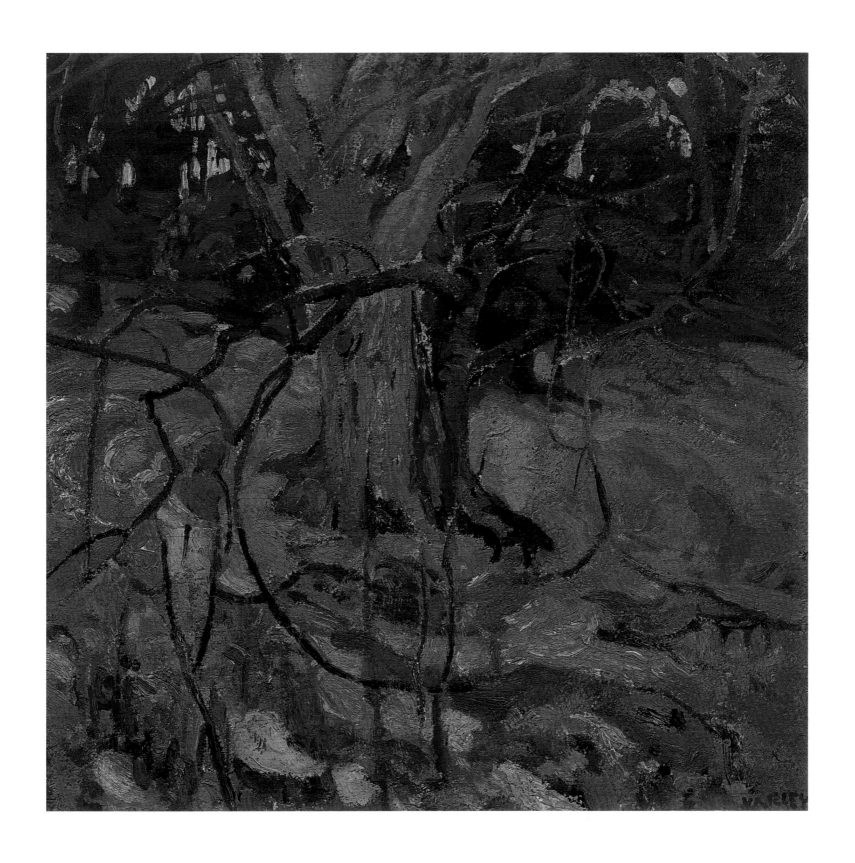

F.H. Varley *The Wonder Tree* (also known as *Magic Tree*) 1924

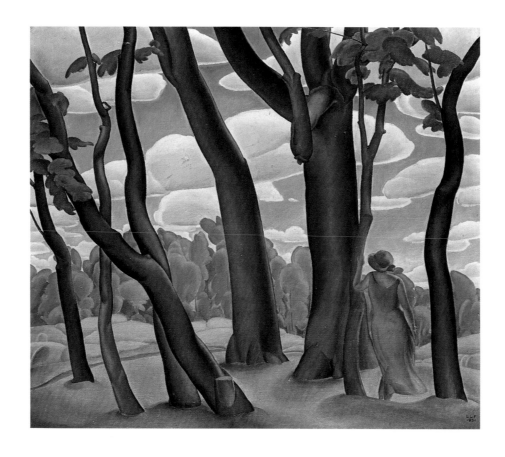

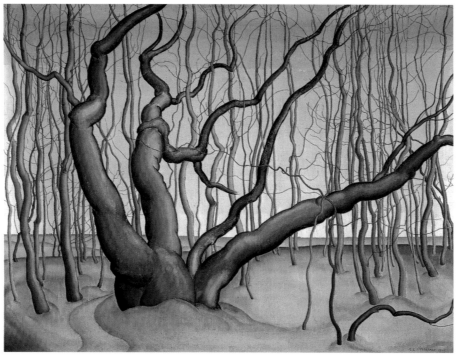

LeMoine FitzGerald *At Silver Heights* 1931

LeMoine FitzGerald *Untitled (Poplar Woods; Poplars)* 1929

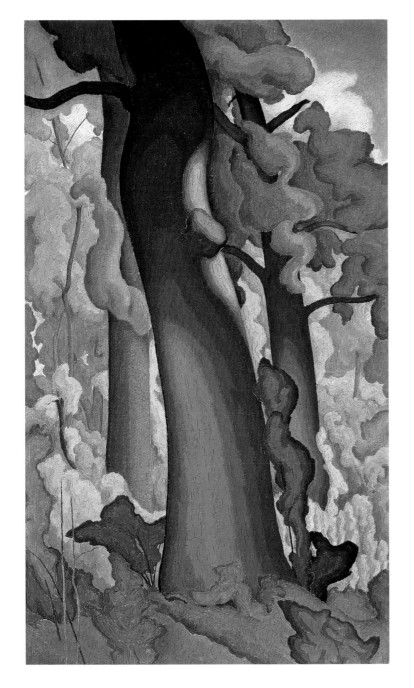

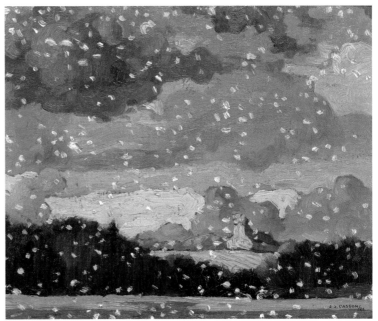

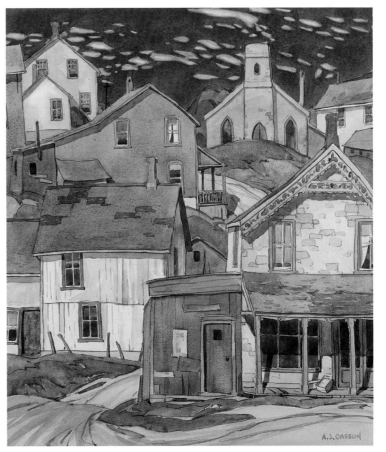

LeMoine FitzGerald *Untitled (Tree Study II)* 1949

A.J. Casson *First Snow, Grenadier Pond* 1921

A.J. Casson *Hillside Village* 1927

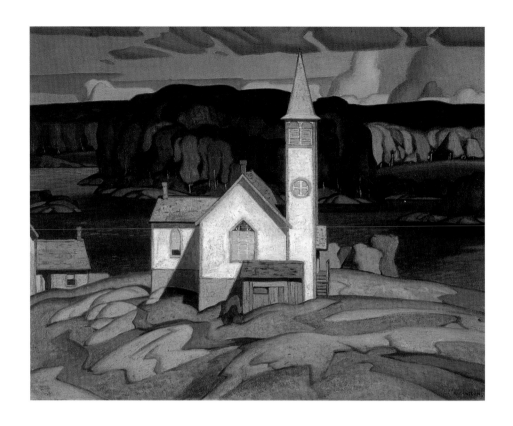

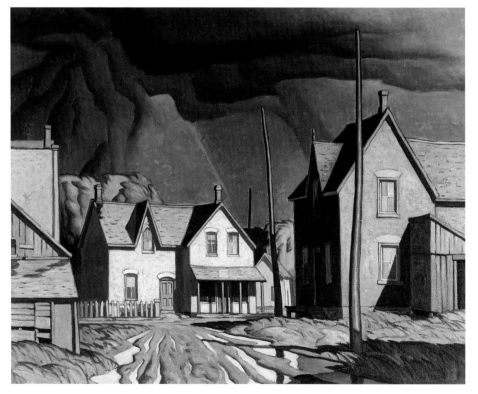

A.J. Casson *Anglican Church at Magnetawan* 1933

A.J. Casson *Thunderstorm* 1933

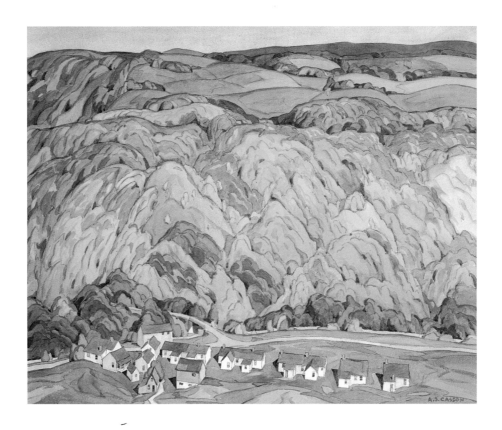

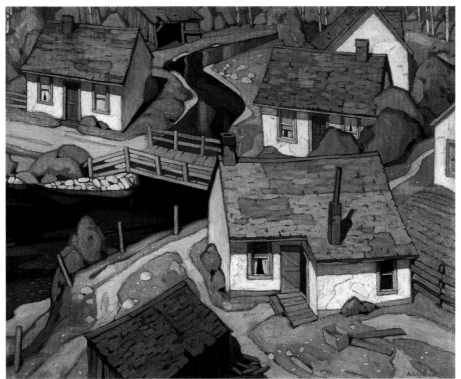

A.J. Casson *Credit Forks* c. 1930

A.J. Casson *Mill Houses* 1928

153

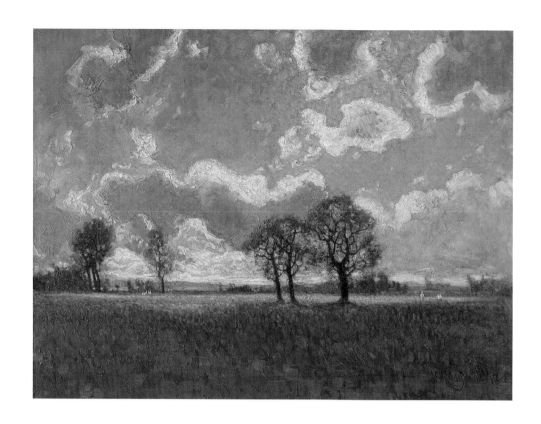

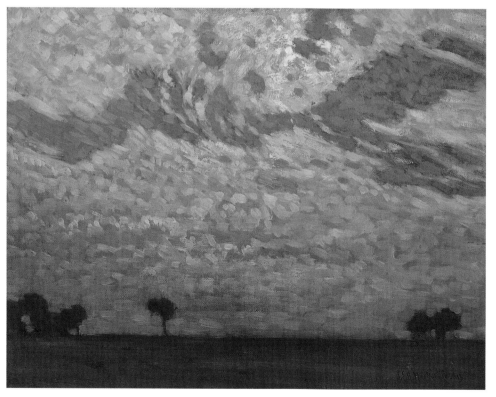

J.E.H. MacDonald *Spring Breezes, High Park* 1912
J.E.H. MacDonald *Sleeping Fields* 1915

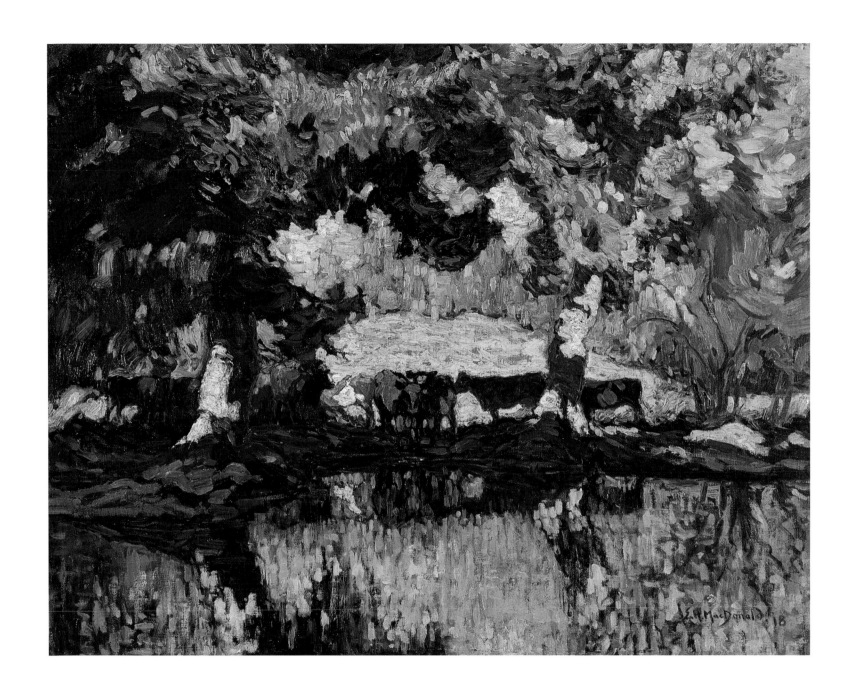

J.E.H. MacDonald *Cattle by the Creek* 1918

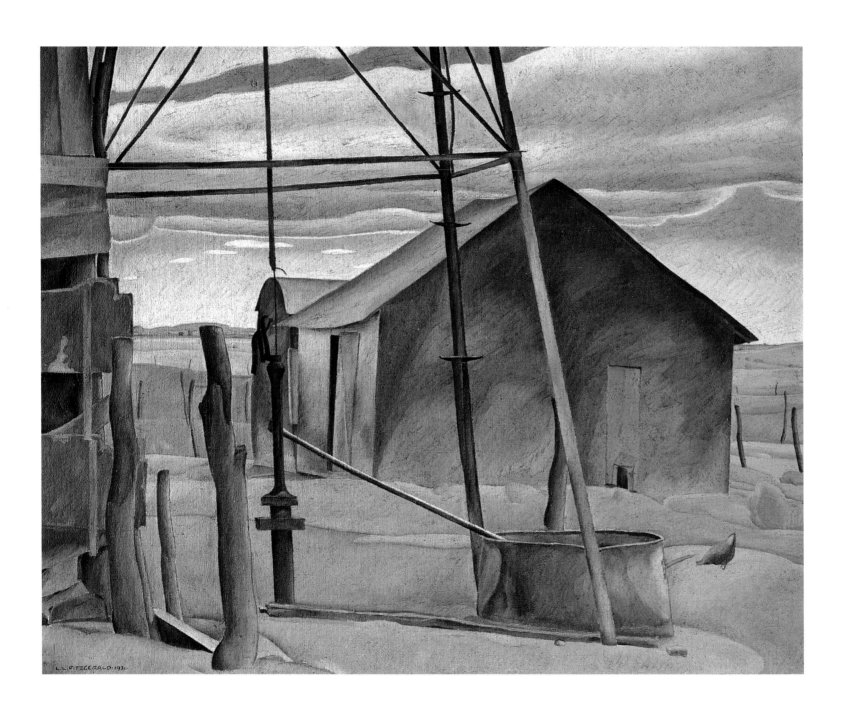

LeMoine FitzGerald *Farmyard* 1931

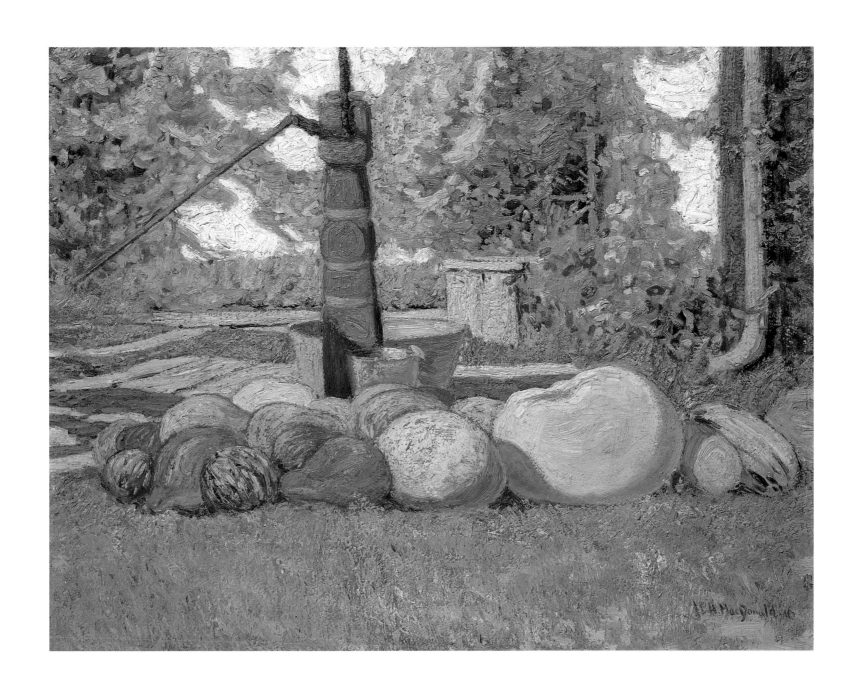

J.E.H. MacDonald *Pump and Pumpkins* 1916

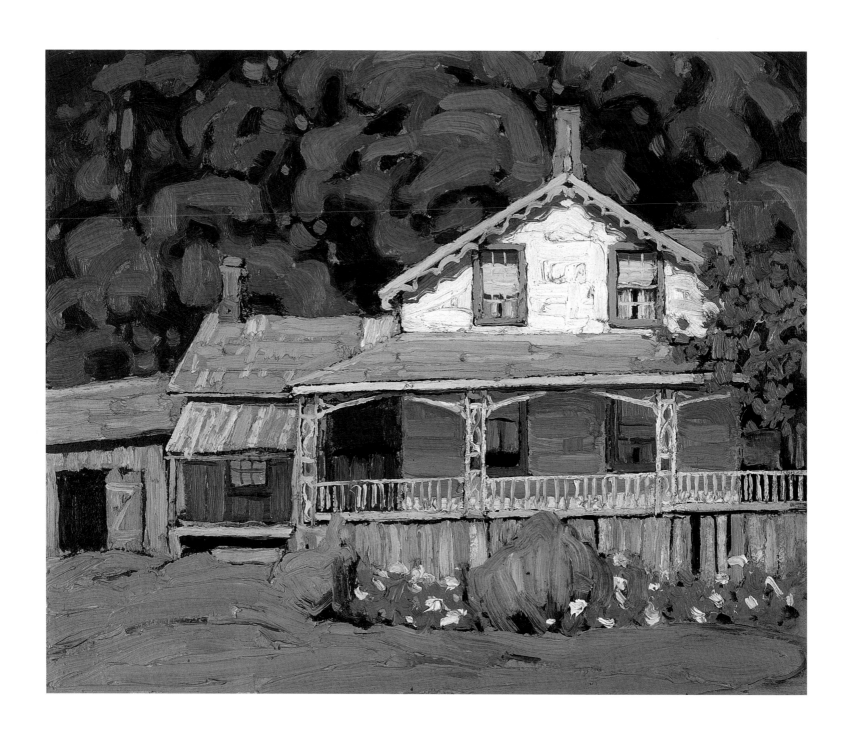

Lawren Harris *Untitled (Lake Simcoe Summer)* 1918

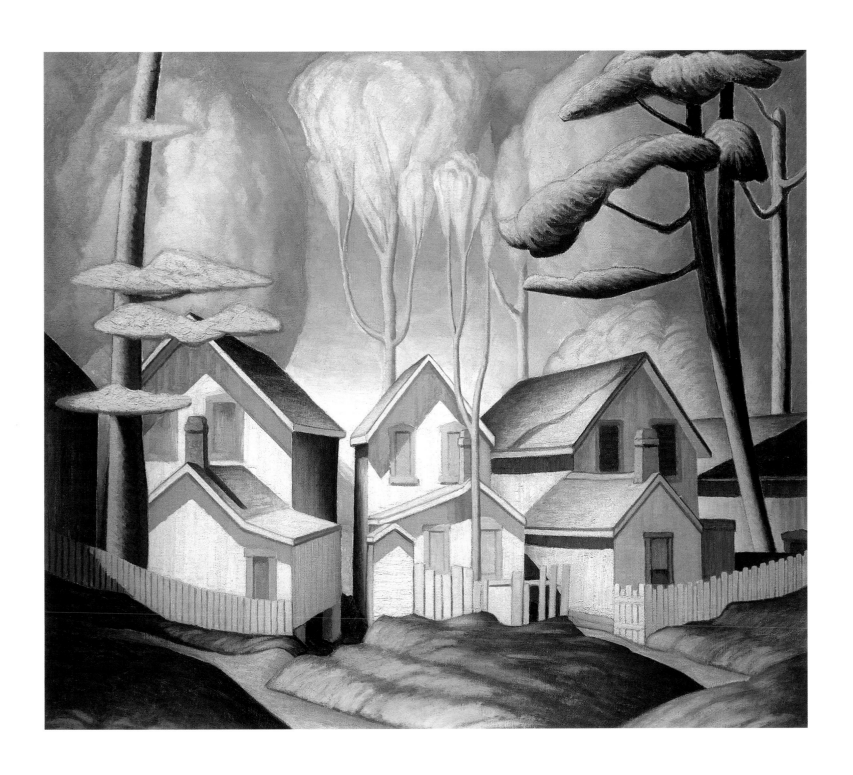

Lawren Harris *Summer Houses, Grimsby* c. 1926

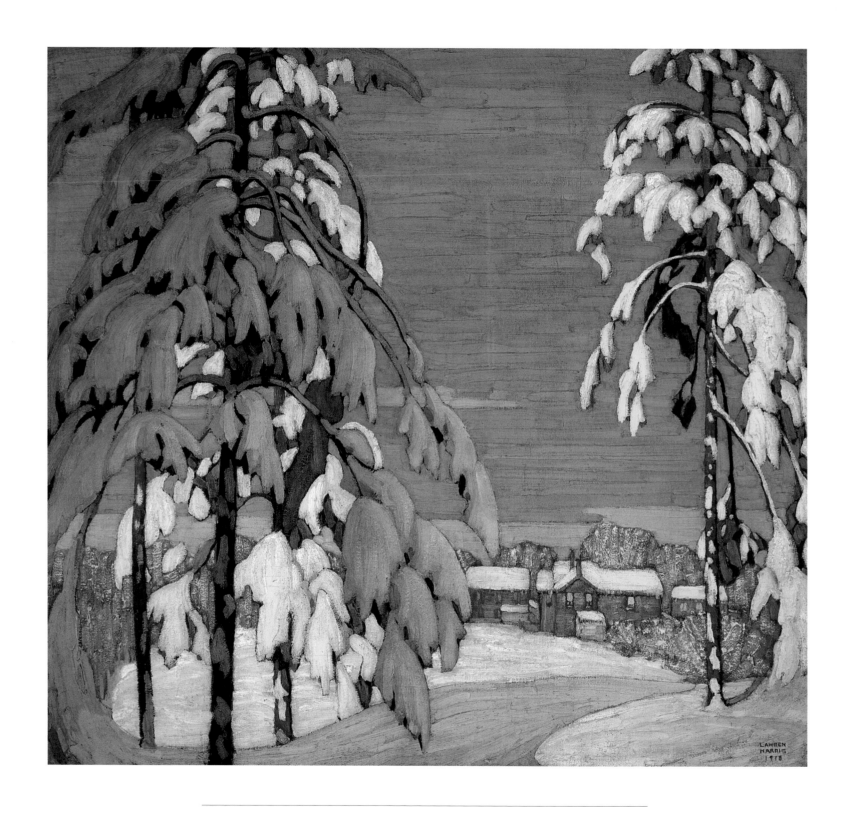

Lawren Harris *Winter Landscape with Pink House* 1918

The East Coast

The entire east coast of Canada, which runs from the northern tip of Ellesmere Island near the North Pole, down the jagged length of Baffin Island and the Labrador coast, around Newfoundland and along the shores of Cape Breton and Nova Scotia to the mouth of the Bay of Fundy, is nearly as long as Canada is wide. It runs for nearly seven thousand kilometres, headland to headland, down a full forty degrees of latitude, more than is found in almost any other country in the world – longer by far than Chile's Pacific coast, and longer than Australia is wide.

From the bleak and stony terrain of Ellesmere, Bylot, and Baffin islands and Labrador's windy Torngat Mountains, to the rocky bays and inlets of the Avalon Peninsula and Newfoundland's South Shore, to the gentler hills, forests, and meadows of Nova Scotia and New Brunswick, around the Gulf of the St Lawrence, the Gaspé, Cape Breton, and the Bay of Fundy, the East Coast presents a variety of geography that is endlessly captivating.

This landscape inspired the Group of Seven to paint many fine sketches and canvases. Lawren Harris and A.Y. Jackson travelled along the Gaspé shore, visited the Avalon Peninsula in Newfoundland, and travelled down the Labrador coast, although at the time Newfoundland and Labrador were not part of Canada. They were the only members of the Group to do so, until F.H. Varley boarded the supply ship *Nascopie* in 1938 to make his journey to the Arctic.

Arthur Lismer lived and taught in Halifax for several years, beginning in 1915. J.E.H. MacDonald, Edwin Holgate, and A.J. Casson went on several painting trips to Nova Scotia and New Brunswick. Only Varley (except for his Arctic trip), Frank Carmichael, and Frank Johnston did not visit the Maritime provinces. Much of what these Group members painted along eastern shores and in maritime communities was picturesque: the tiny fishing villages, the lobster pots, the fishing gear, wharves for fishermen, piers for lumber and other goods, schooners, dinghies, surf, drying nets, fish flakes, and meadows that ran down to the water's edge. Wherever there was a small village there was surely at least one church steeple – and in most villages usually two: Catholic on one side of the bay and Protestant on the other.

Harris was drawn to the slums of Halifax and to Sydney and Glace Bay, where miners and their families lived lives of hard toil, great danger, and grinding poverty. Paintings like *Miners'*

Houses, Glace Bay (p. 175), *Morning* (p. 174), and *Black Court, Halifax* (p. 172) are among the grimmest of Harris's work throughout his career. His visit in 1921 was prompted by a vicious miners' strike, and there is little doubt of Harris's own attitude toward the misery he witnessed. The stark conditions he portrayed speak volumes more than words might have done, and one small drawing of a miner's wife and child, published in *Canadian Forum* (July 1925), forcefully but poignantly summed up the family's hardship.

Logging was another major industry in Nova Scotia and New Brunswick, for it was this region's forests that had supplied the masts and spars for the naval fleets of the British Empire in the days of sail and still sent tons of lumber to the mother country. Lismer depicted logging nearly as well here as Thomson had in Algonquin Park. And Lismer's years in Halifax, when he taught and then painted for the Canadian War Memorials program, gave him a particular affection for marine subjects: his later paintings of fishing and sailing bric-a-brac all helter-skelter on a dock are among many people's favourites.

In the Maritimes the Group found good painting subjects, an audience moved by their pictures, and fellow artists who readily absorbed their ideas and ambitions. Fellow artists in Halifax, Fredericton, Saint John, and Moncton were buoyed up by the Group's mission and their occasional presence, and took up the cause of art with more confidence. Jack Humphrey, Millar Brittain, and others worked to make Canadian art and artists an integral part of the lives of Canadians.

Yet the most compelling images were inspired not by the southern part of the coast, but by the more dramatic sights and vistas of the north, with its steep bluffs, dangerous ice fields and immense icebergs, and treeless, windswept grandeur.

■

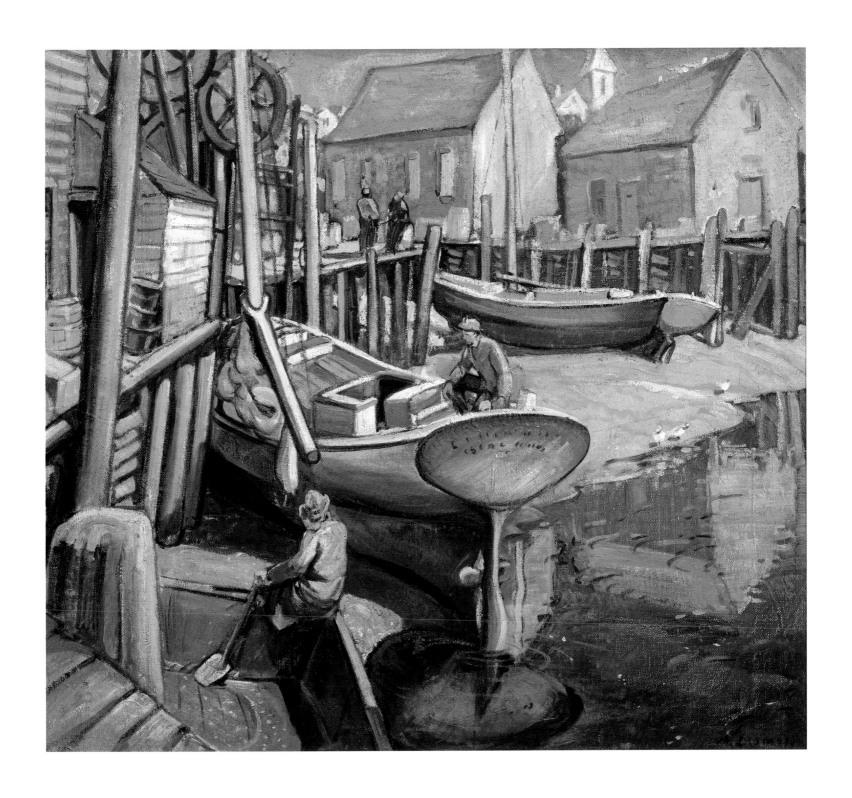

Arthur Lismer *Seal Cove, Grand Manan* 1931

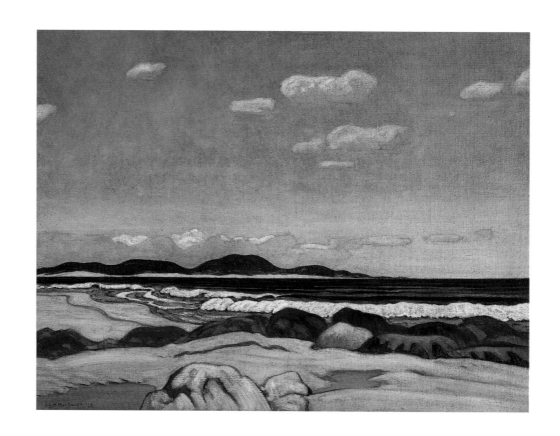

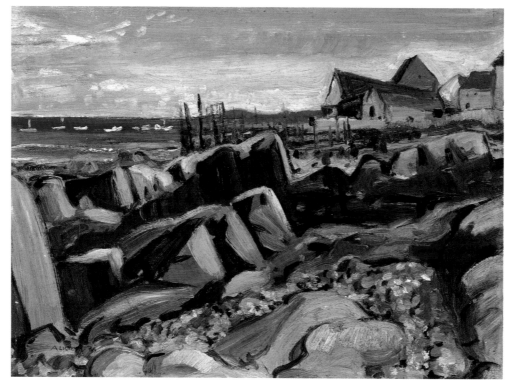

J.E.H. MacDonald *Seashore, Nova Scotia* 1923
Arthur Lismer *Fishing Village, New Brunswick* 1929

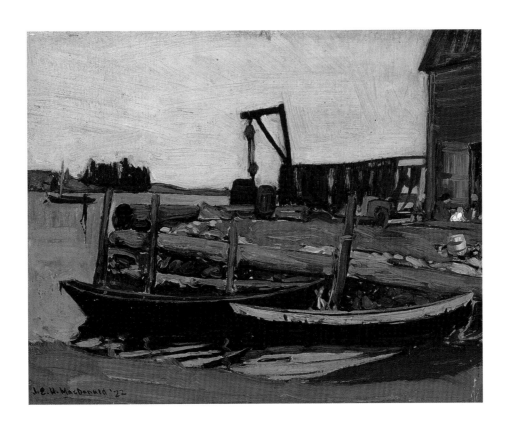

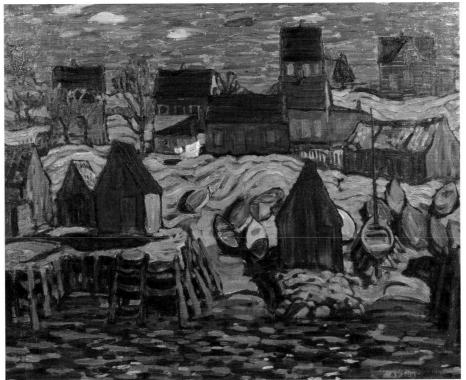

J.E.H. MacDonald *Old Dock, Petite Rivière, Nova Scotia* 1922

A.Y. Jackson *Herring Cove, Nova Scotia* 1919

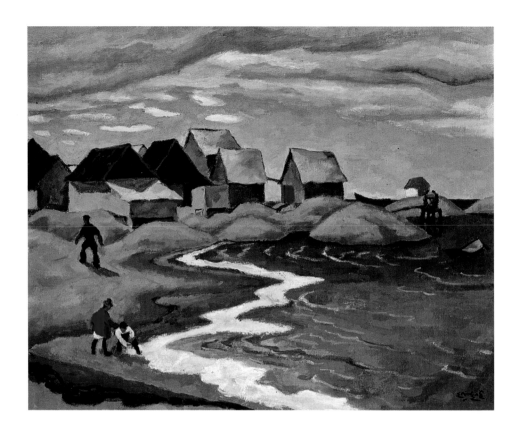

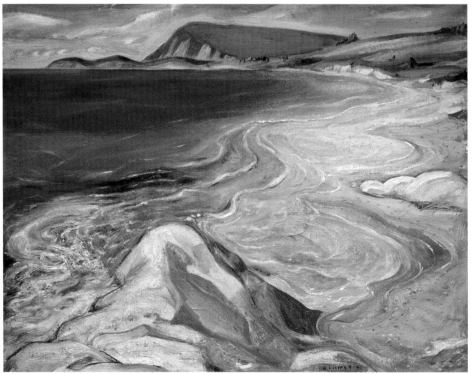

Edwin Holgate *Fishermen's Houses* c. 1933
Arthur Lismer *Cape Breton Island Beach* 1924

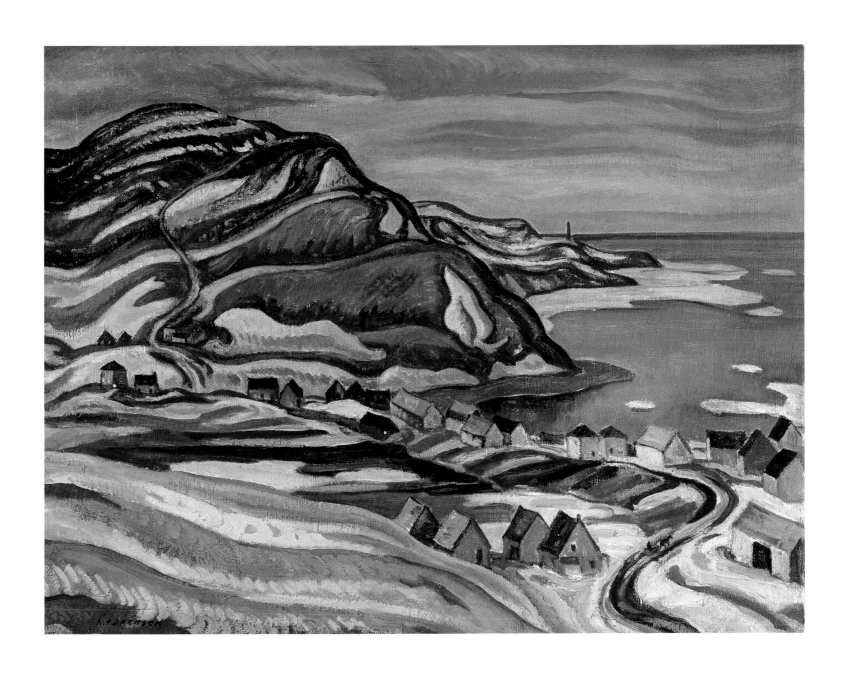

A.Y. Jackson *Gaspé Landscape* c. 1938

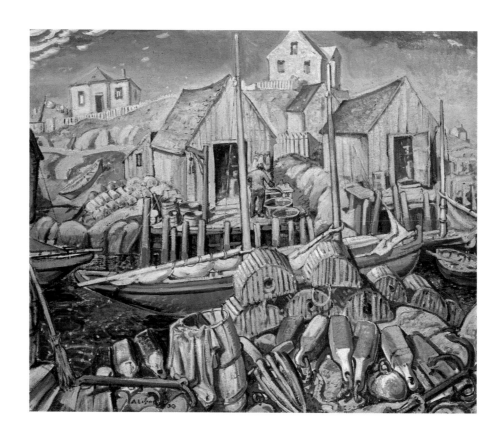

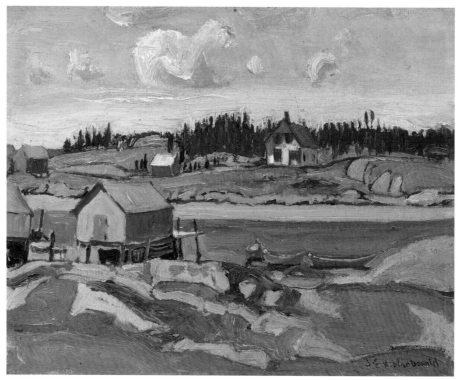

Arthur Lismer *Nova Scotia Fishing Village* 1930

J.E.H. MacDonald *Nova Scotia Coastal Scene* 1922

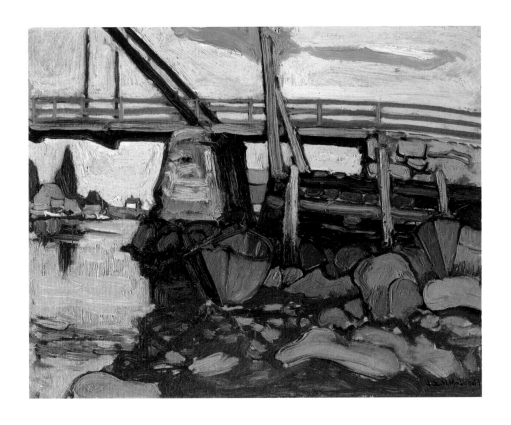

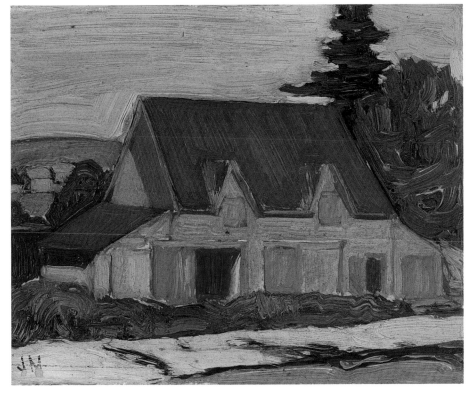

J.E.H. MacDonald *Bridge at Petite Rivière, Nova Scotia* 1922

J.E.H. MacDonald *Nova Scotia Barn* c. 1922

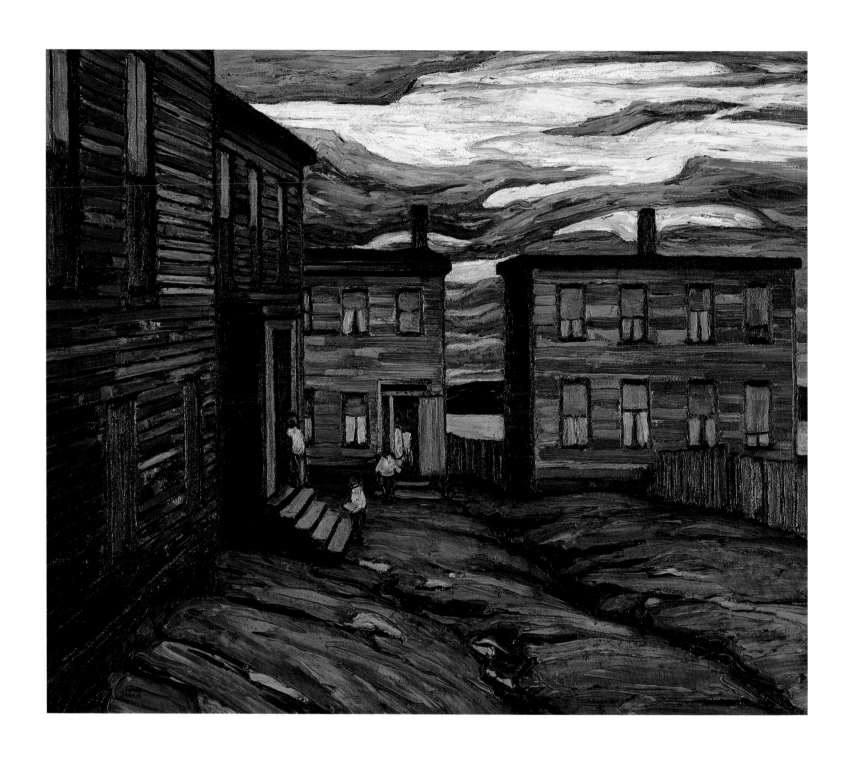

Lawren Harris *Black Court, Halifax* 1921

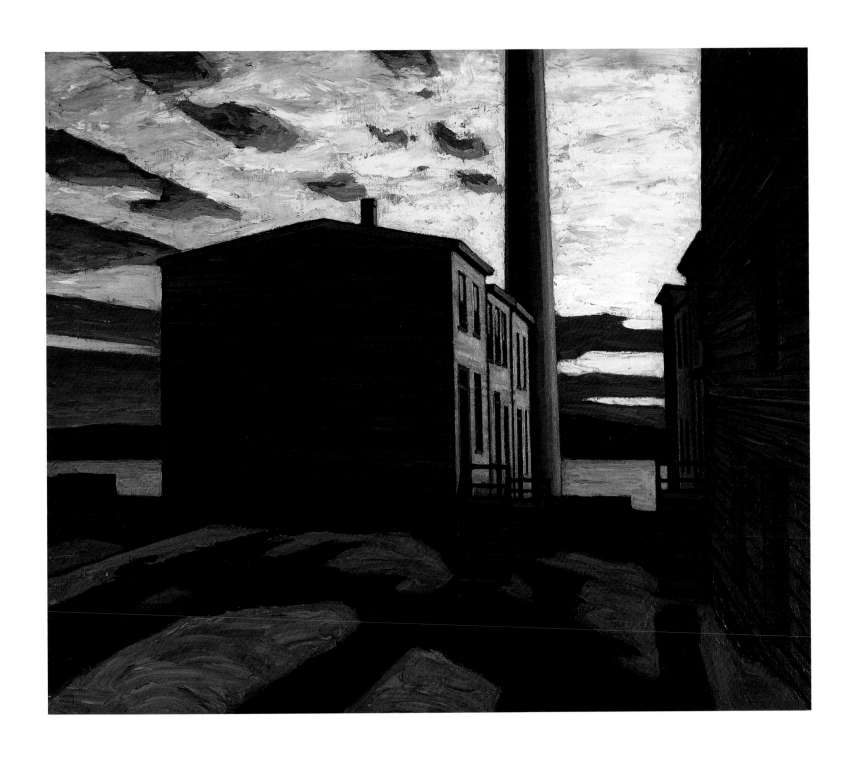

Lawren Harris *Elevator Court, Halifax* 1921

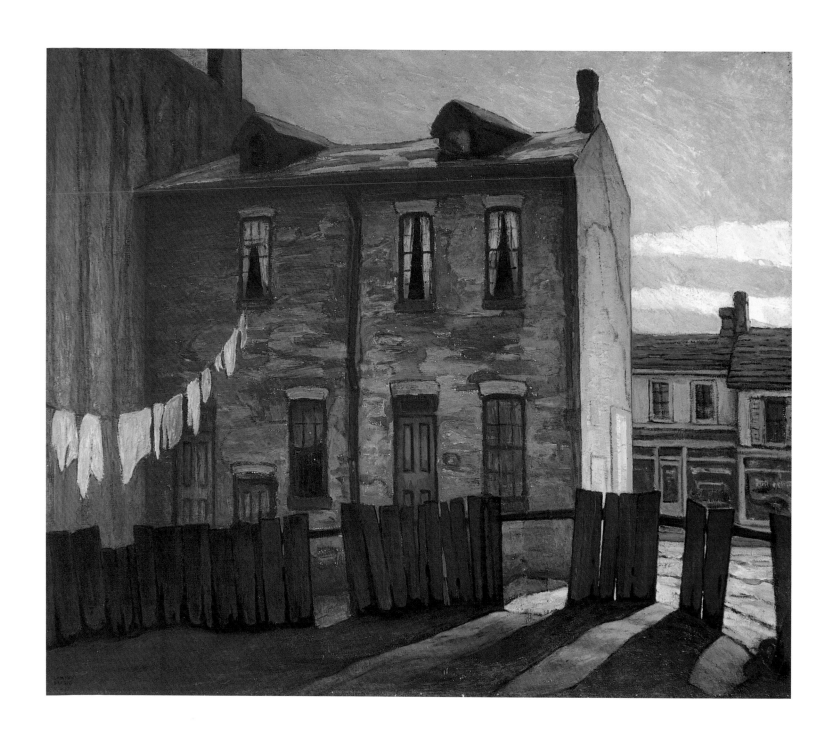

Lawren Harris *Morning* c. 1921

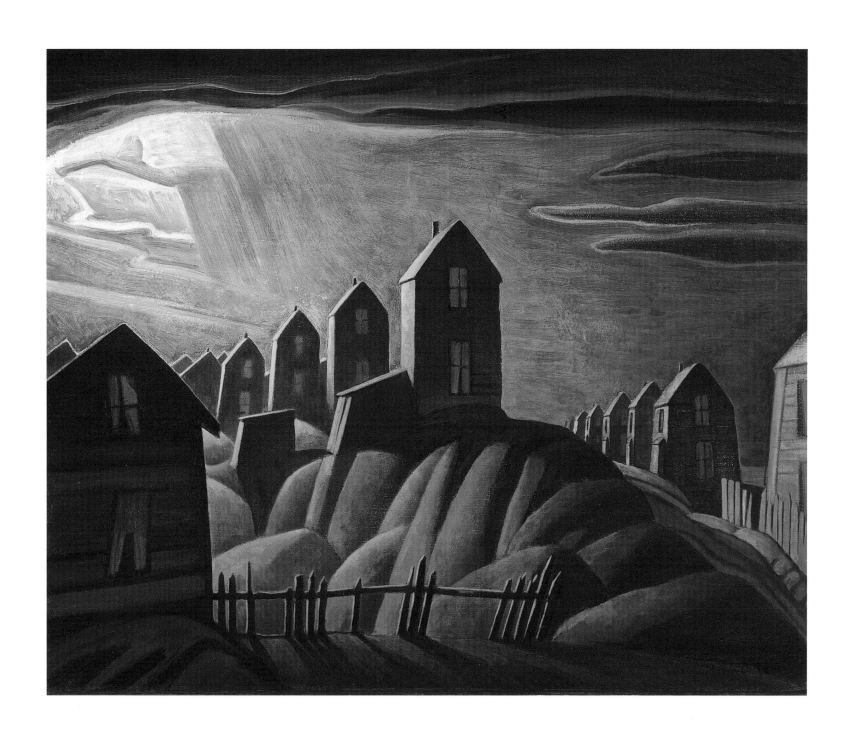

Lawren Harris *Miners' Houses, Glace Bay* c. 1925

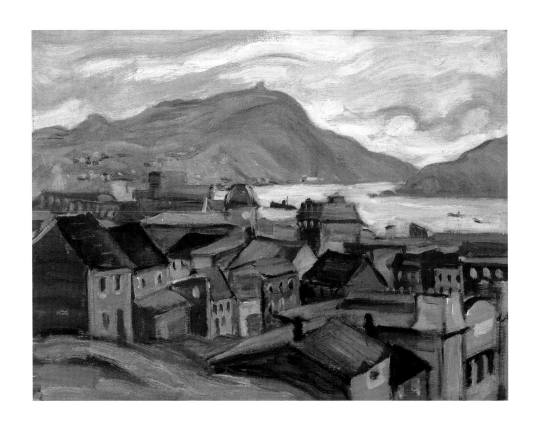

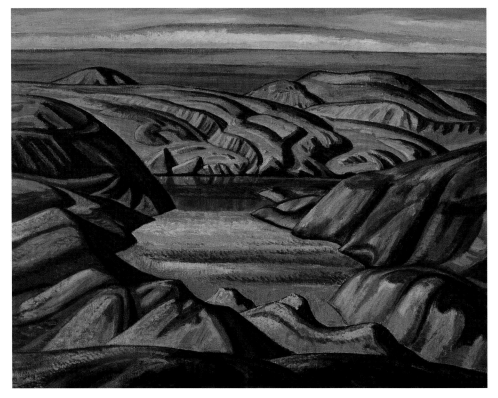

A.Y. Jackson *St. John's Harbour, Newfoundland* 1951

A.Y. Jackson *A Lake in Labrador* 1930

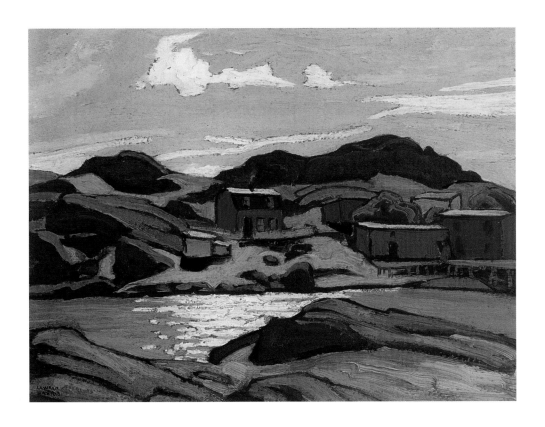

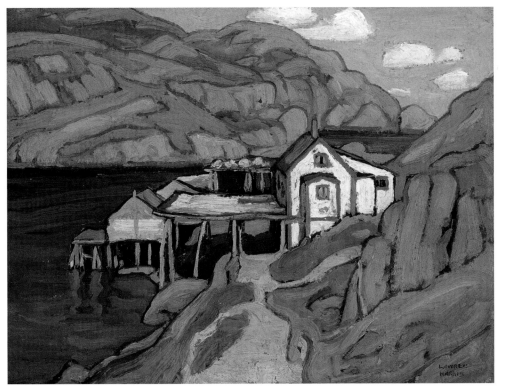

Lawren Harris *Newfoundland Sketch* 1921

Lawren Harris *Fish Stage, Quidi Vidi, Newfoundland* 1921

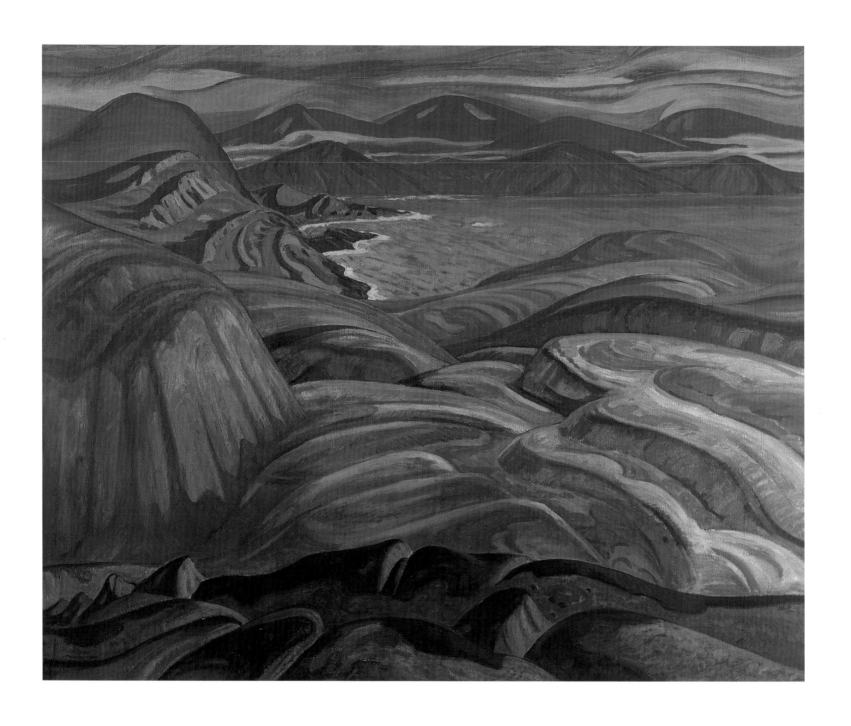

A.Y. Jackson *Labrador Coast* 1931

The St Lawrence River and Quebec

LIGHTHOUSE, FATHER POINT (p. 185) is one of the most compelling images Lawren Harris ever painted, and it beckons us to a part of Canada that is layered with history. The St Lawrence River is both Canada's entrance and its greatest highway. You can travel inland on it for hundreds of kilometres, then cross the Great Lakes, and go even farther on the rivers that flow into it from the Rockies (the North and South Saskatchewan, the Assiniboine, the Athabasca, the Churchill), traversing half a vast continent and more. The first continuous European settlements in North America took hold and then flourished along the St Lawrence River, starting with Jacques Cartier's first encampment in 1535. Canada is, truthfully, an old country, but one for whom the idea of age is still not a conscious reality.

When the artists of the Group of Seven and Tom Thomson were getting to know each other at the beginning of the twentieth century, railways and waterways provided the main travel routes in Canada, although first automobiles and then airplanes changed that rapidly. Trains, horses, and canoes were still the chief means of getting anywhere in the unpopulated parts of the country, and most settlements were at river mouths or confluences; villages and farms tended to hug river shores. The topography of Quebec, particularly, shows the pattern to this day, with farm lots running back from the river's edge, along the St Lawrence, the Saguenay, the Murray, the Gatineau, and other rivers. Like the generation before them, the Group of Seven's exploration of Canada's geography was limited by the reach of rail service and their ability to paddle and hike. Their distinctive styles were more telling than their subject-matter which, with the exception of the Arctic paintings of Harris and A.Y. Jackson in 1930 and F.H. Varley in 1938, was taken from the same areas already visited by O'Brien, Kane, Jefferys, Beatty, and other artists.

A.Y. Jackson and Edwin Holgate (although he was born in Allandale, Ontario) were the only two members of the Group of Seven to come from Quebec, and they regularly turned to the Quebec landscape for their subject matter. Indeed, they painted it much more than anyone else among the Group. One of Jackson's early works, *The Edge of the Maple Wood* (p. 187) of 1910, was done in Sweetsburg (now part of Cowansville). 'It was good country to paint,'

he wrote in his autobiography, 'with its snake fences and weathered barns, the pasture fields that had never been under the plough, the boulders too big to remove, the ground all bumps and hollows.' This was the painting that initially drew him to the attention of his future companions, when they saw it in an Ontario Society of Artists exhibition in 1913. Arthur Lismer (quoted in *The Group of Seven: Why Not Eight or Nine or Ten?*, Arts and Letters Club of Toronto) described this decisive encounter:

> *It stood out among the usual pictorial array of collie dogs, peonies, and official portraits like a glowing flame packed with potential energy and loveliness. I can remember looking at it with MacDonald, Thomson and Harris, and talking enthusiastically about the quality. Jackson's contribution was the beginning of a kinship and a movement in Canada.*

In his autobiography Jackson recalled that J.E.H. MacDonald wrote to him to ask if he still had *The Edge of the Maple Wood*: 'If I still possessed it, he wrote, a young Toronto artist, Lawren Harris, wanted to buy it. If I still possessed it! I still possessed everything I had ever painted.' Harris's purchase led to Jackson's move to Toronto that year. Oddly, Jackson returned to this area (and nearby Emileville) and style again in 1915 to paint *Spring, Lower Canada* (p. 186), his last work before leaving for France and the war.

Jackson spoke French, and for many years he made an annual pilgrimage in the early spring to the Îles aux Coudres, the Île d'Orléans, the small villages along the north shore of the St Lawrence in the Charlevoix region, or the south shore east of Lévis and toward the Gaspé. *The St. Lawrence at St. Fidèle* (p. 197), *The St. Lawrence in Winter* (p. 192), *Red Barn, Petite Rivière* (p. 201), *Barns* (p. 200), and *Winter, Charlevoix County* (p. 205) are among the many charming and vigorous works in Jackson's documentation of this region. In more than thirty years after the war, Jackson missed only his spring trip in 1925, the year he taught at the Ontario College of Art. He was known throughout these areas as Père Raquette, since he usually made his way along on snowshoes. His painting companions included Frederick Banting, one of the chief discoverers of insulin, who used the alias Frederick Grant in order not to be recognized or known as a doctor. Lismer joined Jackson from time to time and added to the record with such works as *Quebec Village* (p. 198) and *Baie St. Paul* (p. 195).

Jackson's depiction of the small villages with their prominent church steeples – St-Tite-des-Caps, St-Hilarion, St-Fidèle, Bic, Cacouna, St-Aubert, St-Urbain, La Malbaie, Baie St-Paul,

Les Éboulements – was a sort of nostalgic condescension following, in a more modern mode, the intent of Cornelius Krieghoff; certainly Jackson painted them because he loved them, but he also found the paintings were saleable. He believed that he was recording for posterity, as Paul Kane had done, a way of life that was rapidly disappearing with the advance of modernity and the population explosion in Canada. This was the impulse, reinforced by Marius Barbeau, behind Jackson's and Holgate's paintings of the Northwest Coast Indian villages in the late 1920s.

Holgate found Morin Heights in the Laurentian hills north of Montreal a fruitful place to work, and he painted there in all seasons and conditions for many years. The subsistence farms, tiny hamlets nestled in the hills, winter lakes, farms in summer, and village cemeteries (*Laurentian Cemetery*, p. 190), gave him a wide scope for his engaging canvases. His nude studies, as we have already seen, were also set in this Precambrian home territory, as was the exquisite *Frances' Tree* (p. 191).

Quebec's charms attracted other members of the Group: Harris's first paintings in Canada after his studies in Germany and travels in the Middle East, were done in the Laurentians and along the St Lawrence shore in 1908, and later he returned to this region from time to time. MacDonald, Lismer, and A.J. Casson also found the Laurentians a source of inspiration. MacDonald's *Laurentian Village* (p. 188) and *Laurentian Hillside, October* (p. 188) stand out as fine examples of these trips. Later in his life, Lismer taught in Montreal and made his home there. These colleagues shared Jackson's love of the small villages of the Charlevoix and of the south shore, but their visits were sporadic, whereas Jackson's were annual and extended sojourns.

Frank Carmichael, LeMoine FitzGerald, and Tom Thomson never (and F.H. Varley rarely) painted in Quebec. Jackson's contempt for the anglophone collectors of Dutch paintings in Montreal and for their lack of even a faint enthusiasm for Canadian work helped him to decide to relocate in Toronto in 1913, although he kept his connections with his fellow painters in Montreal: Albert Robinson, Robert Pilot, Maurice Cullen, Prudence Heward, Anne Savage, Sarah Robertson, and others. These painters showed regularly with the Group by invitation (some of them were included in six of the eight Group exhibitions) and supported their ambitions for a distinctly Canadian style and purpose in art. Other artists, such as Clarence

Gagnon, Marc-Aurèle de Foy Suzor-Coté, William Brymner, and Ozias Leduc, had a cordial acquaintance with the Group, but did not share their sense of national mission. Others, like John Lyman and Marc-Aurèle Fortin, were already light-years ahead of the Group in terms of adherence to modernist painting ideas. The Group of Seven was, truthfully speaking, a Toronto-based regional school of painting, which made a national name for itself by painting in various parts of the country.

The greatest influence of the Group of Seven in Quebec was the inspiration it provided, mostly through Edwin Holgate, for the creation of the Beaver Hall Group, which was formed in 1921. Its members (initially nineteen, although reduced to a core of about a dozen almost immediately) held several exhibitions and were able to galvanize their city to some degree with their adventurous and capable work.

Compared with the prolonged alliance of the Group's activities to Robinson, Pilot, Cullen, and others, the Group made little apparent impact on the emerging generation of Francophone artists, among them Jacques de Tonnancour, Paul-Émile Borduas, Jean-Paul Lemieux, and Alfred Pellan. These artists, and those who followed them and finally signed the *Refus Global* manifesto in 1948, went directly to sources of inspiration in Europe: Henri Matisse, Fernand Léger, André Bréton, Pablo Picasso, and Marcel Duchamp. This later manifestation of artistic rebellion was raised against the Catholic church and Quebec's social institutions, and not, as in the case of the Group of Seven, against the Academy. Although the Canadian land-scape emerged pervasively in the work of these younger modernists, it was not seen through the eyes of the Group of Seven or filtered through their styles of depicting it.

■

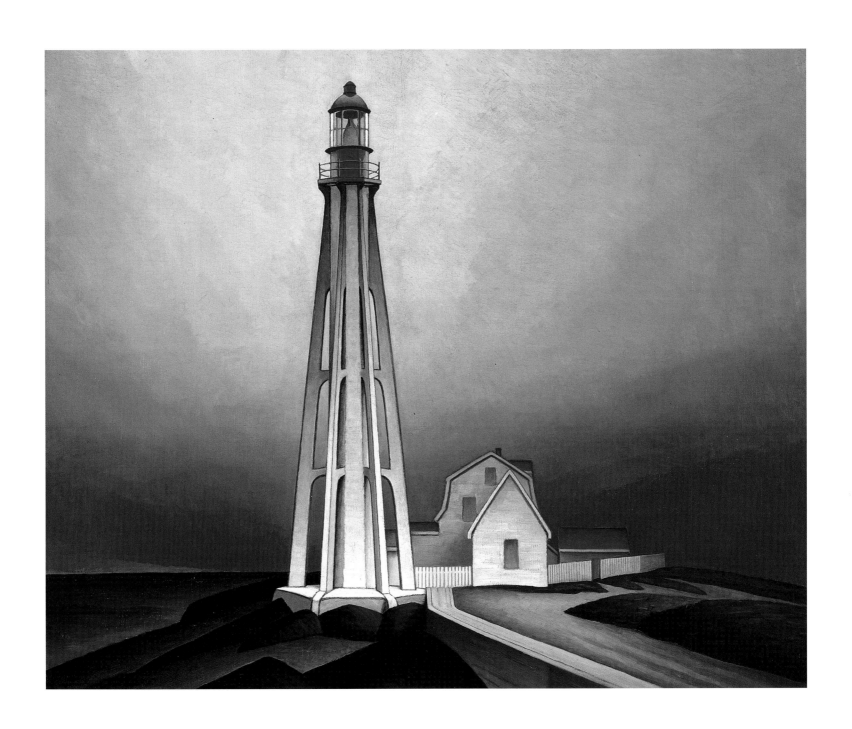

Lawren Harris *Lighthouse, Father Point* 1930

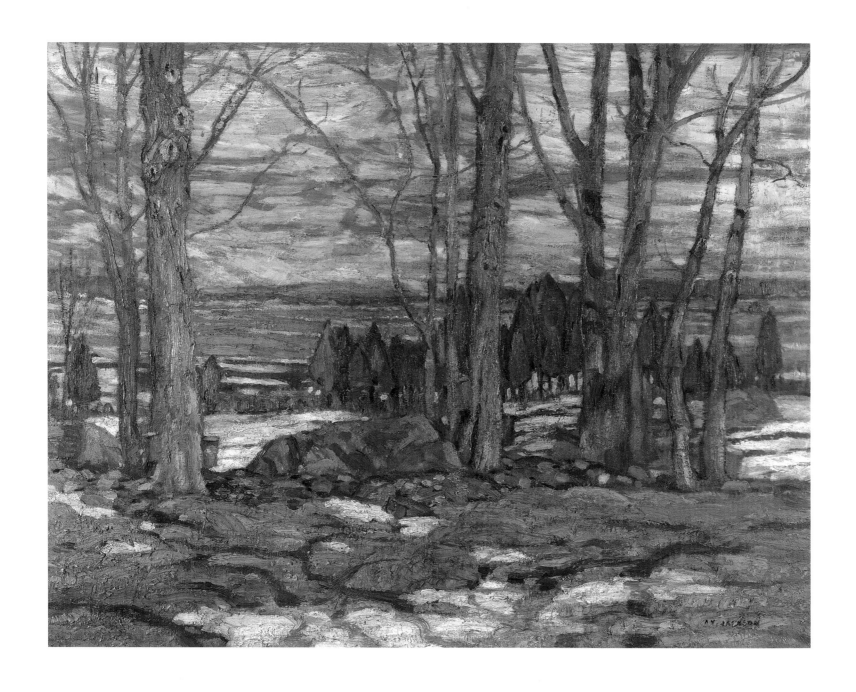

A.Y. Jackson *Spring, Lower Canada* 1915

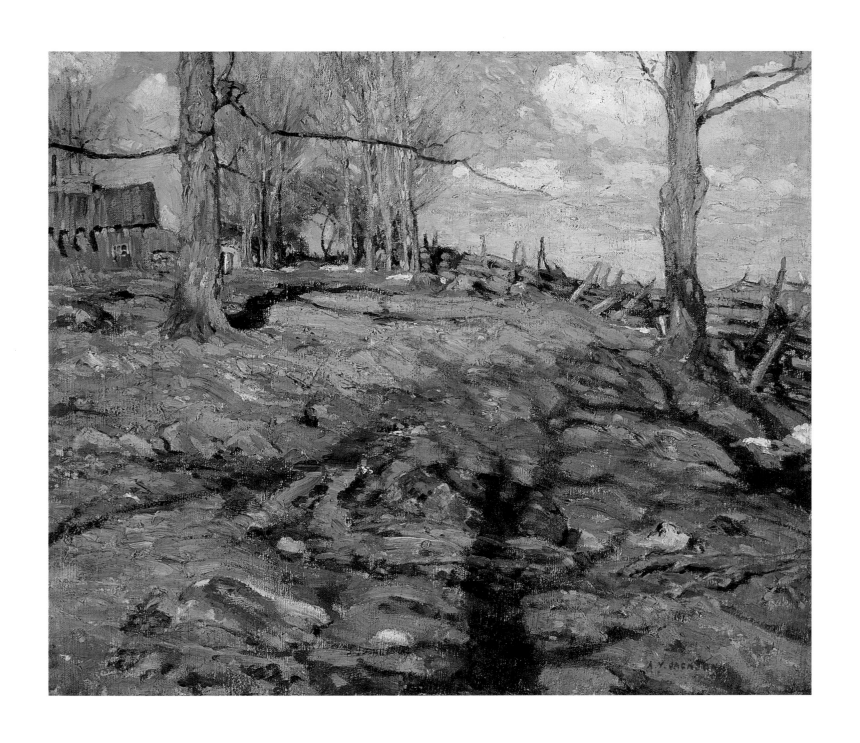

A.Y. Jackson *The Edge of the Maple Wood* 1910

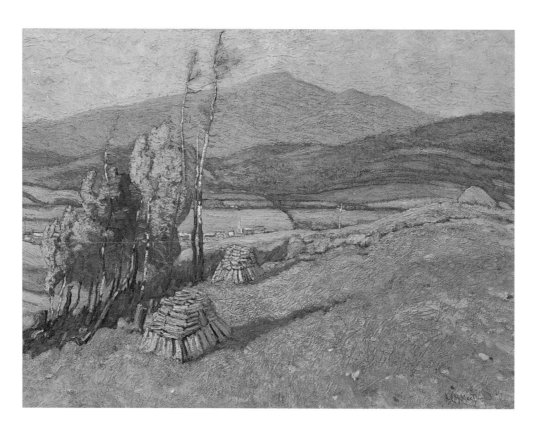

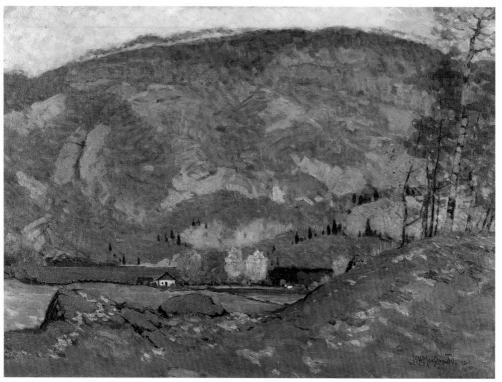

J.E.H. MacDonald *Laurentian Village, October* 1916

J.E.H. MacDonald *Laurentian Hillside, October* 1914

188

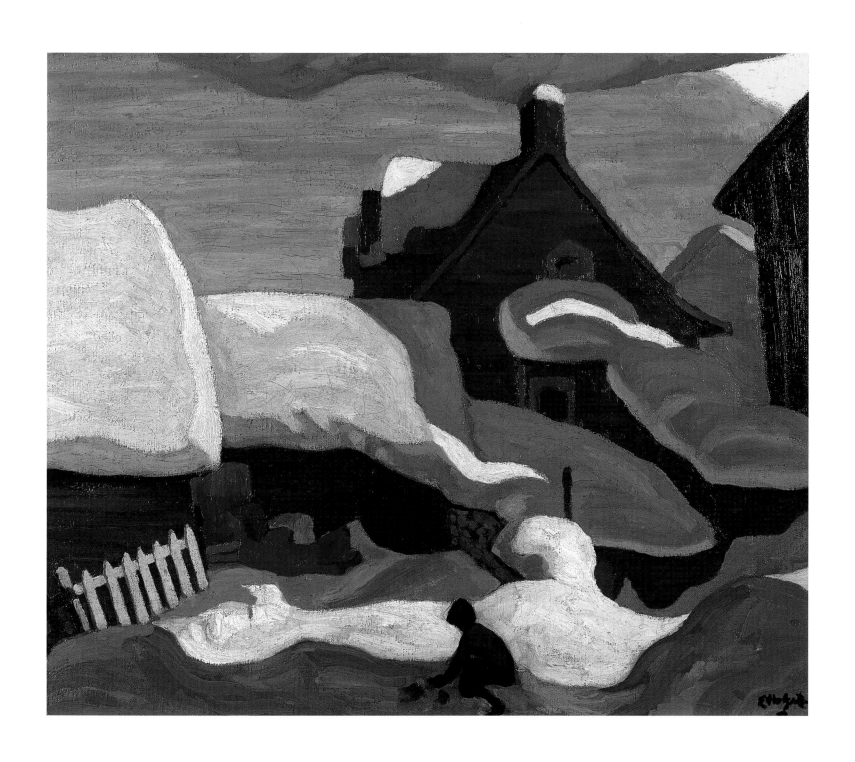

Edwin Holgate *Baie St. Paul* 1924

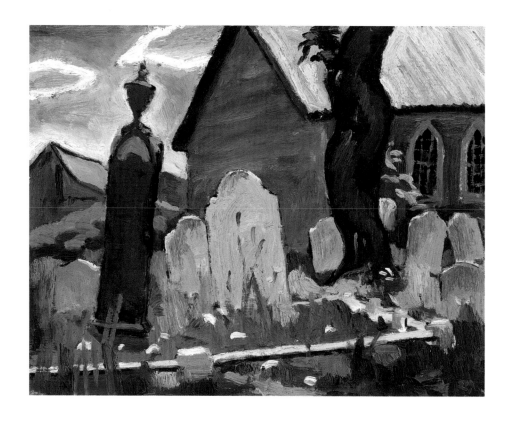

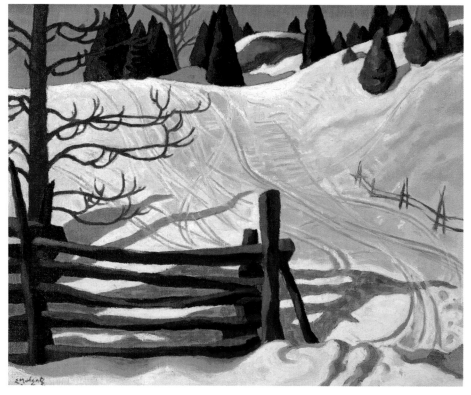

Edwin Holgate *Laurentian Cemetery* 1948

Edwin Holgate *Ski Tracks* c. 1935

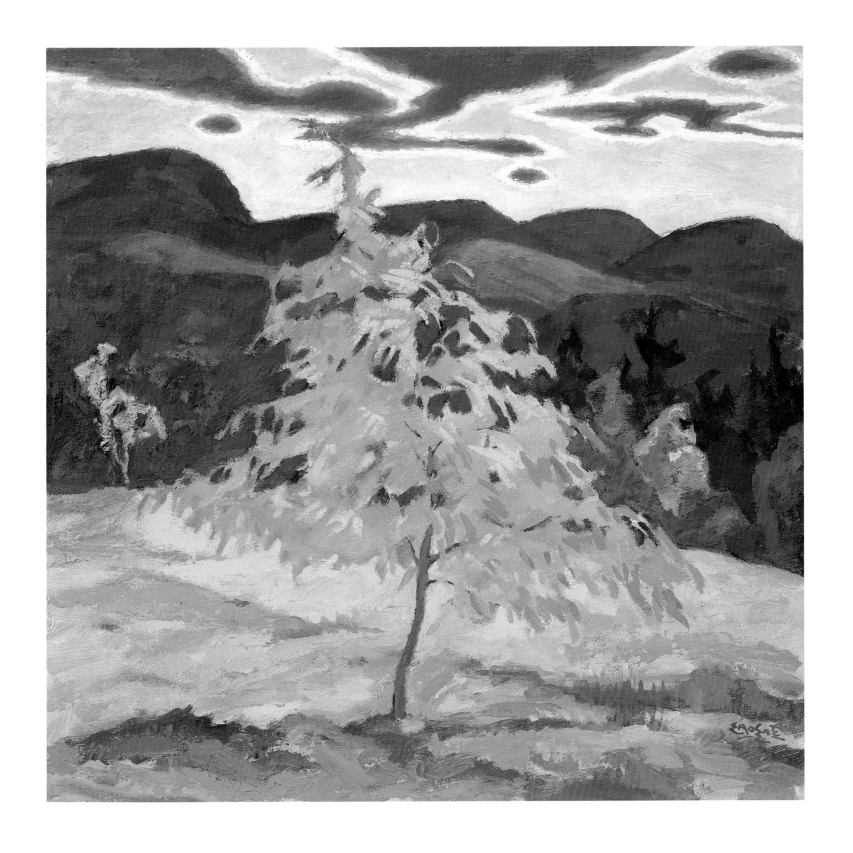

Edwin Holgate *Frances' Tree* c. 1950

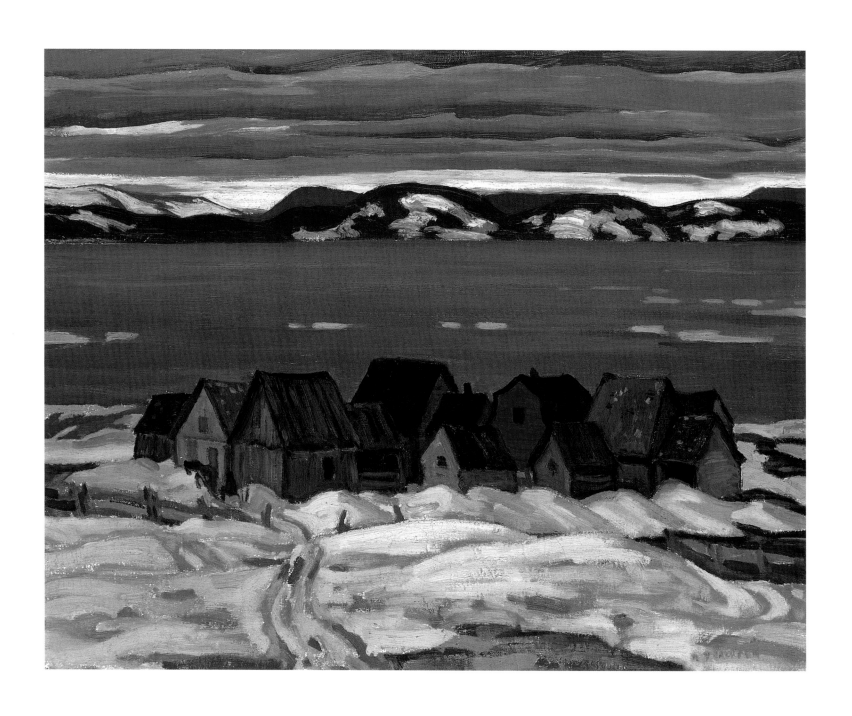

A.Y. Jackson *St. Lawrence in Winter* n.d.

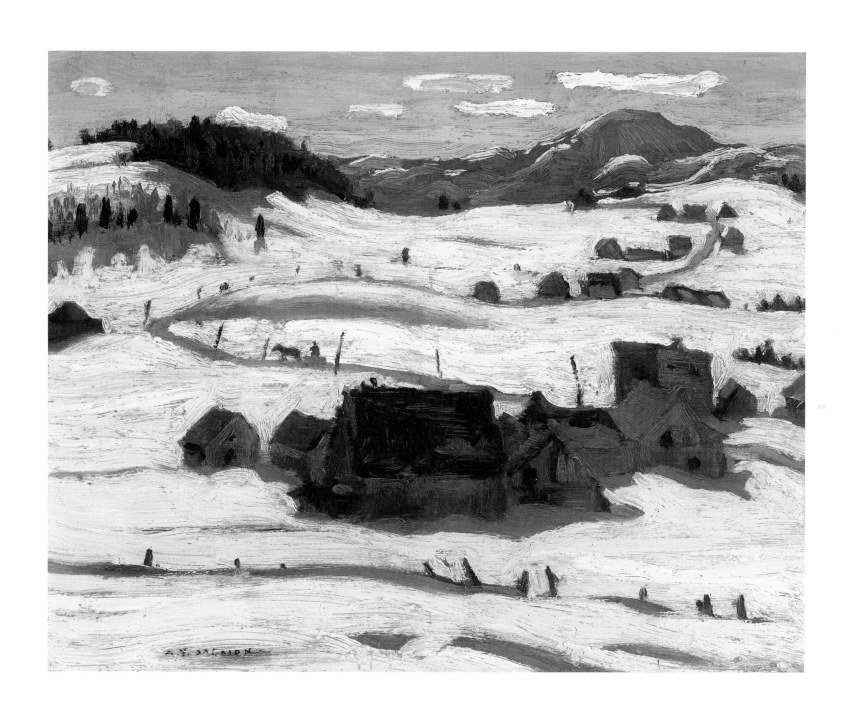

A.Y. Jackson *Afternoon, St. Hilarion* n.d.

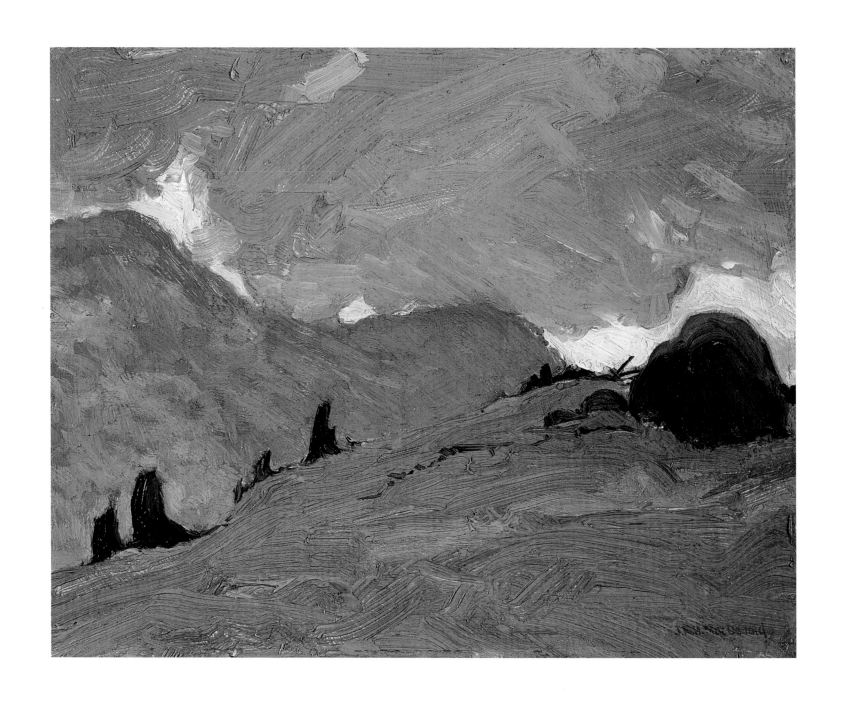

J.E.H. MacDonald *Rain, Laurentians* 1913

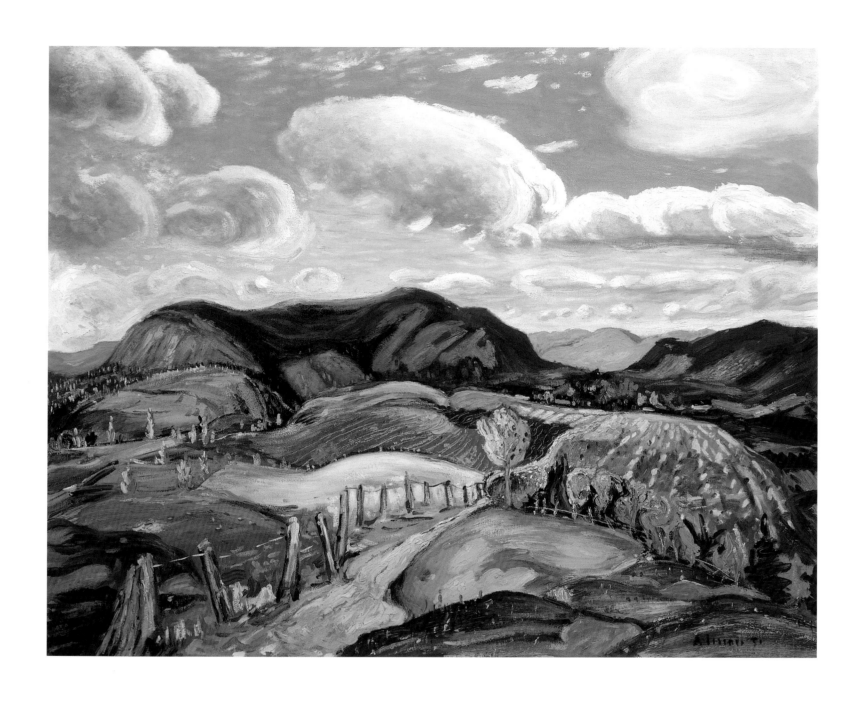

Arthur Lismer *Baie St. Paul* 1931

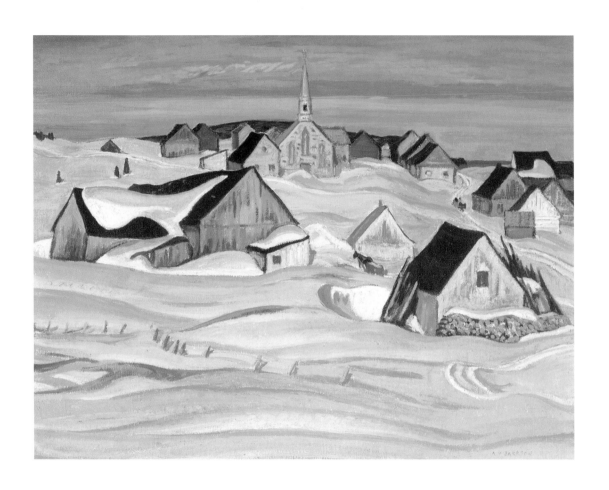

(above) A.Y. Jackson *St. Fidèle* c. 1930

A.Y. Jackson *The St. Lawrence at St. Fidèle* c. 1928

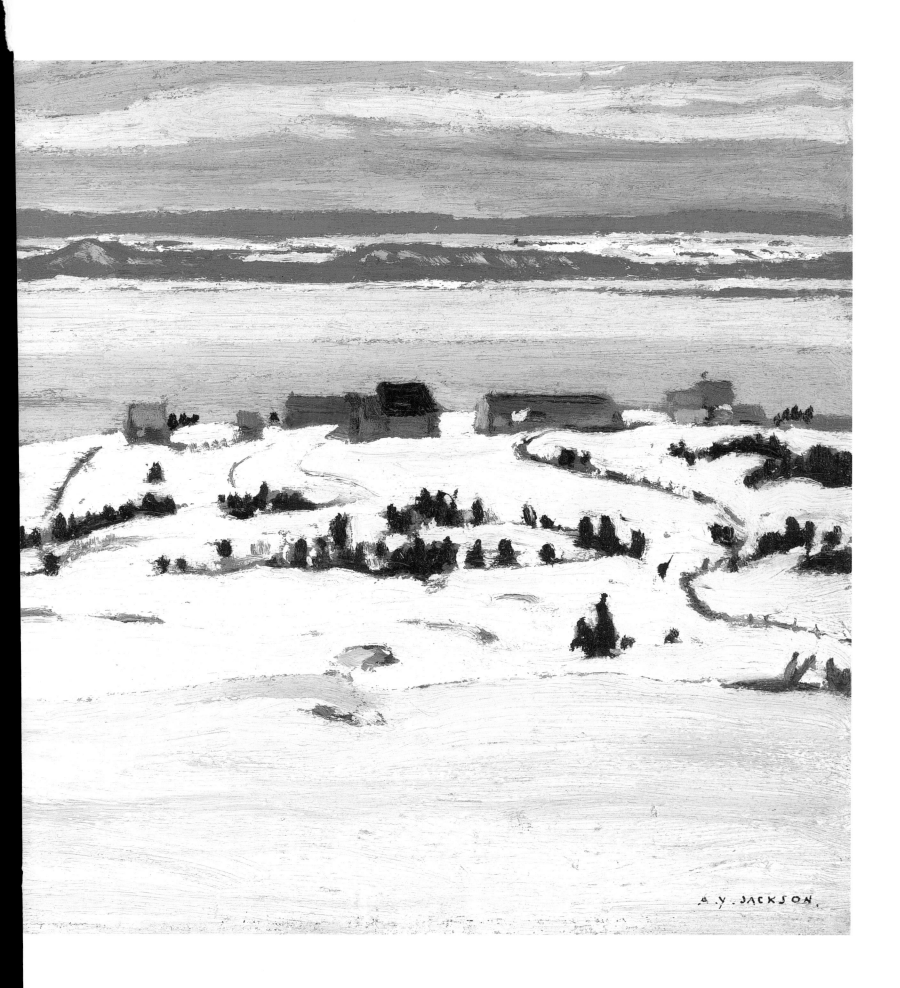

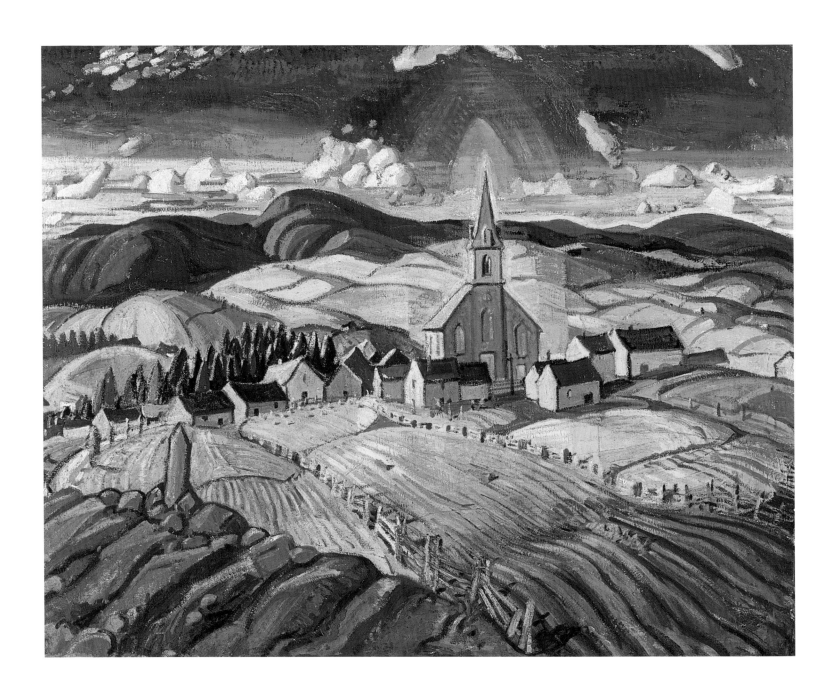

Arthur Lismer *Quebec Village* 1926

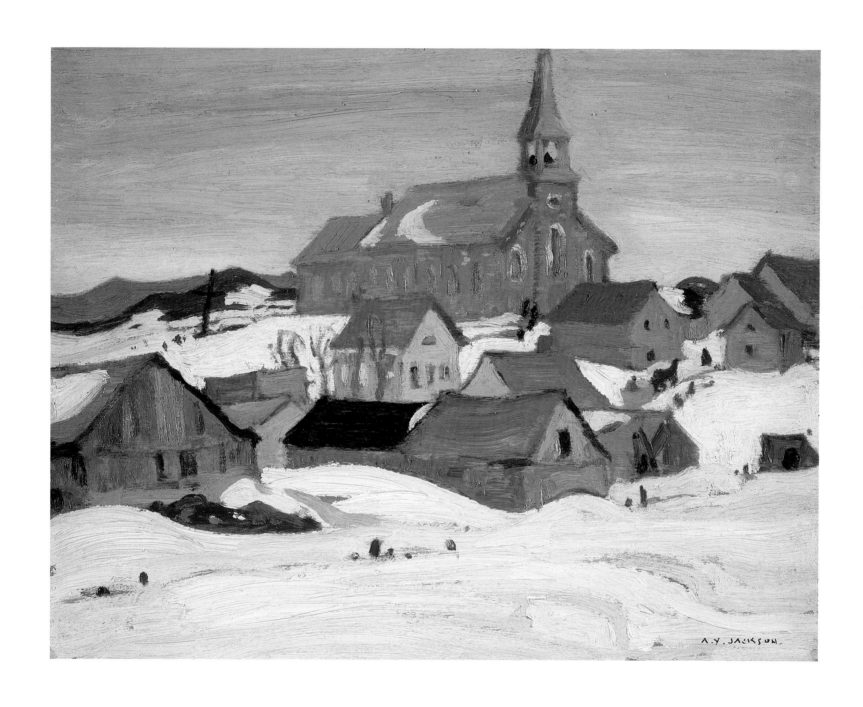

A.Y. Jackson *Saint-Hilarion* 1926

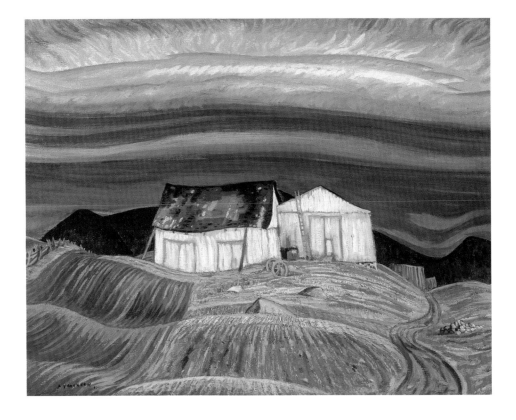

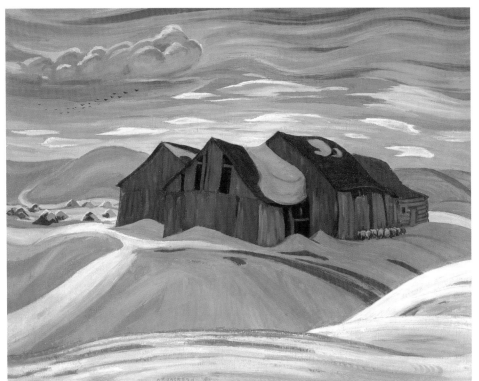

A.Y. Jackson *A Quebec Farm* c. 1930

A.Y. Jackson *Barns* c. 1926

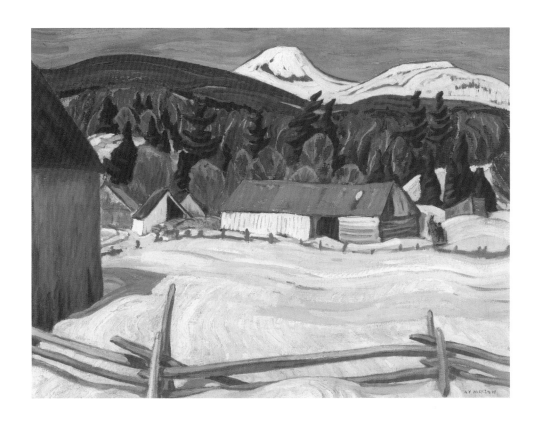

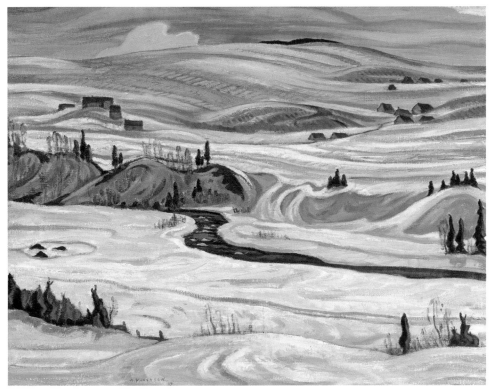

A.Y. Jackson *Red Barn, Petite Rivière* c. 1930

A.Y. Jackson *Hillside, St.-Tite-des-Caps* 1937

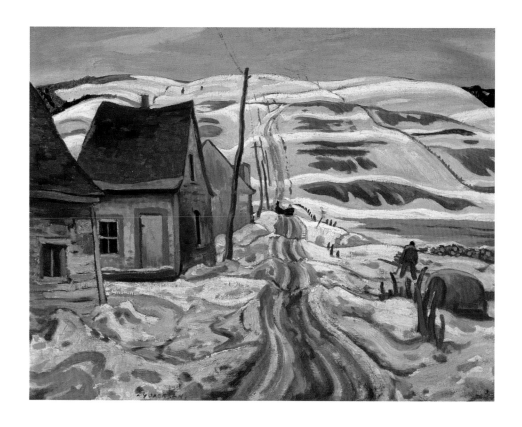

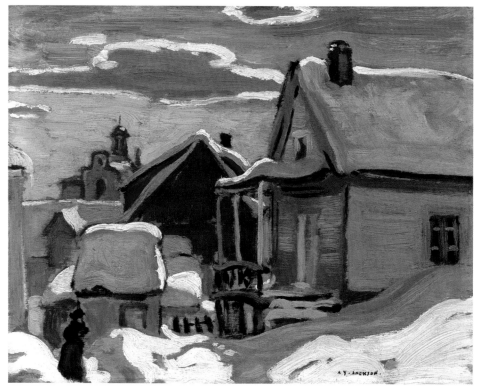

A.Y. Jackson *Early Spring, Quebec* 1927
A.Y. Jackson *A Street in Murray Bay* c. 1926

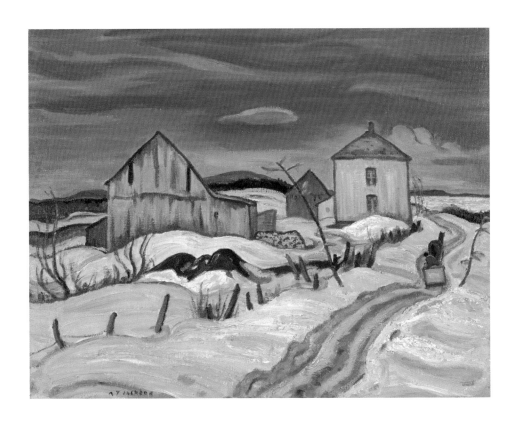

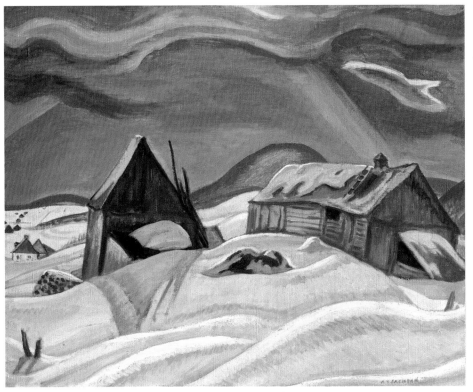

A.Y. Jackson *Winter: L'Islet, Quebec* 1940

A.Y. Jackson *March Day, Laurentians* c. 1933

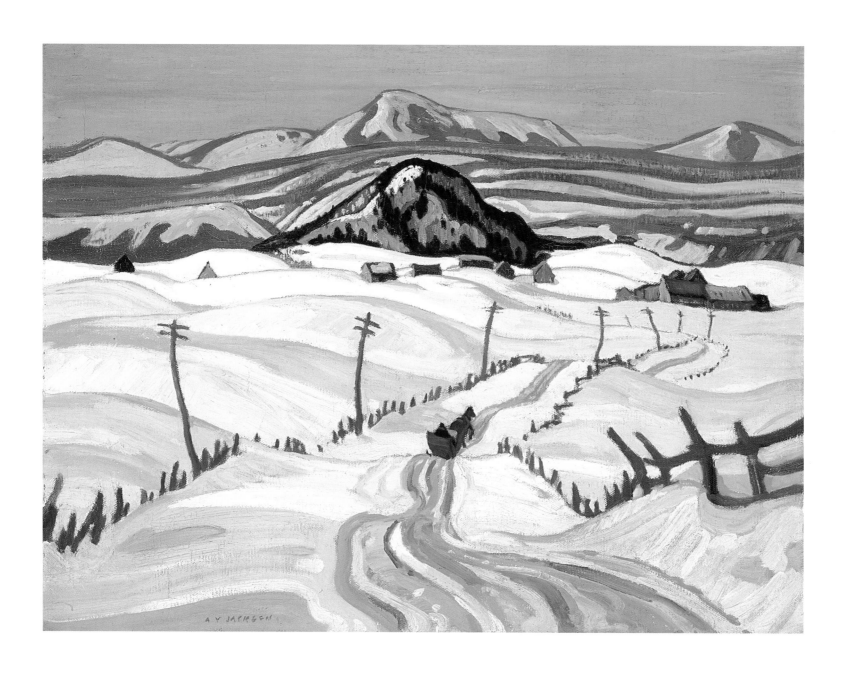

A.Y. Jackson *Grey Day, Laurentians* c. 1930–1931

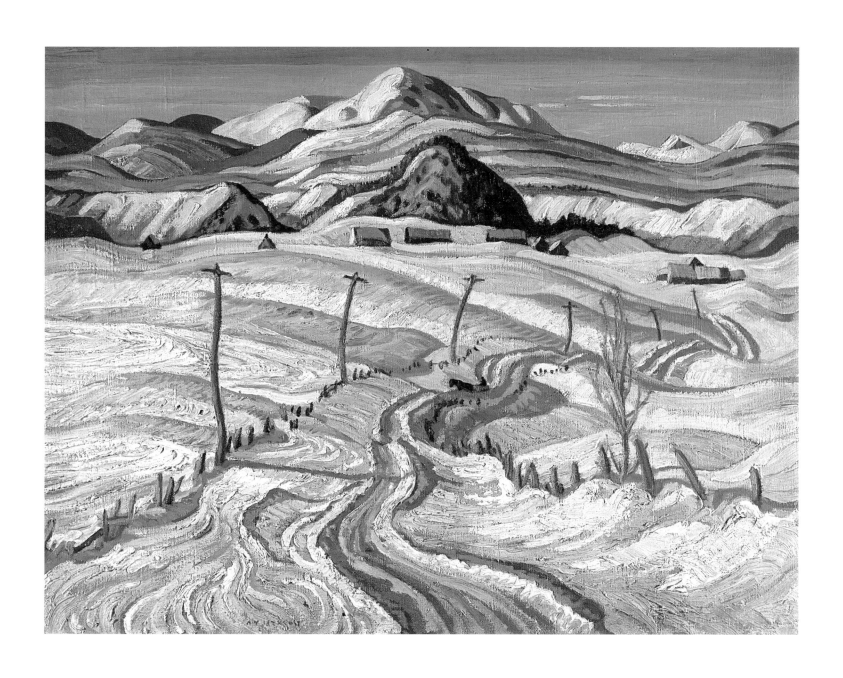

A.Y. Jackson *Winter, Charlevoix County* 1932–1933

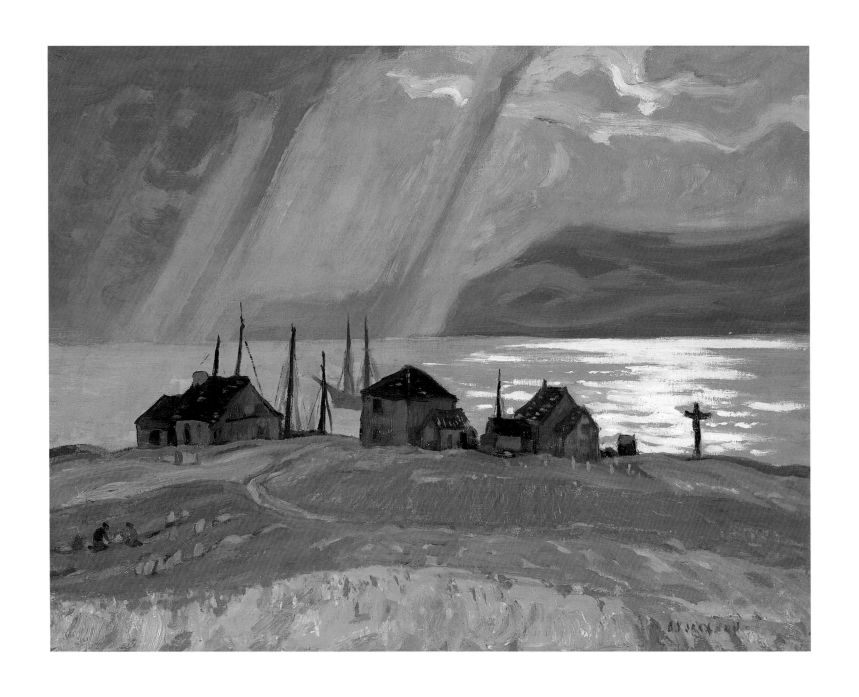

A.Y. Jackson *Île aux Coudres* c. 1926

ALGONQUIN PARK AND GEORGIAN BAY

ALGONQUIN PARK, about two hundred kilometres north and a little east of Toronto, is often thought to be 'heartland country' for the Group of Seven and Tom Thomson. It gave them some of their best-loved images, including Thomson's *The Jack Pine* and *The West Wind,* which were probably sketched at Grand Lake in 1916. The first major paintings he sold were Algonquin Park subjects. In 1915, *Northern River* (see the study for it, p. 52) sold for $500, which represented a year's wages as a designer. Thomson first visited the park briefly in 1912, spent the summer of 1913 there, and the following year enticed Arthur Lismer, F.H. Varley, and A.Y. Jackson to join him in the fall. Until his death on 8 July 1917, a scant three years later, he spent spring, summer, and fall months in the park (with winters in Toronto), apart from short trips to Georgian Bay to visit Dr James MacCallum at Go Home Bay.

Established as an enormous recreation and game sanctuary in 1893, Algonquin Park was promoted for its restorative air – a special place for tubercular patients and convalescents. Mowat Lodge on Canoe Lake, Thomson's 'headquarters' during his sojourns there, touted its 'health-compelling climate.' Thomson, who had 'weak lungs,' may have gone there initially for reasons of health. The University of Toronto's forestry research station was established in the park in 1908. Telephones were installed in 1911. Over a hundred and fifty kilometres of roads and two railways sliced through this 'wilderness.' Regular air patrols began by 1921, when the Taylor Statten summer camps for children were established. The former town of Mowat, close to Canoe Lake, had a population of six to seven hundred souls at the turn of the century, but declined and then disappeared with the bankruptcy of a lumber firm.

A civilizing aspect of the park was the presence of four large luxury hotels, where city 'toffs,' as Lismer called them, holidayed in the summers – donning formal wear for dinner and enjoying the glories of the bush with the amenities of urban life always at hand. Such resorts, which were popular at the time, could be found in many places in Canada where rail service reached – in Ontario at Bon Echo, Muskoka, Lake Temagami, and Madawaska, among other places. The summer population of Algonquin Park during Thomson's years there was estimated to be two thousand.

This gentrified intrusion into 'the northern wilderness' gave way, within a kilometre or two, or after a lake and two portages beyond the railway stations and the hotels, to a terrain that had once been a virgin forest of immense white pines, yellow birches, tamaracks, spruces, and maples, but which had been, and still was being, extensively logged by rapacious lumber companies. Referring to his first visit in early 1914 in the foreword to the Thomson exhibition catalogue in Montreal in 1919, Jackson gave this description of it:

> *Round Canoe Lake is a ragged piece of Nature, hacked up many years ago by a lumber company that went broke. It is fire-swept, dammed by both man and beaver, and overrun with wolves ...*

And in his autobiography, Jackson wrote:

> *Thomson was much indebted to the lumber companies. They had built dams and log chutes, and had made clearings for camps. But for them, the landscape would have been just bush, difficult to travel in and with nothing to paint.*

From these descriptions, Jackson's opinion was ambivalent, depending on his theme, but the area gave him several masterpieces, such as *Frozen Lake, Early Spring, Algonquin Park* (p. 233).

The park became a favourite painting ground for Thomson and his circle from 1913 to 1917. Indeed, the future members of the Group were sometimes referred to, informally or pejoratively, as the 'Algonquin School' of painting before 1920, when they named themselves the Group of Seven. The early identification of paintings by the Group with this section of the Precambrian shield was stamped on all subsequent ideas about them, regardless of where painted. This summer playground, and its Georgian Bay equivalent, evoked happy associations, since camping out was usually a pleasant adventure with warm summer breezes, the scent of pines in the air, the wildlife chary but not invisible, the nights full of stars, and the autumn skies ablaze with the *aurora borealis*. Mosquitoes and black flies were seldom mentioned. The easy life seems to emanate from Lismer's *The Guide's Home, Algonquin* (p. 60) and his *Autumn, Bon Echo* (p. 222), or from MacDonald's *Fine Weather, Georgian Bay* (p. 242); even Harris's *Algonquin Park* (p. 252) seems remote from any threat of raw nature.

Thomson painted all the structures and machinery the lumber companies had abandoned: timber chutes and dams (like *Lumber Dam*, p. 254), sluiceways, rotting flumes, old log

jams, and the caterpillar-like 'alligator' that hauled logs and log-booms. In parts of the park, lumbering continued and the annual spring drive of logs down rivers to the sawmills near the railways offered dramatic action that drew the attention of Thomson (*The Drive*, p. 255), who once followed the Booth Company drive on the Madawaska River. J.E.H. MacDonald (*Logs on the Gatineau*, p. 256) and Lismer were also drawn to the subject. Canadians believed that their immense natural resources were assets to be exploited, and that those who did so were the heroes of industry and society.

To travel into the wilderness in search of subjects, Thomson and his colleagues naturally resorted to the trusty cedar canoe. The canoe had opened Canada to commerce, settlement, and European civilization, and was the favoured form of transportation in Algonquin Park, with its interconnected lakes, rivers, and portages, since it could be carried easily from lake to lake and could navigate rapids and shallow water while carrying a formidable load of supplies and equipment. Thomson quickly became proficient at paddling, as did Jackson and most of the other members of the circle of friends, with the exception of MacDonald, who, Jackson reported, could neither paddle nor swing an axe.

The canoe gave Thomson a point of view he used in many of his sketches. The aesthetic pattern thus created was to have an inch of foreground water painted along the bottom of a panel so that one looks across water toward a far shore, a device one can see in such paintings as *Sunset* (p. 247) and *Autumn Foliage* (p. 266). The horizon is cut off by a bend in the river or a hill or a forest. The canoe was also, although clearly practical, somewhat old-fashioned and romantic, a recollection of earlier, braver, and possibly more adventuresome days in the country's history. In the public mind, the canoe was a link with Canada's earliest explorers and it lent the Group's work historical validity.

Thomson's connection with the character of Algonquin Park, especially, cannot be underestimated. Jackson, even though he knew Thomson for only a year and a half, knew how profound that relationship was. As he wrote for the catalogue of the 1919 Montreal tribute to Thomson: 'The intimate charm with which he endows his waste of rock and swamp, friezes of spruce, the slim birch which clings to the meagre soil on the rocks, are but an expression of his love for the country.' However much wilderness, civilization, and exploitation over-lapped in Algonquin Park, when Thomson arrived there the signature works, which would be

forever associated with the Group of Seven, began to appear. Somehow, the combination of that terrain and the evolution of Thomson's painting style coaxed out of him sketches that embodied the atmosphere, colours, and forms that we recognize as uniquely ours as Canadians. They directly inspired and informed the work of his colleagues, particularly Jackson, Lismer, MacDonald, and Lawren Harris, who soon joined him there.

Thomson died in July 1917, not three years before the Group was formed; yet for some time after his death he remained their centre of gravity and their boldest spirit. During his short career as an artist, he was remarkably productive and his work was greatly admired. His debut as an artist was almost startling, since his early formation gave little or no hint of what was to come. Not until he was about thirty-five did the Thomson we know now reveal himself. Harris recalled him, in *The Story of The Group of Seven,* in about 1912: 'Thomson began to develop. His work commenced to emerge into the clear Canadian daylight. His work had been tight and sombre, almost a grey monotone in colour. Jackson's sparkling, vibrant, rich colour opened his eyes, as it did the eyes of the rest of us, and Tom saw the Canadian landscape as he had never seen it before. It amounted to a revelation. From then on nothing could hold him.' For too few years his brazen colours, his memorable designs, and his touchstone subjects poured forth, and then there were no more Thomsons.

Thomson's mature work has a sense of a hidden presence behind the landscapes of lakes and skies, of looming gorges (*Petawawa Gorges,* p. 226; *Petawawa Gorges, Night,* p. 225), ice-filled rivers (*Spring Ice,* p. 238), majestic pines (*The West Wind,* p. 2; *The Jack Pine,* p. 3), and golden tamaracks (*Tamarack,* p. 280; and *Tamarack,* p. 281). This uncanny identification of subject and object, the idea that some sort of being was inherent in the land, embodied the spiritual grail that Harris believed was the purpose of the true Canadian artist. Thomson was the first to give expression to this, and he is forever identified with the idea of 'The North.' Jackson, writing in a foreword for Blodwen Davies' *Tom Thomson,* gave Thomson credit as the 'instigator of the movement to the North Country,' but we know that he had been preceded by many others, and that Harris and MacDonald, particularly, were as avid as Thomson in promoting the concept. Nevertheless, he planted in his work the seed that his colleagues were able to nurture to maturity over the next ten to fifteen years.

The artist Harold Town (1924–1990) gave a brilliant assessment of Thomson's work, when he wrote about him as *The Pathfinder* in a centennial-year publication, *Great Canadians:*

Thomson's small oil sketches of the last years palpitate and throb. They are as direct in
attack as a punch in the nose, and the sense of movement in them has the sweep and pull of
a paddle entering water. Paint is thrust and smashed onto the board with axe-like swings;
it seems almost a substitute for the coarse fare of the bush, making of the final picture a
banquet for Thomson's Spartan senses. 'To him his most beautiful sketches were only paint,'
to quote his benefactor, Dr. MacCallum. It would not surprise me to find that Thomson had
eaten some paint in sheer love of its completeness and tactile affinity to the tumult of colour
around him in the bush.

Writing to Harry McCurry at the National Gallery in April 1932, the artist David Milne summed up Thomson's legacy: 'I rather think it would have been wiser to have taken your ten most prominent Canadians and sunk them in Canoe Lake – and saved Tom Thomson.'

Algonquin Park lost its allure for the members of the Group when Thomson died. They erected a cairn to his precious memory, MacDonald created a stamp to authenticate the panel sketches he had left in his studio, and memorial exhibitions, one in Montreal for which Jackson wrote the catalogue introduction, and one in Toronto, were organized as soon as the war was over. Then, their respects paid, they moved to other parts of the country for their inspiration. For them, Tom Thomson *was* Algonquin Park – its spirit, its idea, its symbol for the whole of Canada; without him, there was nothing except memories.

■

Georgian Bay – the Group of Seven's other 'home' – is a huge eastern part of Lake Huron, about a hundred and twenty kilometres northwest of Toronto; its eastern shore is riddled with inlets and sprinkled with thousands of granite islands that make an exceptionally beautiful recreational area for people from Toronto, southern Ontario, and the United States. Here, at Go Home Bay, James MacCallum, who had helped Harris to finance the Studio Building in Toronto in 1913, had a cottage to which he invited Jackson, Lismer, MacDonald, Varley, and Thomson. He supported these artists by buying their work and promoting it among his friends. For his cottage, he commissioned murals, now in the National Gallery of Canada, which were done by MacDonald, Thomson, and Lismer. The murals include MacDonald's portrait of Thomson as a lumberjack.

MacCallum's friendship with and support of Jackson, Thomson, Lismer, MacDonald, and Varley produced an atmosphere of possibility that gave birth to a stunning array of superb works: Jackson's *Terre Sauvage* (p. 381), *The Red Maple* (p. 57), and *Frozen Lake, Early Spring, Algonquin Park* (p. 233), with their strong influence from Thomson's work; as well as *First Snow, Georgian Bay* (p. 289), *March Storm, Georgian Bay* (p. 239), and *Night, Pine Island* (p. 224). Here Varley created *Squally Weather, Georgian Bay* (p. 4, the sketch for *Stormy Weather, Georgian Bay*), Lismer painted *A September Gale, Georgian Bay* (p. 220), and MacDonald created *Fine Weather, Georgian Bay* (p. 242), which depicts Jackson, on the left, and Thomson at work.

Along the north shore of Georgian Bay and Lake Huron, where Manitoulin Island creates the North Channel, is Killarney Park, and just west of it are the hills of the La Cloche area. Frank Carmichael had a cottage in the region, a long-time favourite of his, at his beloved *Grace Lake* (p. 62). A.J. Casson, who began as Carmichael's assistant at Rous and Mann before being elected a member of the Group in 1926, was also enamoured of the area. This area has spectacular views from high ground, broad lakes, and a dramatic shoreline. Carmichael's *The Hilltop* (p. 270) and *Bay of Islands* (p. 265) give a sharp sense of the geography.

Not far from Algonquin Park and Georgian Bay are other lake-and-forest areas to which city dwellers have long repaired for summer holidays, whole summers often. Lake Simcoe, where Harris painted *Sunset, Kempenfelt Bay* (p. 245) and *Untitled (Lake Simcoe, Summer)* (p. 158), is only fifty kilometres north of Toronto. To the east is Lake Scugog and then Haliburton; and east of that, Madawaska, which is not far from what is now Bon Echo Provincial Park (130 kilometres northwest of Kingston), where Flora and Merrill Denison, theatrical producers and patrons of the Group (and committed theosophists), renovated the old Bon Echo Inn and supported activities in all the arts. Lismer's *The Big Rock, Bon Echo* (p. 275) and *Autumn, Bon Echo* (p. 222) were painted there. These places were explored before Thomson drew attention to Algonquin Park and MacCallum enticed artists to Georgian Bay, but they were also places to which members of the Group returned regularly. They function as springboards for the work that started the inexorable movement northward, the movement that made the Group of Seven distinctive and indelible in the national consciousness.

■

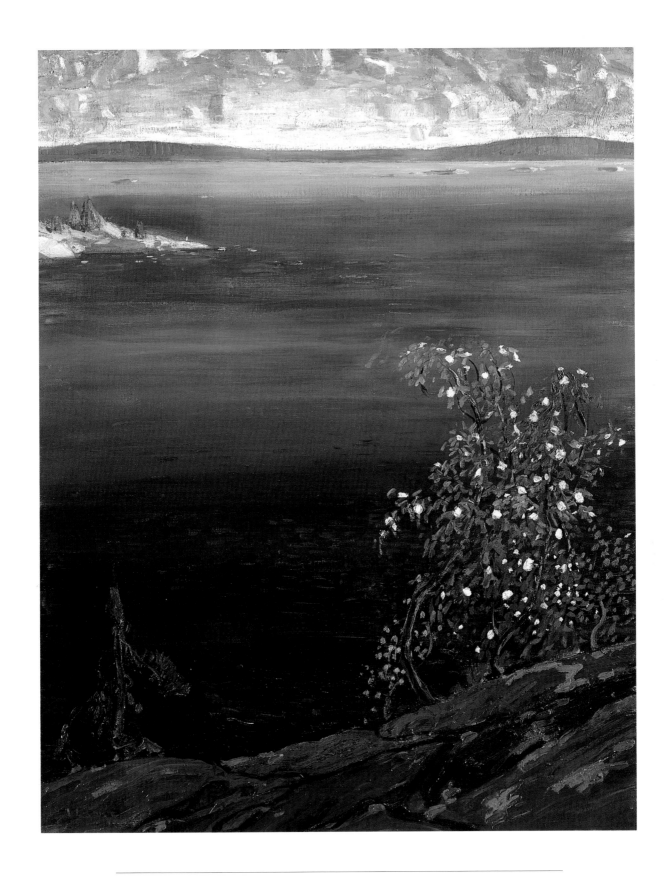

Arthur Lismer *Georgian Bay, Spring* 1917

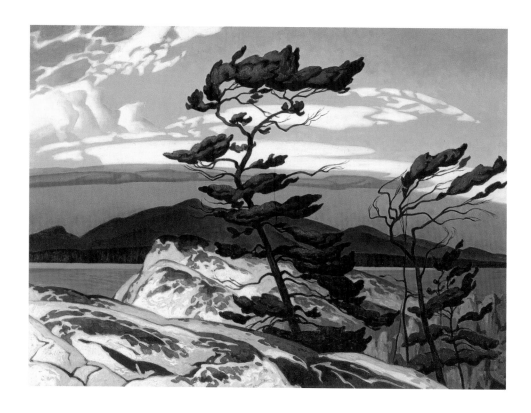

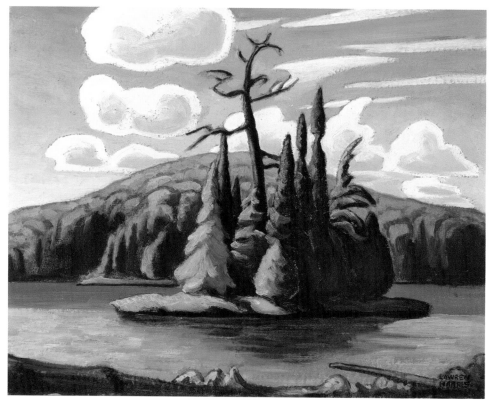

A.J. Casson *White Pine* c. 1957

Lawren Harris *Island in the Lake, Algonquin Park* 1916

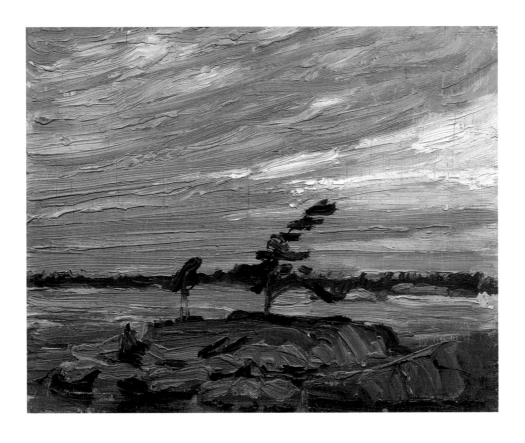

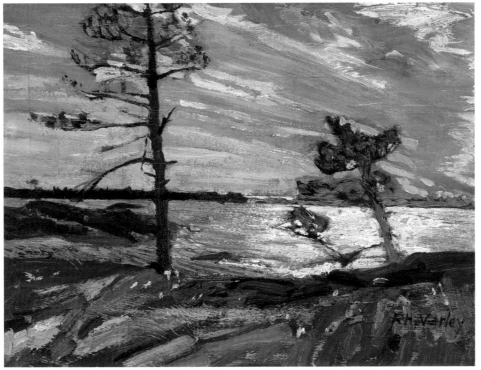

Tom Thomson *Split Rock Gap, Georgian Bay* 1914

F.H. Varley *Sun and Wind, Georgian Bay* c. 1915

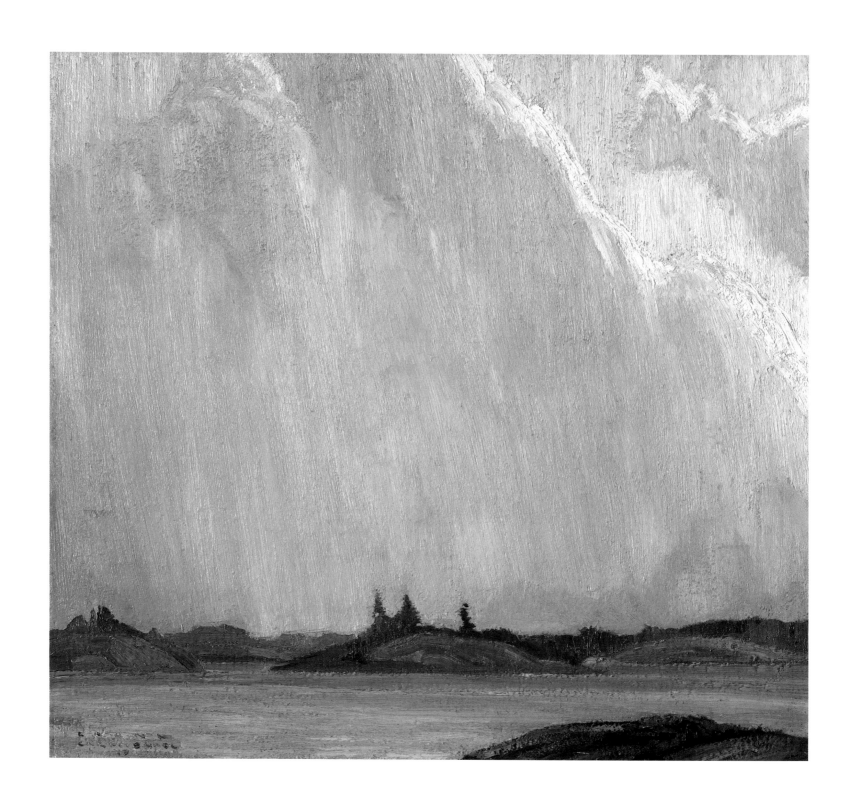

Frank Carmichael *Clouds, Georgian Bay* 1919

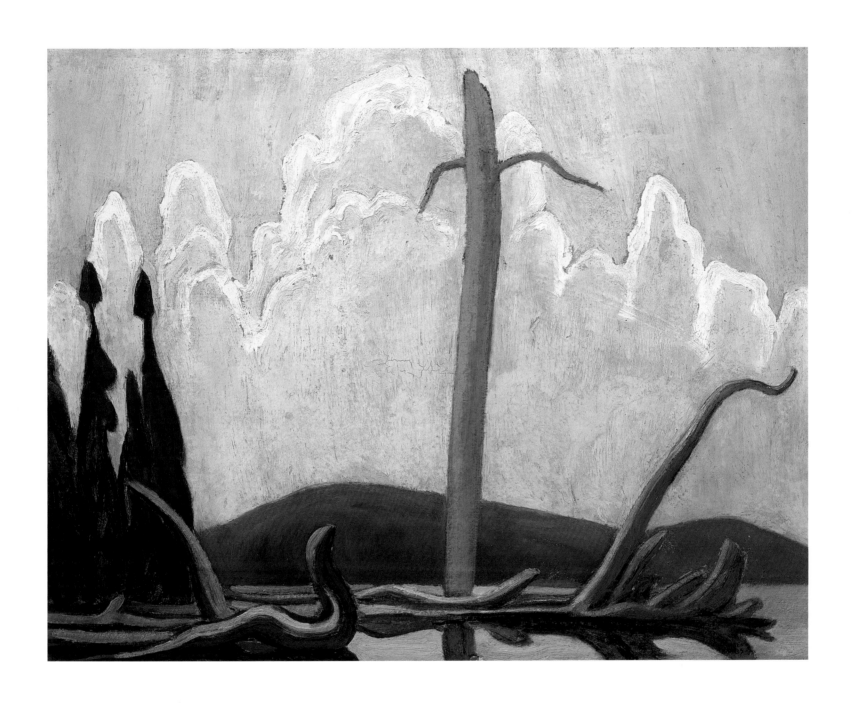

Lawren Harris *Joe Lake, Algonquin Park* c. 1914

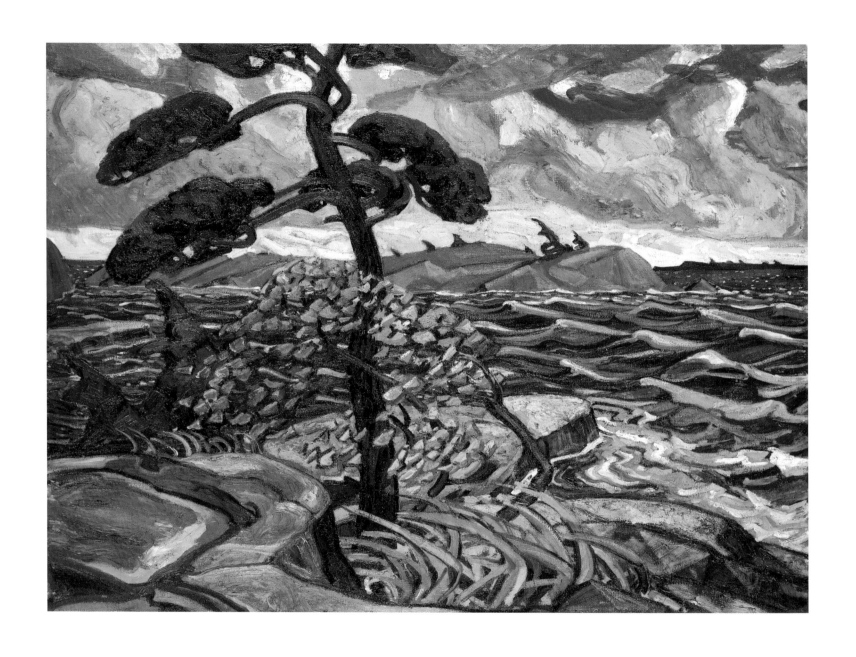

Arthur Lismer *A September Gale, Georgian Bay* 1921

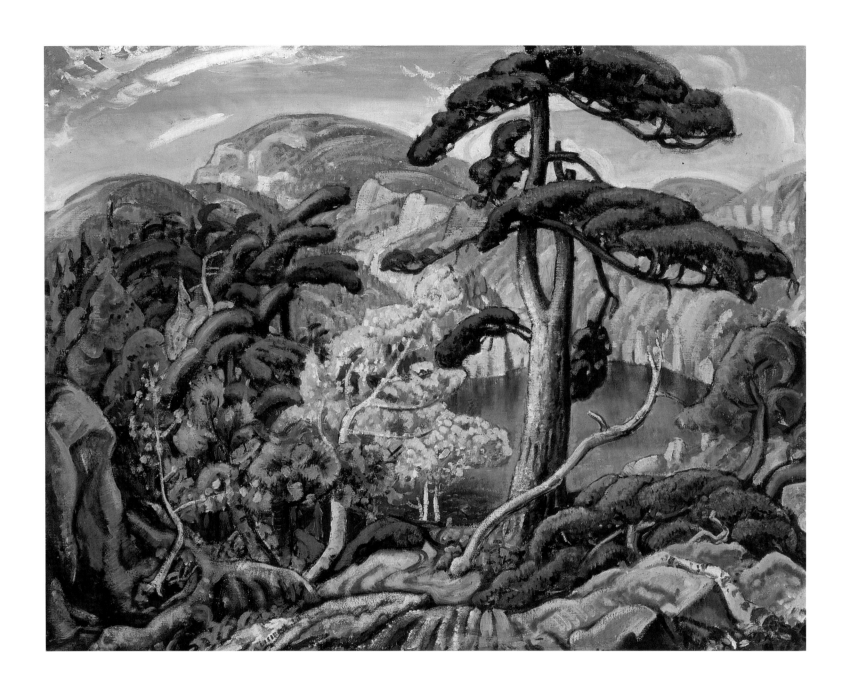

Arthur Lismer *Bright Land* 1938

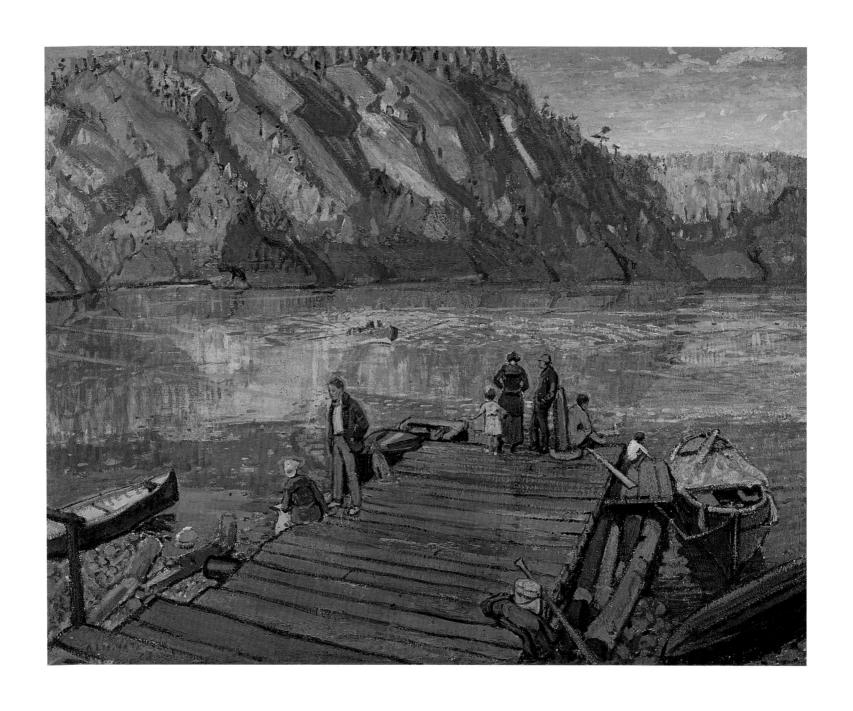

Arthur Lismer *Autumn, Bon Echo* 1923

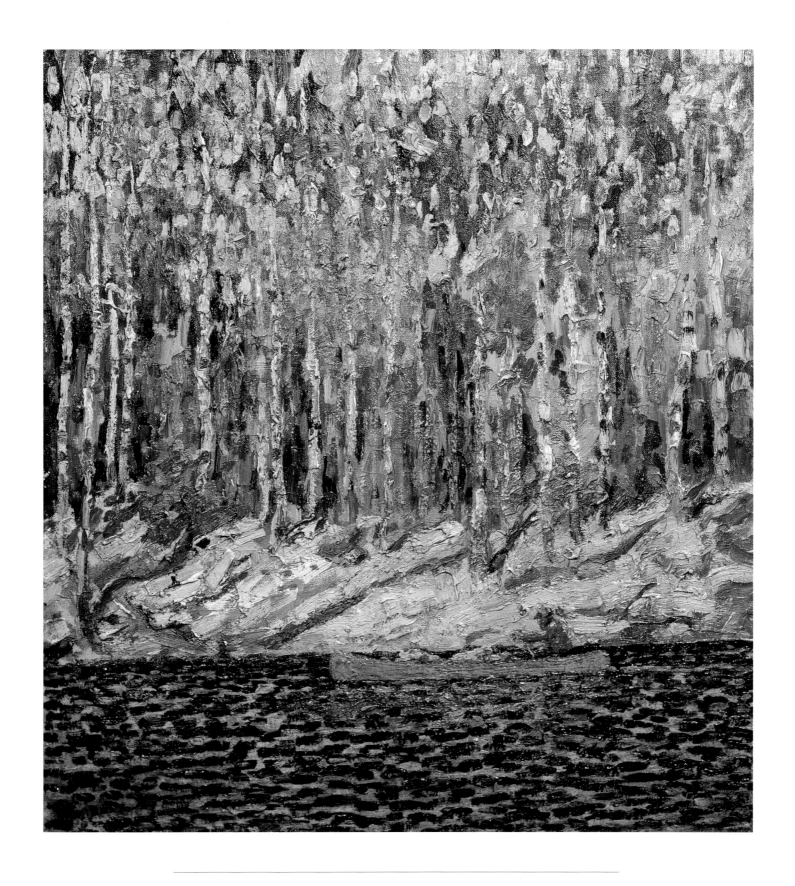

Arthur Lismer *Sunglow* 1915

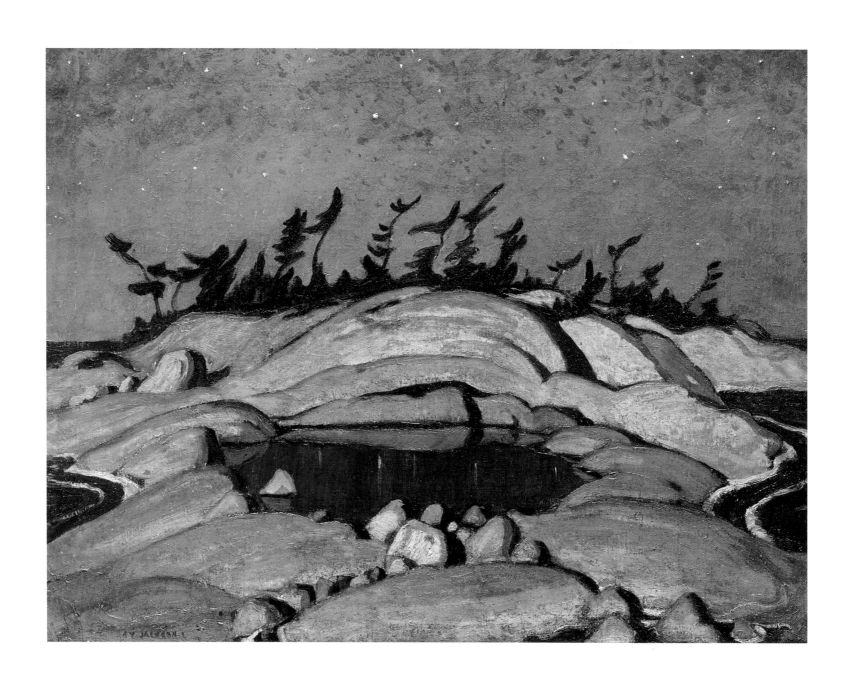

A.Y. Jackson *Night, Pine Island* 1924

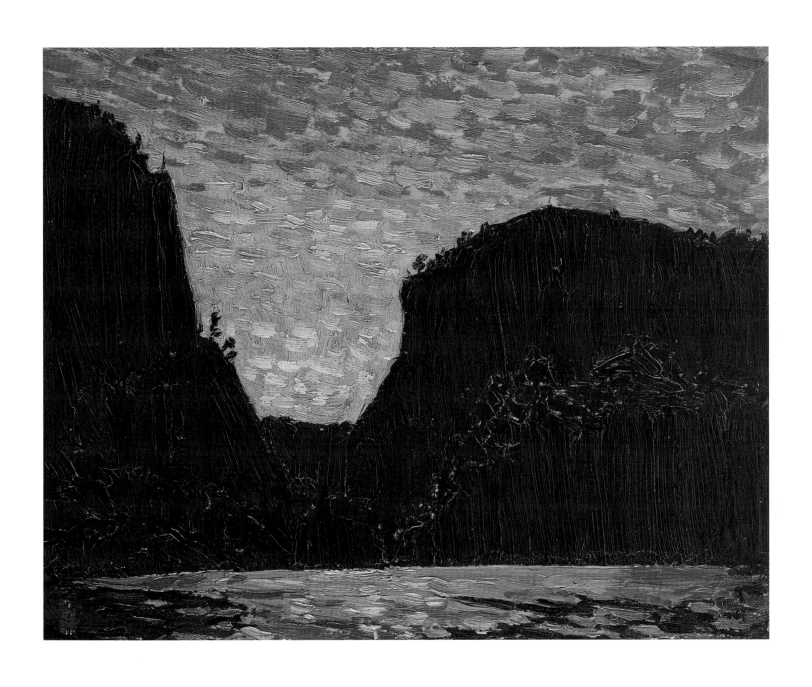

Tom Thomson *Petawawa Gorges, Night* c. 1916–1917

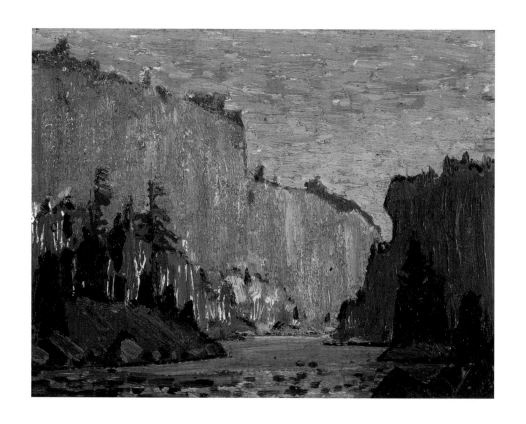

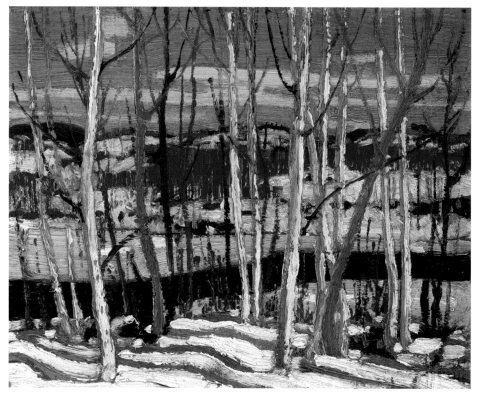

Tom Thomson *Petawawa Gorges* c. 1916

Tom Thomson *Open Water, Joe Creek* c. 1914

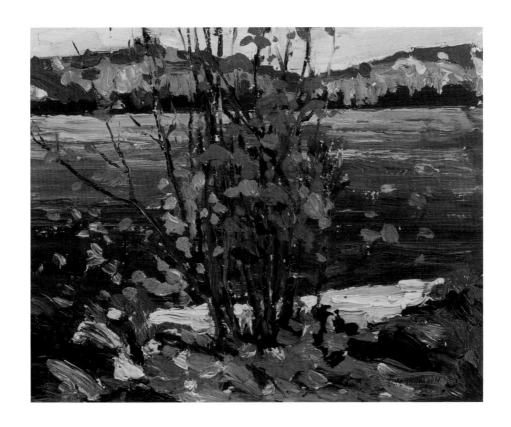

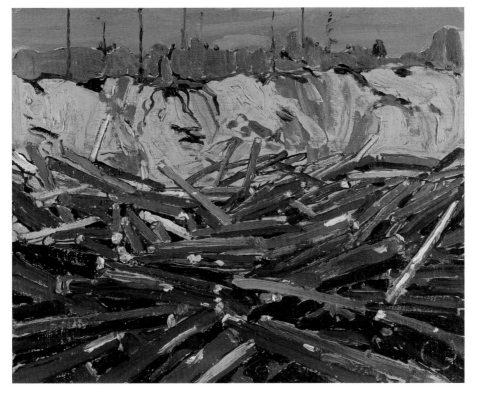

Tom Thomson *Lake and Red Tree* c. 1916

Tom Thomson *Sandbank with Logs* 1916

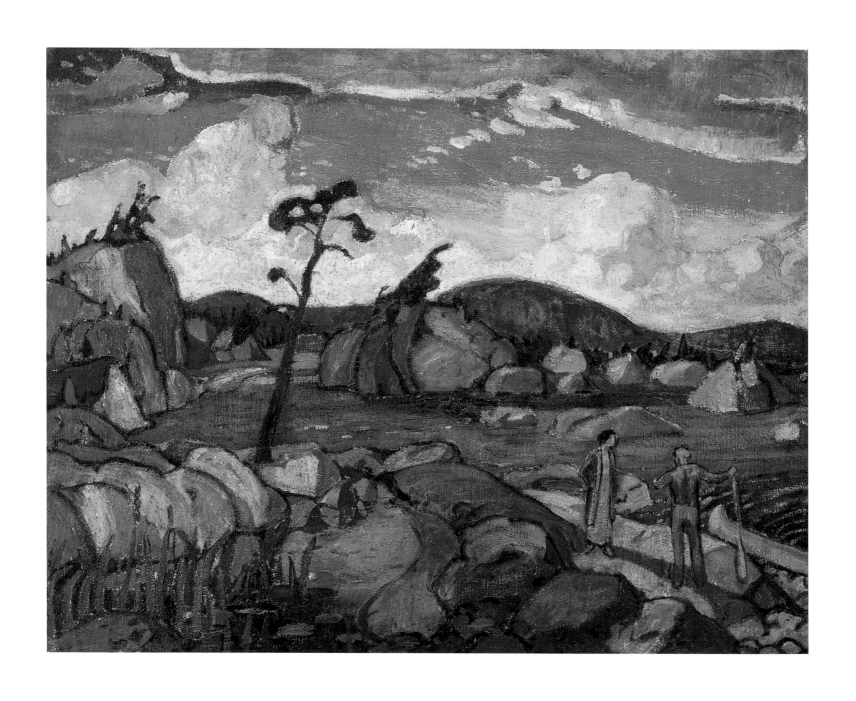

Arthur Lismer *The Happy Isles* 1924

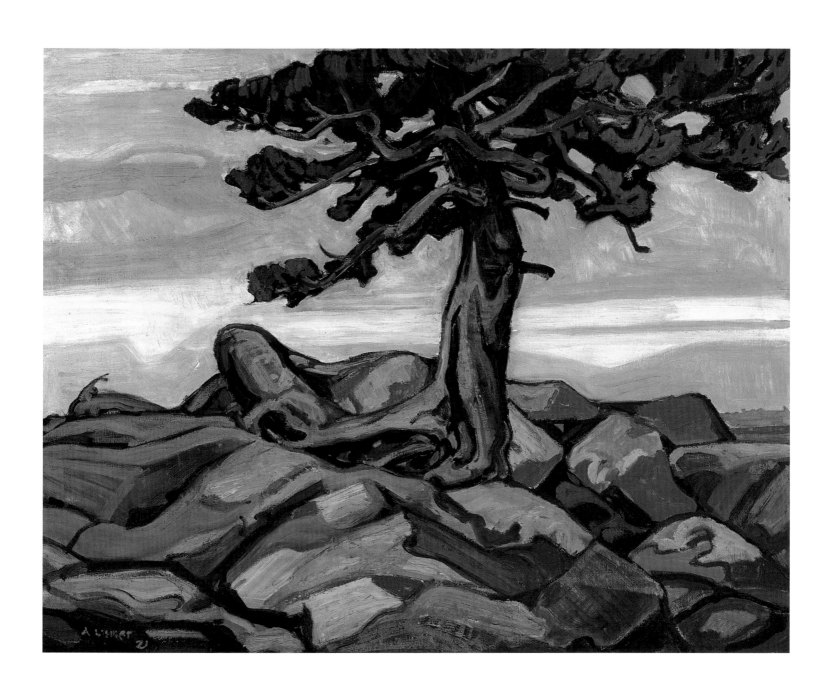

Arthur Lismer *Pine Tree and Rocks* 1921

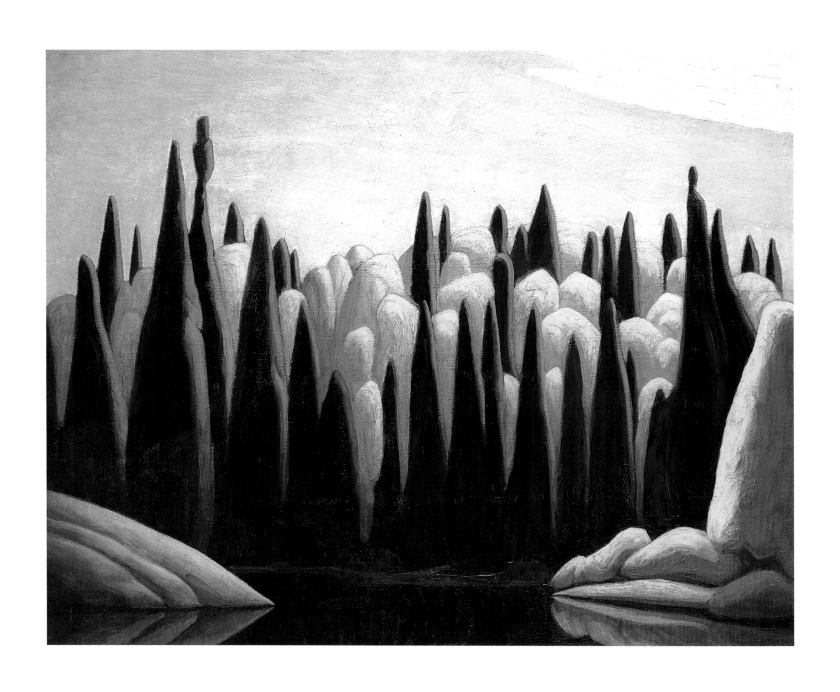

Lawren Harris *Spring on the Oxtongue River* 1924

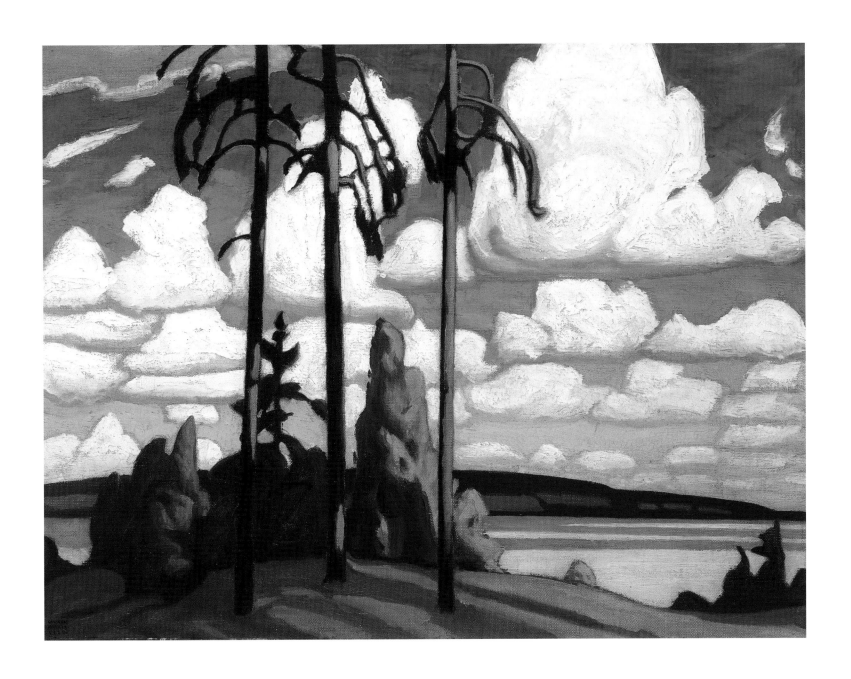

Lawren Harris *Pines, Kempenfelt Bay* n.d.

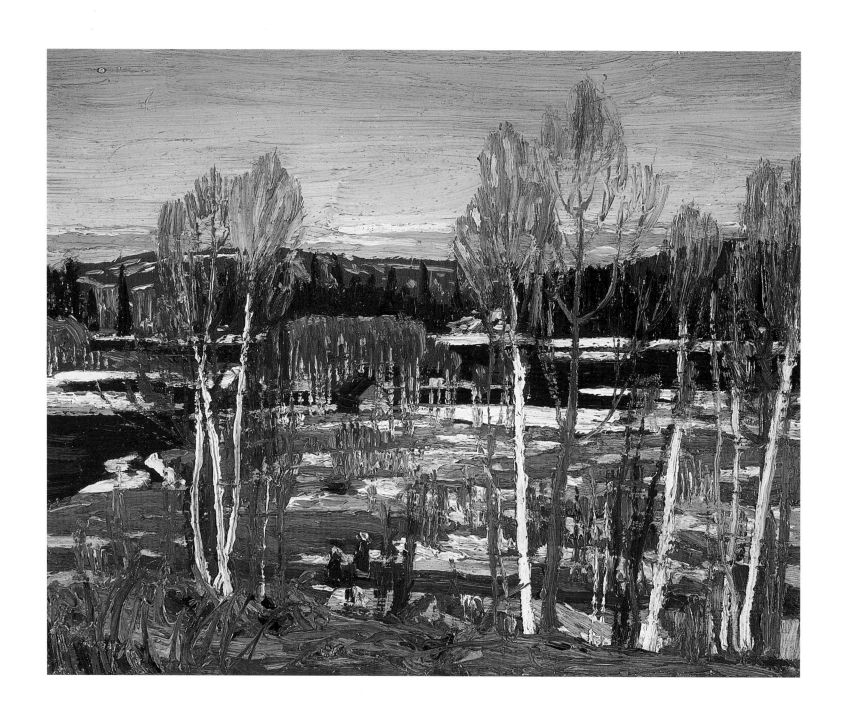

Tom Thomson *Larry Dickson's Cabin* 1917

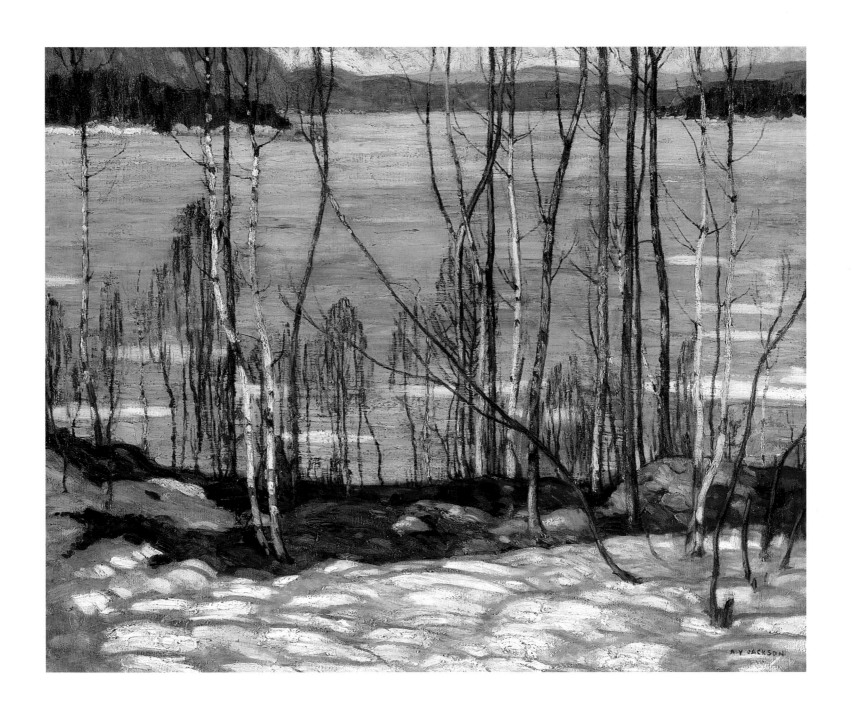

A.Y. Jackson *Frozen Lake, Early Spring, Algonquin Park* 1914

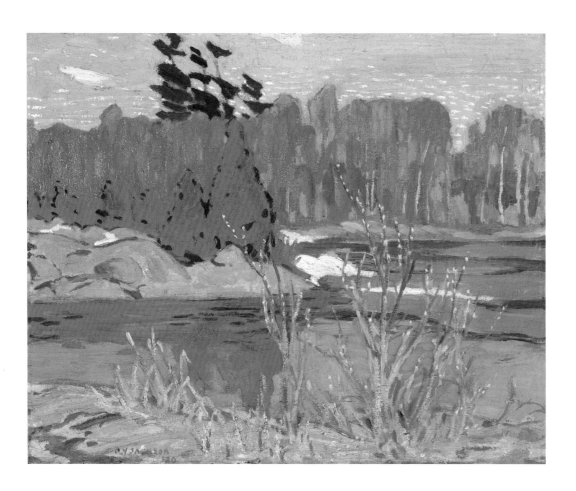

(above) A.Y. Jackson *Early Spring, Georgian Bay* 1920

A.Y. Jackson *Lake Cognaschene* 1920

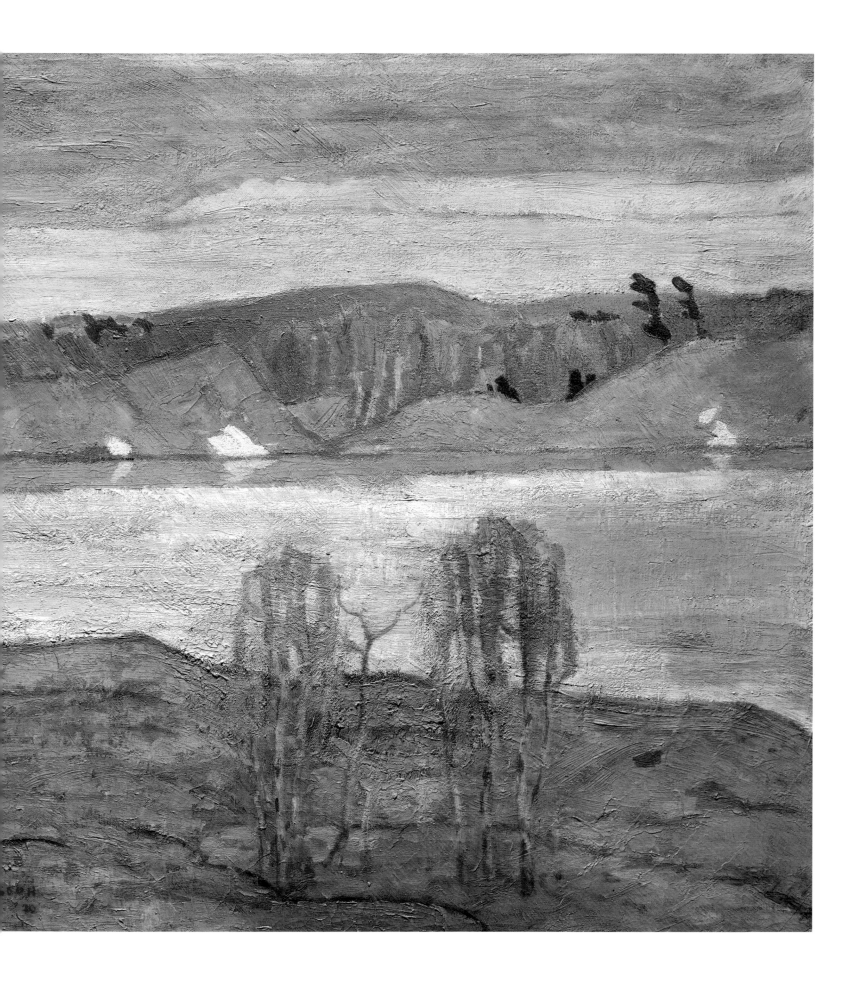

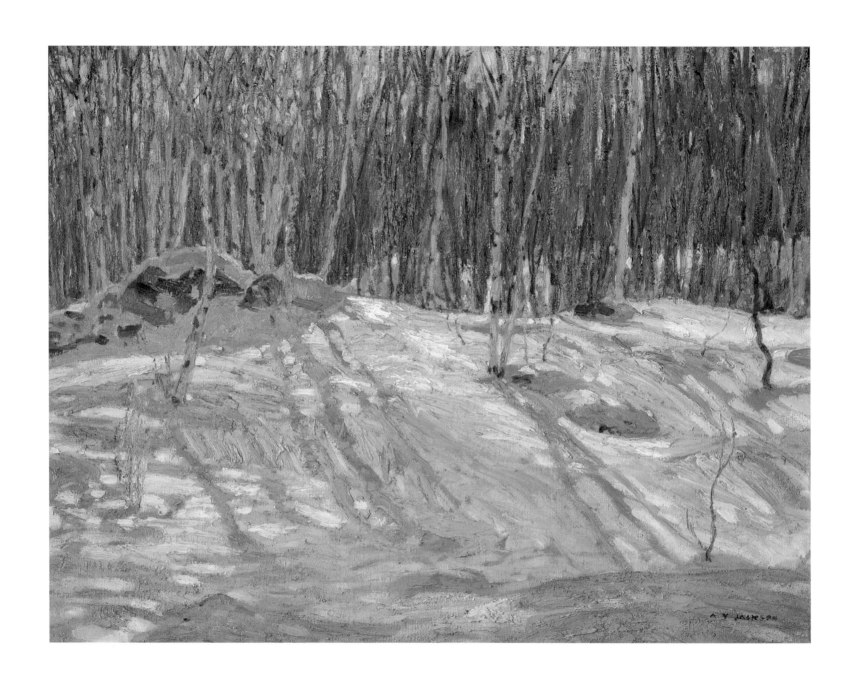

A.Y. Jackson *Birches in Winter, Algonquin Park,* 1914

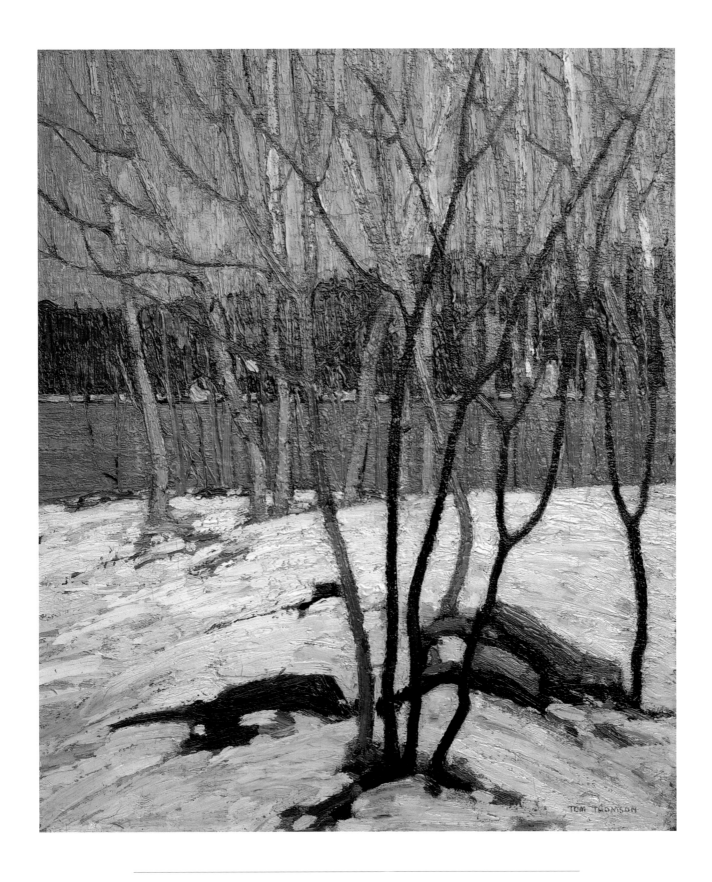

Tom Thomson *White Birch Grove* c. 1917

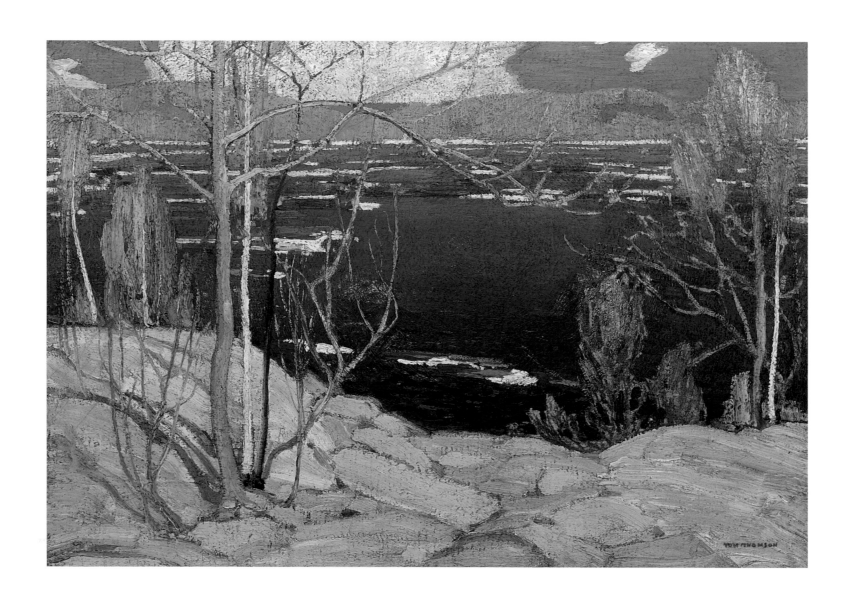

Tom Thomson *Spring Ice* 1916

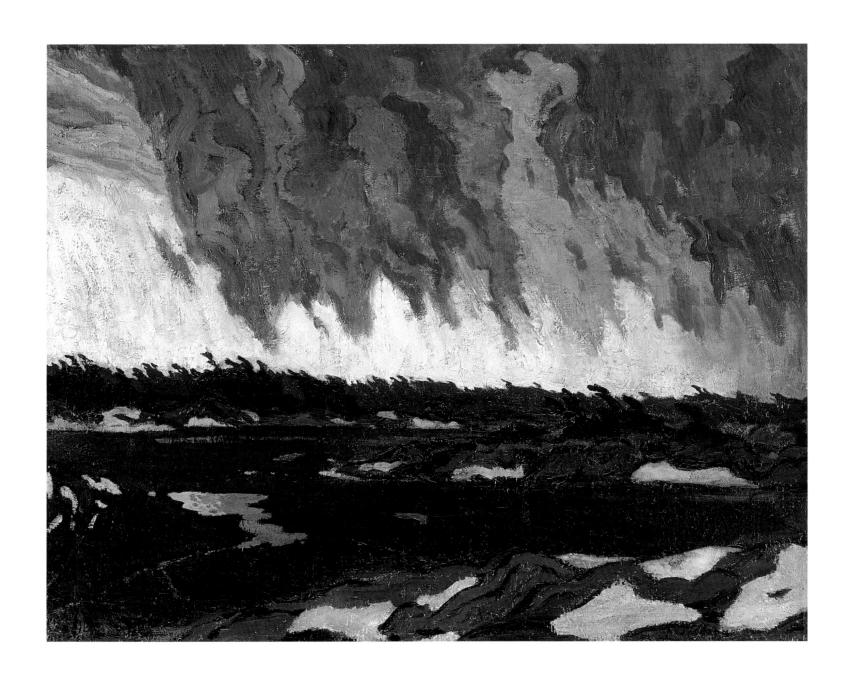

A.Y. Jackson *March Storm, Georgian Bay* 1920

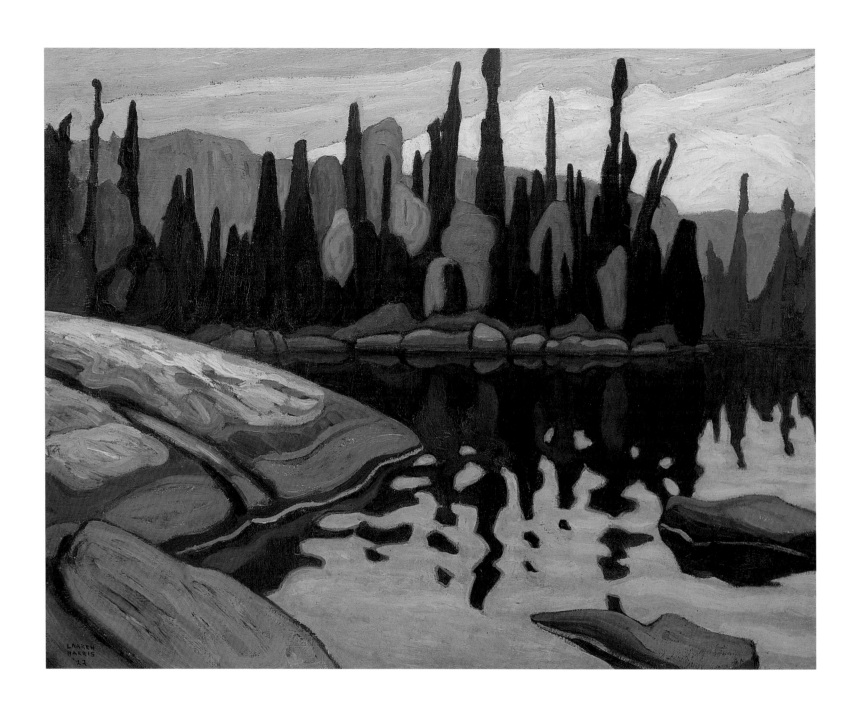

Lawren Harris *Shimmering Water, Algonquin Park* 1922

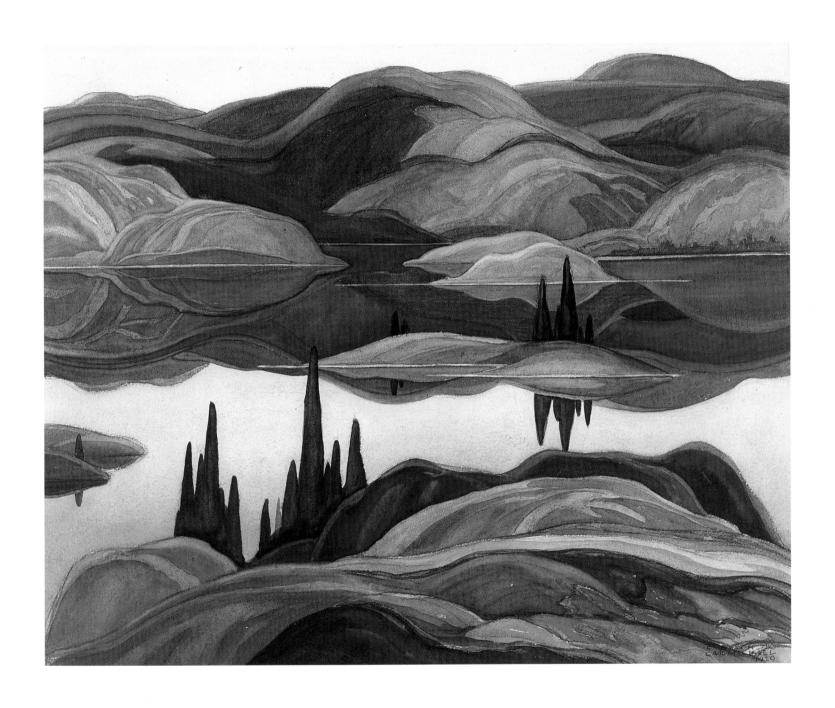

Frank Carmichael *Mirror Lake* 1929

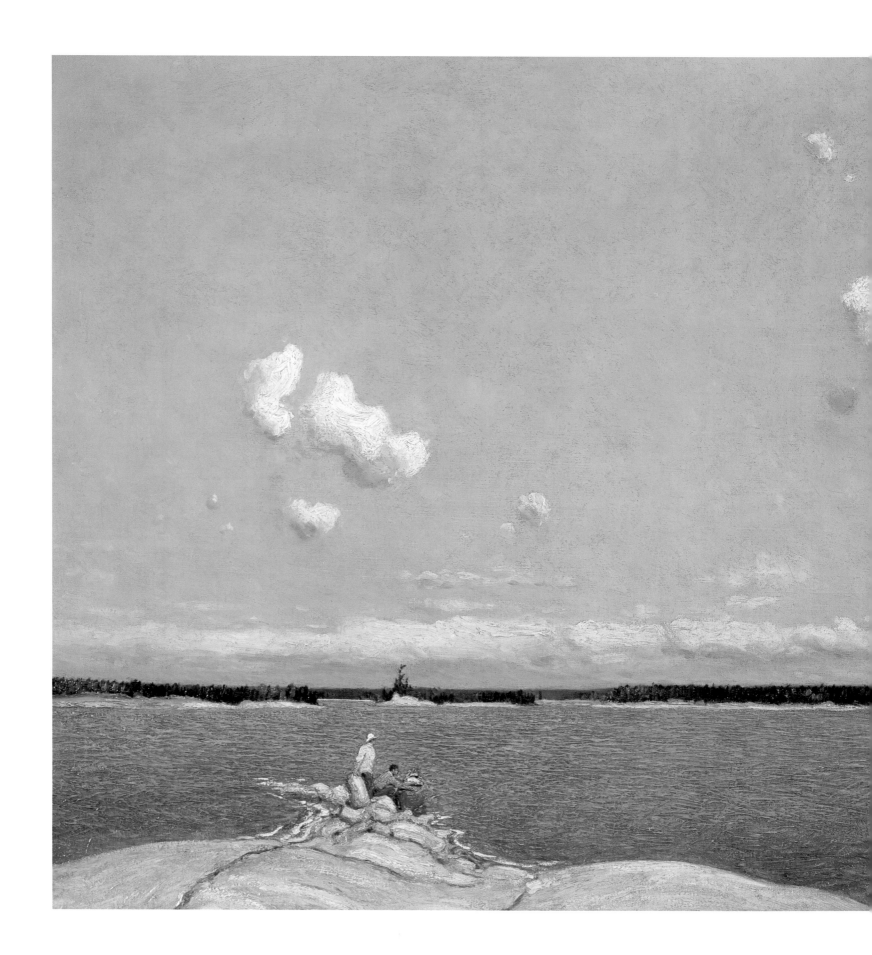

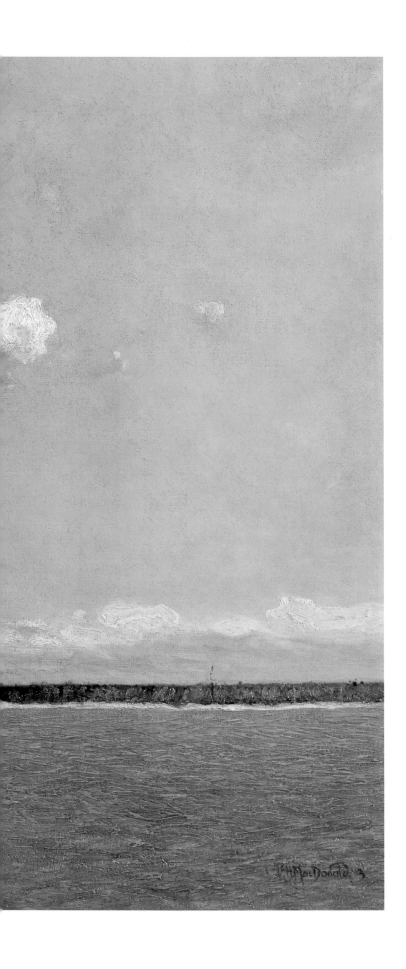

J.E.H. MacDonald *Fine Weather, Georgian Bay* 1913

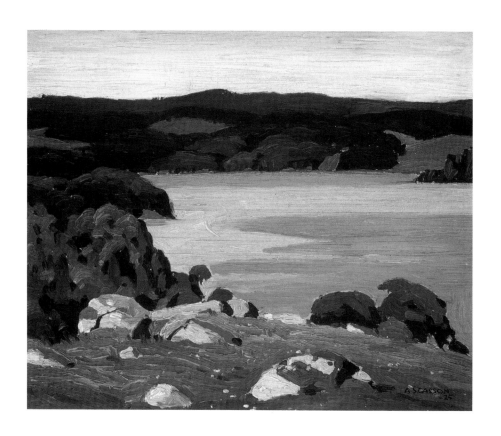

A.J. Casson *Lake Kushog* 1925

J.E.H. MacDonald *Logs Coming Down the Narrows, Turtle Lake* n.d.

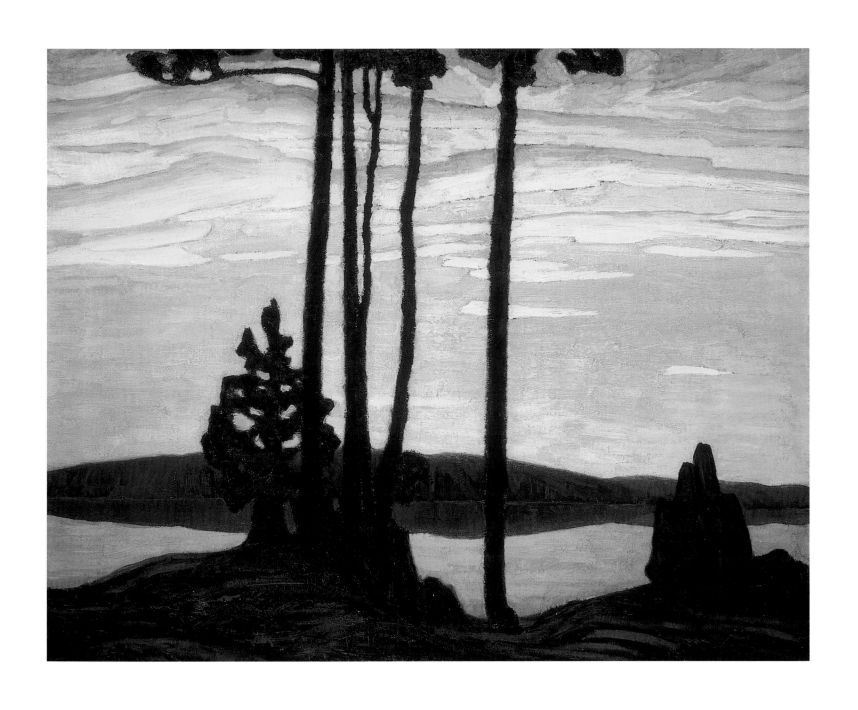

Lawren Harris *Sunset, Kempenfelt Bay* 1921

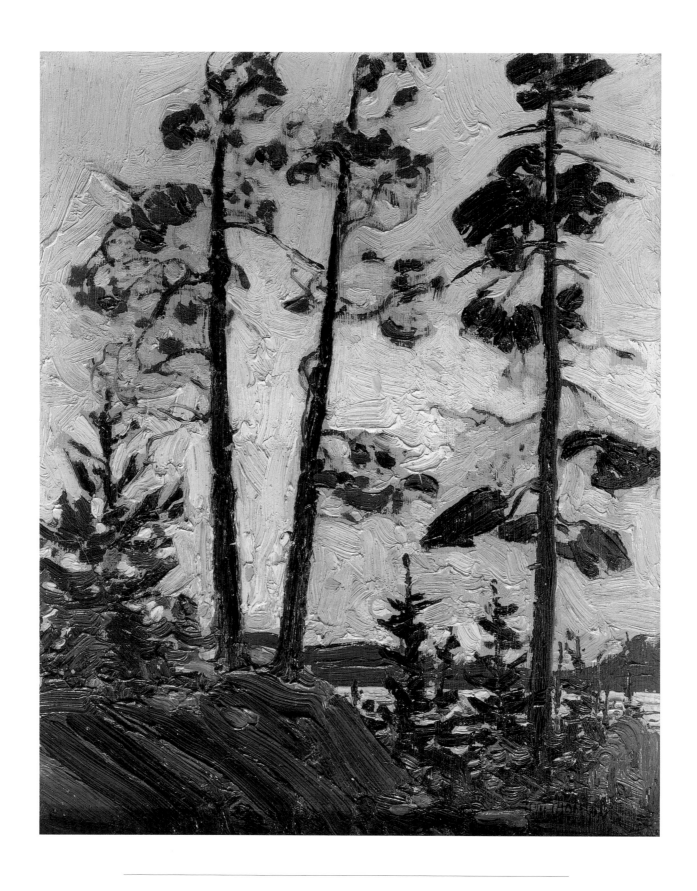

Tom Thomson *Pine Trees at Sunset* c. 1915–1916

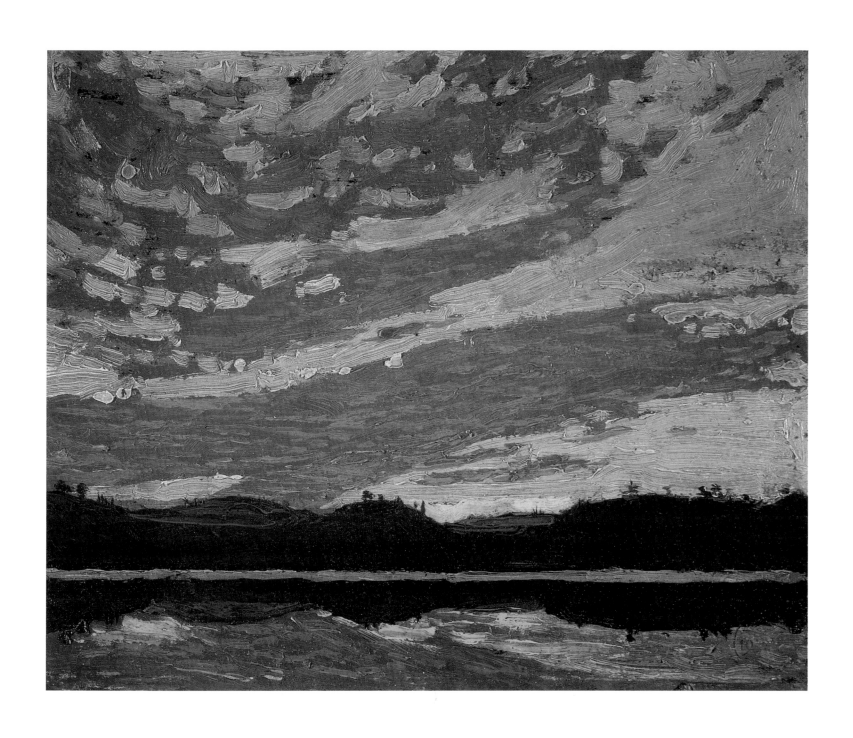

Tom Thomson *Sunset* 1915

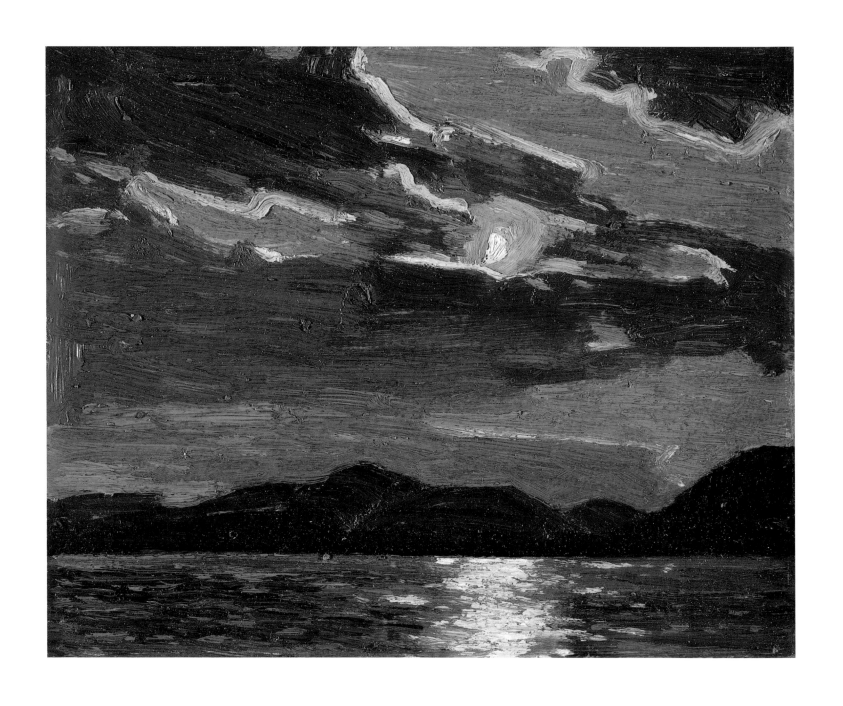

Tom Thomson *Hot Summer Moonlight* c. 1915

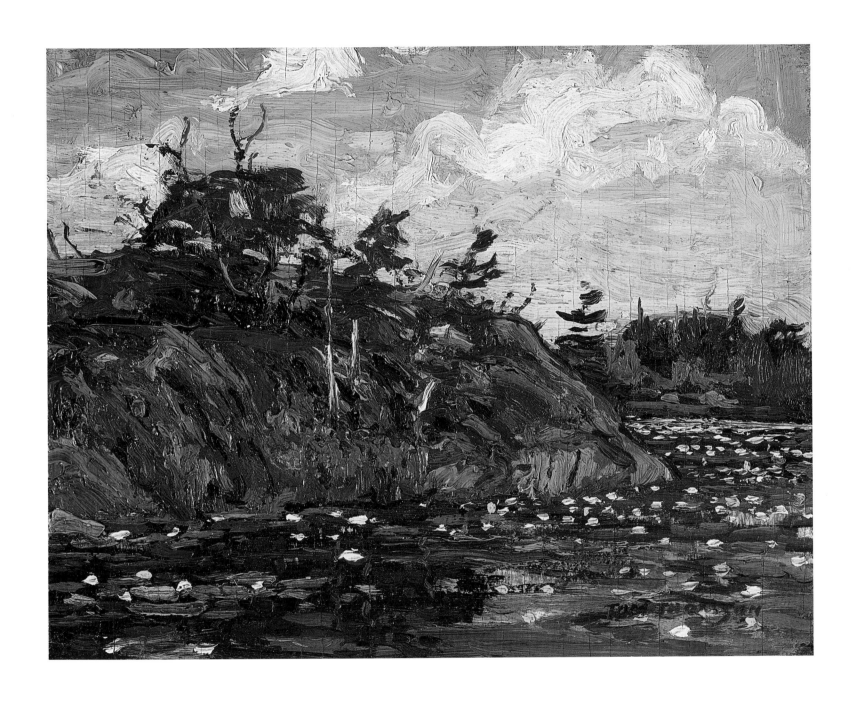

Tom Thomson *The Lily Pond* 1914

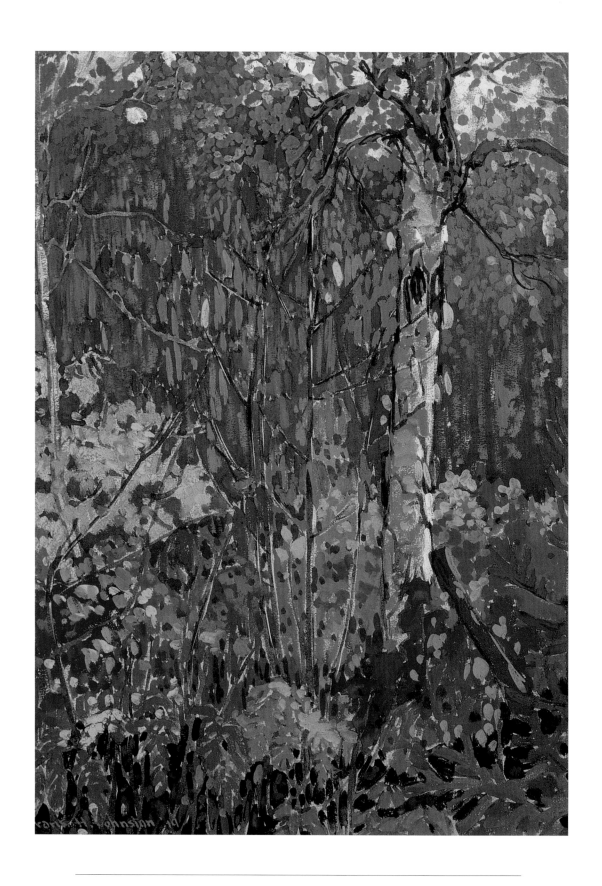

Frank Johnston *Woodland Tapestry* 1919

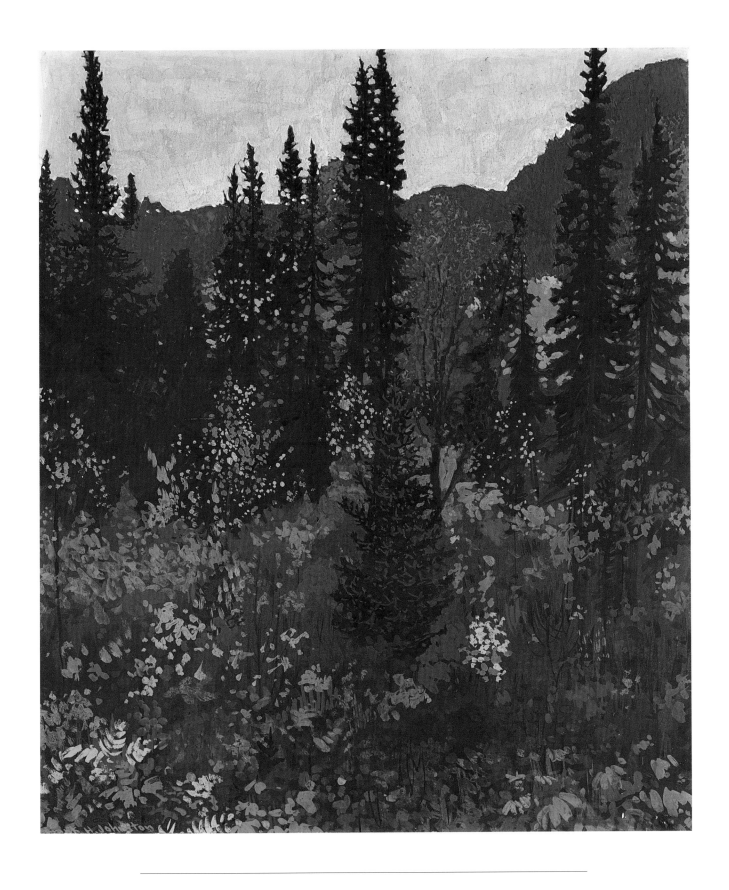

Frank Johnston *The Dark Woods, Interior* c. 1921

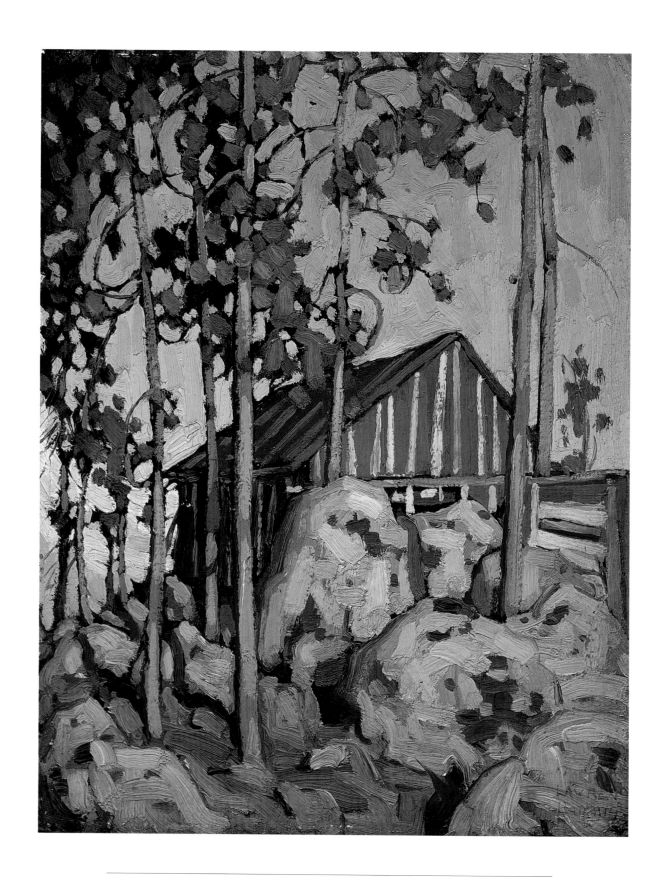

Lawren Harris *Algonquin Park* C. 1917

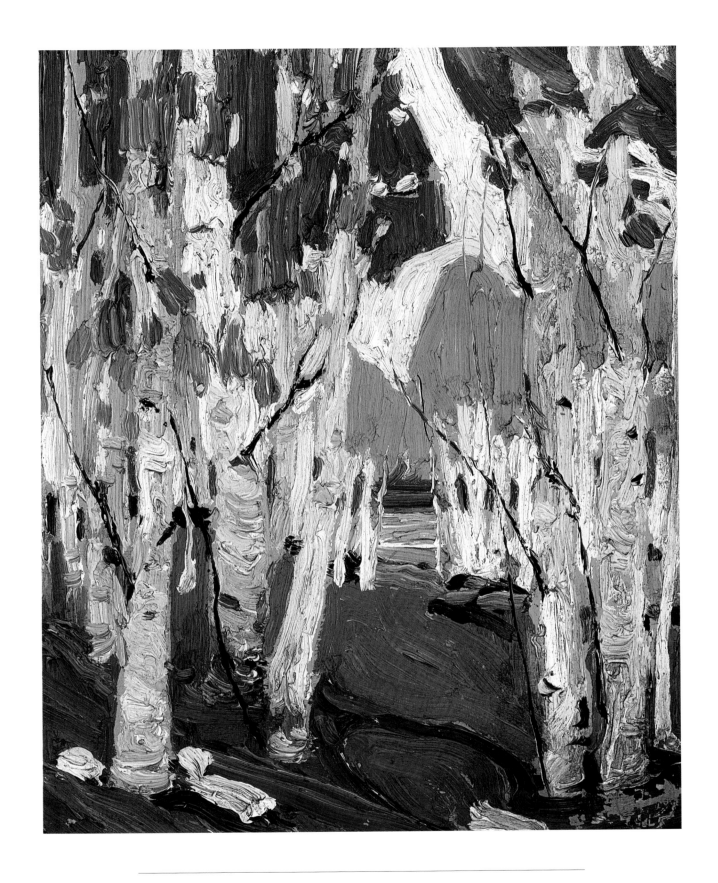

Tom Thomson *Pink Birches* 1915

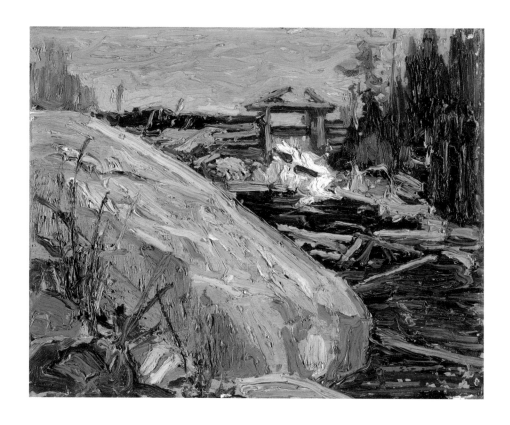

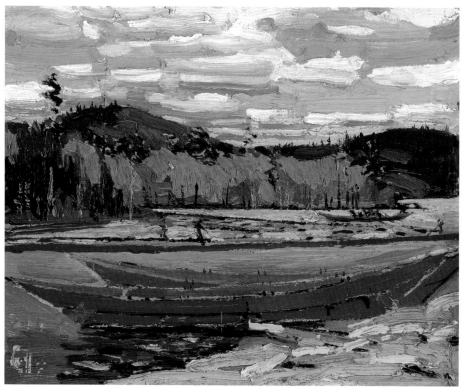

Tom Thomson *Lumber Dam* 1915

Tom Thomson *Bateaux* 1916

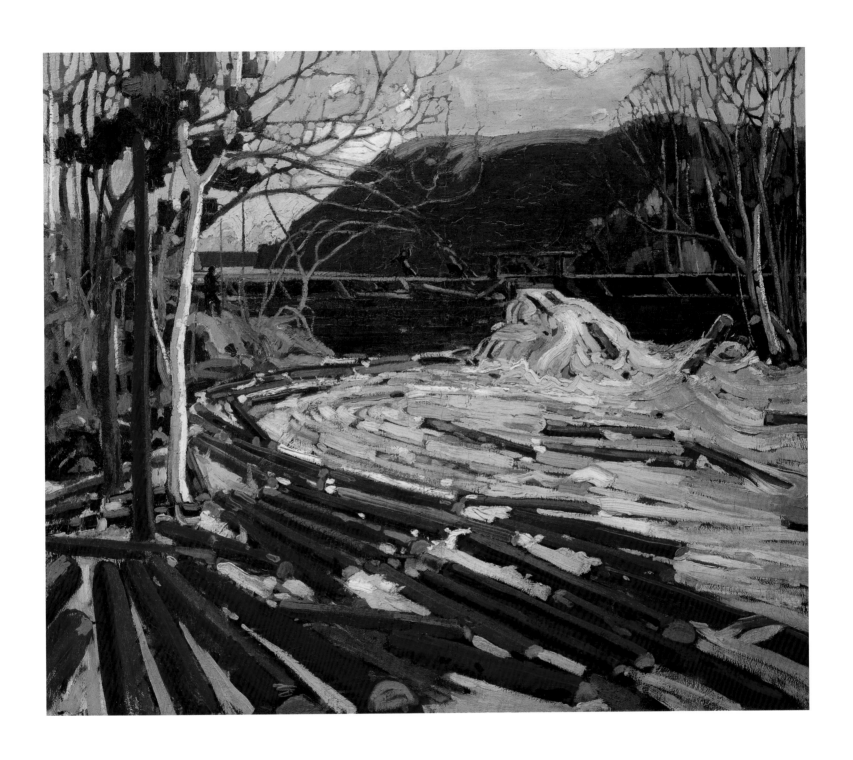

Tom Thomson *The Drive* c. 1916

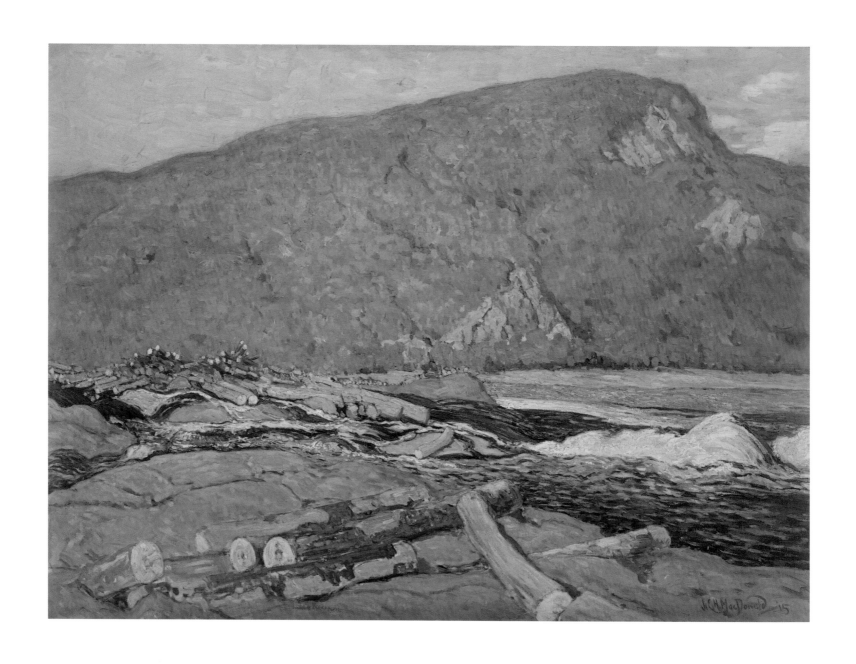

J.E.H. MacDonald *Logs on the Gatineau* 1915

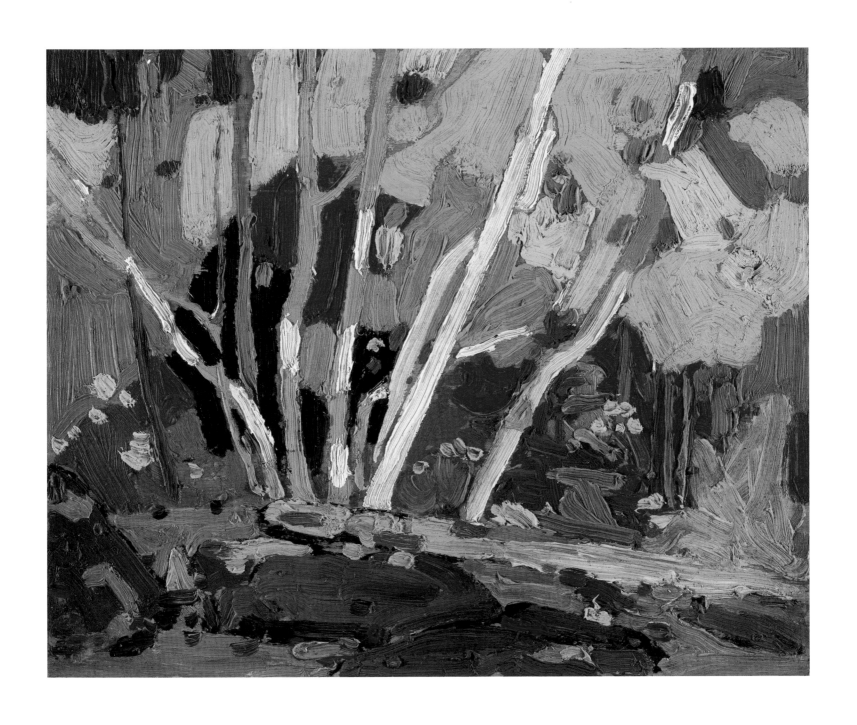

Tom Thomson *Autumn Birches* c. 1916

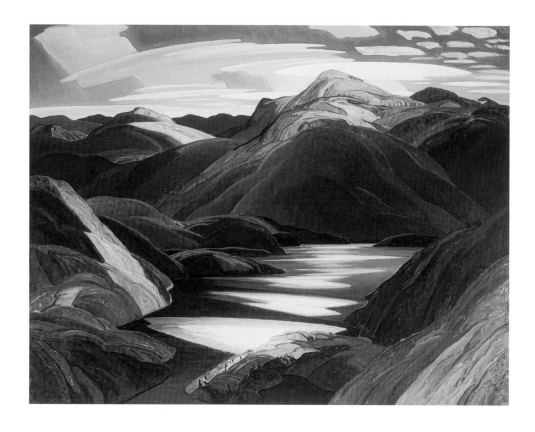

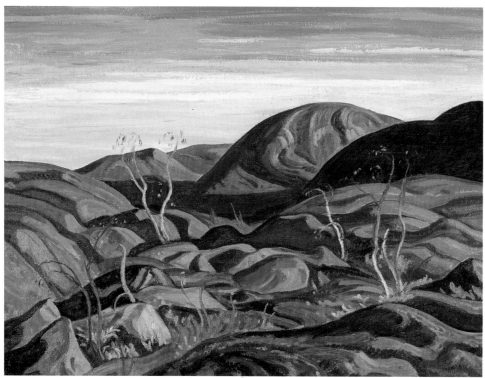

Frank Carmichael *Light and Shadow* 1937

A.Y. Jackson *Precambrian Hills* 1939

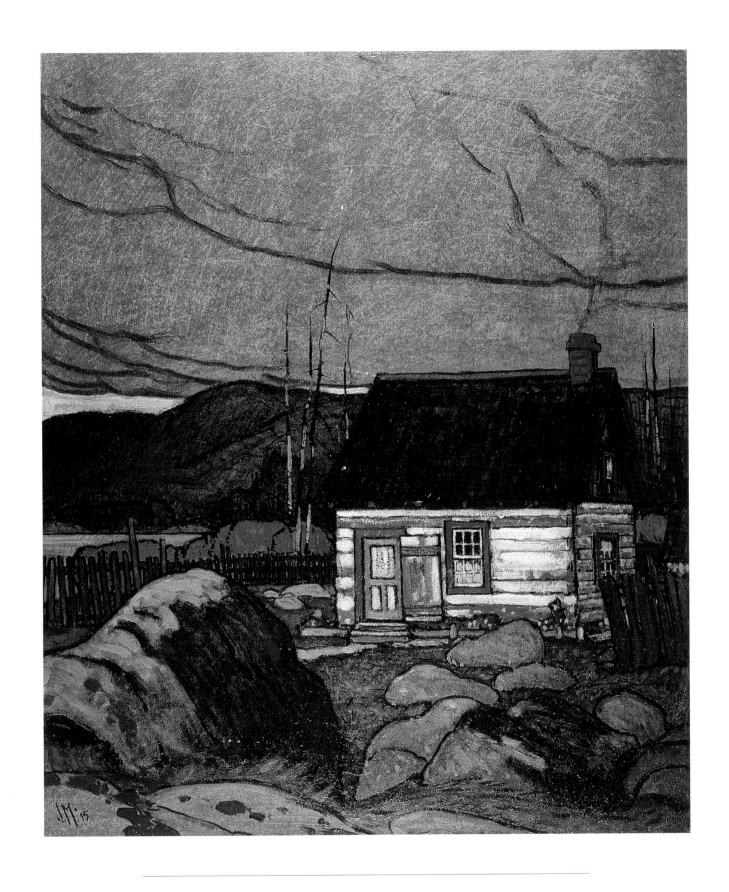

J.E.H. MacDonald *A Northern Home* 1915

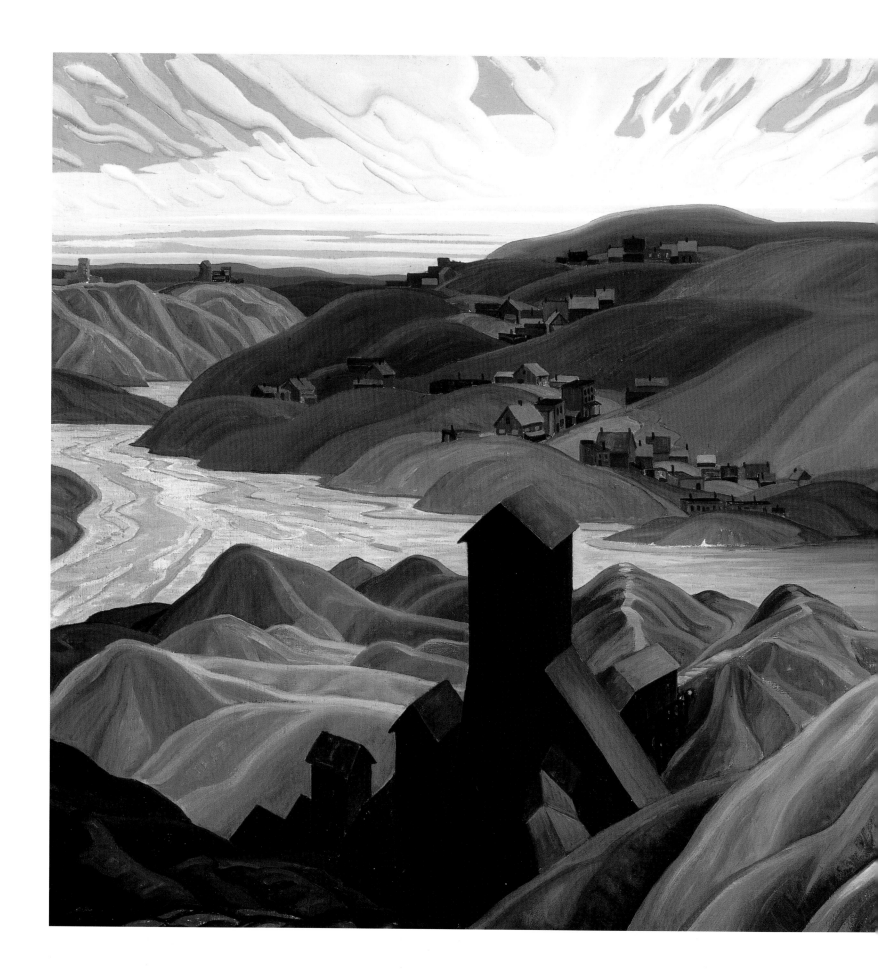

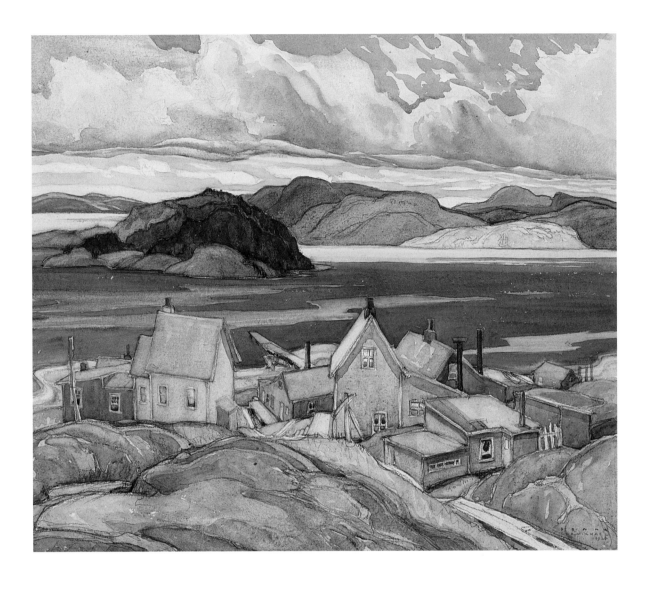

(left) Frank Carmichael *A Northern Silver Mine* 1930

Frank Carmichael *Jackfish Village* 1926

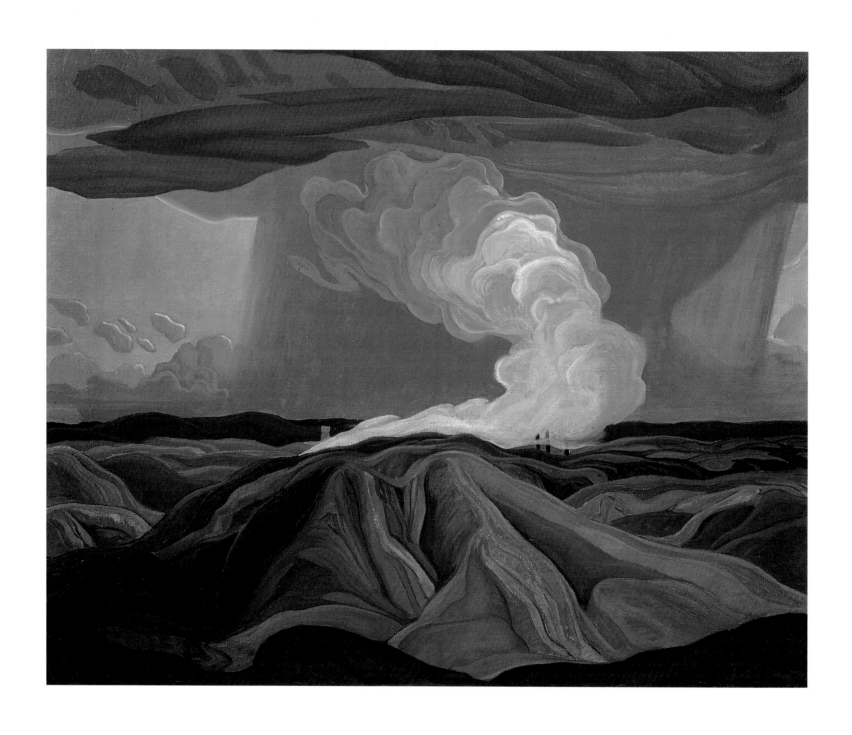

Frank Carmichael *The Nickel Belt* 1928

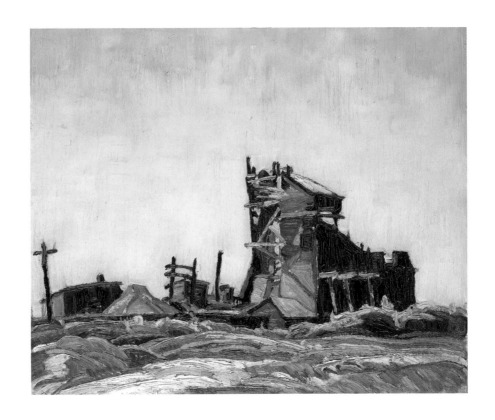

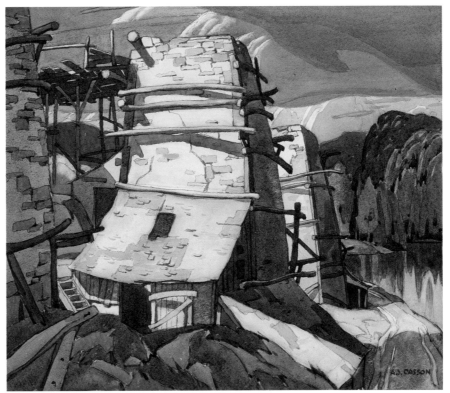

Frank Carmichael *Untitled (Industrial Building)* c. 1934–1937

A.J. Casson *Old Lime Kilns* c. 1925

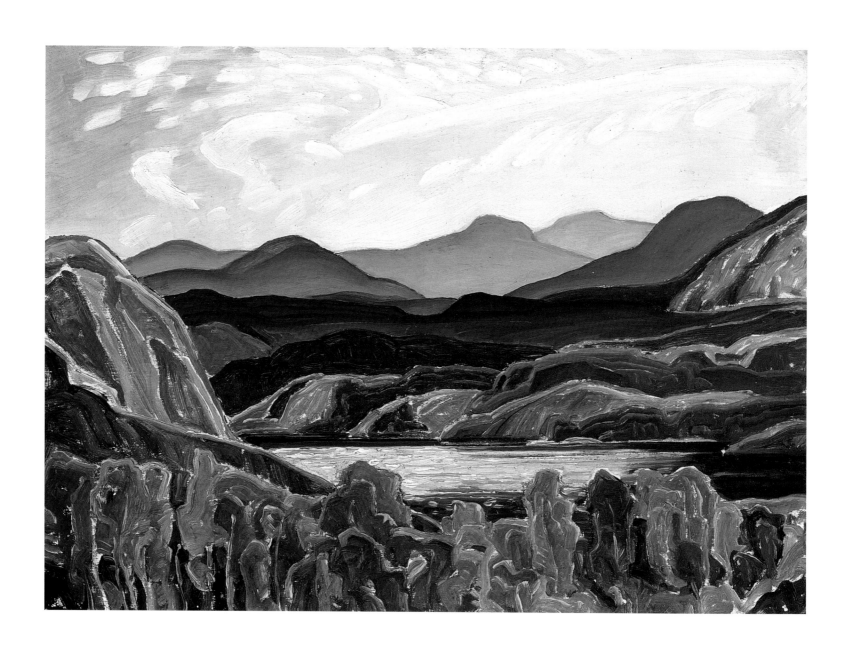

Frank Carmichael *La Cloche Mountain and Lake* c. 1940

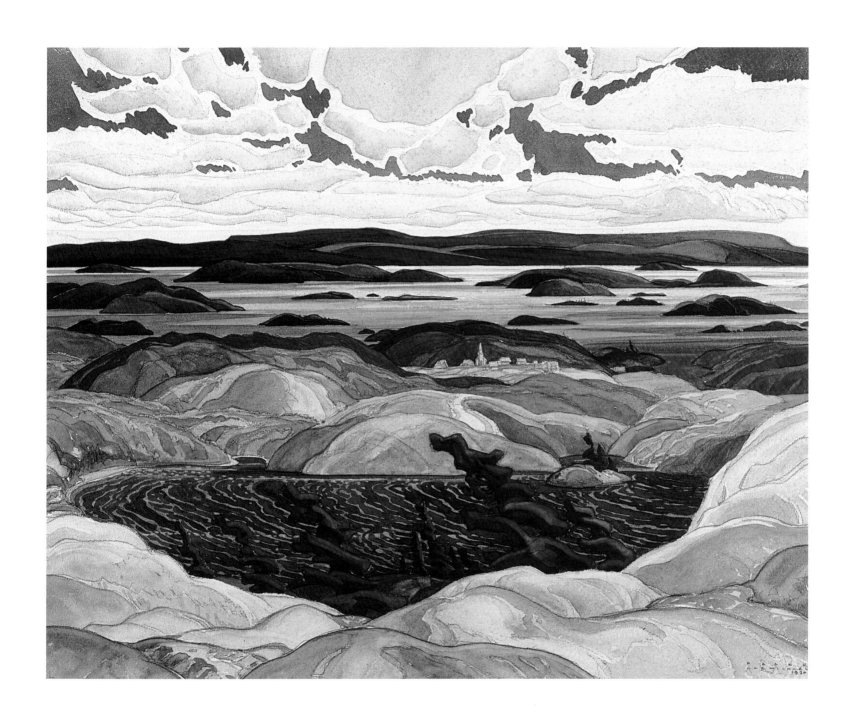

Frank Carmichael *Bay of Islands* 1930

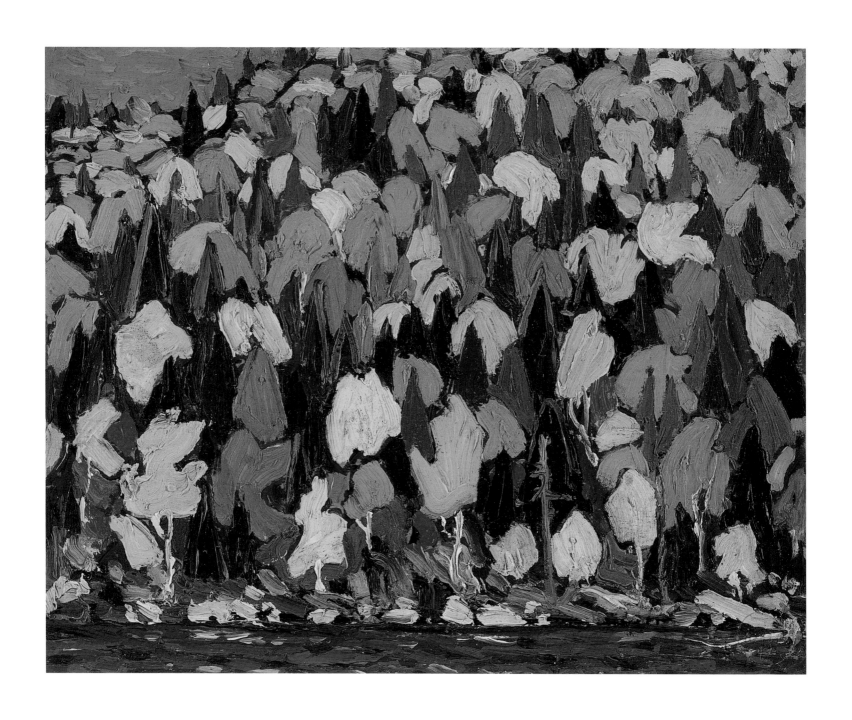

Tom Thomson *Autumn Foliage* 1915

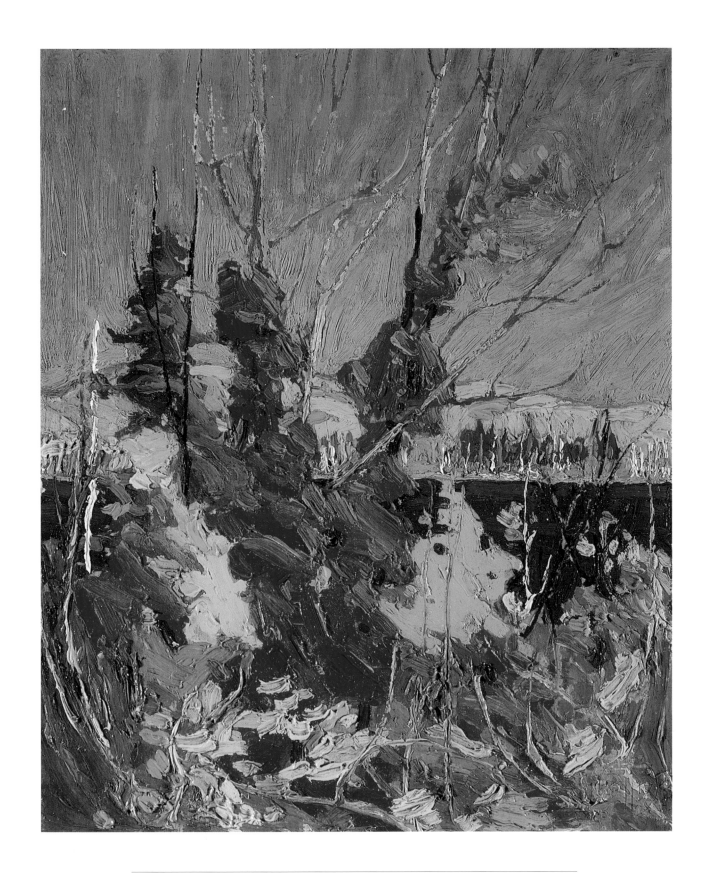

Tom Thomson *Autumn Foliage* 1916

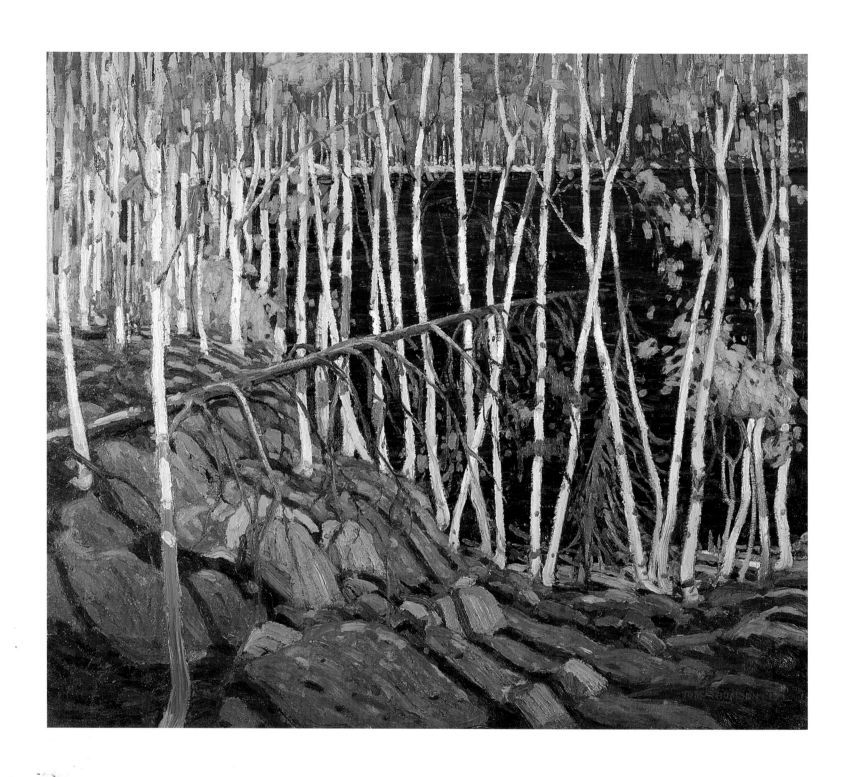

Tom Thomson *In the Northland* 1915

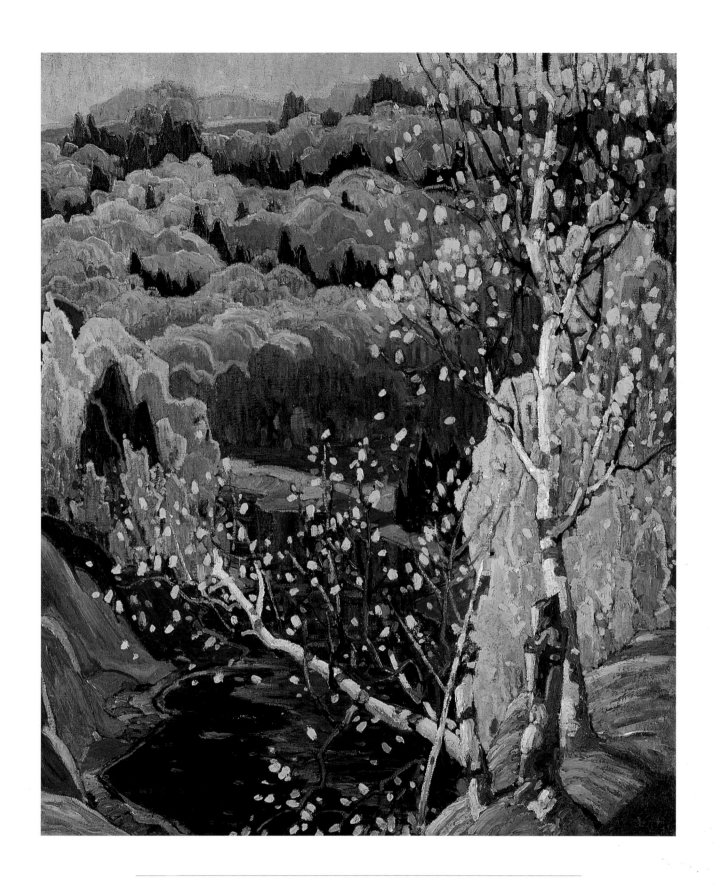

Frank Carmichael *October Gold* 1922

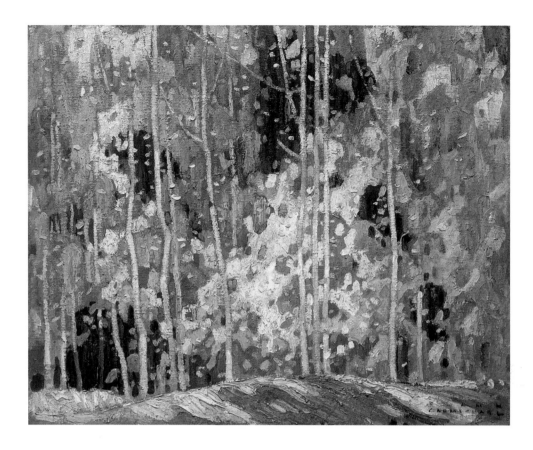

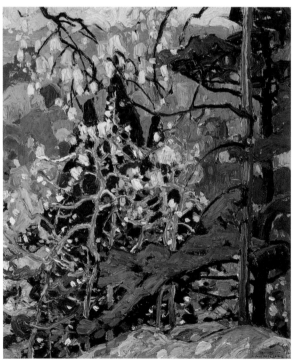

Frank Carmichael *Fanciful Autumn* (also known as *The Glade*) 1922
Frank Carmichael *Autumn Splendour* 1921

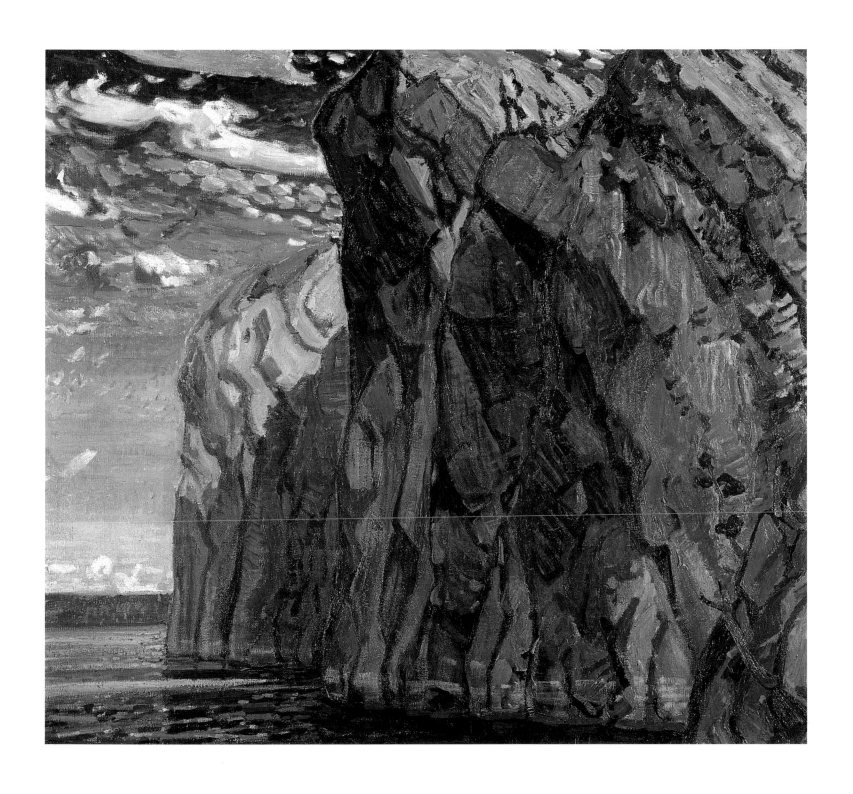

Arthur Lismer *The Big Rock, Bon Echo* 1922

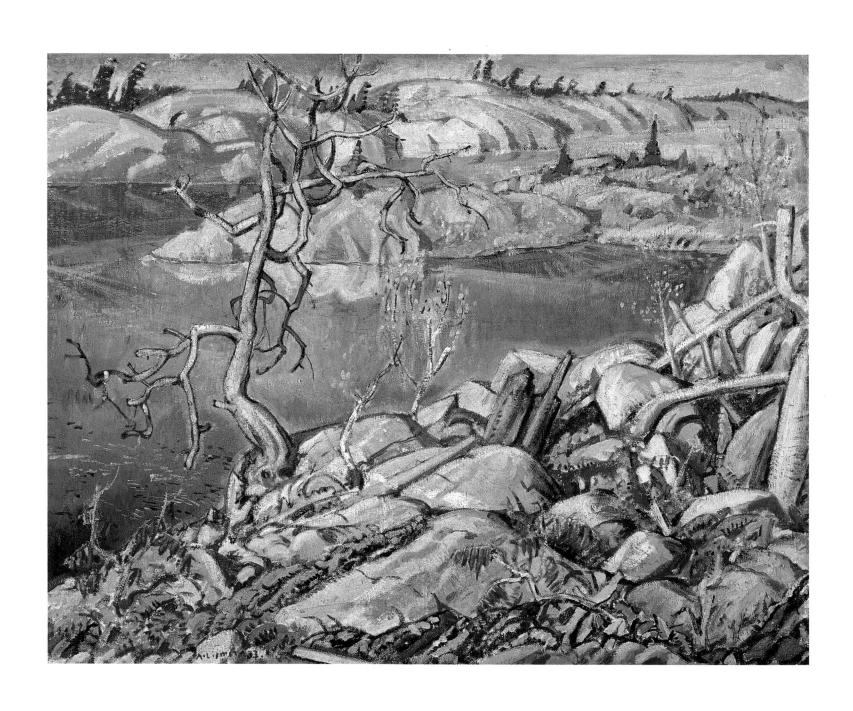

Arthur Lismer *September Sunlight, Georgian Bay* 1933

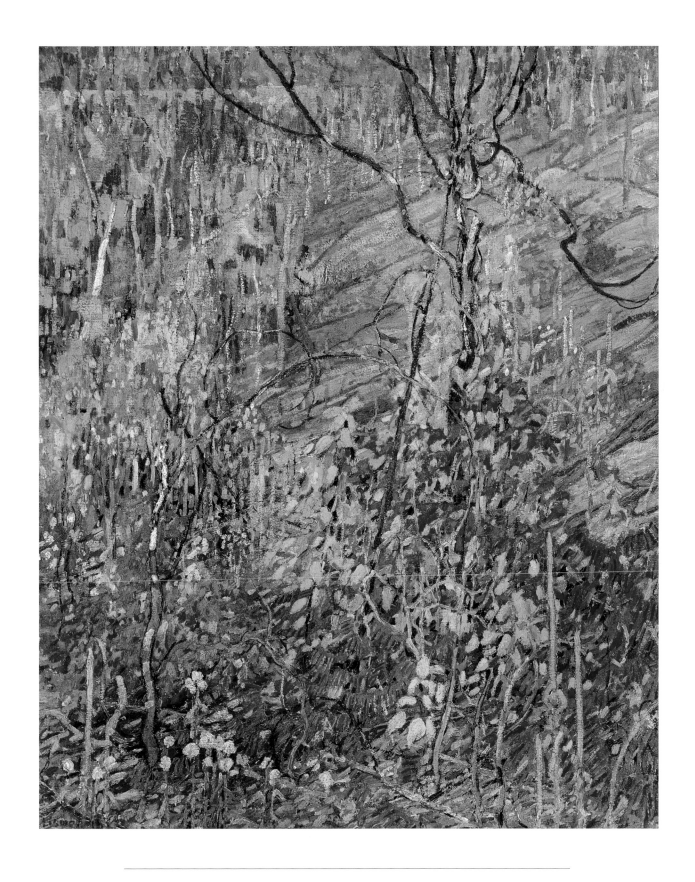

Arthur Lismer *Sumach and Maple* 1915

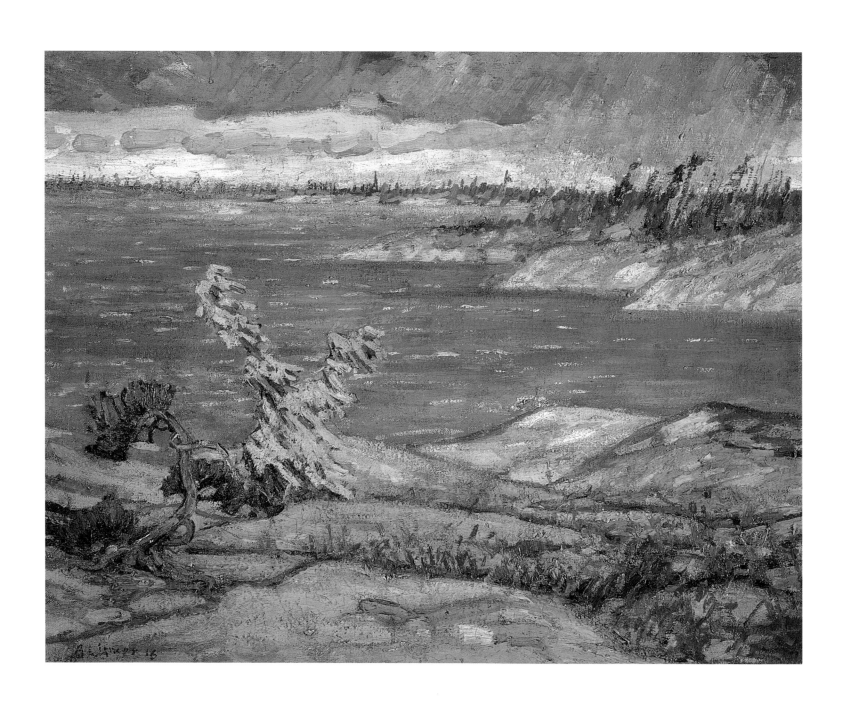

Arthur Lismer *A Westerly Gale, Georgian Bay* 1916

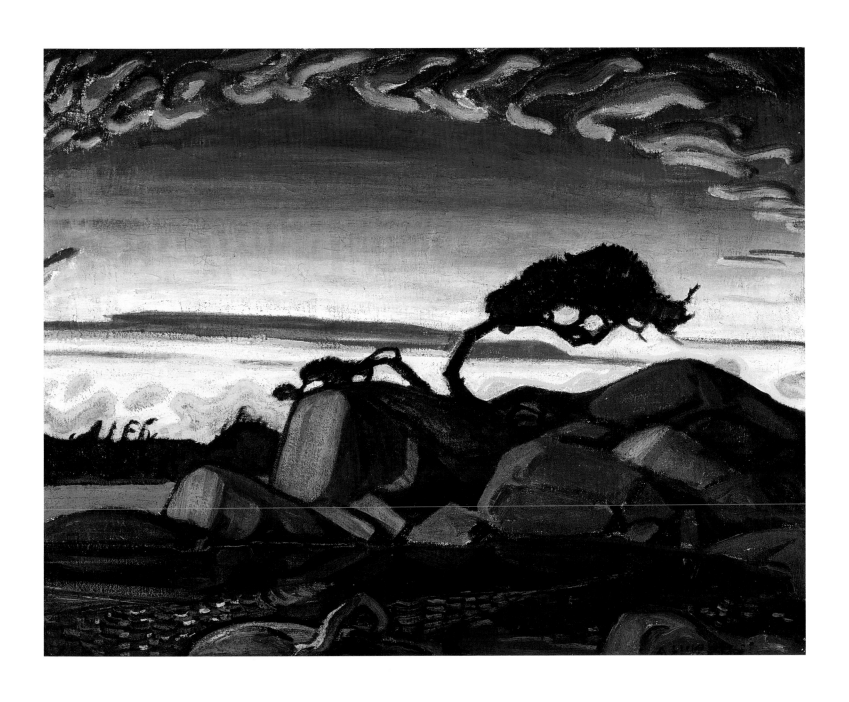

Arthur Lismer *Evening Silhouette* 1928

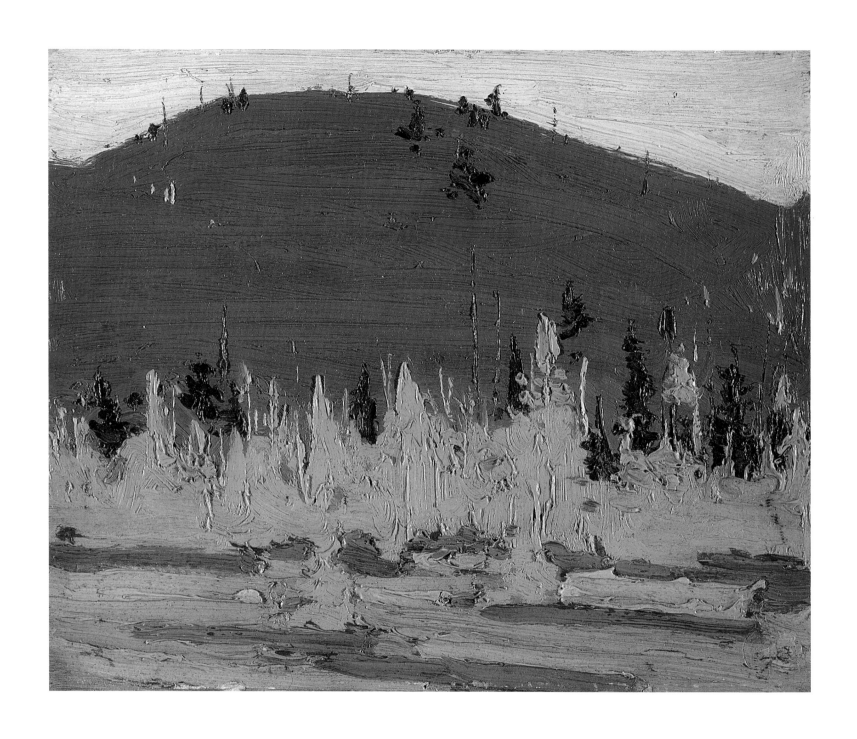

Tom Thomson *Tamarack* 1916

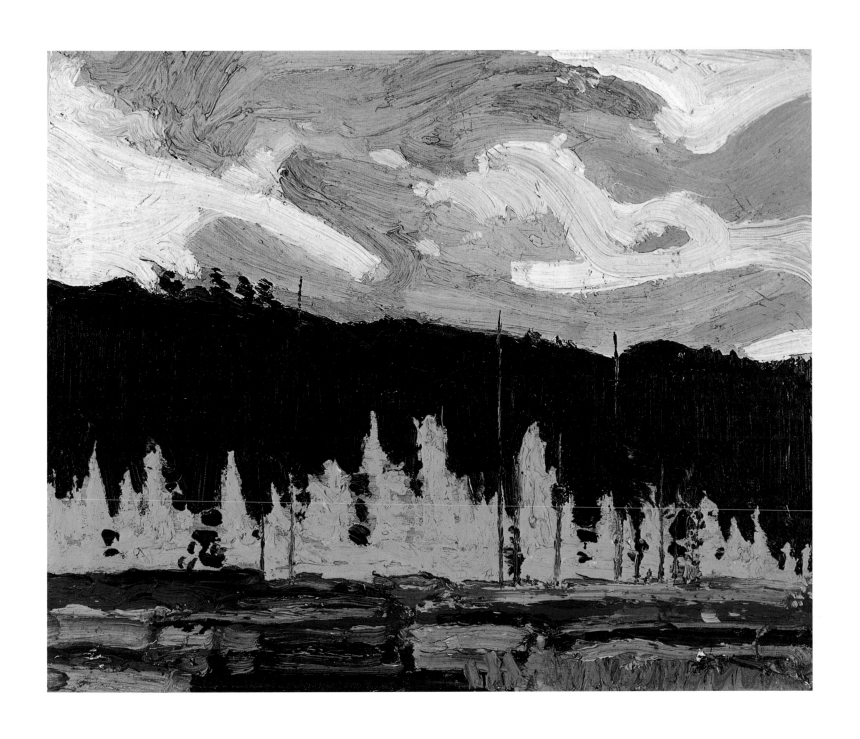

Tom Thomson *Tamarack* 1916

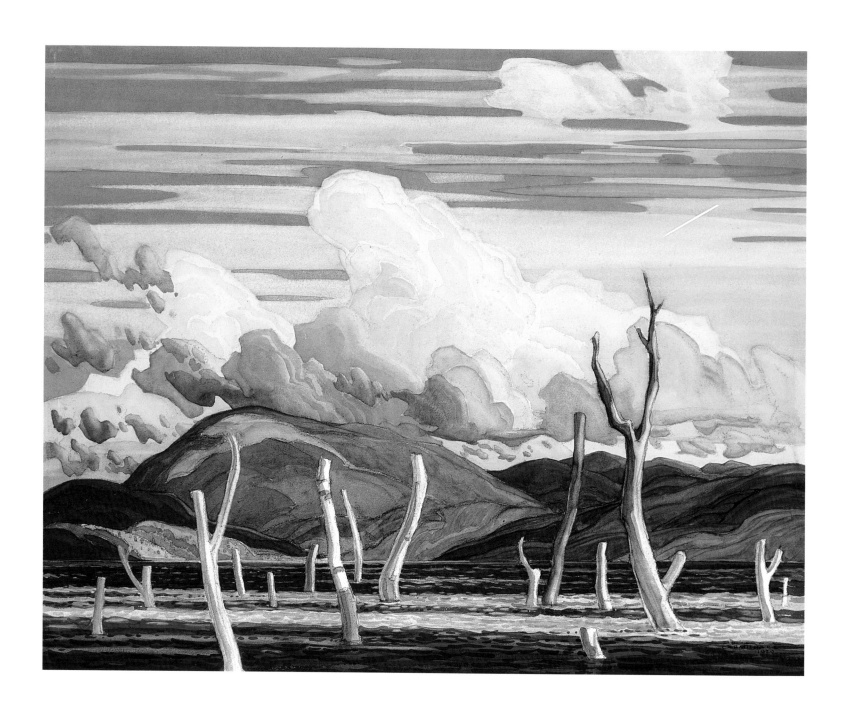

Frank Carmichael *Wabajisik: Drowned Land* 1929

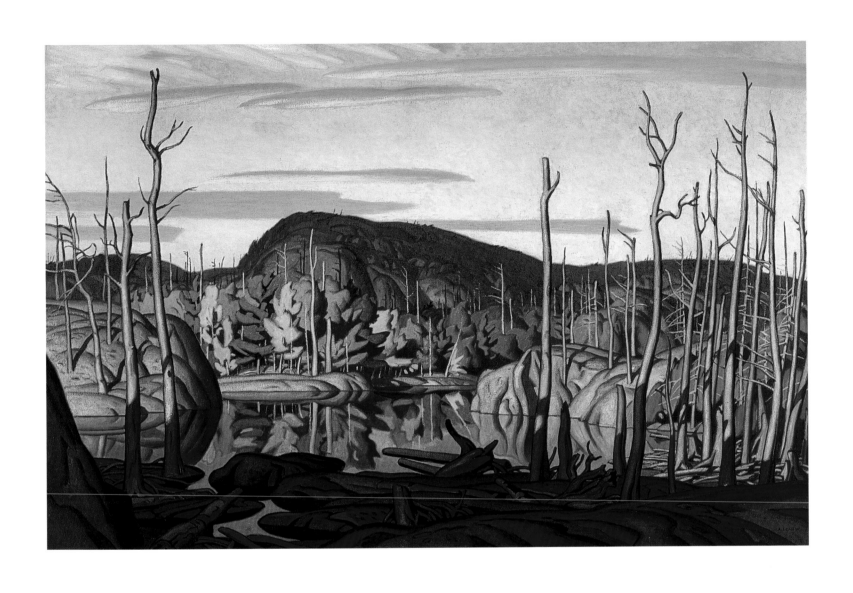

A.J. Casson *Autumn Evening* (originally titled *October Evening*
and also known as *Golden October*) 1935

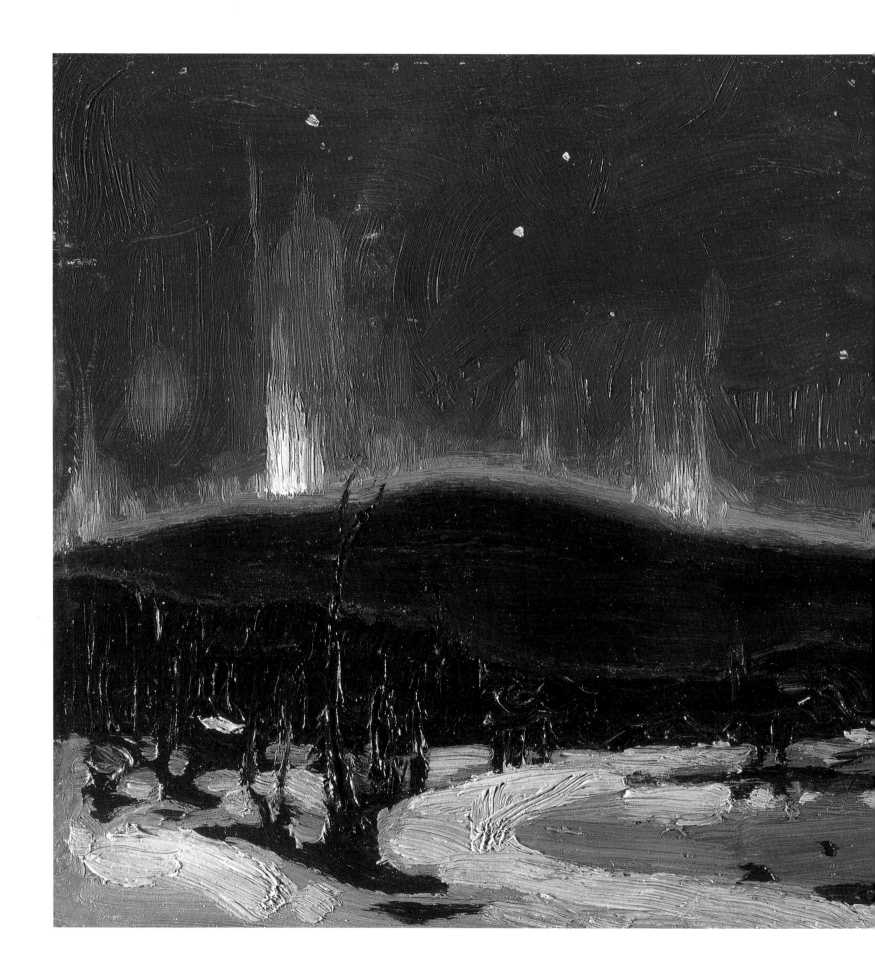

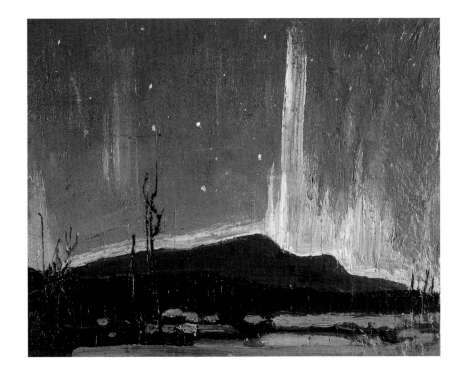

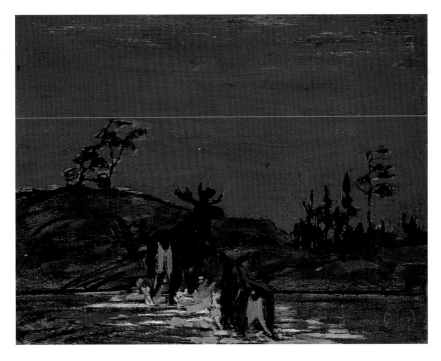

(left) Tom Thomson *Northern Lights* c. 1916

(upper) Tom Thomson *Northern Lights* 1916

(lower) Tom Thomson *Moose at Night* 1916

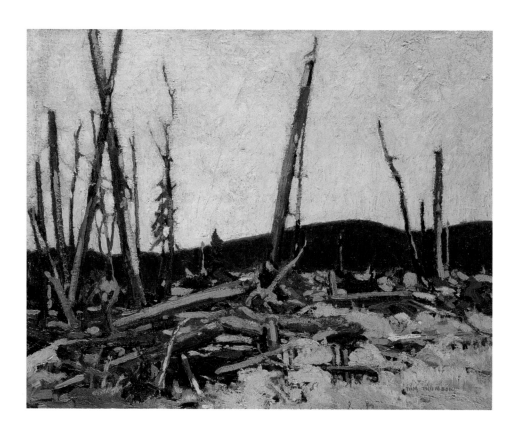

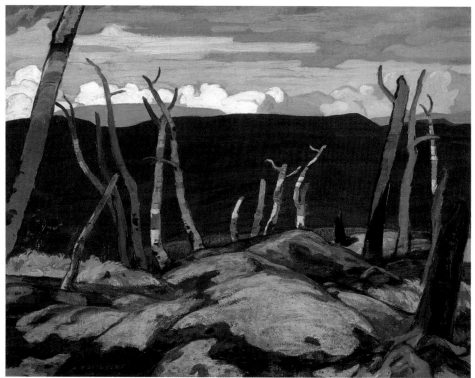

Tom Thomson *Burnt Land* c. 1915

A.Y. Jackson *November* 1922

286

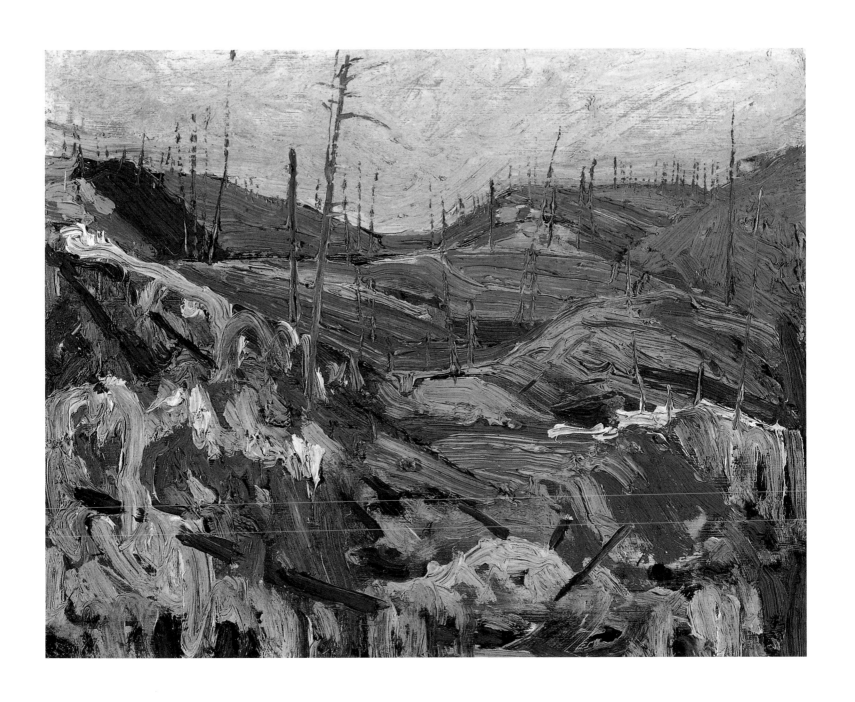

Tom Thomson *Fire-swept Hills* 1915

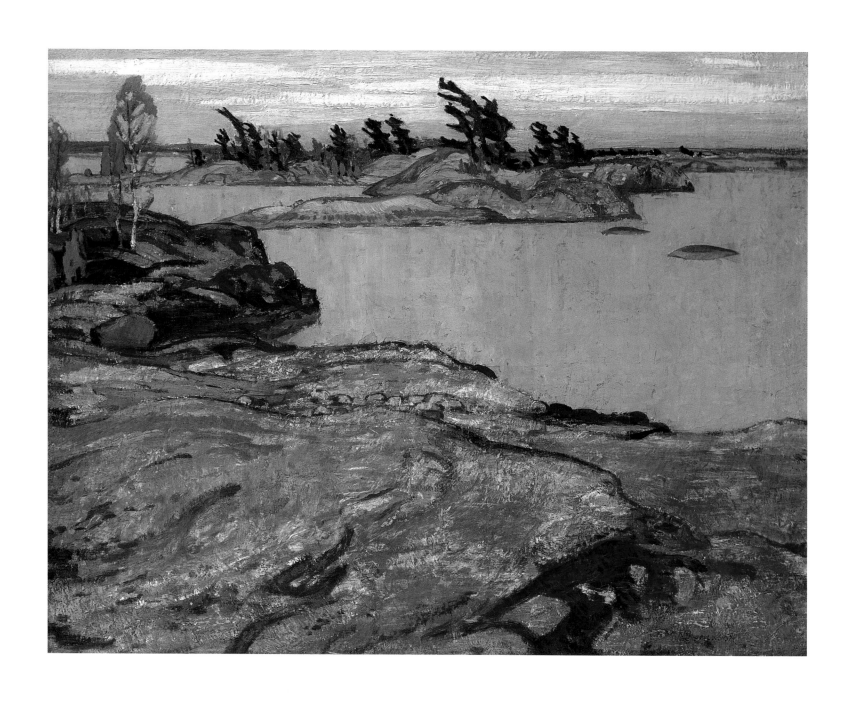

A.Y. Jackson *Georgian Bay, November* c. 1921

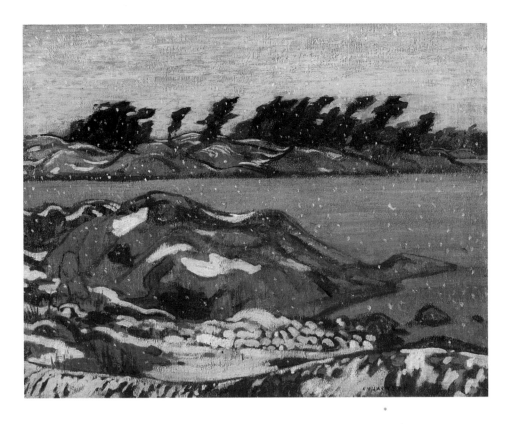

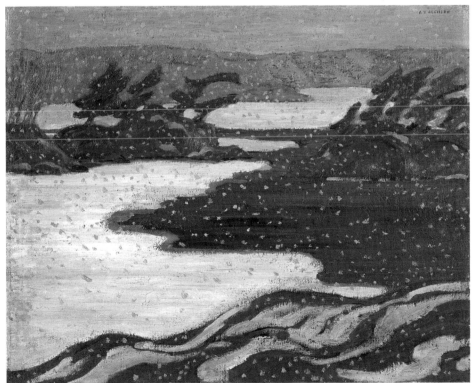

A.Y. Jackson *First Snow, Georgian Bay* c. 1920

A.Y. Jackson *Freddy Channel* c. 1930

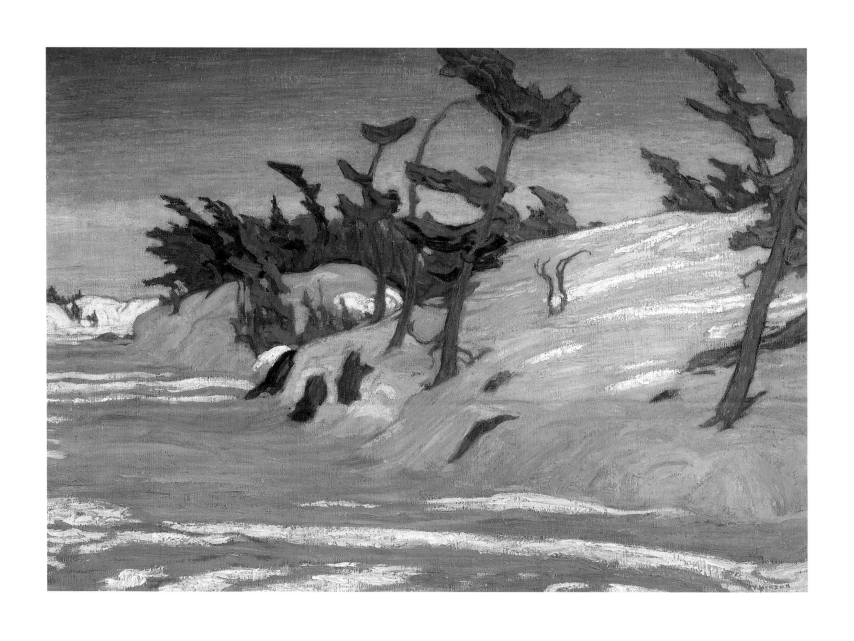

A.Y. Jackson *Winter, Georgian Bay* c. 1914

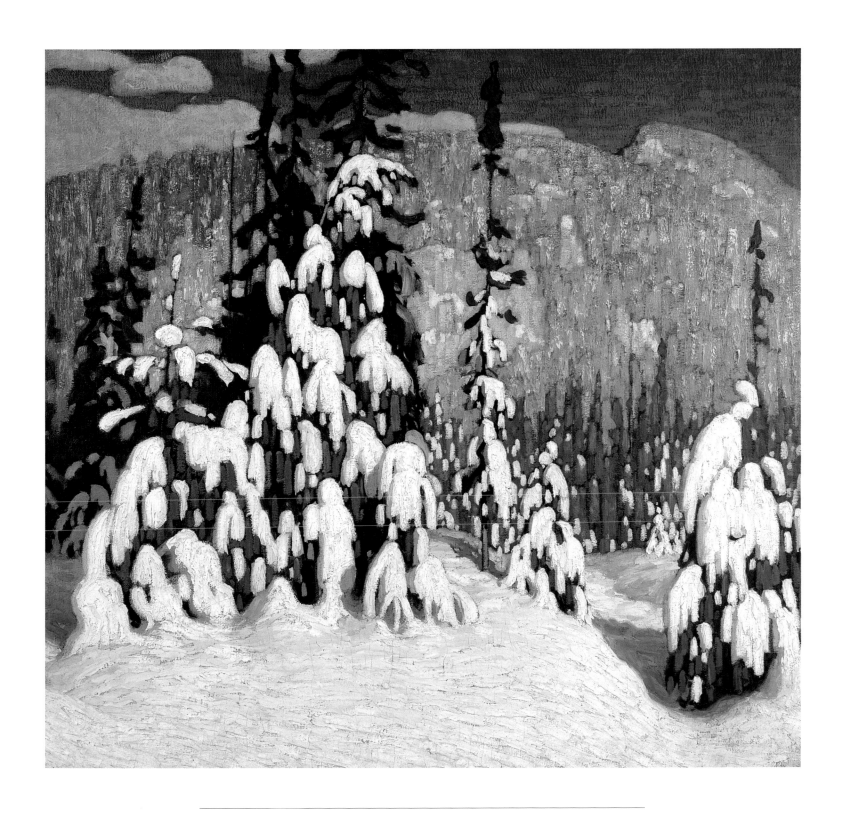

Lawren Harris *Winter Landscape* c. 1916

Lawren Harris *Winter in the Northern Woods* c. 1915

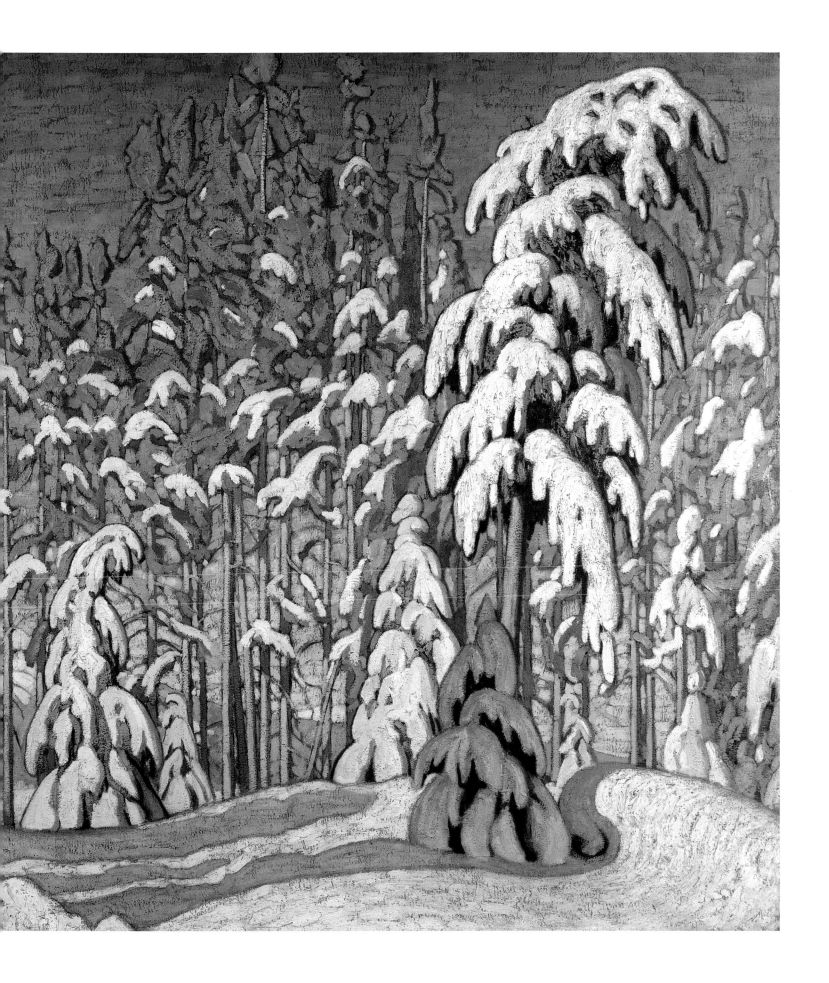

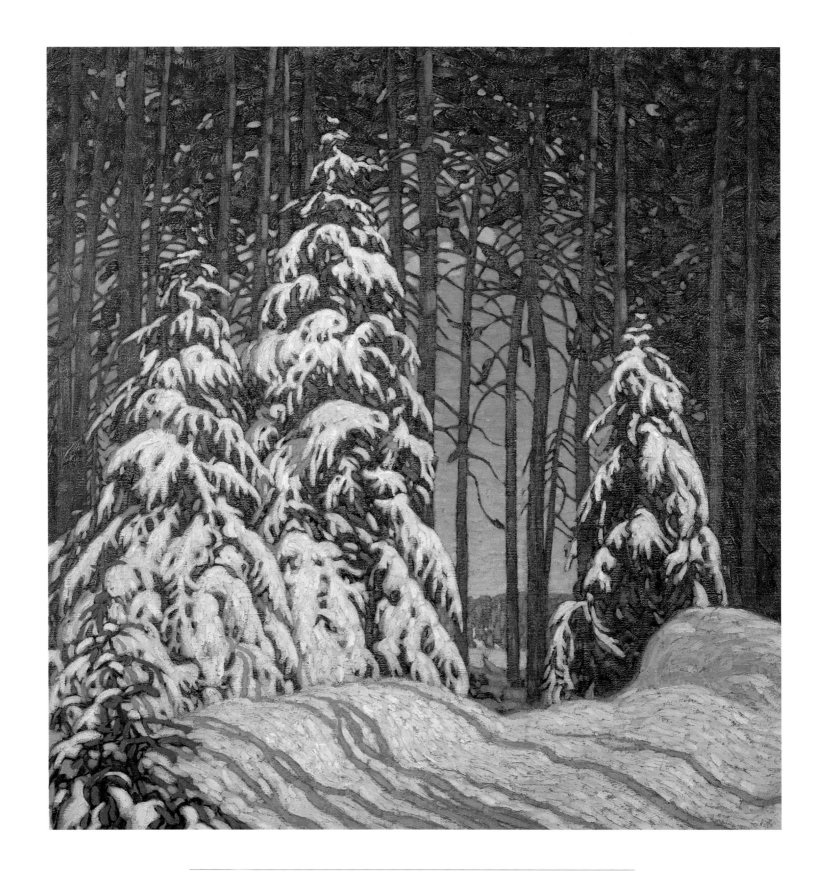

Lawren Harris *Winter Sunrise* 1918

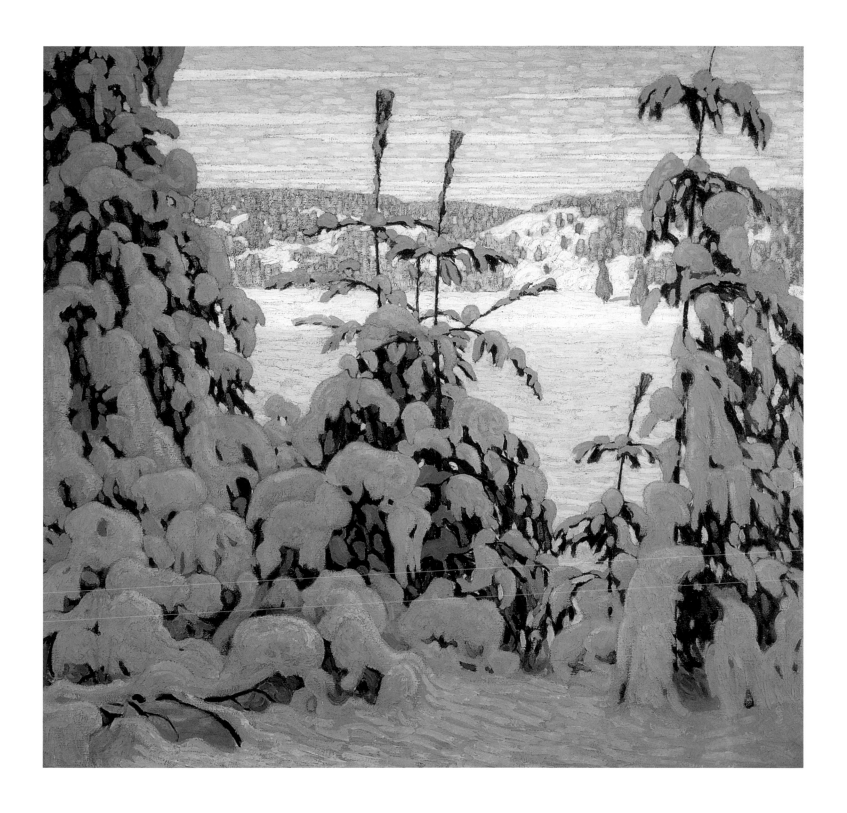

Lawren Harris *Snow II* 1915

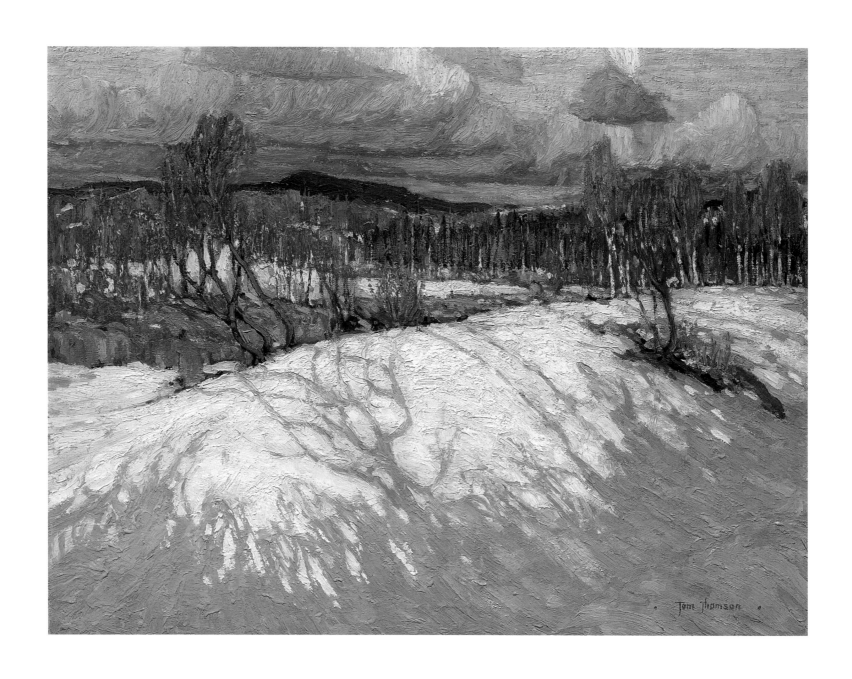

Tom Thomson *In Algonquin Park* 1914

ALGOMA AND LAKE SUPERIOR

LAWREN HARRIS'S first trip to Algoma was in May 1918. He had just been discharged from the army on medical grounds – a breakdown following the death of his brother, Howard, on the battlefields of France, and compounded, perhaps, by his antipathy to war and the military. He travelled with Dr James MacCallum and meant to explore the area around Sault Ste Marie by car, but finding the geography not to his liking they boarded the Algoma Central Railway and went farther north.

Algonquin Park had never been a favourite painting place for Harris, although he had painted there from time to time (his family's cottage was on Canoe Lake), and it had lost most of its magic with Tom Thomson's death. Georgian Bay and Lake Simcoe had been more congenial for him, but he was looking for something more dramatic, more austere, and wilder than the flat granite of MacCallum's Go Home Bay. He found it along the eastern shore of Lake Superior, near the mouths of the Montreal, Agawa, and Batchawana rivers and along the Agawa Canyon. Here, the scale of the terrain was completely different from that of Algonquin Park or Georgian Bay. Some vistas were open to the horizon, the Precambrian shield showed another kind of face, and the raw virginity of the place was palpable. This locale was to give each of the soon-to-be members of the Group (except F.H. Varley, who never painted there) a tremendous new impetus after the travails and sorrows of the First World War.

The area was so appealing to Harris's sensibility that he returned that fall, 1918, with J.E.H. MacDonald and Frank Johnston in tow, and with MacCallum once again tagging along. The region was not a settled or a resort area, and going there meant camping out. Harris, in an inspired moment, rented a railway boxcar and had it fitted up as a rolling boarding-house, complete with bunks and a stove, which the railway obligingly shunted along from siding to siding whenever a new location was required. The outing was so successful that a year later, in September 1919, they all set off again. It was Johnston's last official outing with his colleagues, apart from the first Group of Seven show itself. This time A.Y. Jackson joined them. 'In addition to a canoe,' Jackson recalled in his autobiography, 'we had a three-wheel jigger, worked by hand, to go up and down the tracks.' He went on:

The nights were frosty, but in the box car, with the fire in the stove, we were snug and
warm. Discussions and arguments would last until late in the night, ranging from Plato to
Picasso, to Madame Blavatsky and Mary Baker Eddy. Harris, a Baptist who later became
a theosophist, and MacDonald, a Presbyterian who was interested in Christian Science,
inspired many of the arguments. Outside the aurora played antics in the sky, and the
murmur of the rapids or a distant waterfall blended with the silence of the night. Every
few days we would have our box car moved to another siding.

A year later, in 1920, Harris, MacDonald, and Jackson returned twice (spring and fall), the first time with Arthur Lismer. In 1921 they pushed on farther north and west, along the brutal and beautiful coast of Lake Superior between Marathon and Rossport, where Pic Island stands dramatically offshore. Here Harris found an even more inspiring piece of geography, with vast panoramas, steep hills plunging into the lake, and boundless skies with their eastward-marching clouds. This northern coast became the new prime painting territory, and Harris returned yearly to Lake Superior until 1927: with Jackson in 1922; with Lismer in 1923; with Frank Carmichael in 1924; with Jackson, Carmichael, and A.J. Casson in 1925; and in the two following years with Carmichael and Lismer, respectively. Harris painted there annually for almost a decade.

On their arrival in Algoma, Jackson described the scene to his cousin Florence Clement (quoted in Charles C. Hill, *The Group of Seven*, p. 80): 'From a hill nearby one can look over miles of primeval forest, not a clearing in any direction. Here and there is a beaver meadow, but rough stuff.' Harris wrote excitedly about their activities in this region in *The Story of the Group of Seven*, for this was one of the few times that so many of the Group (four), actually painted together:

We worked from early morning until dark in sun, grey weather or in rain. In the evening
by lamp or candlelight each showed the others his sketches. This was a time for criticism,
encouragement, and discussion, for accounts of our discoveries about painting, for our
thoughts about the character of the country, and our descriptions of effects in nature which
differed in each section of the country. We found, for instance, that there was a wild rich-
ness and clarity of colour in the Algoma woods which made the colour in southern Ontario
seem grey and subdued. We found that there were cloud formations and rhythms peculiar
to different parts of the country and to different seasons of the year. We found that, at

times, there were skies over the great Lake Superior which, in their singing expansiveness
and sublimity, existed nowhere else in Canada.

The intense interaction of exploring new subjects, of trying new ways to paint, of competing day after day in a spirit of great camaraderie – the constructive criticism, the sharp intellectual analysis, and the setting out to produce a 'national art' for Canada – made every trip an extraordinary one, both in terms of the effect on each member, and on the joint adventure. Their different treatments of the same subjects, and the strength each gleaned from the others, directly and immediately, made their productivity soar.

The clear, crisp spring and autumn air inspired something special in each painter. For Harris it was such works as *Algoma Hill* (p. 325), *Above Lake Superior* (p. 335), *Beaver Swamp, Algoma* (p. 329), and *North Shore, Lake Superior* (p. 303; members of the Group called the quintessential stump in this painting 'The Grand Trunk.' Harris found it out of sight of the lake itself). The sculptured cloud forms, the deep skies, the ethereal light, the sandpapered stumps and dead trees, the brooding forest around the beaver dam, and the still water of a lake framed between stylized pine branches, as in *Northern Lake* (p. 308) and *Northern Lake II* (p. 309), these all became signature elements in his paintings. For the first time, Harris discovered a direct connection between subject and vision, between painted object and spiritual meaning. He finally, in Northrop Frye's words (Introduction to *Lawren Harris*, edited by Bess Harris and R.G.P. Colgrove), found 'a point of identity between subject and object, a point at which the created world and the world that is really there become the same thing.'

The country was inspirational for all the painters who journeyed there, and its similarity to the La Cloche area to the east made it particularly a favourite of Carmichael, whose love of the La Cloche area lasted till his death. Even Jackson, with his profound affection for the picturesque villages of Quebec, was nearly overwhelmed by it. He wrote in his autobiography:

> *I know of no more impressive scenery in Canada for the landscape painter. There is a sublime order to it, the long curves of the beaches, the sweeping ranges of hills, and headlands that push out into the lake. Inland there are intimate little lakes, stretches of muskeg, outcrops of rock; there is little soil for agriculture. In the autumn the whole country flows with colour: the huckleberry and the pinchberry turn crimson, the mountain ash is loaded with red berries, the poplar and the birch turn yellow and the tamarac greenish gold.*

For MacDonald, too, the torrent of colours, the vertiginous spaces, and the aggressive power of the land's massive shapes and grand vistas provided the ideas for the echoing silences of *The Solemn Land* (p. 321) and *October Shower Gleam* (p. 58). The cantilevered angle at which he painted the cataracts on the Montreal River in *The Wild River* (p. 318) and the odd but powerful conundrum of *Mist Fantasy, Northland* (p. 341) were peak achievements for him as he was approaching his fiftieth year. The scale of the land is cleverly emphasized by MacDonald's inclusion of a man portaging a canoe in *The Wild River*.

Lismer's *Isles of Spruce* (p. 61), *October on the North Shore, Lake Superior* (p. 322), and *Untitled (Sombre Isle of Pic, Lake Superior)* (p. 314) showed him to be as accomplished and original as any of his colleagues. These powerful paintings, especially the *Isles of Spruce*, which has been reproduced so often, demonstrate the way Lismer and his companions were able to adapt the examples of foreign schools to an original way of expressing the Canadian light and landscape. Jackson was also at full power in such works as *October Morning, Algoma* (p. 327, first called *Wartz Lake*), and *First Snow, Algoma* (p. 343). Johnston's *Fire-swept Algoma* (p. 72), *Where the Eagles Soar* (p. 305), and *The Fire Ranger* (p. 274) are among his most compelling works; he later pursued a less original path, painting easier pictures and attracting more buyers. Carmichael painted works as varied as *Snow Clouds* (p. 328), *North Shore, Lake Superior* (p. 332), and *Jackfish Village* (p. 261), and his side-kick, Casson, turned in a few of his best works, such as *October* (p. 322), and *Approaching Storm, Lake Superior* (p. 340).

■

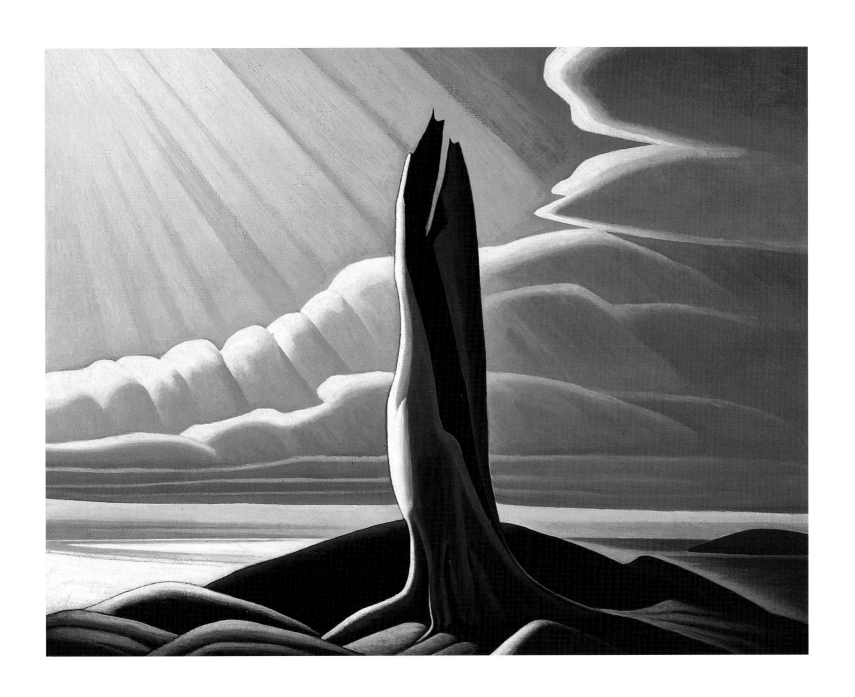

Lawren Harris *North Shore, Lake Superior* 1926

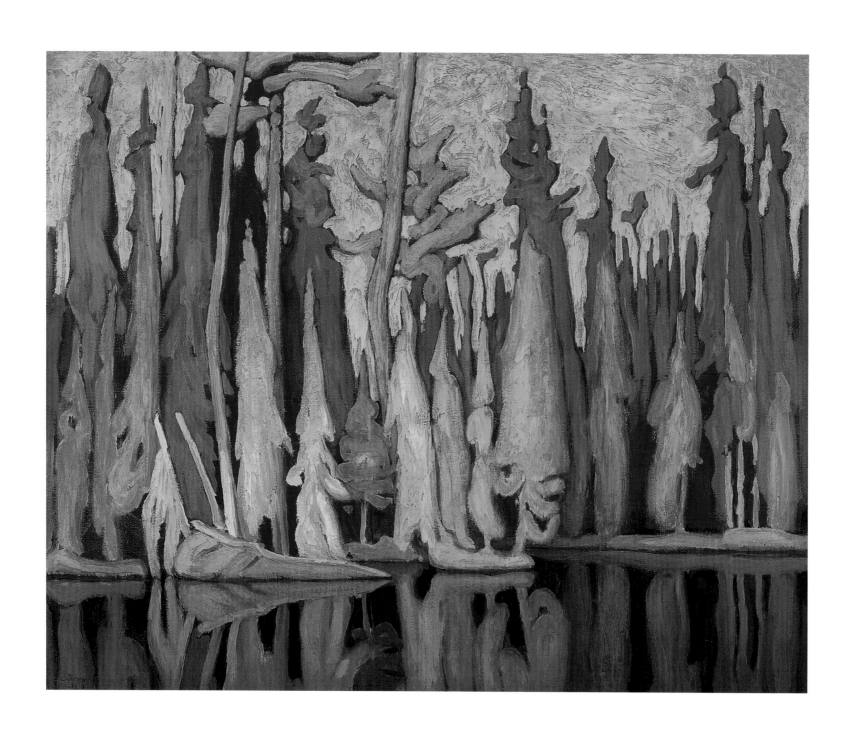

Lawren Harris *Northern Autumn* 1922

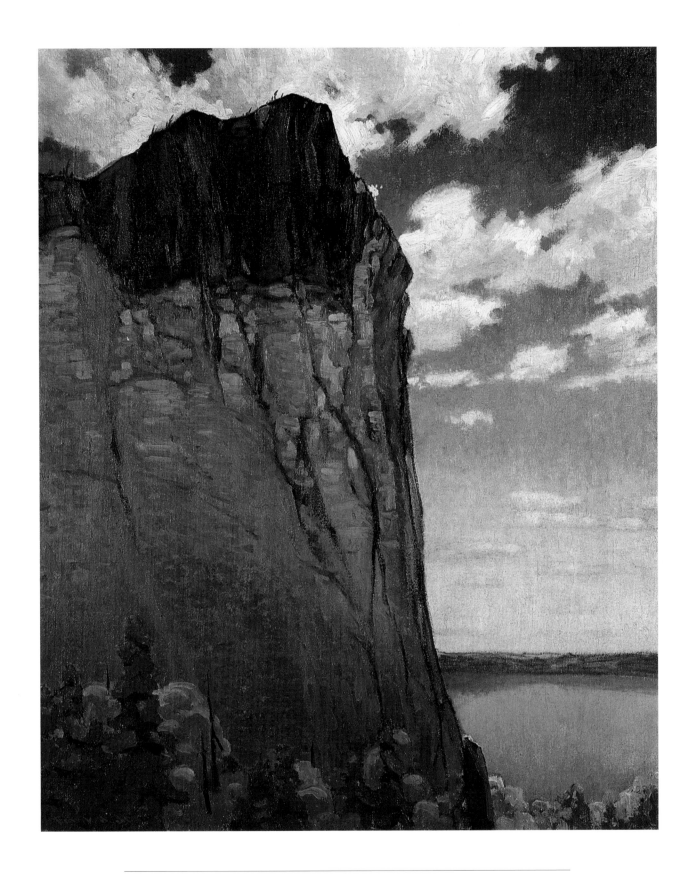

Frank Johnston *Where the Eagles Soar* c. 1920

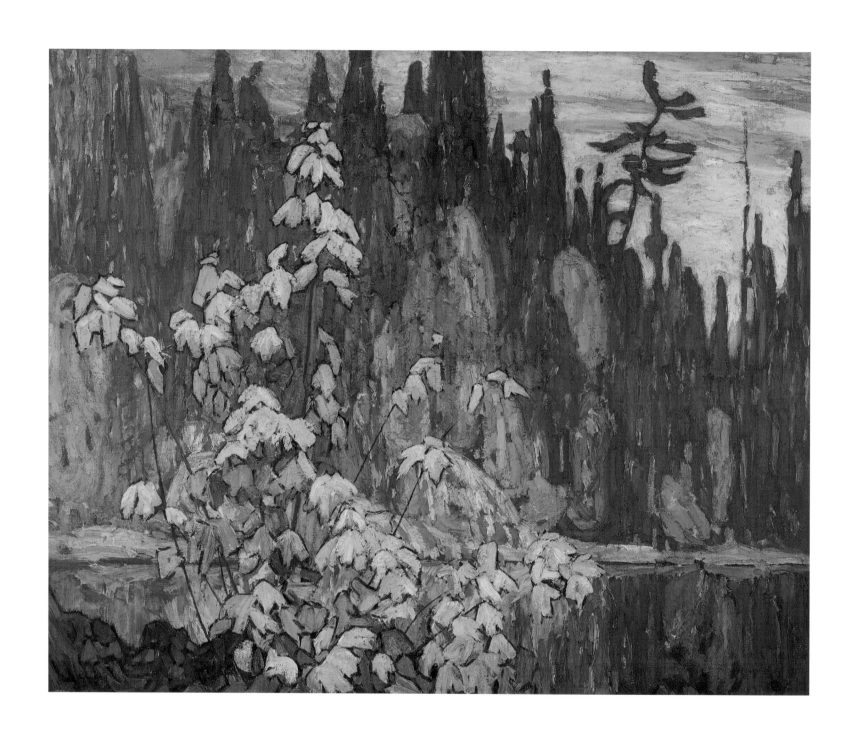

Lawren Harris *Autumn, Algoma* 1920

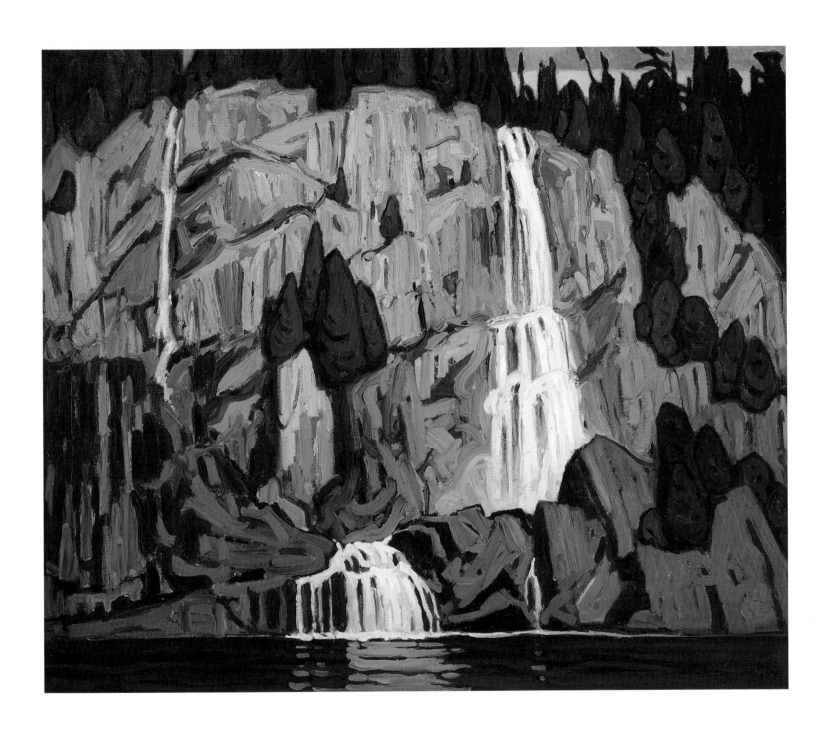

Lawren Harris *Waterfall, Algoma* 1918

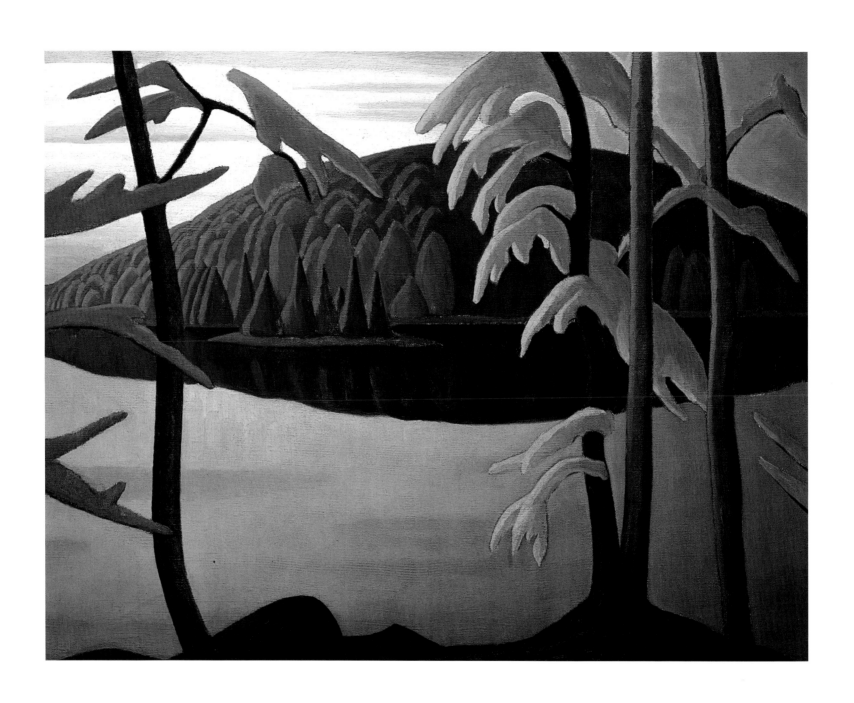

Lawren Harris *Northern Lake* c. 1923

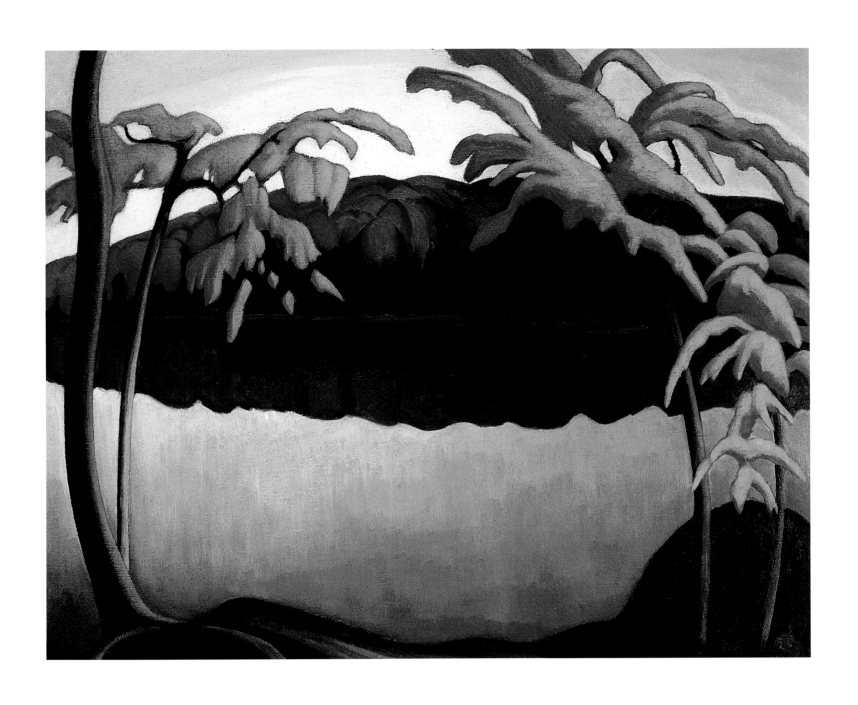

Lawren Harris *Northern Lake II* c. 1926

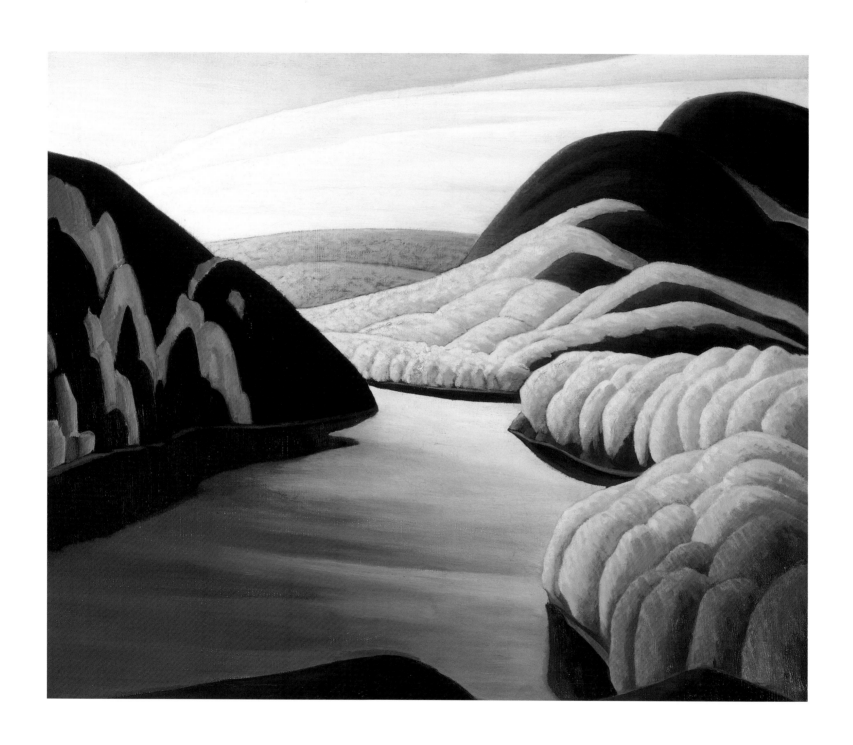

Lawren Harris *Quiet Lake (Northern Painting 12)* c. 1923

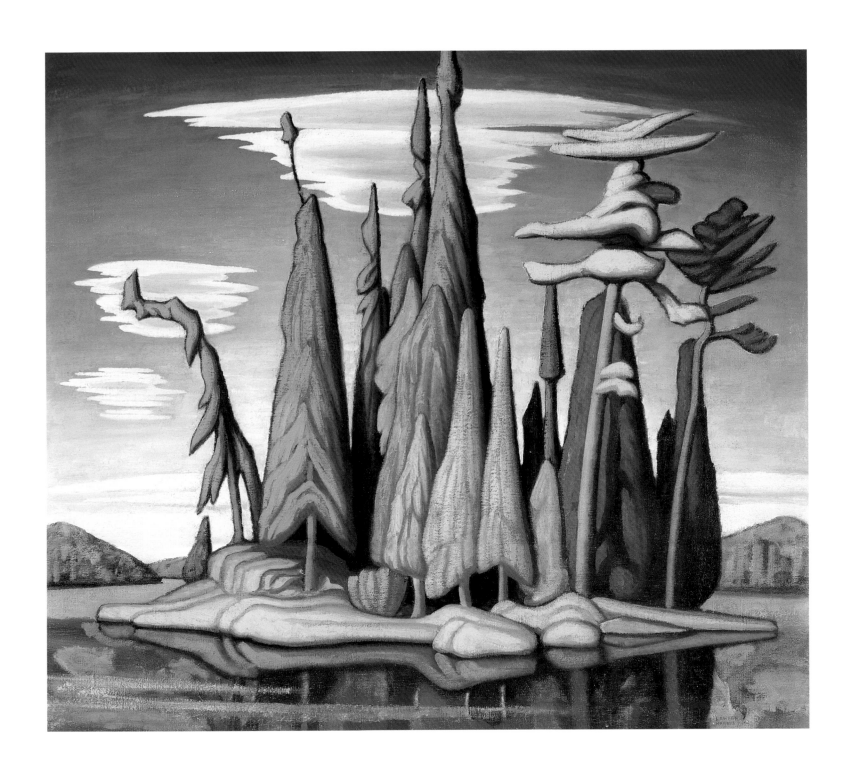

Lawren Harris *Northern Painting 25* 1924

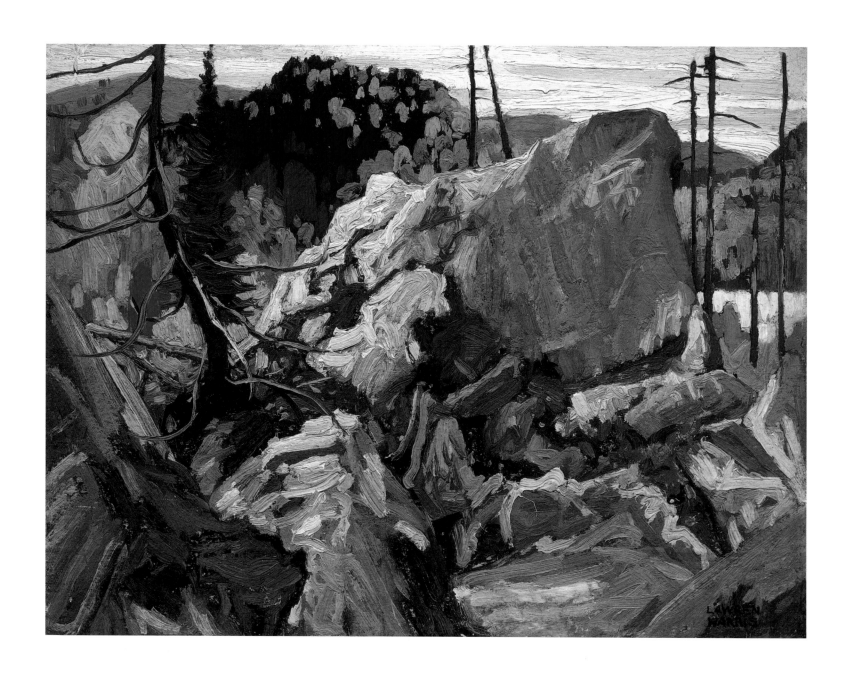

Lawren Harris *Autumn, Batchewana* 1918

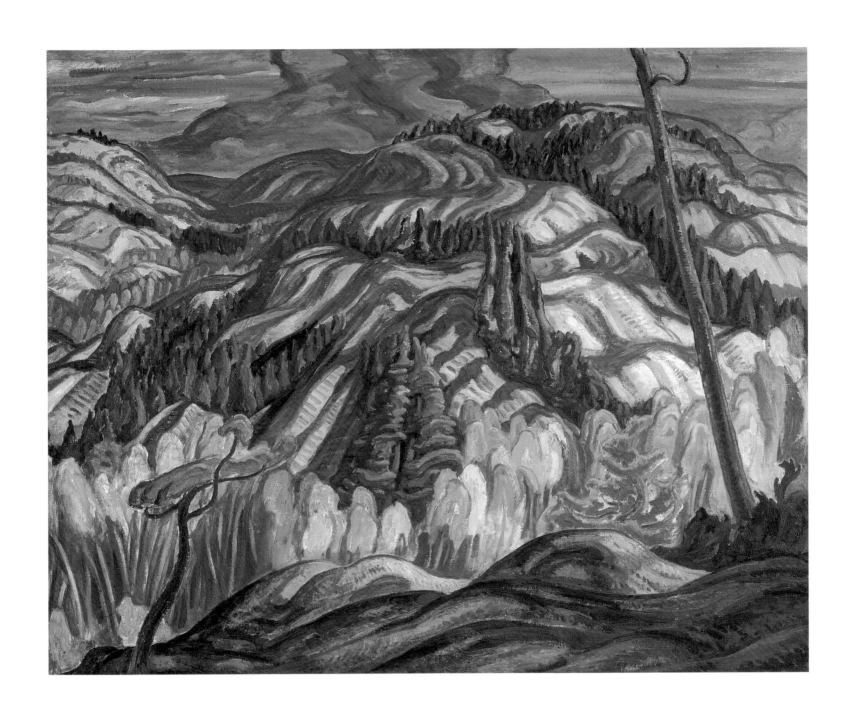

A.Y. Jackson *Northern Landscape* n.d.

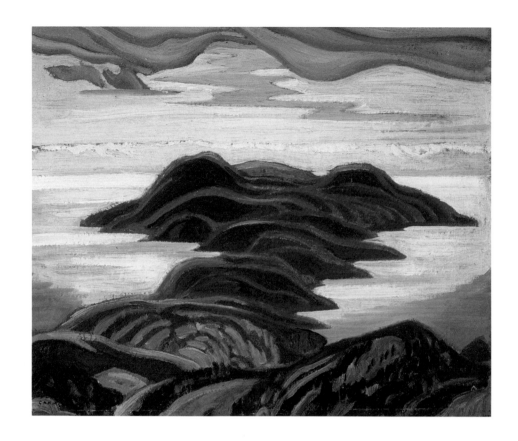

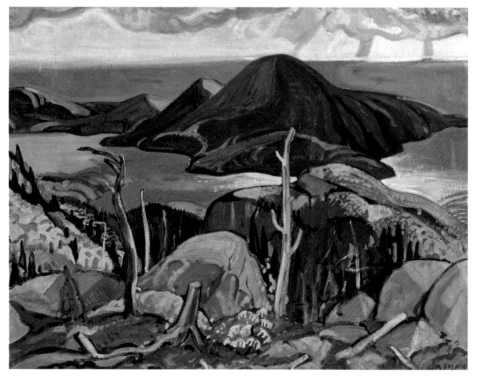

Frank Carmichael *Lake Superior* 1929
Arthur Lismer *Untitled (Sombre Isle of Pic, Lake Superior)* 1927

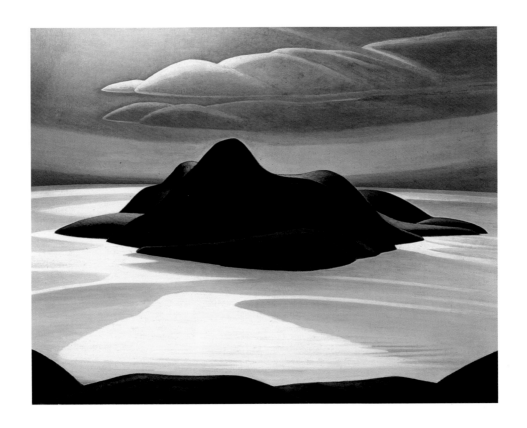

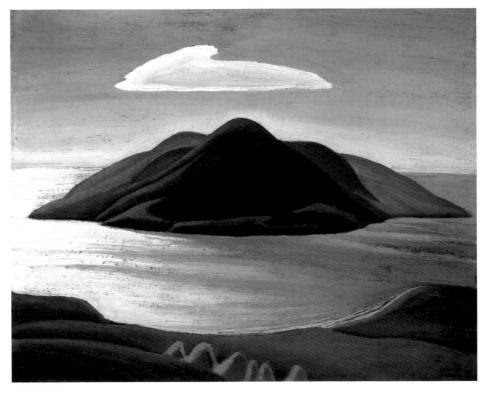

Lawren Harris *Pic Island* c. 1924

Lawren Harris *Pic Island* c. 1923

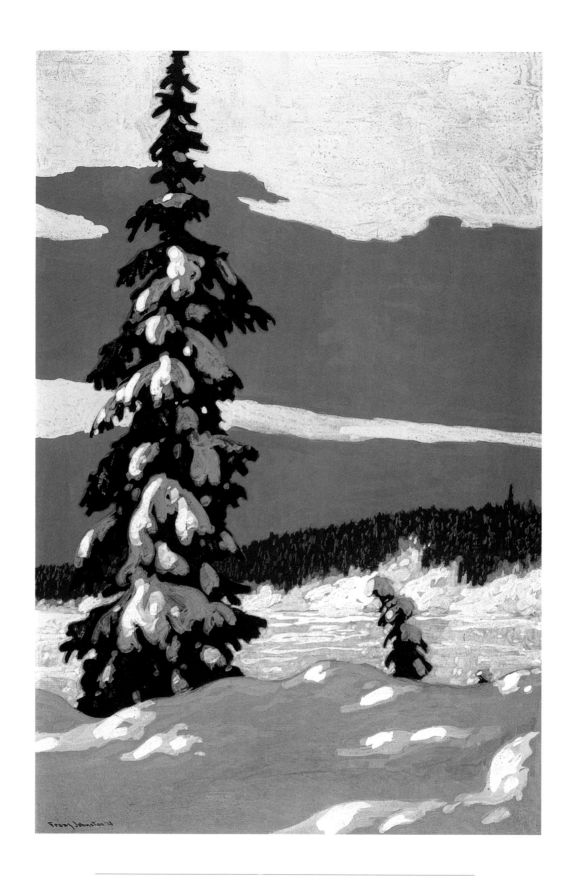

Frank Johnston *Early Evening, Winter* 1928

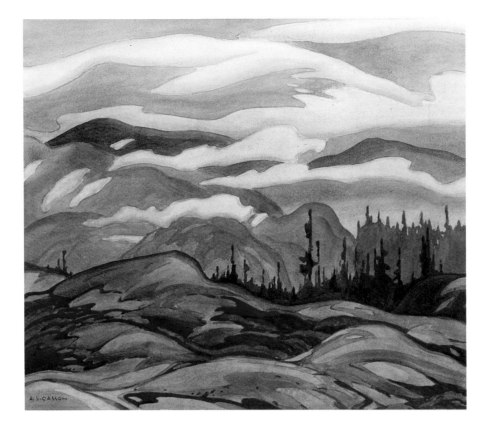

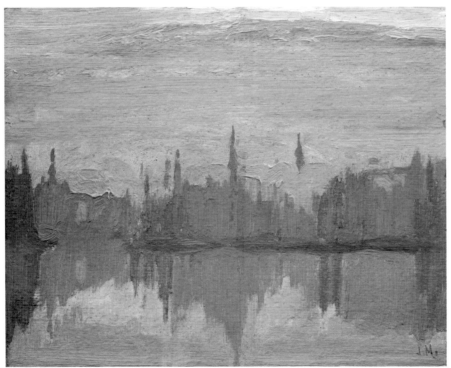

A.J. Casson *Fog Lifting* c. 1929

J.E.H. MacDonald *Misty Morning, Algoma* 1921

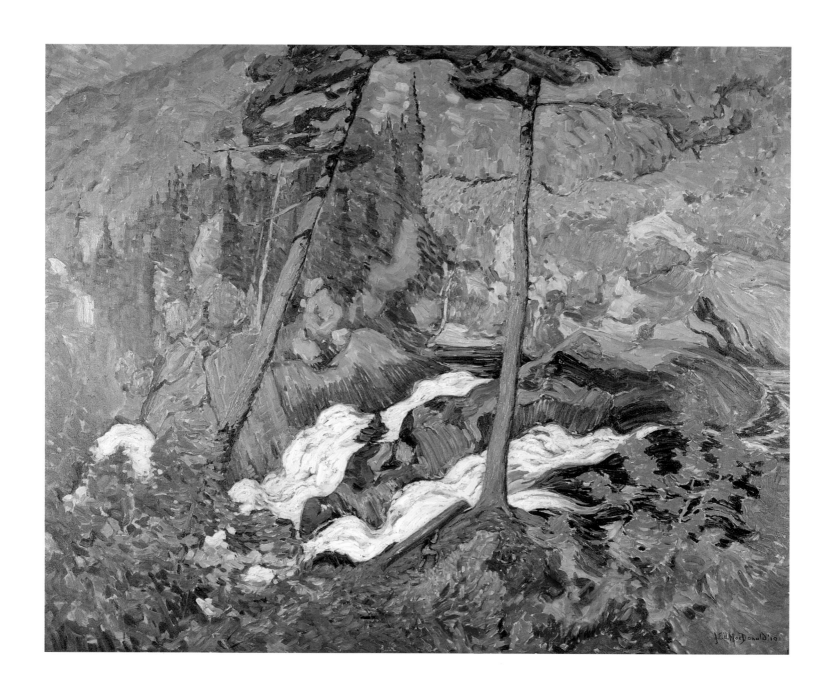

J.E.H. MacDonald *The Wild River* 1919

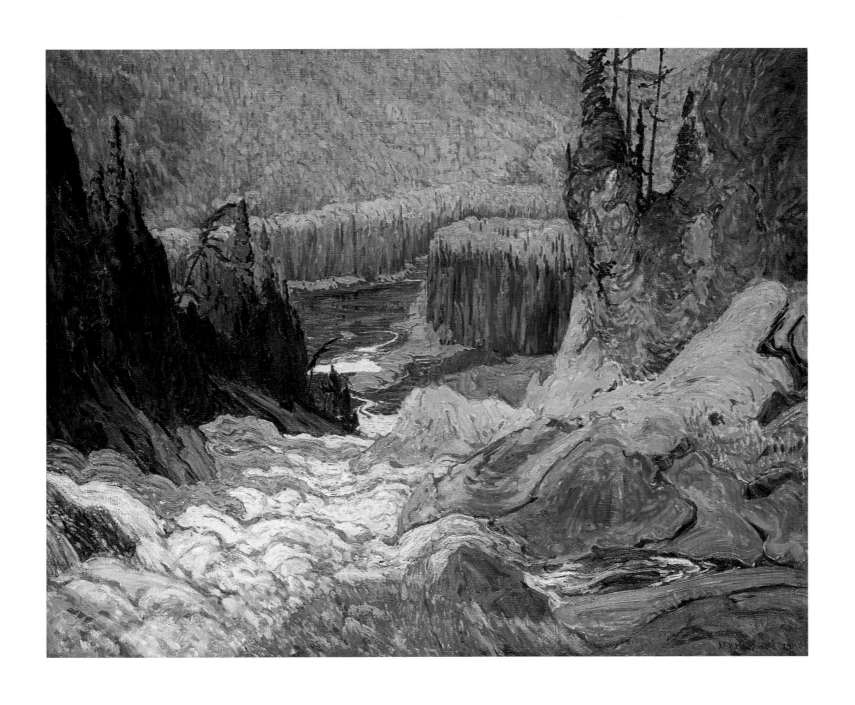

J.E.H. MacDonald *Falls, Montreal River* 1920

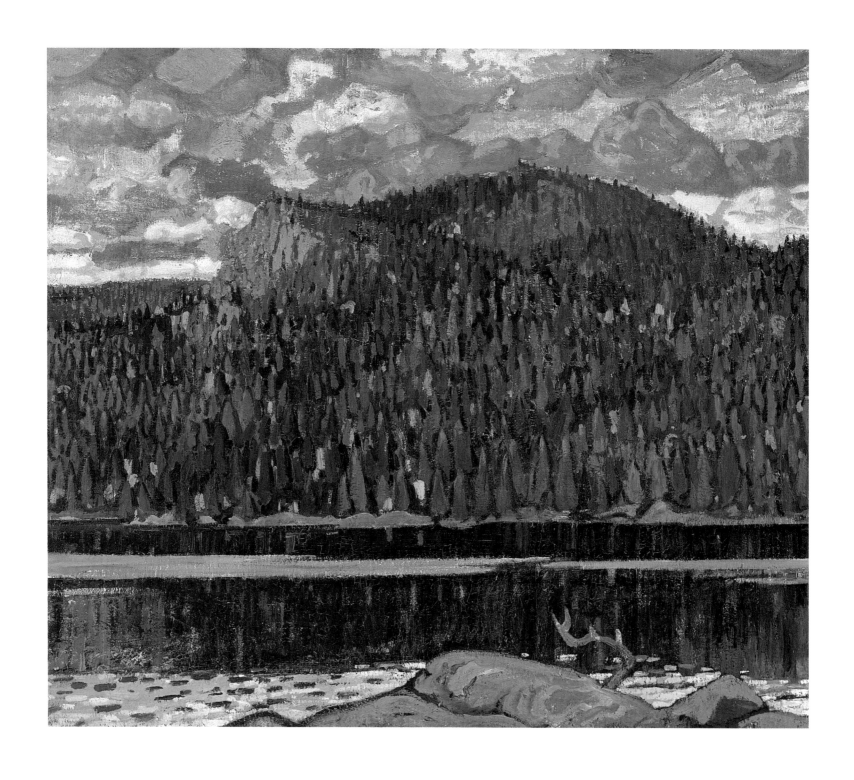

Arthur Lismer *Sombre Hill, Algoma* 1922

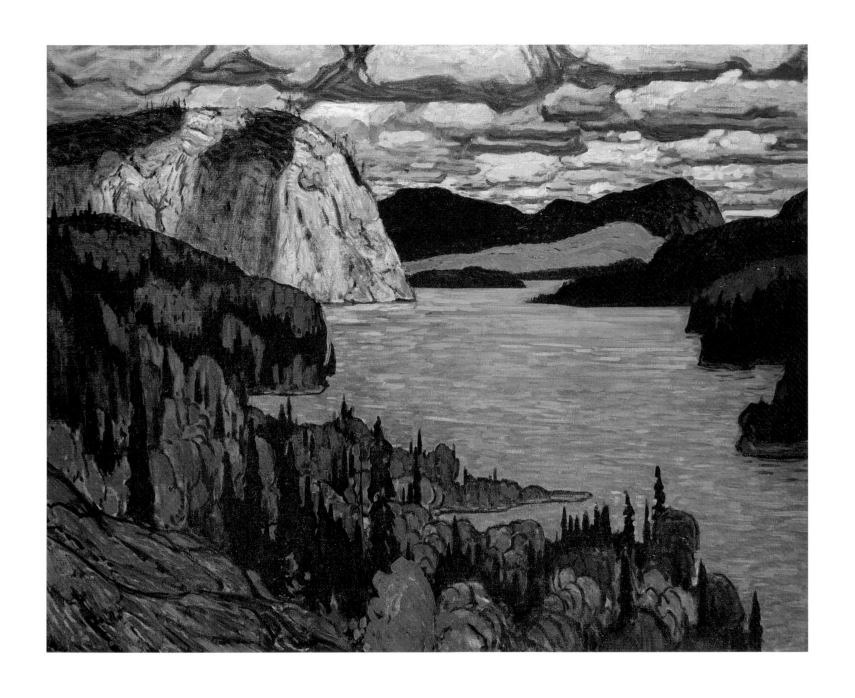

J.E.H. MacDonald *The Solemn Land* 1921

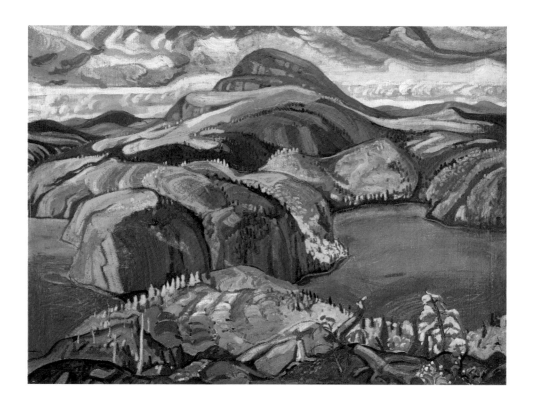

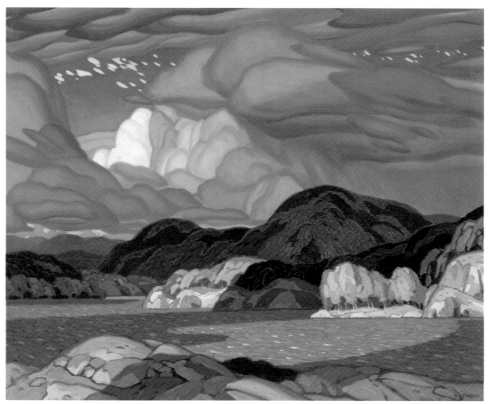

Arthur Lismer *October on the North Shore, Lake Superior* 1927

A.J. Casson *October* 1928

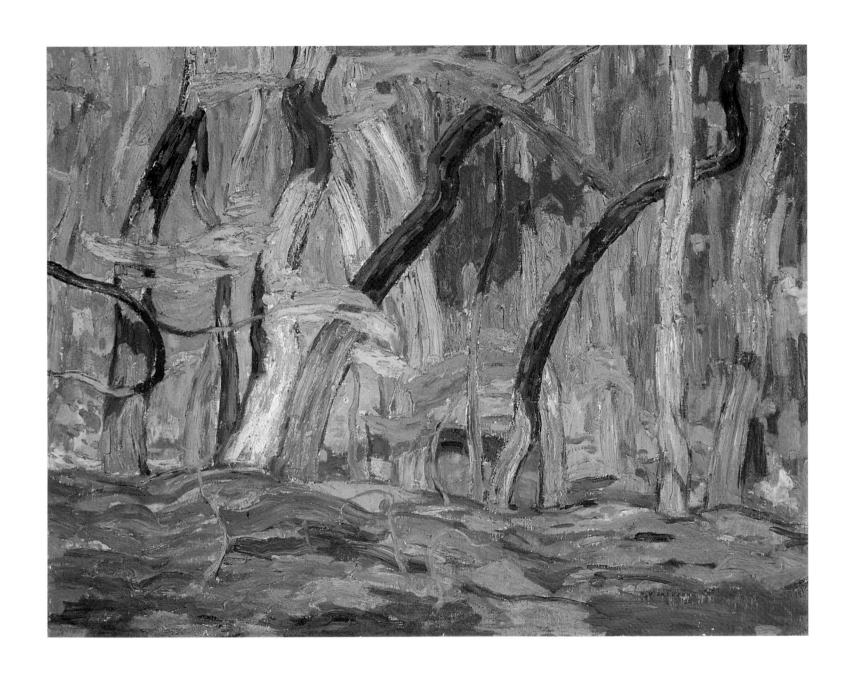

A.Y. Jackson *Maple Woods, Algoma* 1920

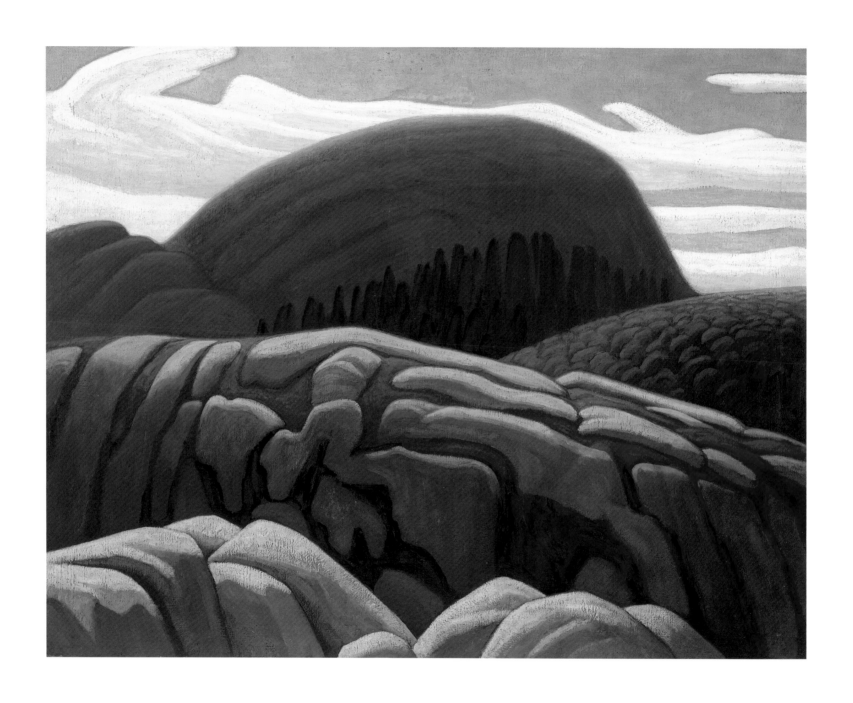

Lawren Harris *Lake Superior Hill* 1925

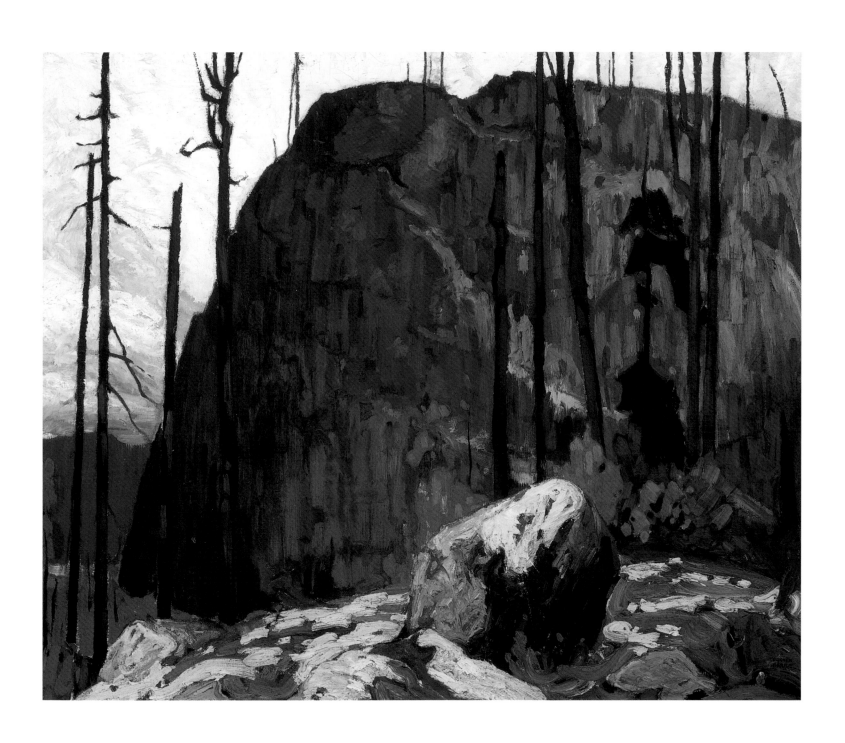

Lawren Harris *Algoma Hill* 1920

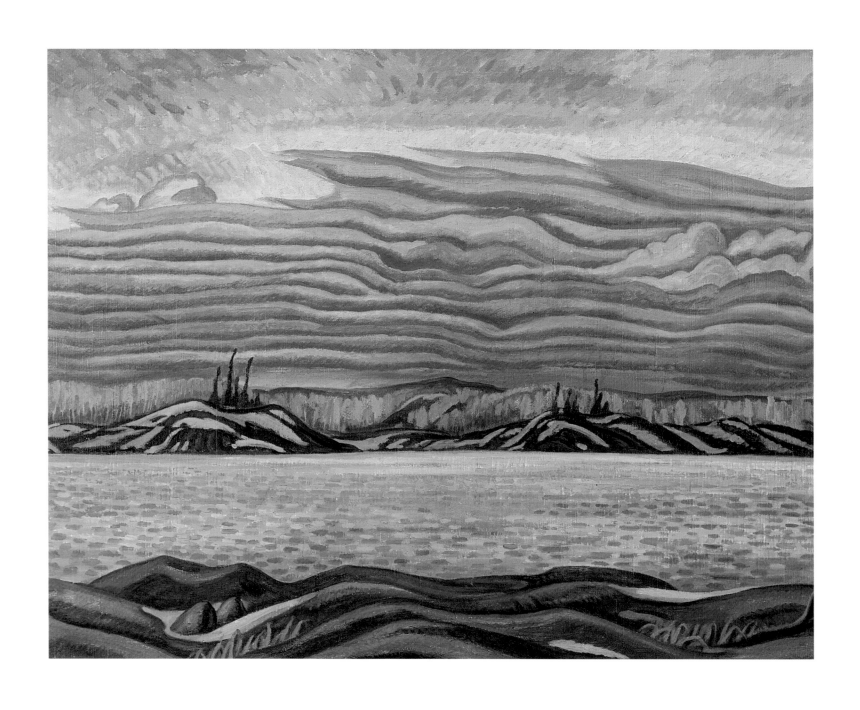

A.Y. Jackson *Algoma, November* 1934

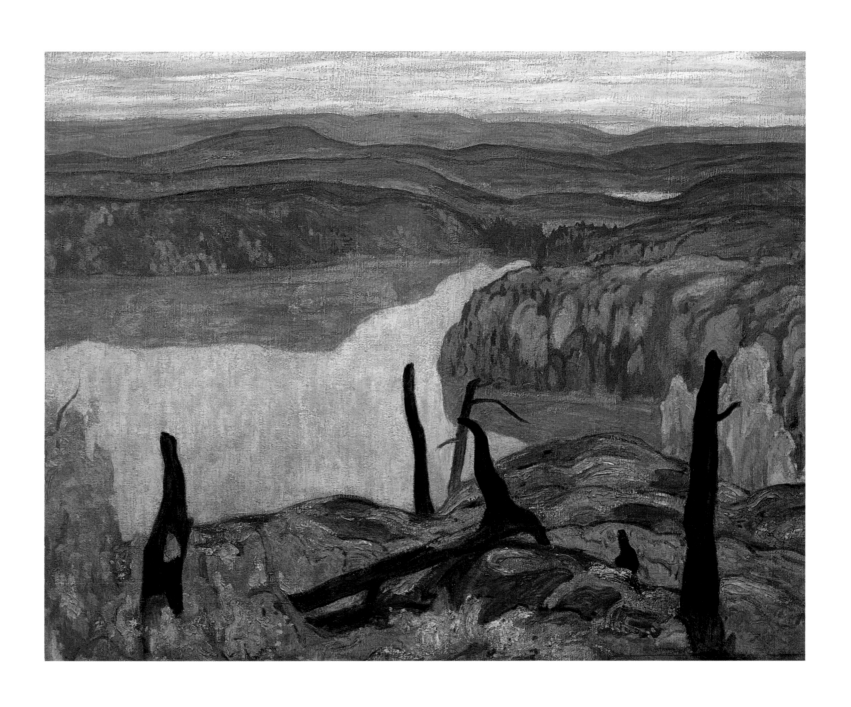

A.Y. Jackson *October Morning, Algoma* 1920

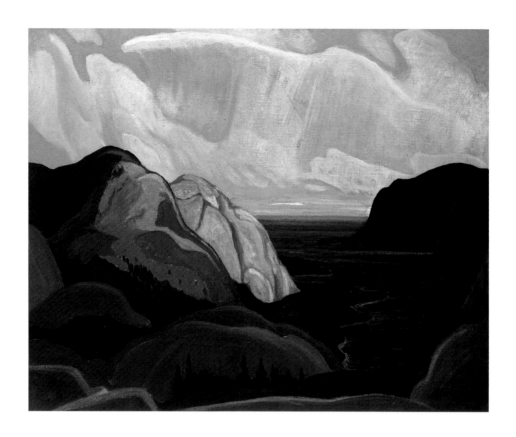

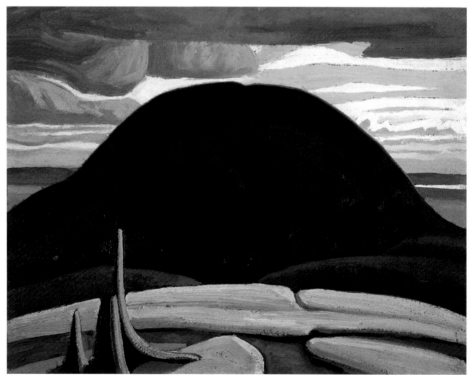

Frank Carmichael *Snow Clouds* 1926

Lawren Harris *Untitled (North Shore, Lake Superior)* c. 1922

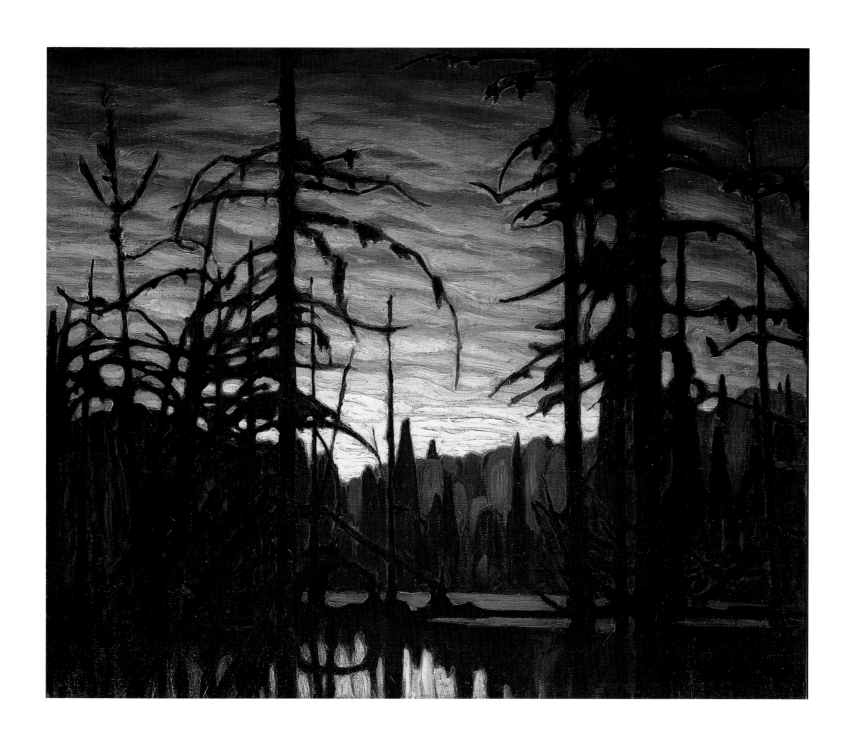

Lawren Harris *Beaver Swamp, Algoma* 1920

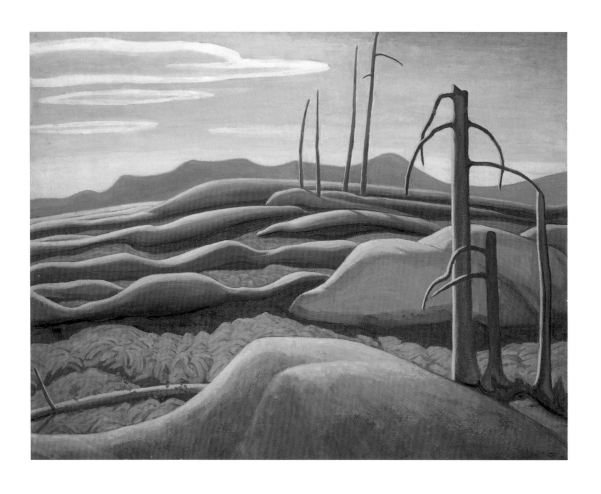

Lawren Harris *Lake Superior Painting 9* 1923
Lawren Harris *First Snow, North Shore of Lake Superior* 1923

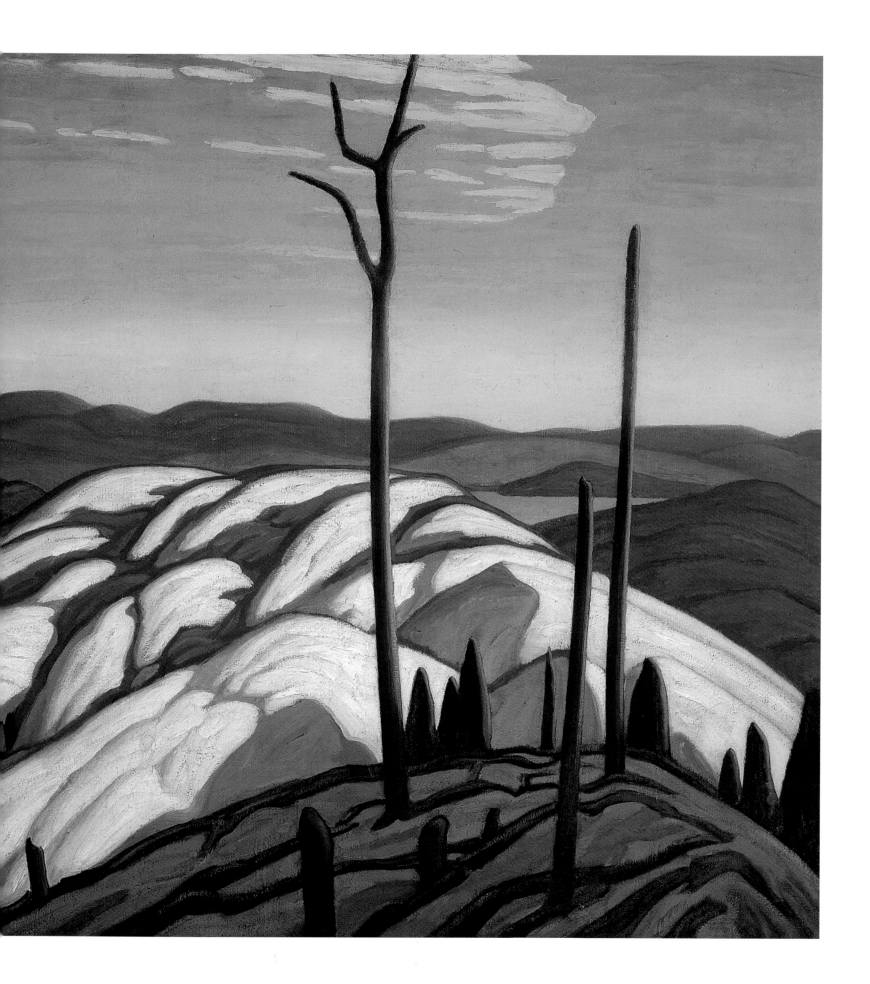

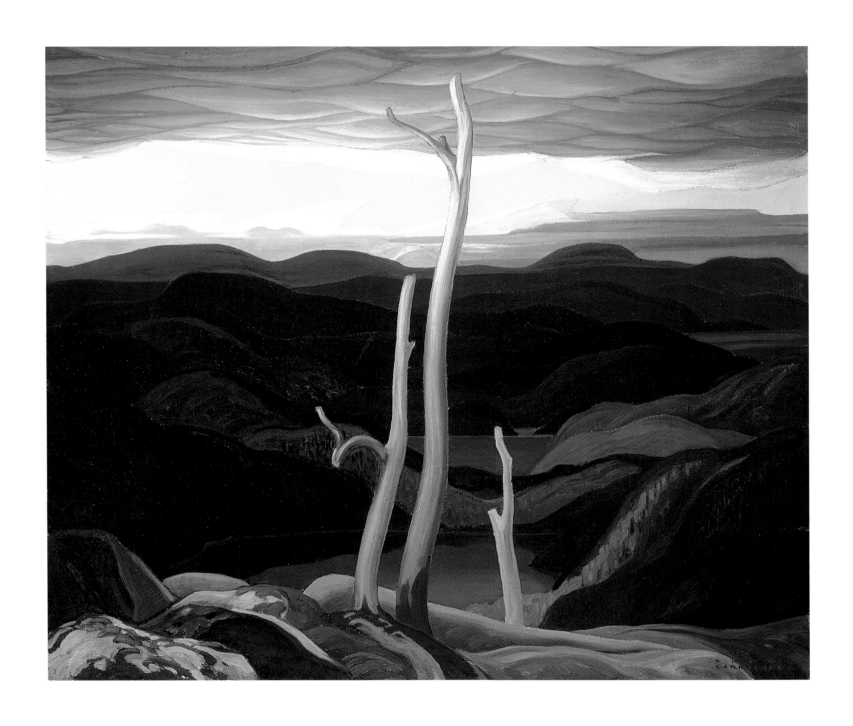

Frank Carmichael *North Shore, Lake Superior* 1927

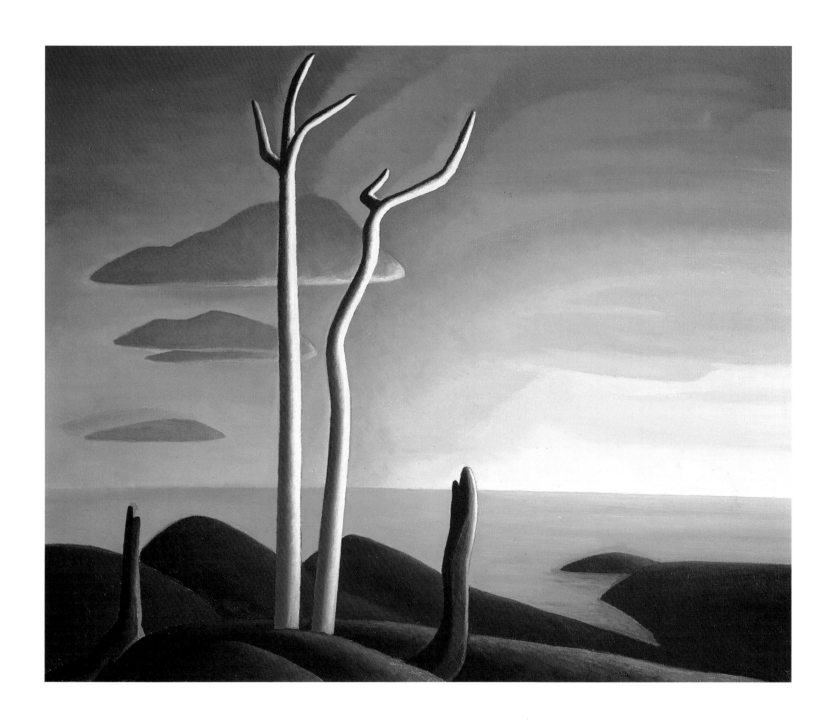

Lawren Harris *Lake Superior* c. 1928

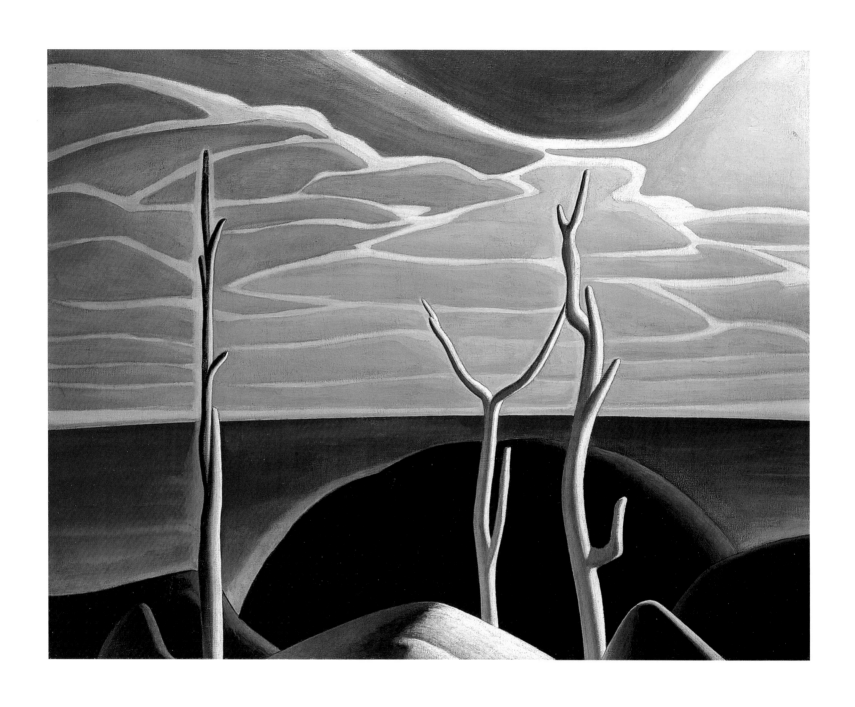

Lawren Harris *Lake Superior* c. 1924

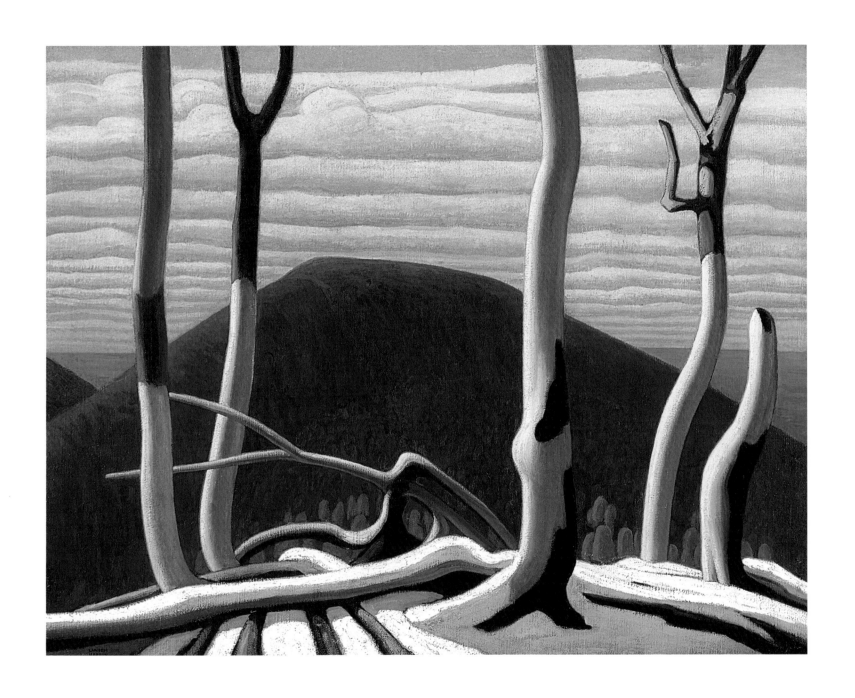

Lawren Harris *Above Lake Superior* c. 1922

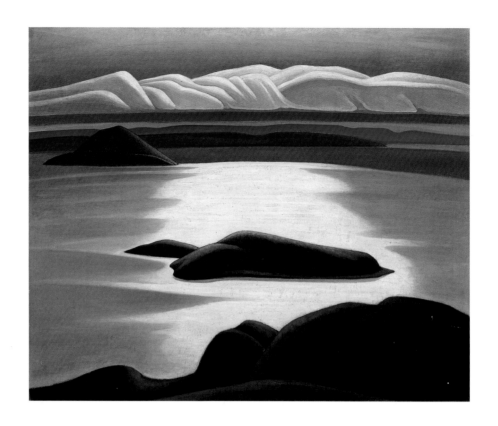

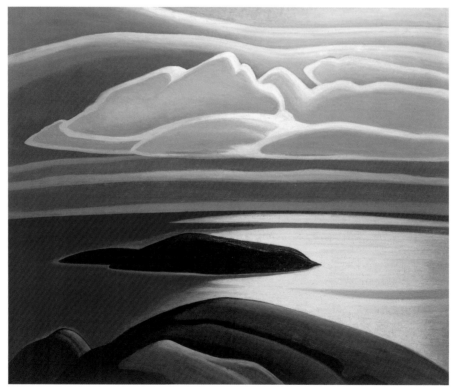

Lawren Harris *Morning, Lake Superior* c. 1921–1928

Lawren Harris *Morning Light, Lake Superior* c. 1927

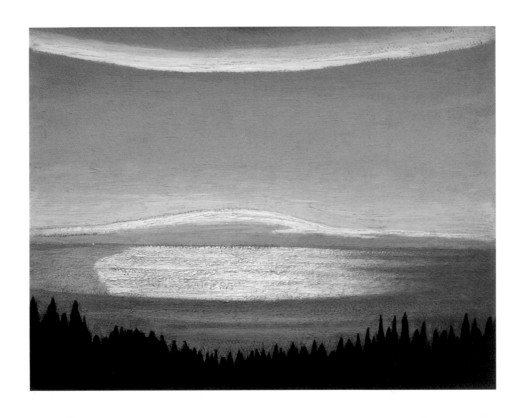

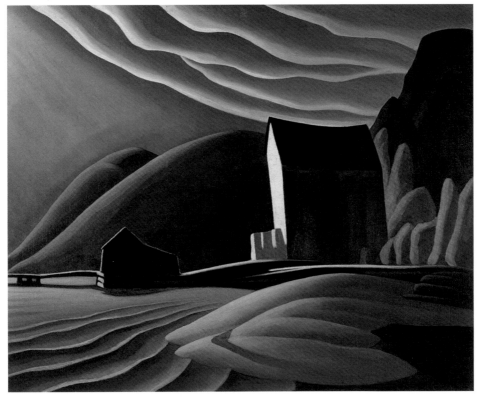

Lawren Harris *Afternoon, Lake Superior (Sketch* CXLIII) c. 1924

Lawren Harris *Ice House, Coldwell, Lake Superior* c. 1923

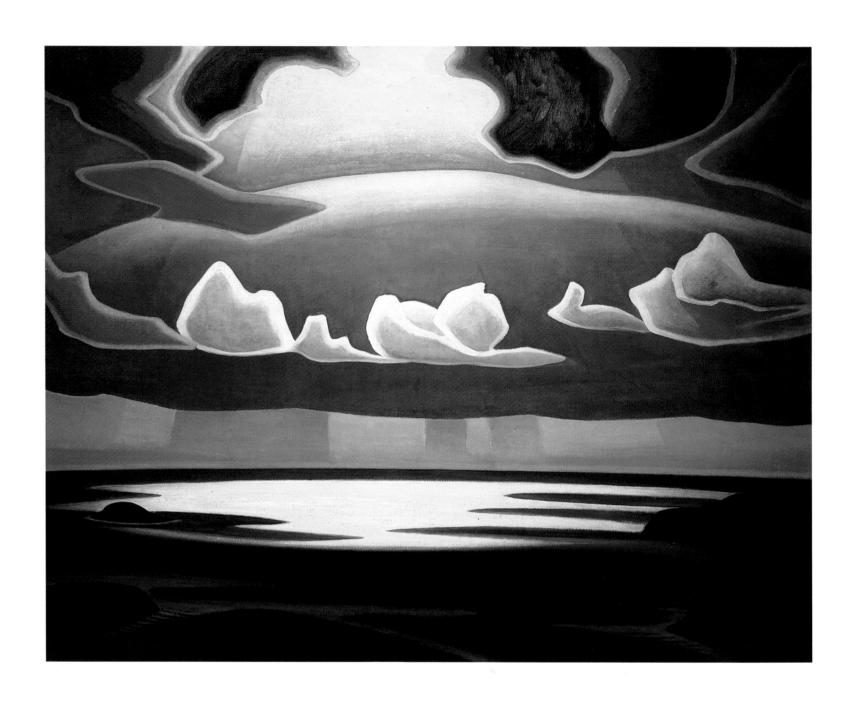

Lawren Harris *From the North Shore of Lake Superior* c. 1923

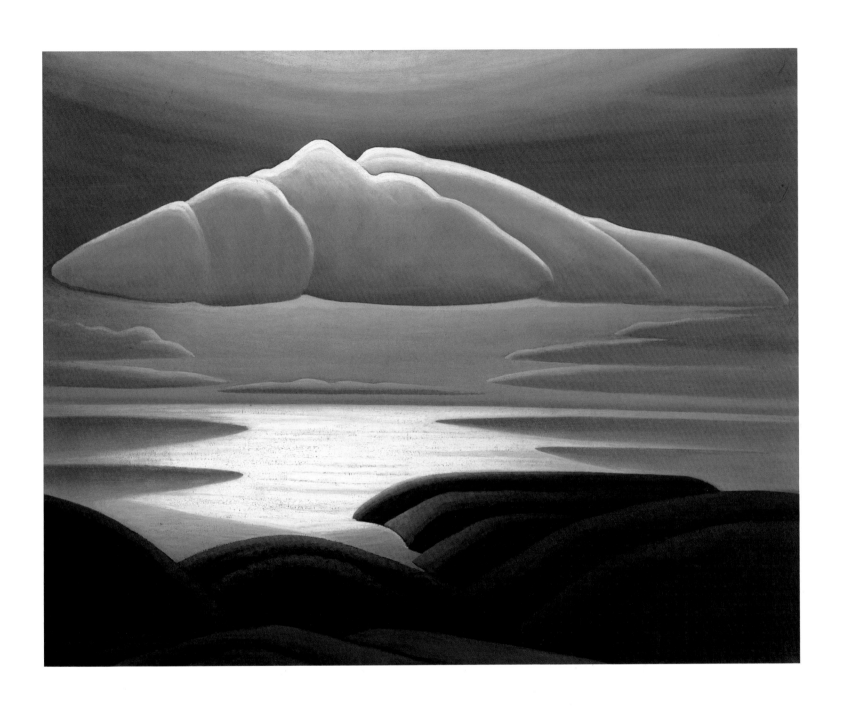

Lawren Harris *Untitled (Clouds, Lake Superior)* 1923

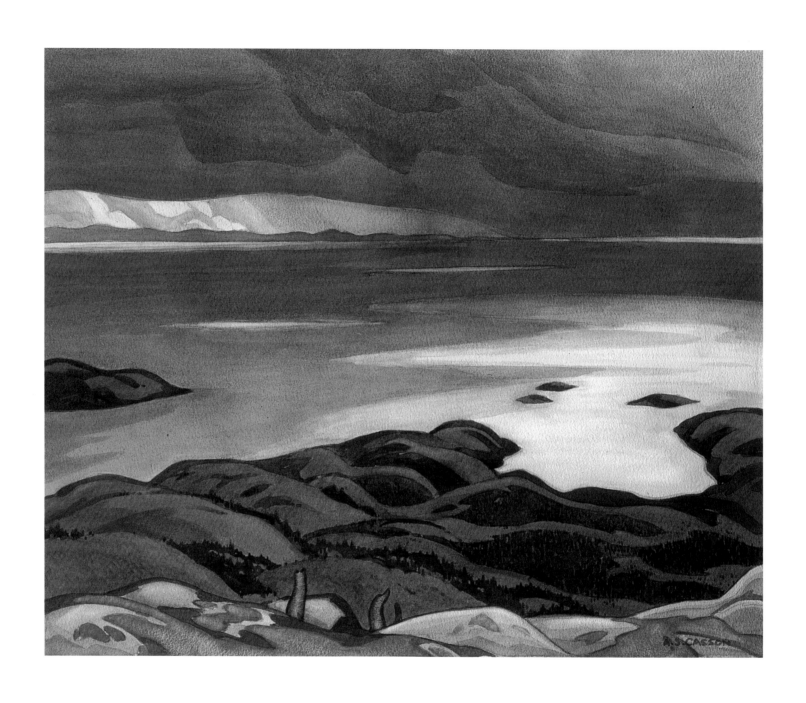

A.J. Casson *Approaching Storm, Lake Superior* c. 1929–1930

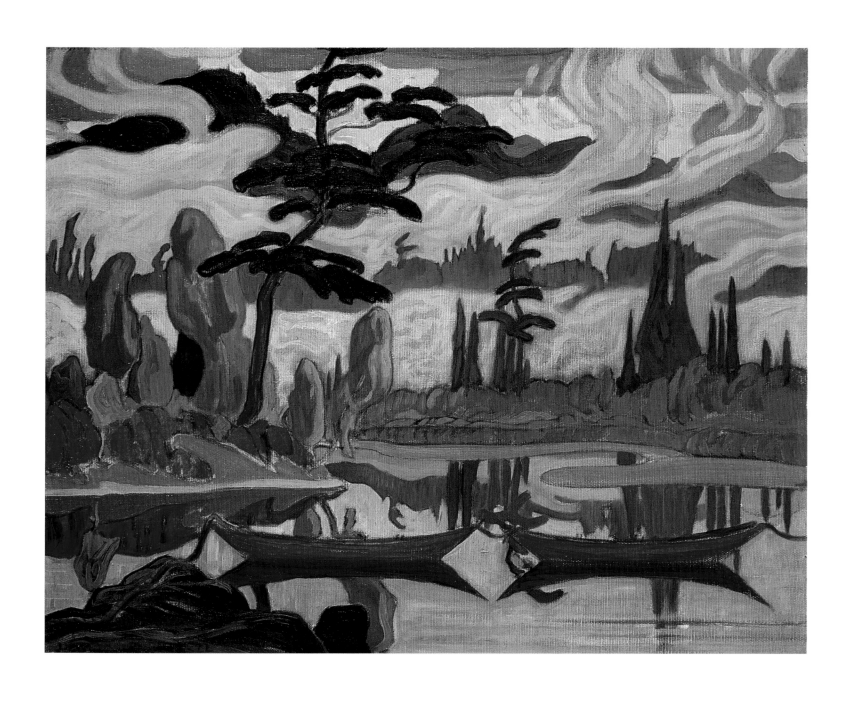

J.E.H. MacDonald *Mist Fantasy, Northland* 1922

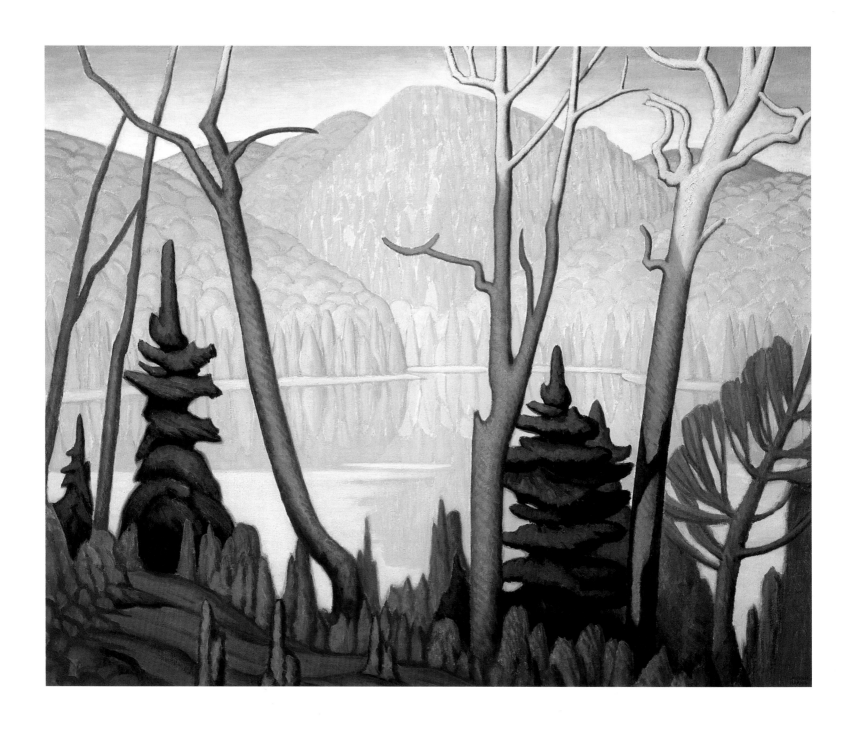

Lawren Harris *Lake in Algoma* c. 1925

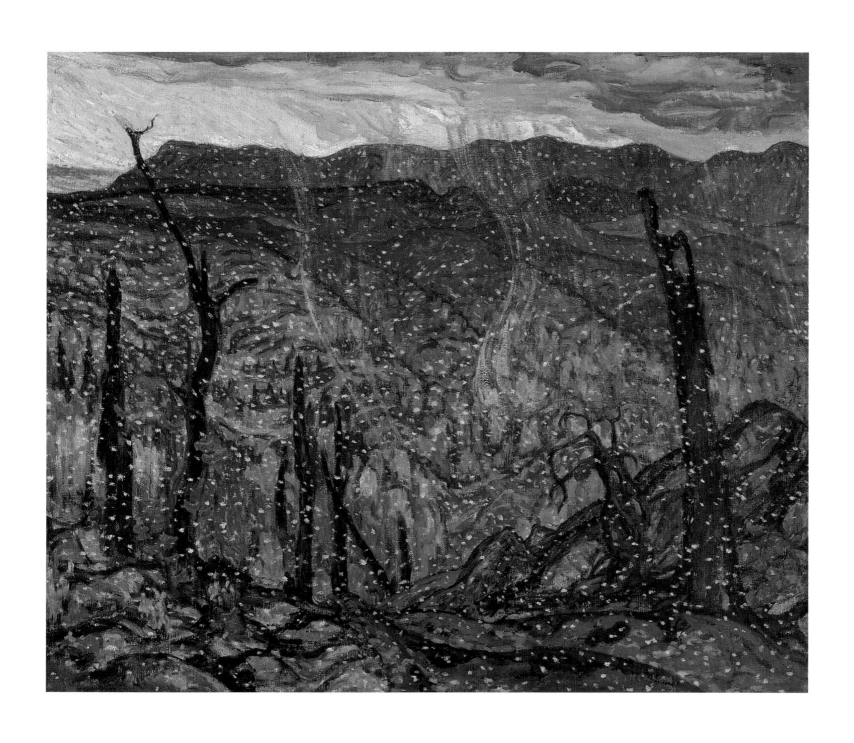

A.Y. Jackson *First Snow Algoma* c. 1920

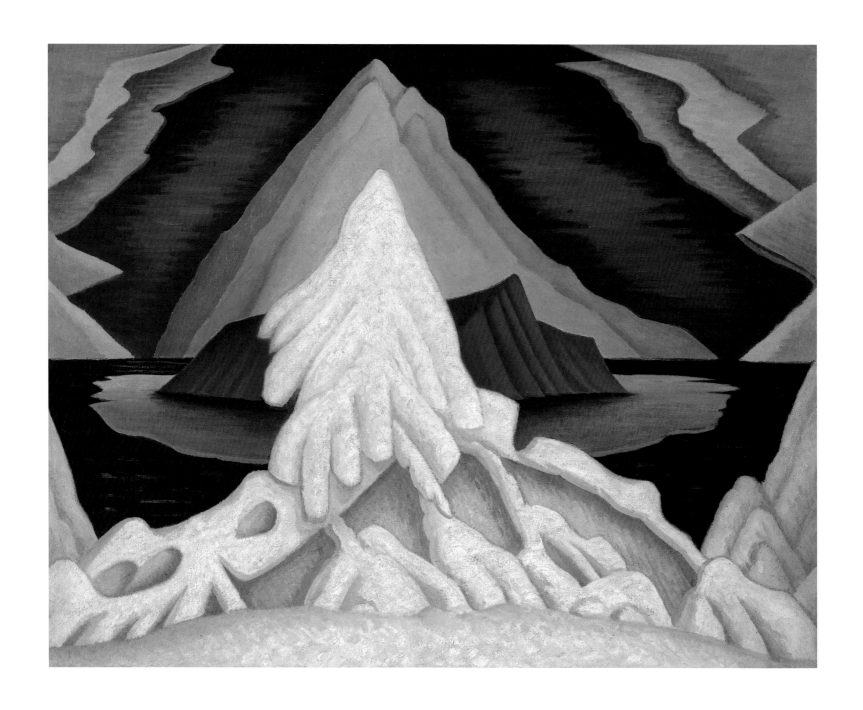

Lawren Harris *Winter Comes from the Arctic to the Temperate Zone* c. 1935

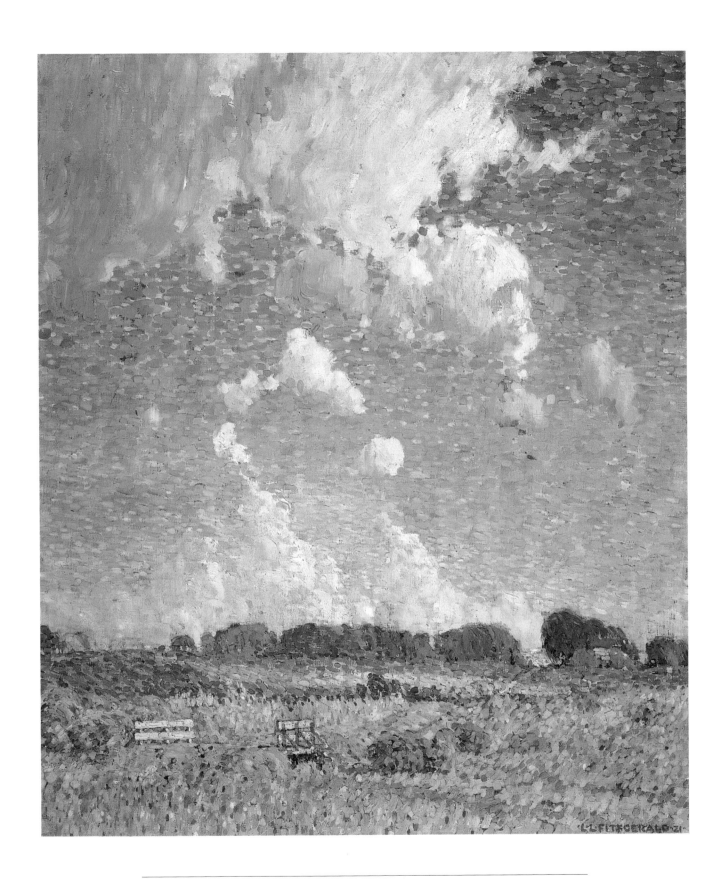

LeMoine FitzGerald *Untitled* (*Summer Afternoon, The Prairie*) 1921

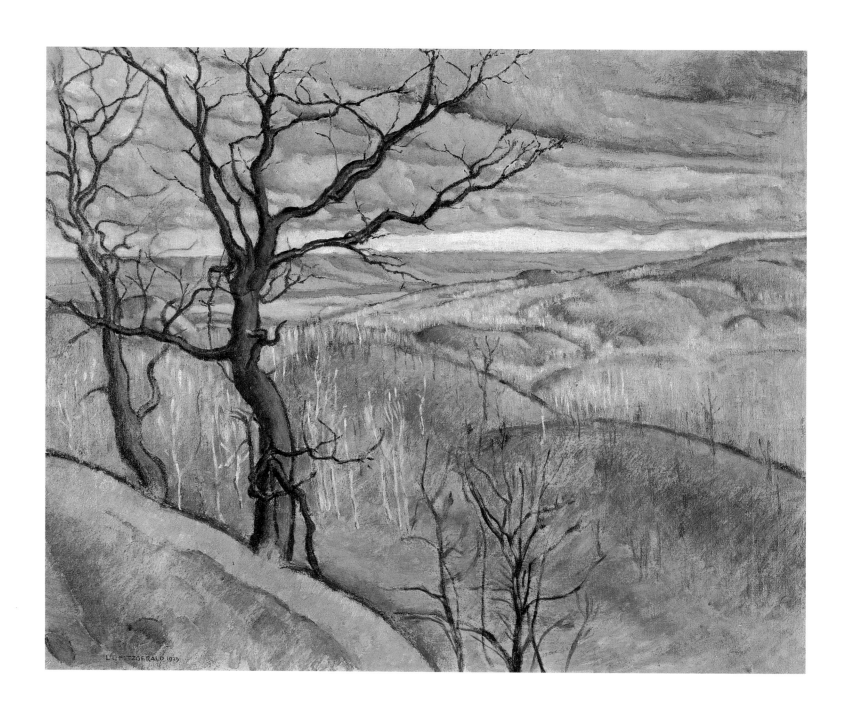

LeMoine FitzGerald *Pembina Valley* 1923

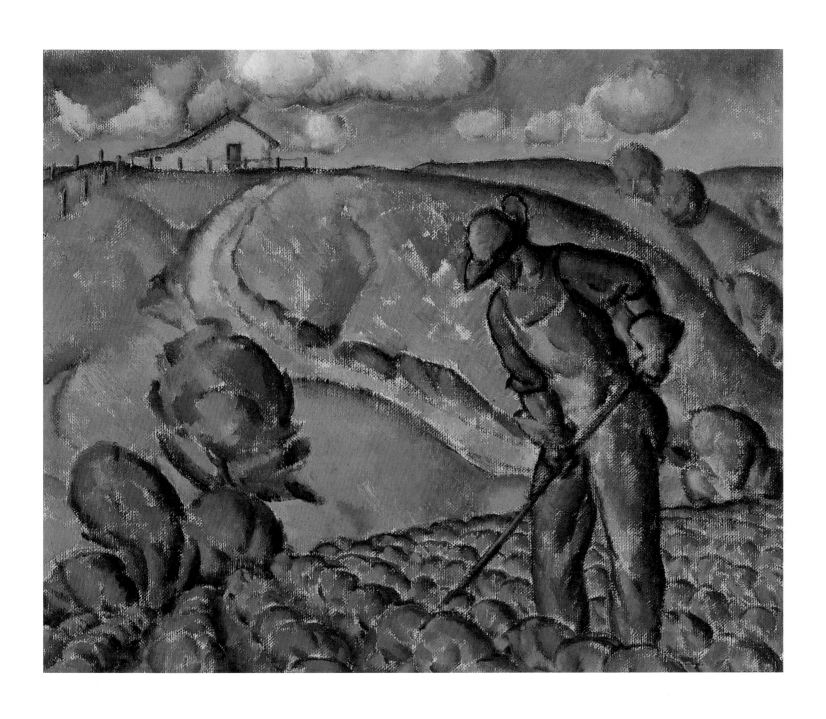

LeMoine FitzGerald *Potato Patch, Snowflake* 1925

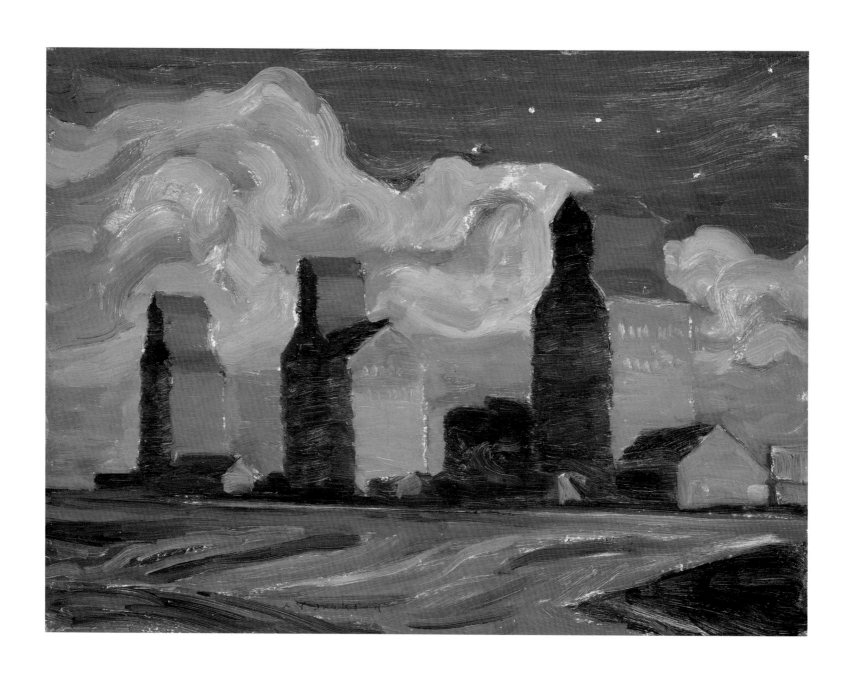

A.Y. Jackson *Elevator, Moonlight* c. 1947

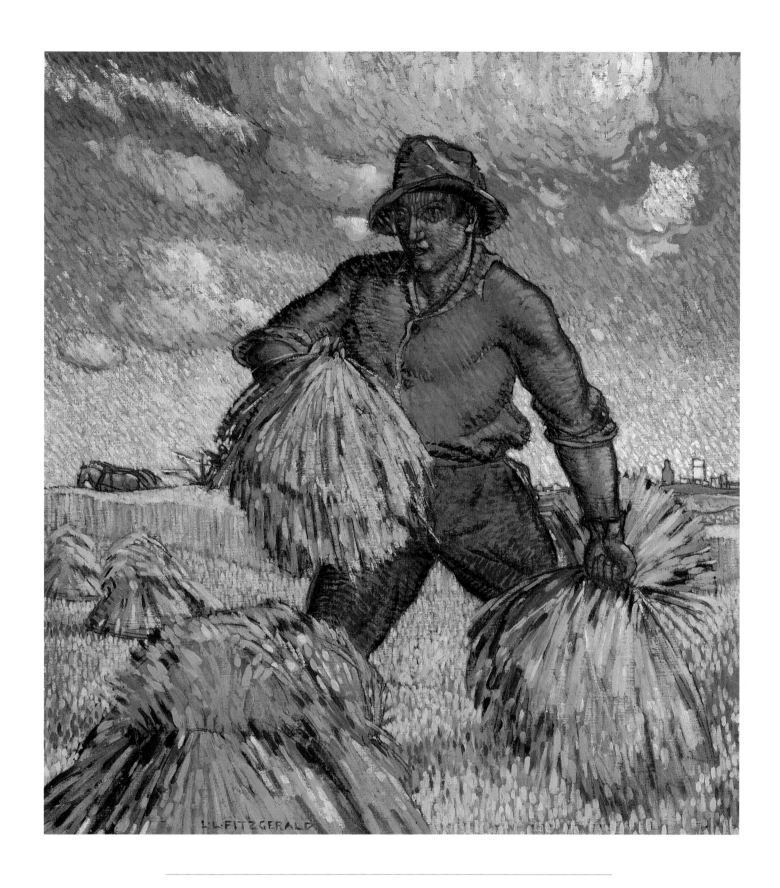

LeMoine FitzGerald *The Harvester* c. 1921

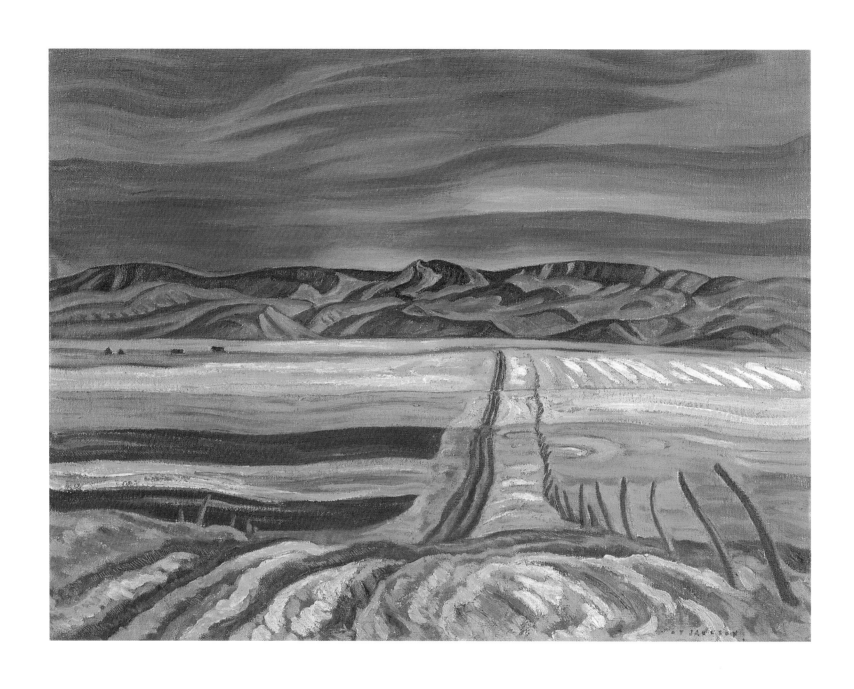

A.Y. Jackson *Blood Indian Reserve, Alberta* 1937

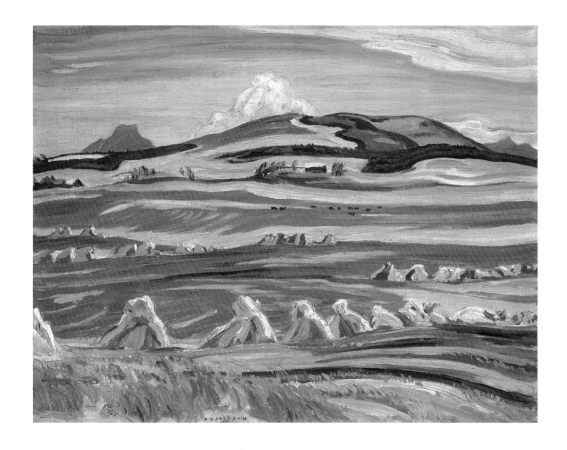

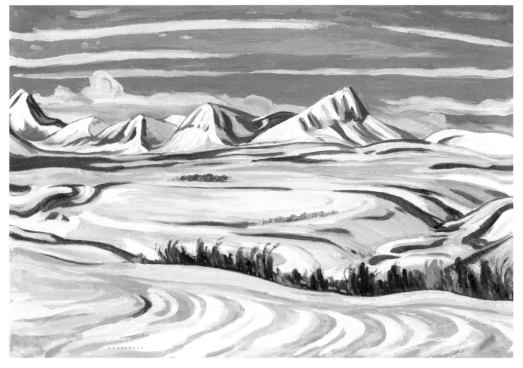

A.Y. Jackson *October, Twin Butte, Alberta* 1951
A.Y. Jackson *Early Snow, Alberta* 1937

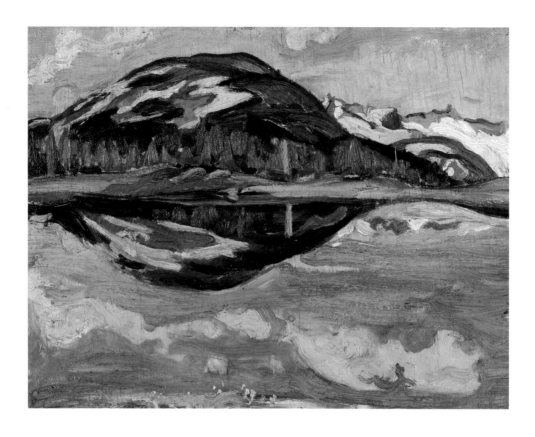

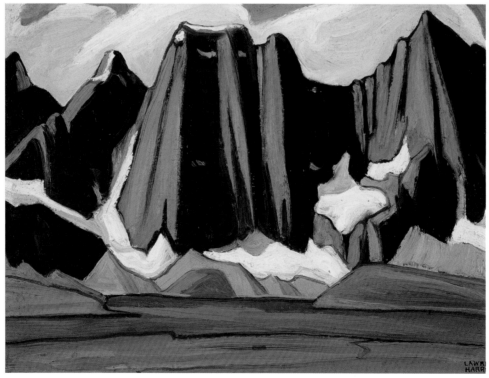

F.H. Varley *Reflections, Garibaldi Park* 1927

Lawren Harris *The Ramparts, Tonquin Valley* c. 1924

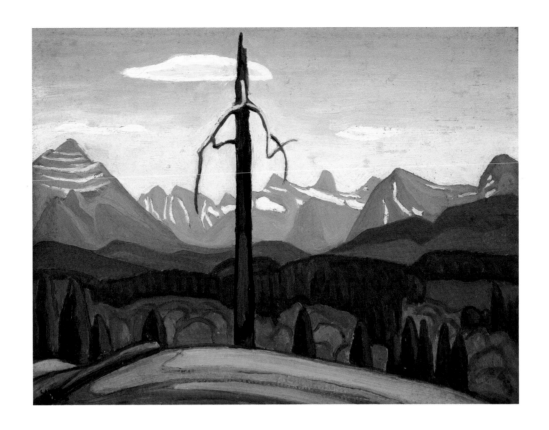

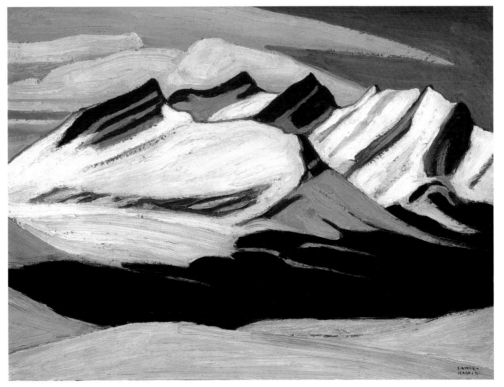

Lawren Harris *Athabaska Valley, Jasper Park* n.d.

Lawren Harris *Mountain at Tonquin Valley, Jasper Park* c. 1924

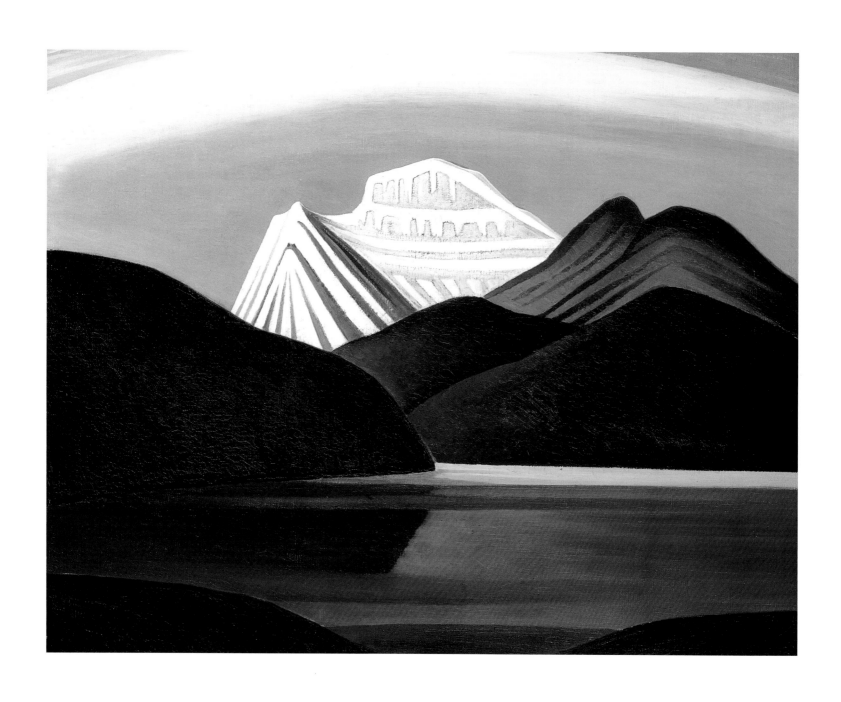

Lawren Harris *Mountains and Lake* 1929

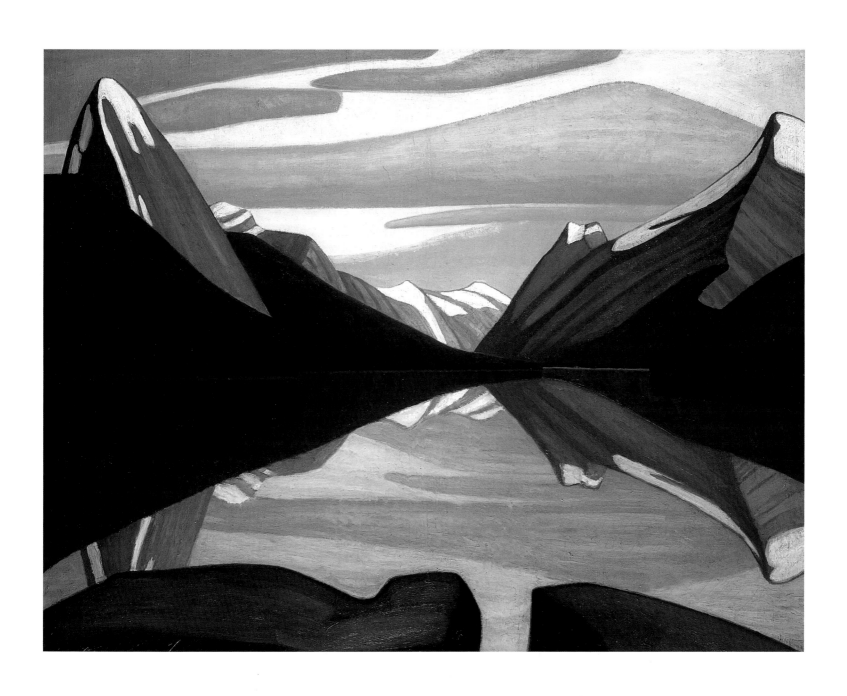

Lawren Harris *Maligne Lake, Jasper Park* 1924

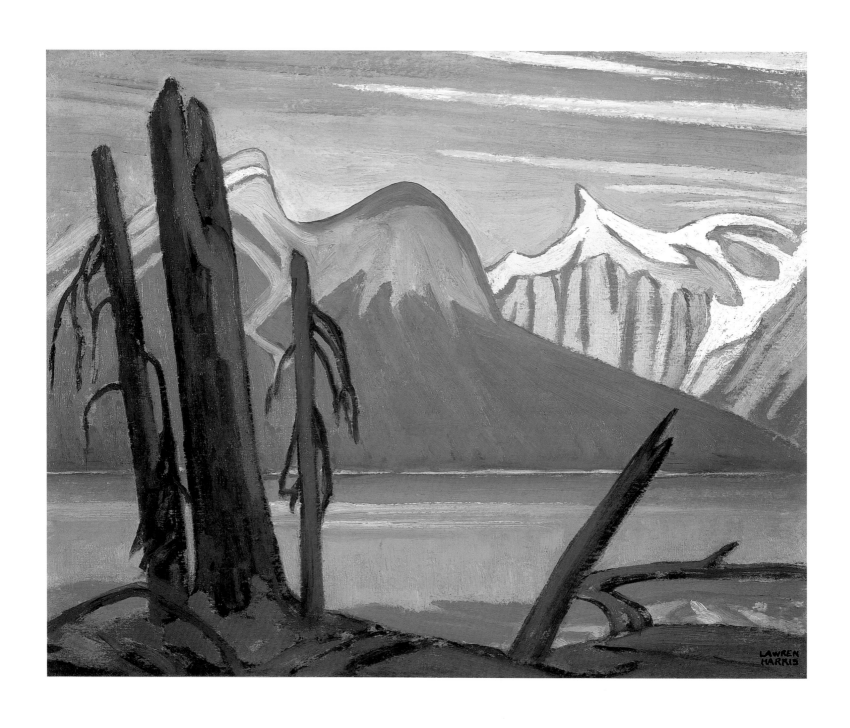

Lawren Harris *Emerald Lake, Rocky Mountains* c. 1925

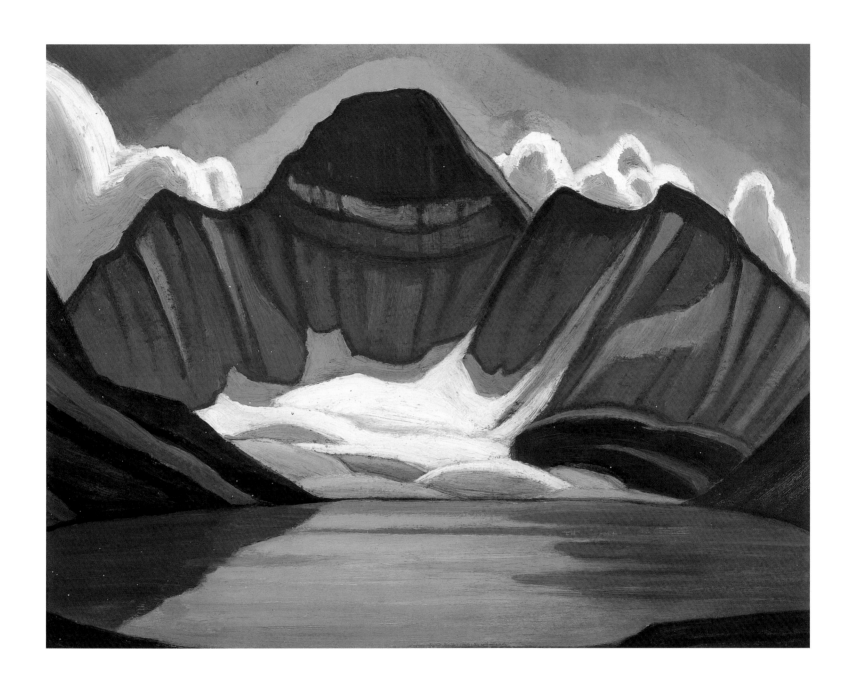

Lawren Harris *Lake McArthur, Rocky Mountains* c. 1924–1928

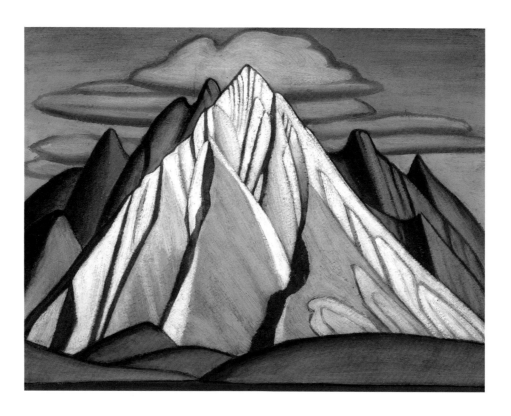

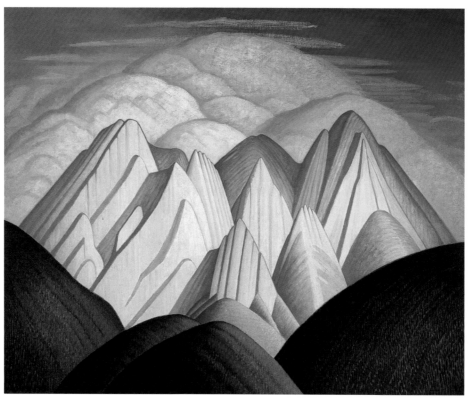

Lawren Harris *Mountain Form* c. 1925

Lawren Harris *Untitled (Mountains near Jasper)* 1934

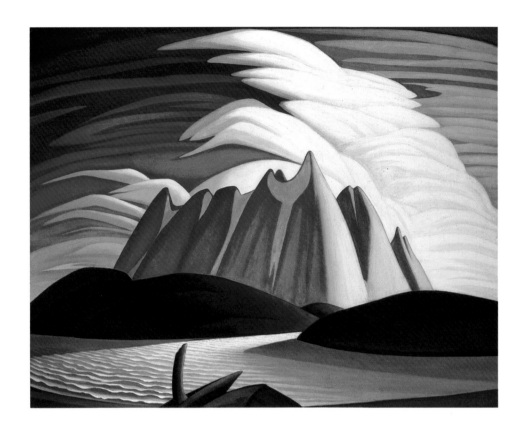

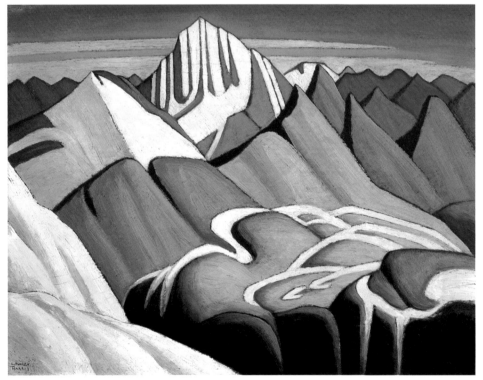

Lawren Harris *Lake and Mountains* 1928

Lawren Harris *Untitled (Mountain Sketch)* c. 1924–1928

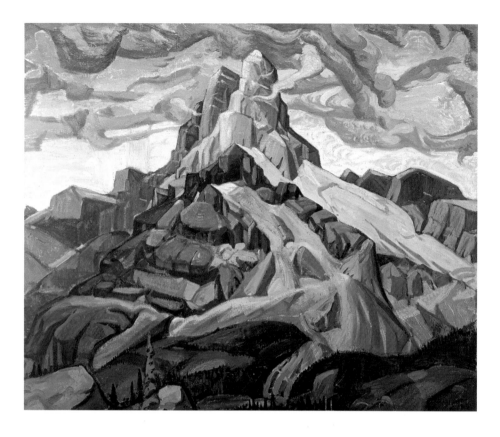

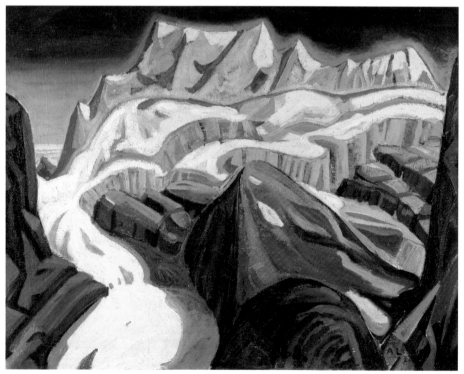

Arthur Lismer *Cathedral Mountain* 1928

Arthur Lismer *The Glacier* 1928

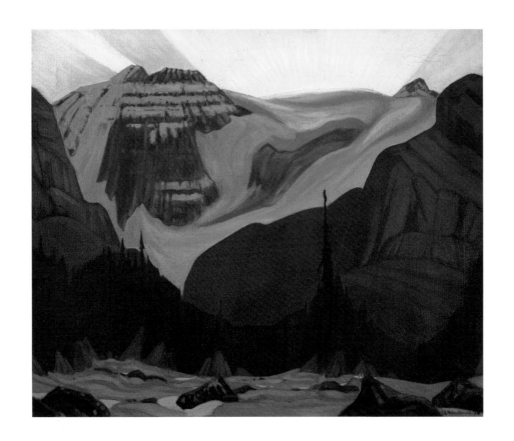

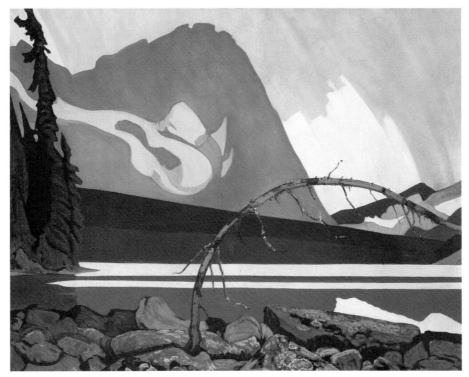

J.E.H. MacDonald *Early Morning, Rocky Mountains* 1928

J.E.H. MacDonald *Rain in the Mountains* 1924

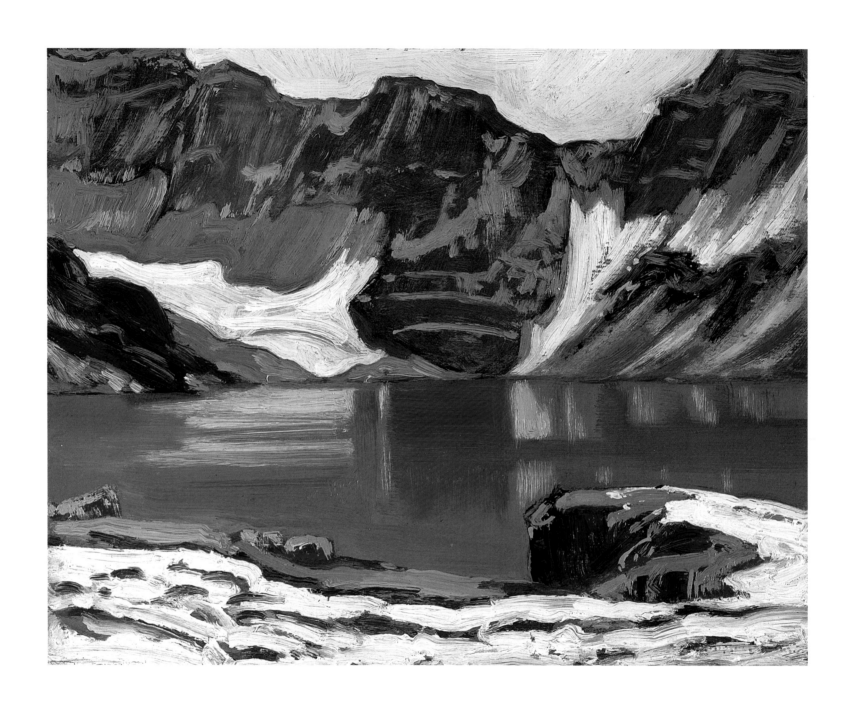

J.E.H. MacDonald *Lake McArthur, Yoho Park* 1924

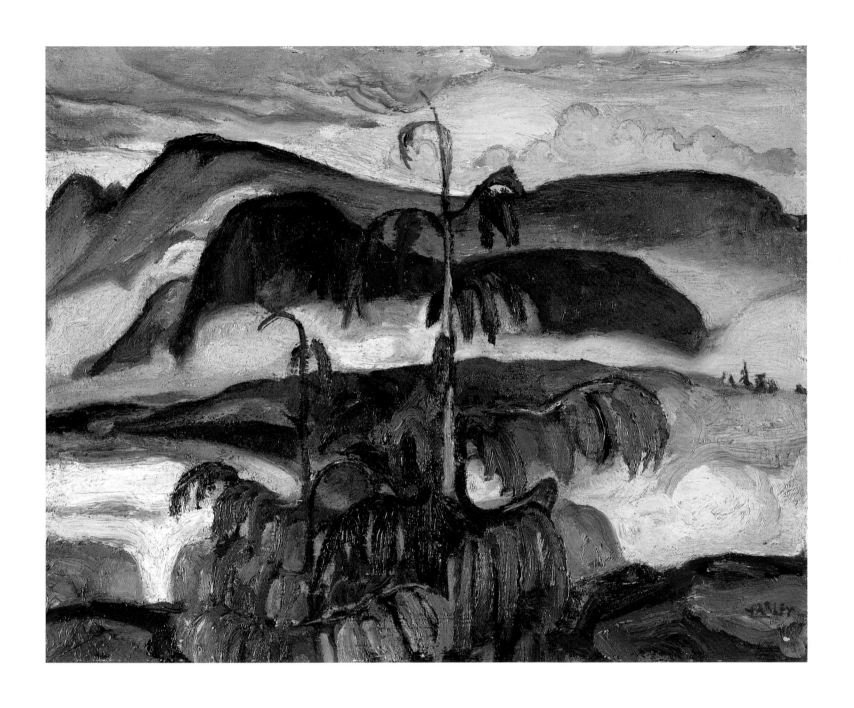

F.H. Varley *Evening after Rain* n.d.

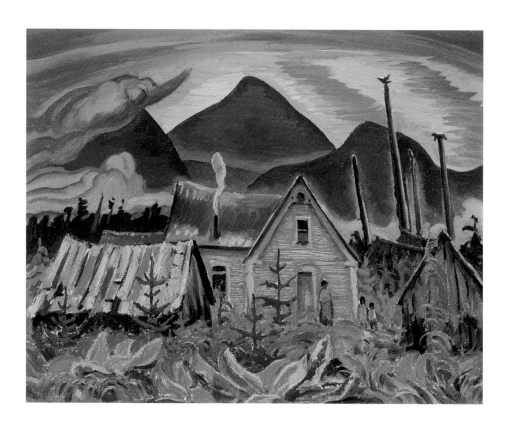

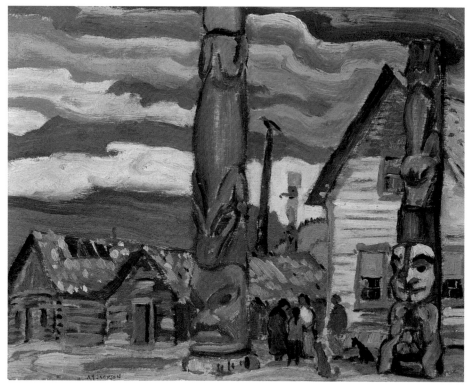

A.Y. Jackson *Indian Home* 1927

A.Y. Jackson *Totem Poles, Kitwanga* c. 1927

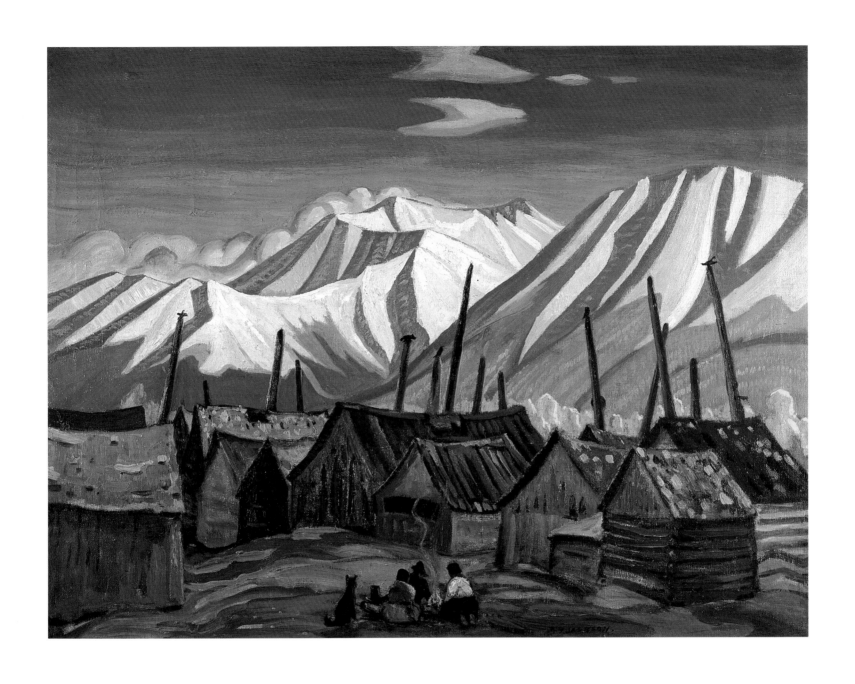

A.Y. Jackson *Kispayaks Village* 1927

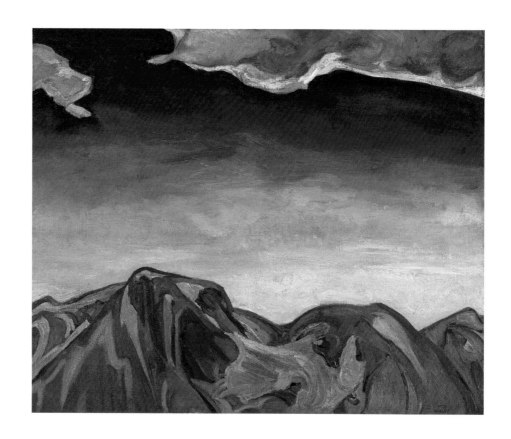

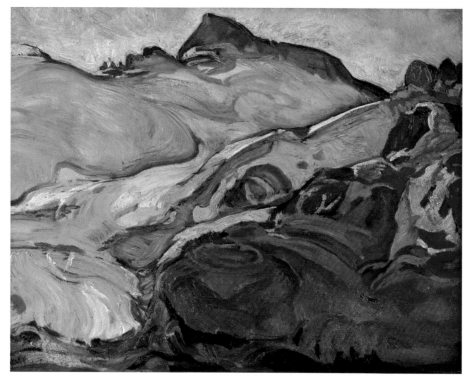

F.H. Varley *The Cloud, Red Mountain* 1927–1928

F.H. Varley *Sunrise, Sphinx Glacier, Garibaldi Park* 1927

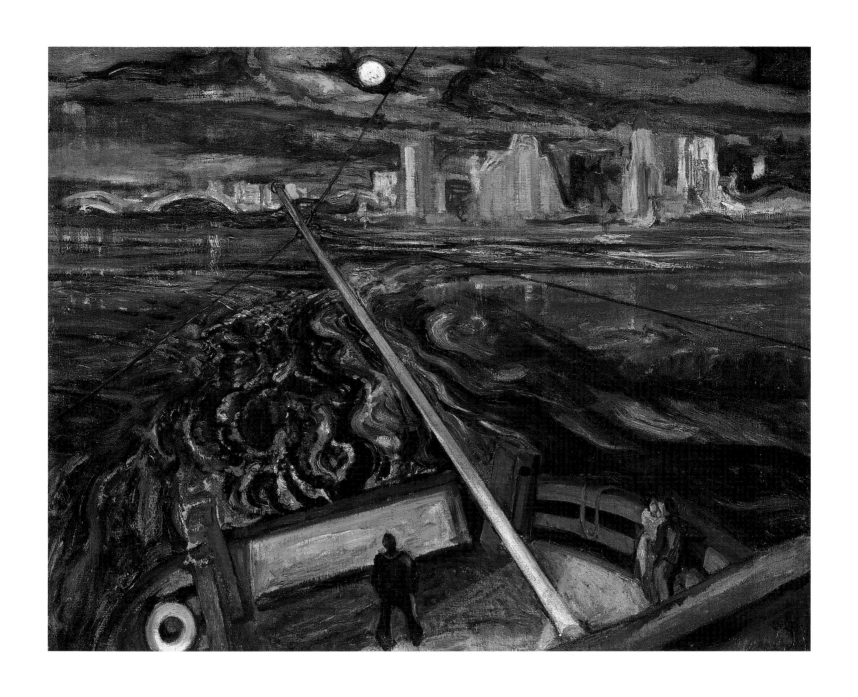

F.H. Varley *Night Ferry, Vancouver* 1937

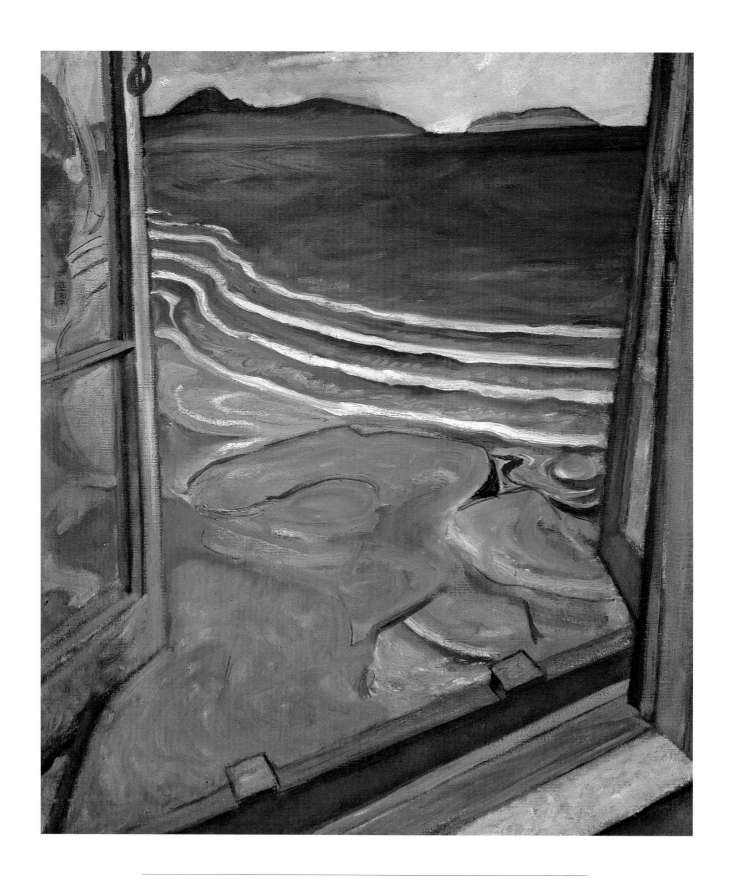

F.H. Varley *View from the Artist's Bedroom Window, Jericho Beach* 1929

THE CANADIAN ARCTIC

THIS SECTION BEGINS with a painting out of sequence and place: A.Y. Jackson's *Terre Sauvage* (p. 381), a Georgian Bay picture of 1913 after his first painting trip there. It was painted in Toronto in a studio shared with Lawren Harris over a bank at Yonge and Cumberland streets, and was greatly admired as soon as it was exhibited that year. J.E.H. MacDonald, according to Jackson in his autobiography, called it 'Mount Ararat, because, he said, it looked like the first land that appeared after the Flood subsided.'

Although it may seem illogical to use it to introduce a section of the country thousands of kilometres away and more than a dozen years later in time, the reason is that this work has, for me at least, always encapsulated and symbolized the kind of scruffy but noble terrain you find just north of Yellowknife, where the tree line seems to hesitate, as if Nature were uncertain whether trees can grow there. It has something in its particular and metaphoric loftiness that I associate with the Group of Seven's core purpose: the painting stands both as a gateway to the northland and for the idea of 'North.' *Terre Sauvage* was called *The Northland* when it was shown in the first Group of Seven exhibition and for sixteen years thereafter.

Only Jackson, Harris, and F.H. Varley travelled to the Far North and the Arctic and painted there. Jackson's first trip to the High Arctic was by supply ship, in 1927; his third and final one, in 1965, was by plane. He trekked into the Yukon and the western part of the Northwest Territories in 1928 and 1938, and then up the Alaska Highway in 1943. On his 1928 journey he painted the scrub bush around Great Slave Lake, where, as one ventures farther north, the vegetation gets smaller and smaller as the growing season gets shorter. Although Jackson had not yet gone there when he painted *Terre Sauvage,* that painting has an uncanny similarity to *Yellowknife Country, Northwest Territories* (p. 382) and *Northern Lake* (p. 382), both painted in 1929.

The influence of northern images and the concept of a northern country and people, the idea of 'North' itself, for Harris, was first a spiritual truth, then a concept, and finally a visual experience. The farther north Harris went, the closer he seemed to get to the ideal confluence of spirit, idea, and image. In the Arctic, the extreme shift of the seasons, the absolute grip of the elements in winter, the bustle of life in the short span of the all-day,

all-light Arctic summer; the eerie and primordial quality of sunlight on ice, snow, and water; and the rough agelessness of the bluffs along the Baffin Island shore all impose a rhythm that no other part of the globe experiences, save, perhaps, the Scandinavian and Russian northlands. In the endless days of the Arctic summer, land, bird, and sea life are teeming and restless, as everything hurries to complete its cycle in the brief summer before the region is once again plunged into winter and darkness.

Jackson's 1927 trip to the High Artic was with Dr Frederick Banting, an amateur painter and one of the discoverers of insulin, on the 2700-ton supply ship *Beothic*. The voyage was a revelation to Jackson, and in 1930 he and Harris travelled together to the Arctic with a Canadian government expedition on the same ship, at the time 'the most extensive trip ever taken in the Arctic region in one season,' according to Harris in *The Story of the Group of Seven*. The crew of Newfoundlanders took the *Beothic* down the Labrador coast, around Baffin Island (the fifth largest in the world), and into such settlements as Pangnirtung and Frobisher Bay (now Iqaluit); then around Bylot Island at Baffin's north end; and on to Pond Inlet, Arctic Bay, Rice Strait, and Dundas Harbour on Devon Island. They went up the Davis Strait into the Kane Basin; along the coast of Ellesmere Island, only a few hundred kilometres from the North Pole; back down and into the Lancaster and Hudson straits; and eastward, close to Greenland, from which the monumental icebergs of the Atlantic calve from the world's largest ice fields in the early spring, before beginning their long voyage south on the Labrador Current – 'the most fantastic forms in blue-green and pearl,' in Jackson's words. Jackson's *Iceberg* (p. 390) and *The 'Beothic' at Bache Post, Ellesmere Island* (p. 391) both show his fascination with this new world. His strong documentary impulses also prompted him to record native life in *Eastern Arctic* (p. 390). In his autobiography he gave this description:

> *The big ice packs, on the other hand* [unlike the icebergs], *are moved about by wind and tide. As we passed through the Melville pack we observed old ice floes and patches of blue ice, and ice lifted off the shore with mud and stones all over it. To make studies when the ship was zigzagging through the ice fields was very difficult. The old floes were fantastic in shape; some resembled big mushrooms and were beautiful in colour, lavender white on the outside and green-blue under the water.*

Although the arctic landscape was inspiring, Jackson was hampered by aspects of the

environment: 'I could not use my oil colours, as the mosquitoes got all mixed up with the paint.' He and Harris were restricted to drawings and occasional oil sketches in their cabin except when the wind was strong enough to keep the mosquitoes down.

The geography of the eastern Arctic, especially Baffin Island and the northern reaches of Labrador, is mountainous, with glaciers, deep fiords, and fast-tumbling, silt-laden streams. The churning floes of ice often choke bays, harbours, and even large straits. The landscape is barren of trees. Although the summer ground is invariably wet and boggy, the whole Arctic area is, technically at least, a desert. Harris and Jackson found all this novel and immensely stimulating. They sketched continually, thrilled with the vistas, the colours, the sea, and the ice, the primordial power of it all, which reinforced their ideas of Canada's essential nature and their artistic purposes in giving Canada images of its true northern character. The material that Jackson and Harris gathered on their 1930 trip netted them a raft of outstanding subjects – dramatic, compelling, and memorable. Jackson painted the pack ice and icebergs, the sea littered with ice floes, the soaring cliffs, the barren, rolling hills, and the implacable mountains of the area.

Harris was inspired to create some of the most powerful paintings of his long and productive career. The purity of the light and snow struck him most of all in such paintings as *Icebergs, Davis Strait* (p. 388 and p. 389), *Rice Strait, Ellesmere Island* (p. 386), *North Shore, Baffin Island I* (p. 392), *Arctic Peaks, North Shore, Baffin Island* (p. 387), and *North Shore, Baffin Island* (p. 395).

The Arctic west of Baffin and Foxe Basin is an extension of the great plains to the south, much flatter than the east, with gentle rolling hills, lakes and rivers, long, sandy eskers, and even more extreme temperatures, since the mitigating influence of the sea is farther away. Mountains rise again in the Yukon, the northern extension of the Rockies.

Varley was finally invited to visit the Arctic for three months in the summer and fall of 1938, on board the supply ship *Nascopie*. As it had been for Harris and Jackson, the experience was a revelation, and he exulted in the magic he saw all around. In a letter to Elizabeth Gowling, quoted by Christopher Varley in his 1981 exhibition catalogue, he wrote:

> *I'm more drunk than ever in my life – drunk with the seemingly impossible – the glaciers*
> *up the Greenland coast & the weather-rounded mountains – the icebergs – literally hun-*
> *dreds of them, floating sphinxes – pyramids – mountain peaks with castles on them –*

drawbridges & crevasses, huge cathedrals – coral forms magnified a thousand fold – fangs
of teeth hundreds of feet high – strange caves giving out in front of them the intense singing
violet of space until the cave is as unreal as a dream and because of the blue greens & the
violets of these bergs, the grey sky twins mauve & the sea deep purple and red.

Another of his letters is a variation on the same theme:

On dreary days colour becomes precious, ice floes splinter light into colour and the green of
all greens, the translucent glacial green of ice beneath the water, the pure violet light edg-
ing hollow caves, the sea, the washed surface of mauve with a powdering of pale rose and
the palest of yellow-green put the surrounding grey water to shame and tinged it with a
dull smoulder of red like an old Chinese print.

In the western Arctic especially, the flatter curvature of the globe around the North Pole allows you to see much farther than you can in more southerly latitudes. The effect makes one's smallness in that vast land even smaller. For a good dose of humility and a reminder that unknown forces shape our brief lives, the top of the world is a perfect place. No wonder that Harris and Jackson and Varley found it so compelling to paint.

Harris's snow-capped Arctic mountains were symbolic of a remote, pure region of light from which Canada's spiritual energy came. Perhaps the endless daylight of the Arctic summer suggested this idea. The power in Harris's Arctic paintings reflects the conviction he had about this and also provides a dimension to the basic idea that the Group of Seven advanced in their missionary idealism: that the North was strong and true and free, and that Canadians were a northern people.

■

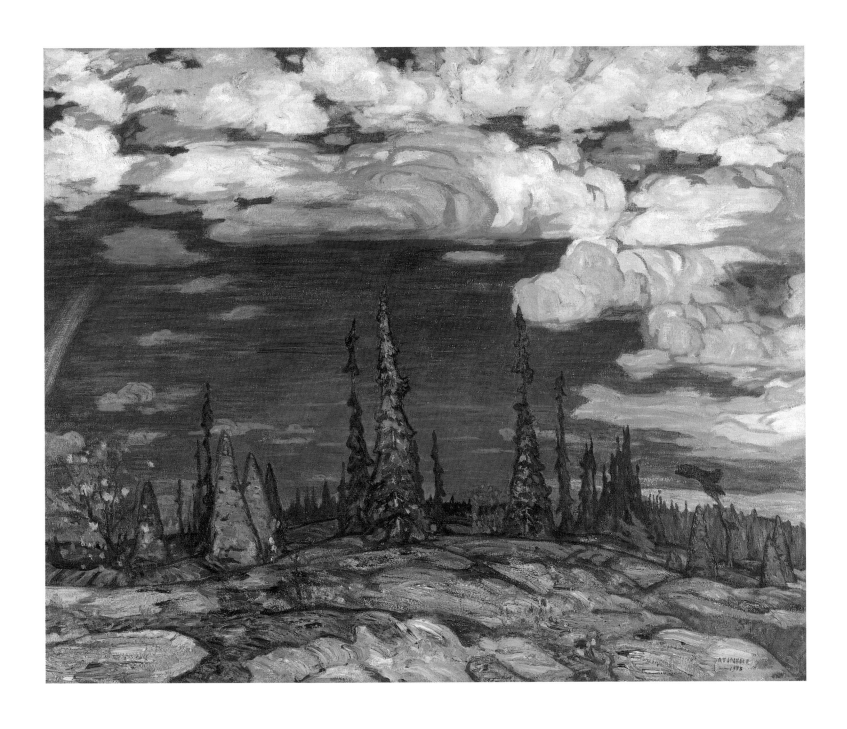

A.Y. Jackson *Terre Sauvage* 1913

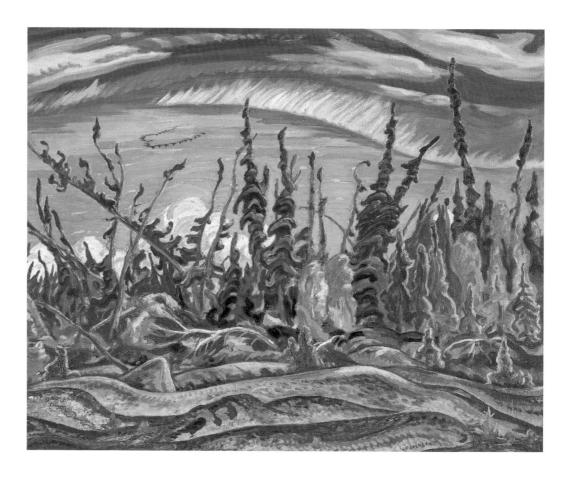

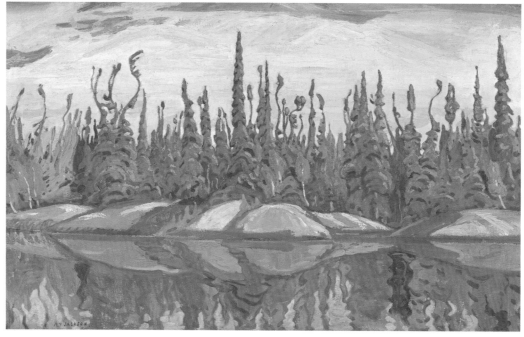

A.Y. Jackson *Yellowknife Country, Northwest Territories* 1929

A.Y. Jackson *Northern Lake* 1928

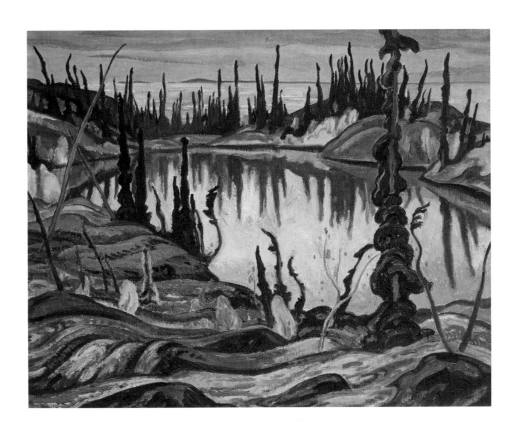

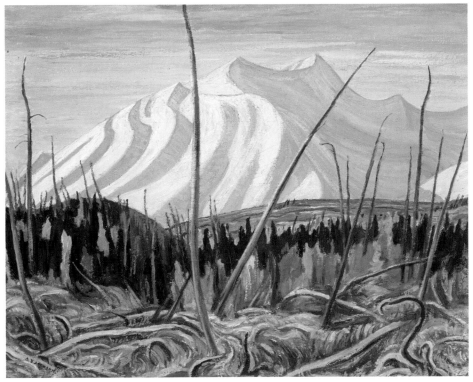

A.Y. Jackson *Northern Landscape, Great Bear Lake* c. 1938–1939

A.Y. Jackson *Dawn in the Yukon* 1943

383

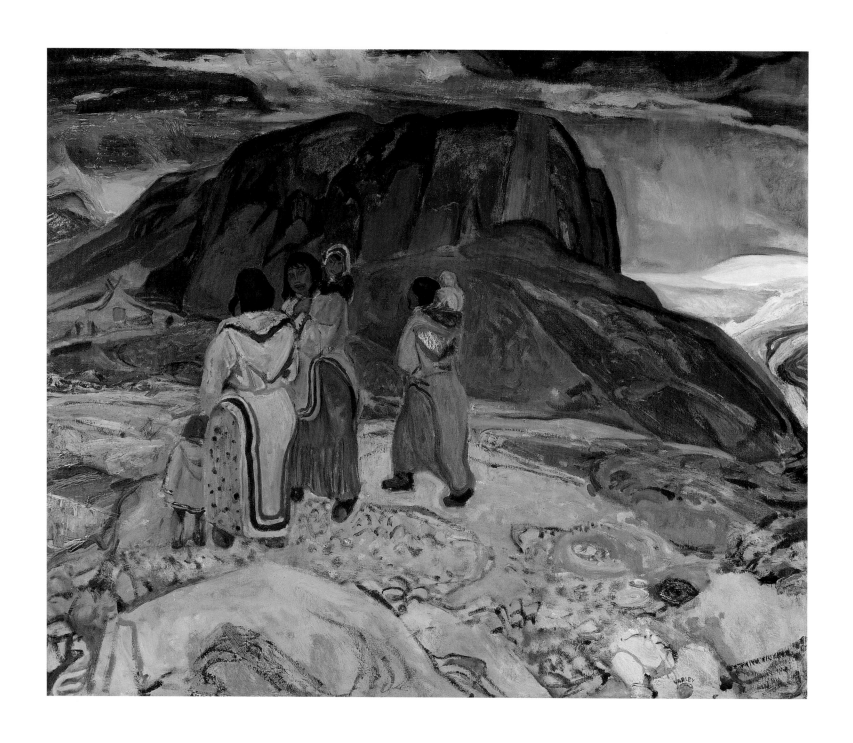

F.H. Varley *Summer in the Arctic* 1938

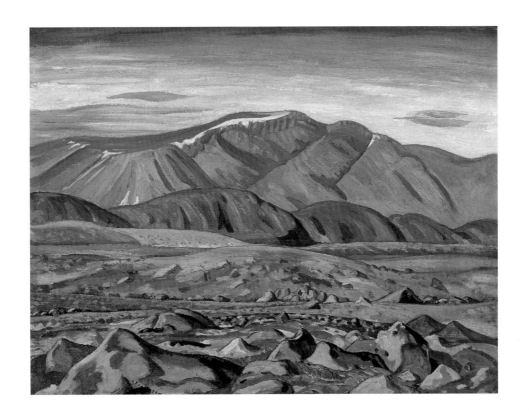

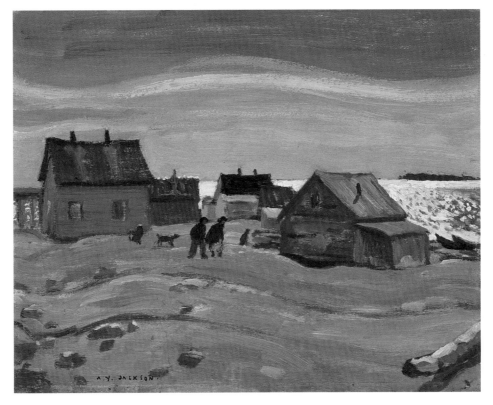

A.Y. Jackson *Morning, Baffin Island* 1930
A.Y. Jackson *Indian Homes, Fort Resolution* 1928

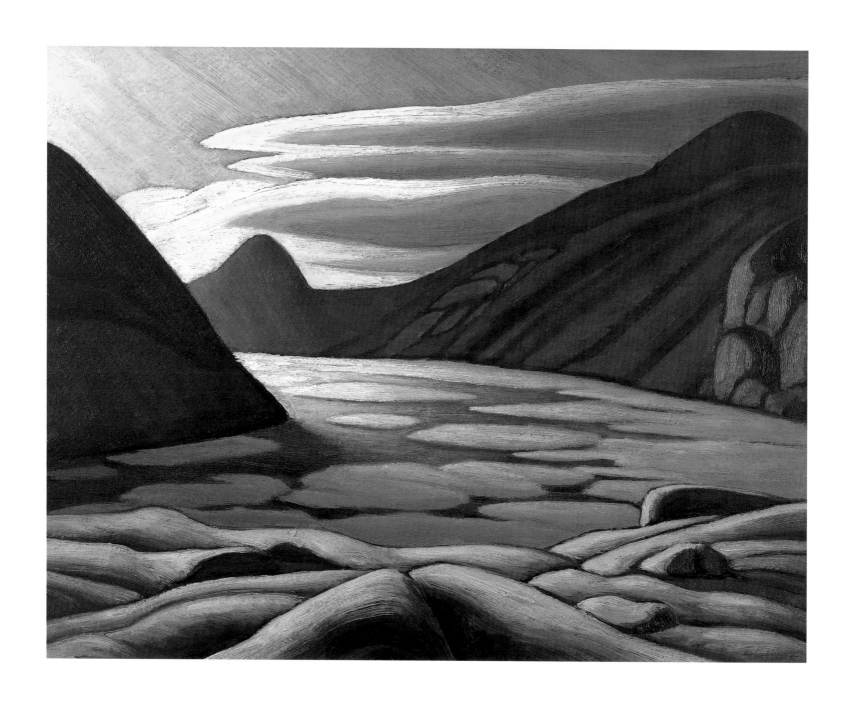

Lawren Harris *Rice Strait, Ellesmere Island* 1930

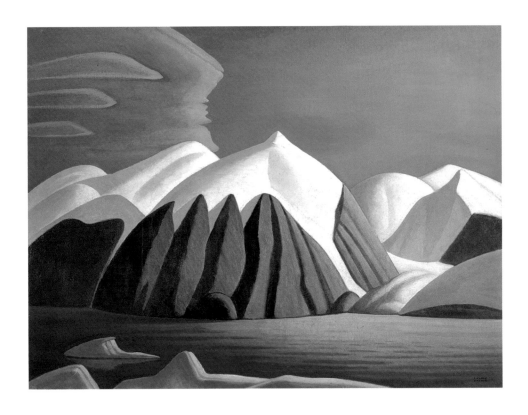

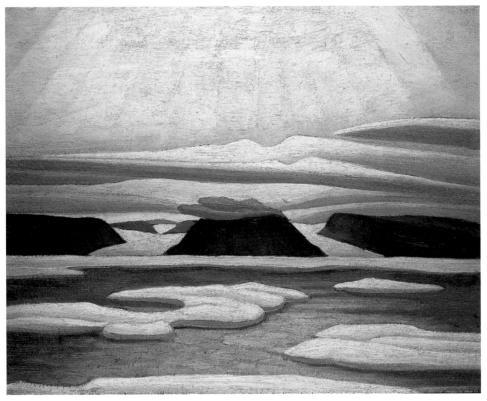

Lawren Harris *Arctic Peaks, North Shore, Baffin Island* 1930
Lawren Harris *Ellesmere Island* c. 1930

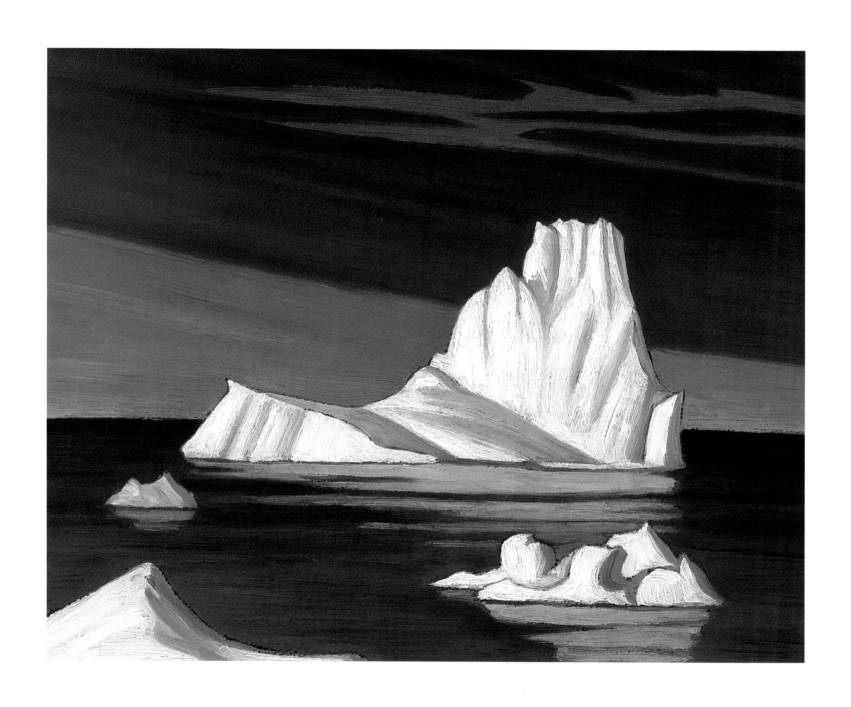

Lawren Harris *Icebergs, Davis Strait* 1930

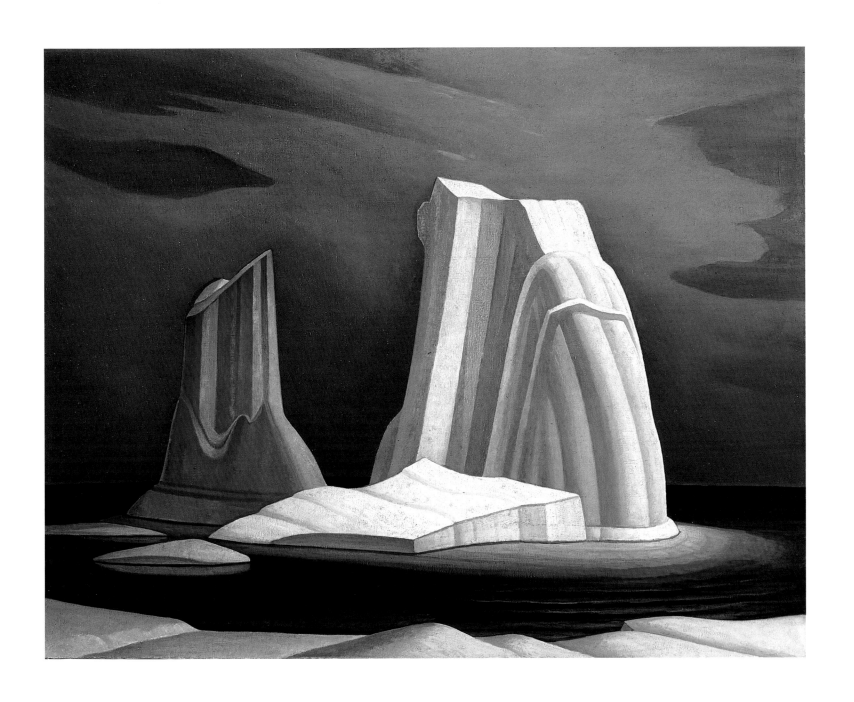

Lawren Harris *Icebergs, Davis Strait* 1930

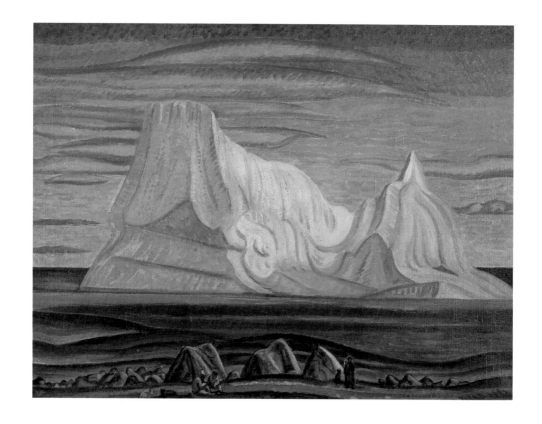

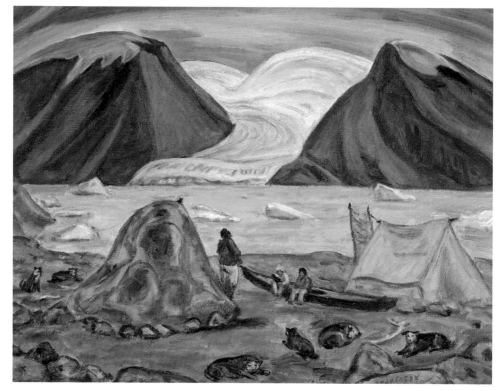

A.Y. Jackson *Iceberg* 1930

A.Y. Jackson *Eastern Arctic* 1965

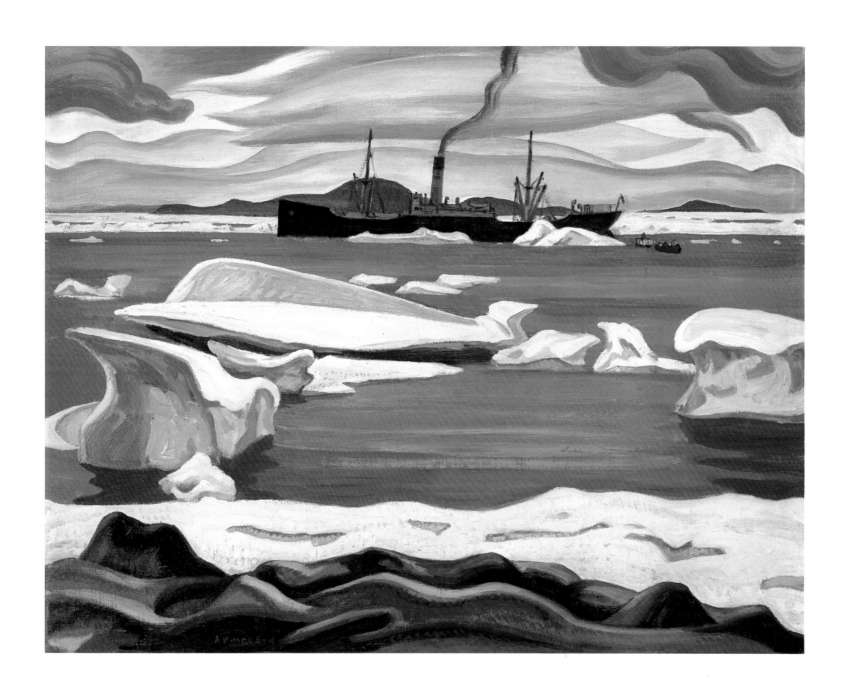

A.Y. Jackson *The "Beothic" at Bache Post, Ellesmere Island* 1929

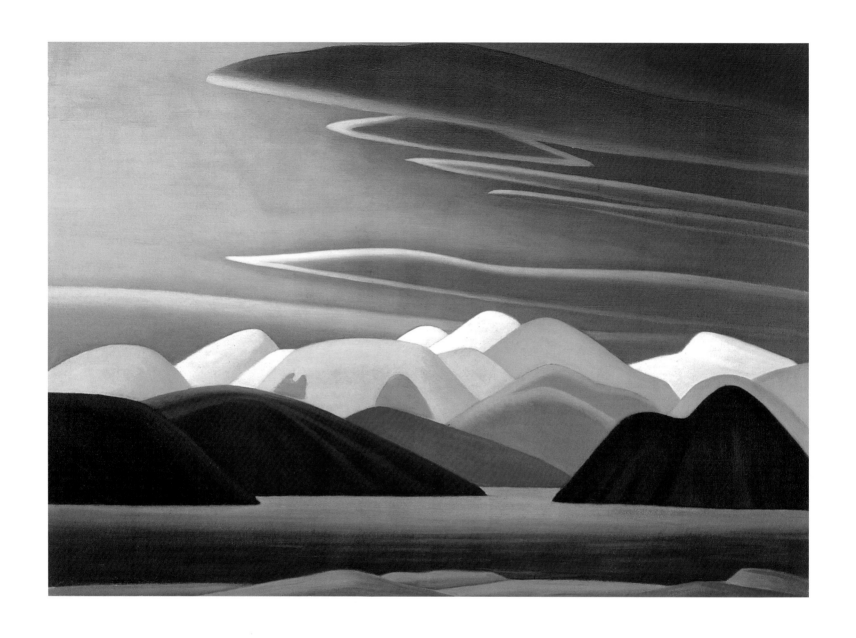

Lawren Harris *North Shore, Baffin Island* I c. 1930

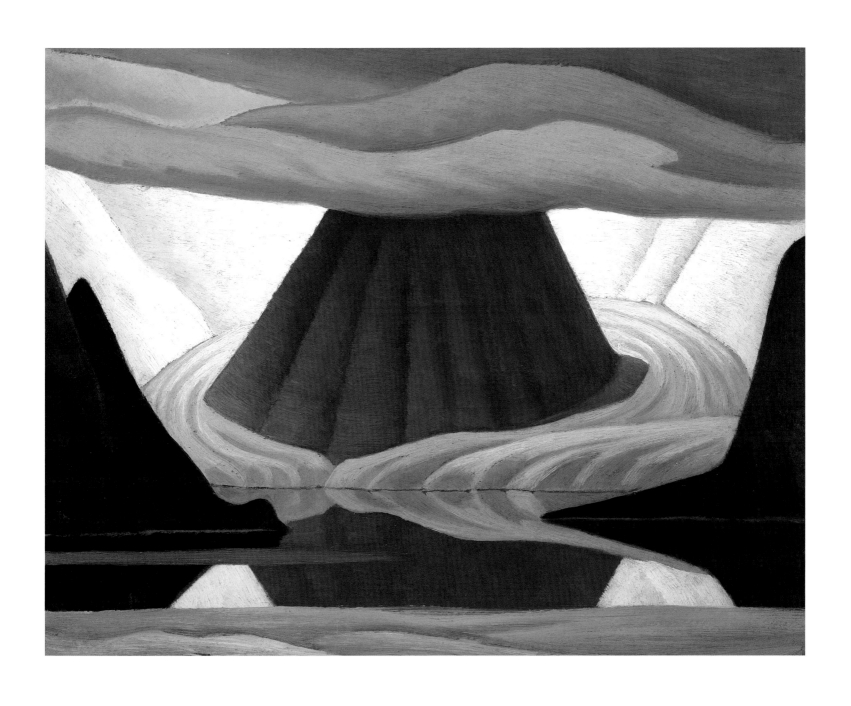

Lawren Harris *Arctic Sketch XIII* 1930

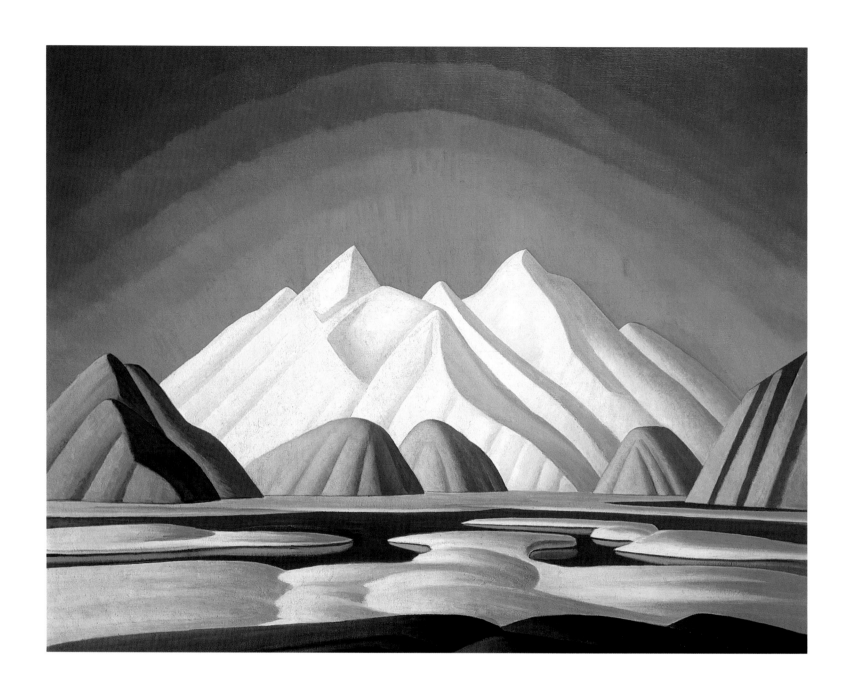

Lawren Harris *Baffin Island* 1930

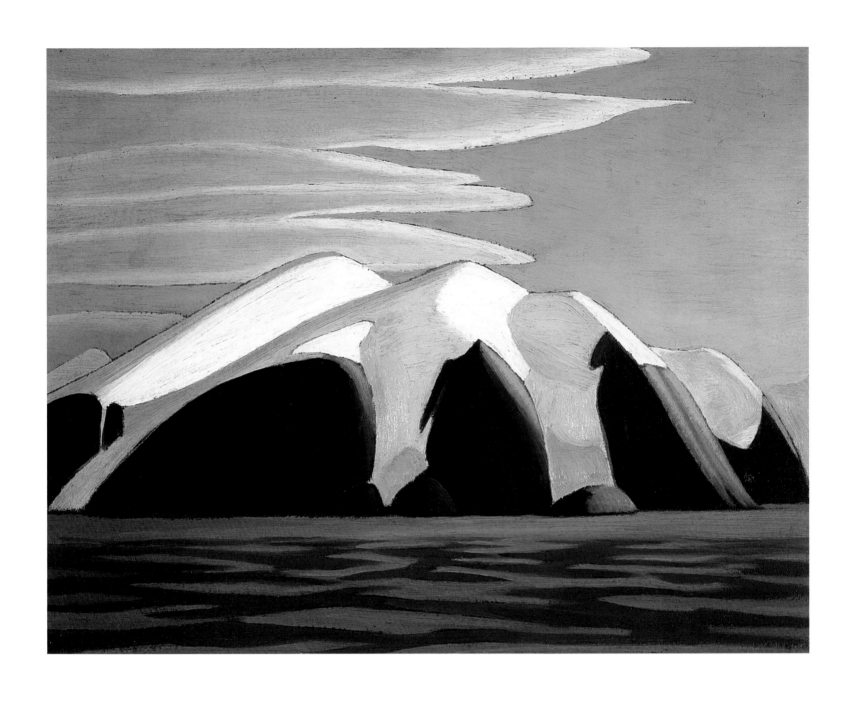

Lawren Harris *North Shore, Baffin Island* 1930

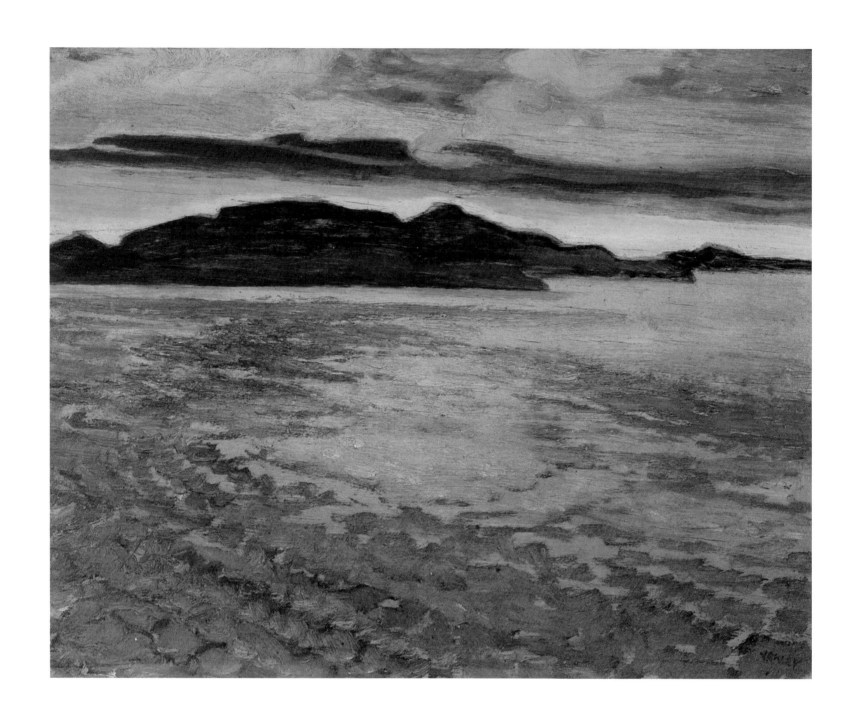

F.H. Varley *Midnight Sun* 1938

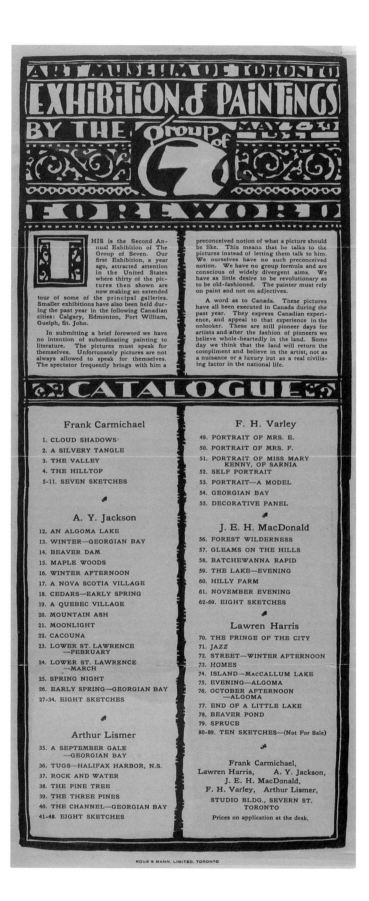

Group of Seven catalogue covers: First Exhibition, 1920;
Second Exhibition, 1921; Fourth Exhibition, 1925.

Chronology

1873 Birth of James Edward Hervey MacDonald, Durham, England, 12 May.

1877 Birth of Thomas John Thomson, near Claremont, Ontario, 4 August.

1881 Birth of Frederick Horsman Varley, Sheffield, England, 2 January.

1882 Birth of Alexander Young Jackson, Montreal, 3 October.

1885 Birth of Arthur Lismer, Sheffield, England, 27 June. Birth of Lawren Stewart Harris, Brantford, Ontario, 23 October.

1887 MacDonald's family returns to Hamilton, Ontario.

1888 Birth of Francis Hans Johnston, Toronto, 19 June.

1889 MacDonald moves to Toronto.

1890 Birth of Lionel LeMoine FitzGerald, Winnipeg, Manitoba, 17 March. Birth of Franklin Carmichael, Orillia, Ontario, 4 May.

1892 Birth of Edwin Headley Holgate, Allandale, Ontario, 19 August.

1893 Algonquin Park made a provincial game preserve.

1898 Birth of Alfred Joseph Casson, Toronto, 17 May.

1904 Harris goes to Germany to study art.

1907 MacDonald joins Grip Ltd, Toronto, where Albert Robson was manager. Thomson hired at Grip Ltd in 1907 or 1908.

1908 Johnston starts at Grip Ltd. Arts and Letters Club founded in Toronto.

1910 Eric Brown appointed director of the collection that became the National Gallery of Canada in 1913. Harris settles into studio at Yonge and Cumberland streets, after travelling and painting in the Middle East.

1911 MacDonald meets Harris. Lismer immigrates to Canada. Lismer and Carmichael join Grip Ltd. MacDonald leaves Grip to paint full-time.

1912 Thomson visits Algonquin Park for first time in May. Varley emigrates from England in August. Albert Robson moves to Rous and Mann Press, followed by Thomson, Carmichael, Johnston, and Lismer. Varley also joins Rous and Mann.

1913 Harris and MacDonald visit *Exhibition of Contemporary Scandinavian Art* in Buffalo, N.Y., in January. Jackson moves from Montreal to Toronto; meets MacDonald, Lismer, Varley, Harris, Thomson, and Dr James MacCallum. Thomson visits MacCallum at Go Home Bay in Georgian Bay with MacDonald and Jackson; leaves Rous and Mann to work full-time as an artist with support from MacCallum, who also supports Jackson.

1914 Completion of Studio Building, financed by Harris and MacCallum. Harris and MacDonald take space in Studio Building; Thomson and Jackson share a studio, January–February. Jackson visits Algonquin Park for the first time, February–March; goes west in April, for the summer. Thomson and Lismer in Algonquin Park in May for two weeks. First World War begins. Thomson, Jackson, Varley, and Lismer paint together in Algonquin Park in the fall. Jackson returns to Montreal in December. Thomson and Carmichael share a studio, then Thomson moves into shack behind Studio Building for winter of 1914–15.

1915 Jackson enlists; goes overseas in fall. MacCallum commissions murals by Thomson, Lismer, and MacDonald for his Go Home Bay cottage. Harris enlists and trains soldiers at Camp Borden.

1916 MacDonald, Jackson, Thomson, and Lismer visit Georgian Bay. Lismer hired as principal, Victoria School of Art and Design, Halifax.

1917 MacDonald suffers a stroke. Thomson drowns in Canoe Lake, Algonquin Park, 8 July. Cairn to Thomson's memory erected at Canoe Lake by MacDonald and J.W. Beatty. Jackson engaged to paint for Canadian War Memorials program in Europe. Lismer paints war activities in Halifax; formally joins Canadian War Memorials program in 1918. Harris has break-down and leaves military service after his brother is killed in Europe.

1918 Harris makes first trip to Algoma in May with MacCallum; returns to Algoma in the fall, with MacDonald, Johnston, and MacCallum. Varley paints for Canadian War Memorials program in Europe; Jackson continues as war artist. First World War ends.

1919 Memorial exhibition of Thomson's paintings in Montreal in March. Jackson paints in Halifax with Lismer for Canadian War Memorials. Jackson, Harris, MacDonald, and Johnston go to Algoma in September. Lismer returns to Toronto. Casson joins Rous and Mann.

1920 Memorial exhibition of Thomson's paintings at Art Museum of Toronto, February. Group of Seven forms in March (Harris, MacDonald, Lismer, Varley, Carmichael, Johnston, and Jackson – *in absentia*). First Group of Seven exhibition at Art Museum of Toronto, 7–27 May. Lismer to Algoma for first time, with Jackson, Harris, and MacDonald. Johnston leaves the Group.

1920–1 First American touring exhibition of Group of Seven paintings.

1921 Western Canada touring exhibition of Group of Seven paintings. Second Group of Seven exhibition at Art Museum of Toronto, 7–29 May. Harris and Jackson travel to Nova Scotia and Newfoundland.

1922 Third Group of Seven exhibition at Art Gallery of Toronto, 5–29 May. Hart House begins its collection by purchasing Jackson's *November.*

1923–4 Second American touring exhibition of Group of Seven paintings.

1924 First British Empire Exhibition, Wembley, England, April–October. Carmichael's first trip to Algoma, with Harris. MacDonald sketches in Rocky Mountains (Lake O'Hara) for first time. Harris and Jackson paint together in Rockies (Jasper, Alberta) for first time. Jackson teaches at Ontario College of Art, where Lismer is vice-principal.

1925 Fourth Group of Seven exhibition at Art Gallery of Toronto, 9 January–2 February. Second British Empire Exhibition, Wembley, England, May–October. Casson goes to Algoma for first time, with Harris, Jackson, and Carmichael. Jackson and Lismer visit Marius Barbeau in Quebec, in August. Harris goes to Cape Breton. Carmichael moves from Grip Ltd to Sampson-Matthews.

1926 Casson joins the Group of Seven. Fifth Group exhibition at Art Gallery of Toronto, 7–31 May. Jackson and Holgate visit Skeena River, British Columbia. Varley moves to Vancouver to teach at Vancouver School of Art. Publication of F.B. Housser's *A Canadian Art Movement.*

1927 Exposition d'art canadien, Musée du Jeu de paume, Paris, 10 April–10 May. Emily Carr travels to Toronto and meets Harris, Lismer, Jackson, and MacDonald. Jackson and Frederick Banting travel to the Arctic on the *Beothic.* MacDonald becomes principal of the Ontario College of Art, and Lismer begins the children's program at the Art Gallery of Toronto.

1928 Sixth Group of Seven exhibition at Art Gallery of Toronto, February. Jackson travels to the Yukon and Northwest Territories with Banting. Lismer paints in Rockies.

1929 Holgate joins the Group.

1930 Seventh Group of Seven exhibition at Art Gallery of Toronto, April. Exhibition of Group of Seven paintings at Art Association of Montreal, 3–18 May. Harris and Jackson travel to the Arctic in August, on the *Beothic.*

1931 Eighth and last Group exhibition at Art Gallery of Toronto, opens 4 December.

1932 FitzGerald joins the Group. MacDonald made full member of Royal Canadian Academy; dies in Toronto, 26 November. Carmichael leaves Sampson-Matthews to join staff of Ontario College of Art.

1933 Memorial exhibition of MacDonald's work at Art Gallery of Toronto in January. Group of Seven dissolves. Canadian Group of Painters formed.

1934 Harris moves to Hanover, New Hampshire, where he is artist-in-residence (unpaid) at Dartmouth College; begins to paint abstract canvases.

1936 Retrospective Exhibition of Paintings by Members of the Group of Seven 1919–1933, at National Gallery of Canada.

1938 Varley travels through the eastern Arctic, on the *Nascopie.* Harris moves to Santa Fe, New Mexico, and becomes a founding member of the Transcendental Painting Group.

1940 Harris moves to Vancouver.

1945 Carmichael dies in Toronto, 24 October.

1949 Johnston dies in Toronto, 9 July.

1956 FitzGerald dies in Winnipeg, 5 August.

1969 Lismer dies in Montreal, 23 March. Varley dies in Toronto, 8 September.

1970 Harris dies in Vancouver, 29 January.

1974 Jackson dies in Kleinburg, 5 April.

1977 Holgate dies in Montreal, 21 May.

1992 Casson dies in Toronto, 19 February.

Selected Bibliography

General

Art Gallery of Toronto. *The Development of Painting in Canada, 1665–1945/Le développement de la peinture au Canada, 1665–1945.* Exhibition catalogue. Toronto: Ryerson Press, 1945

Bermingham, Ann. *Landscape and Ideology.* Berkeley, Calif.: University of California Press, 1986

Buchanan, Donald W., editor. *Canadian Painters: From Paul Kane to the Group of Seven.* London: Phaidon, 1945

———. *The Growth of Canadian Painting.* Toronto: Collins, 1950

———. 'The Story of Canadian Art.' *Canadian Geographical Journal* 17, No. 6 (Dec 1938): 273–94

Colgate, William. *Canadian Art: Its Origin and Development.* Toronto: Ryerson Press, [1943]. Also Montreal: McGraw-Hill, 1967

Davis, Ann. *The Logic of Ecstacy: Canadian Mystical Painting, 1920–1940.* Toronto: University of Toronto Press, 1992

Duval, Paul. *Canadian Drawings and Prints.* Toronto: Burns and MacEachern, 1952

———. *Four Decades: The Canadian Group of Painters and Their Contemporaries.* Toronto: Clarke, Irwin, 1972

Harper, J. Russell. *Painting in Canada: A History.* Toronto: University of Toronto Press, 1966. 2nd ed., 1977. French-language ed., *La peinture au Canada des origines à nos jours,* Quebec City: Les Presses de l'université Laval, 1966

———. 'Three Centuries of Canadian Painting.' *Canadian Art* 19, No. 6 (Dec 1962): 405–52

Hill, Charles C. *Canadian Painting in the Thirties.* Ottawa: National Gallery of Canada, 1975. French-language ed., *Peinture canadienne des années trente*

Housser, Frederick B. 'The Amateur Movement in Canadian Painting.' In *Yearbook of the Arts in Canada, 1928–1929,* ed. by Bertram Brooker, 81–90. Toronto: Macmillan Company of Canada, 1929

Hubbard, Robert H. *An Anthology of Canadian Art.* Toronto: Oxford University Press, 1960

———. *Canadian Landscape Painting, 1670–1930.* Exhibition catalogue. Madison, Wis.: Elvehjem Art Center, 1973

———. *The Development of Canadian Art.* Ottawa: National Gallery of Canada, 1964 [1963]. French-language ed., *L'évolution de l'art au Canada*

———. 'Growth in Canadian Art.' In *The Culture of Contemporary Canada,* ed. by Julian Park, 95–142. Ithaca, N.Y.: Cornell University Press, 1957

Hubbard, Robert H., and Jean-René Ostiguy. *Three Hundred Years of Canadian Art.* Exhibition catalogue. Ottawa: National Gallery of Canada, 1967

Kamloops Art Gallery, Kamloops, B.C. *Towards the Group of Seven and Beyond: Canadian Art in the First Five Decades of the Twentieth Century.* Essay by Leslie Dawn; foreword by Jann L.M. Bailey. Exhibition catalogue. Kamloops: Kamloops Art Gallery, 1998

Lord, Barry. *The History of Painting in Canada: Toward a People's Art.* Toronto: N.C. Press, 1974

Lowrey, Carol. *Visions of Light and Air: Canadian Impressionism, 1885–1920.* Exhibition catalogue. New York: Americas Society Art Gallery, 1995

McInnes, Graham Campbell. *A Short History of Canadian Art.* Toronto: Macmillan Company of Canada, 1939. Another ed., retitled *Canadian Art,* 1950

Mellen, Peter. *Landmarks of Canadian Art.* Toronto: McClelland and Stewart, 1978

Murray, Joan. *Canadian Art in the Twentieth Century.* Toronto: Dundurn Press, 1999

———. *Impressionism in Canada: 1895–1935.* Exhibition catalogue. Toronto: Art Gallery of Ontario, 1973 [c1974]

Nasgaard, Roald. *The Mystic North: Symbolist Landscape Painting in Northern Europe and North America, 1890–1940.* Publication for an exhibition at the Art Gallery of Ontario, Toronto. Toronto: University of Toronto Press, 1984

Newlands, Anne. *Canadian Art: From Its Beginnings to 2000.* Toronto: Firefly Books, 2000

Reid, Dennis. *A Concise History of Canadian Painting.* Toronto: Oxford University Press, 1973. 2nd ed., 1988

Robertson, John K.B. 'Canadian Geography and Canadian Painting.' *Canadian Geographical Journal* 39, No. 6 (Dec 1949): 262–73

Robson, Albert H. *Canadian Landscape Painters.* Toronto: Ryerson Press, 1932

Saunders, Audrey. *Algonquin Story.* [Toronto:] Ontario Department of Lands and Forests, [1947]. Also 1963. 2nd ed., Whitney, Ont.: Friends of Algonquin Park, [1998]

Walton, Paul H. 'Beauty My Mistress: Hector Charlesworth as Art Critic.' *Journal of Canadian Art History* 15, No. 1 (1992): 85–107

Weisberg, Gabriel P. *Beyond Impressionism: The Naturalist Impulse.* New York: Harry N. Abrams, 1992

Woodcock, George. 'There Are No Universal Landscapes.' *Artscanada* 35, No. 3 (Oct–Nov 1978): 36–42

Wylie, Liz. *In the Wilds: Canoeing and Canadian Art.* Exhibition publication. Kleinburg, Ont.: McMichael Canadian Art Collection, 1998

Books

Boulet, Roger. *The Canadian Earth.* Biographies by Paul Duval; foreword by A.J. Casson. Toronto: Prentice-Hall, 1981

Duval, Paul. *Group of Seven Drawings.* Toronto: Burns and MacEachern, 1965

The Group of Seven: Why Not Eight or Nine or Ten?: Revelations by Members of the Arts and Letters Club, with Rare Illustrations from the Club's Archives. [Toronto:] Publication Committee, Arts and Letters Club of Toronto, [1995]

Harris, Lawren Stewart. *The Story of the Group of Seven.* Toronto: Rous and Mann Press, 1964

Housser, F.B. *A Canadian Art Movement: The Story of the Group of Seven.* Toronto: Macmillan Company of Canada, 1926

Hunkin, Harry Preston. *There Is No Finality … A Story of the Group of Seven.* 1st ed., Toronto: Burns and MacEachern, 1971. Another ed., retitled *A Story of the Group of Seven,* Toronto: McGraw-Hill Ryerson, 1976. Reprint, retitled *The Group of Seven: Canada's Great Landscape Painters,* Edinburgh: P. Harris, 1979

MacDonald, Thoreau. *The Group of Seven.* Canadian Art Series. Toronto: Ryerson Press, 1944

Mellen, Peter. *The Group of Seven.* Toronto: McClelland and Stewart, 1970. French-language ed., *Le Groupe des sept,* Laprairie, Que.: Éditions Marcel Broquet, 1980. Rev. English-language ed., 1981

Murray, Joan. *The Best of the Group of Seven.* With an essay by Lawren Harris. Edmonton: Hurtig, 1984. French-language ed., *Le Groupe des sept,* [Laprairie, Que:] Éditions M. Broquet, [1989?]. Reprint of English ed., Toronto: McClelland and Stewart, 1993

———. *Northern Lights: Masterpieces of Tom Thomson and the Group of Seven.* Toronto: Key Porter Books, 1994

Newlands, Anne. *The Group of Seven and Tom Thomson: An Introduction.* For children. Toronto: Firefly Books, 1995

Pattison, Jeanne L. *The Group of Seven and Tom Thomson: The McMichael Canadian Collection, Kleinburg, Ontario.* Kleinburg, Ont.: McMichael Canadian Art Collection, 1978

Putnam, Joyce. *Seven Years with the Group of Seven: A Memoir in Words and Pictures.* Preface by A.J. Casson. Kingston, Ont.: Quarry Press, 1991

Reid, Dennis. *The MacCallum Bequest of Paintings by Tom Thomson and Other Canadian Painters and the Mr and Mrs H.R. Jackman Gift of the Murals from the Late Dr MacCallum's Cottage Painted by Some of the Members of the Group of Seven/Le legs MacCallum, peintures par Tom Thomson et par d'autres peintres canadiens et le don de M et Mme H.R. Jackman de panneaux décoratifs du chalet de feu le Dr MacCallum peints par quelques-uns des membres du Groupe des sept.* Exhibition catalogue. Ottawa: National Gallery of Canada, 1969

Wistow, David. *Tom Thomson and the Group of Seven: Selected Works from the Collection of the Art Gallery of Ontario.* Medaenas Monographs on the Arts series. Toronto: Art Gallery of Ontario, 1982

Articles and Parts of Books

Amaya, Mario. 'Canada's Group of Seven.' *Art in America* 58, No. 3 (May–June 1970): 122–5

Bloore, Ronald L. 'The Group of Seven: Toronto and Ottawa: Then and Now.' *Artscanada* 27, No. 4 (Aug 1970): 52–4

Brooker, Bertram. 'Canada's Modern Art Movement.' *Canadian Forum* 6, No. 69 (June 1926): 276–9

Burrell, Martin. 'A New Art Movement.' In *Betwixt Heaven and Charing Cross,* New York: Macmillan, 1928, 163–71

Comfort, Charles. 'Georgian Bay Legacy.' *Canadian Art* 8, No. 3 (Spring 1951): 106–9

Davidson, Margaret. 'A New Approach to the Group of Seven.' *Journal of Canadian Studies/Revue d'études canadiennes* 4, No. 4 (Nov 1969): 9–16

Davies, Blodwen. 'The Canadian Group of Seven.' *American Magazine of Art* 25, No. 1 (July 1932): 13–22

Fulford, Robert. 'Regrouping the Group: Charles Hill to Curate Revisionist Exhibit on Group of Seven Painters at National Gallery, Ottawa.' *Canadian Art* 12 (Fall 1995): 68–77

Grande, John. 'Oh! Canada. Eh? Critical Responses to the Art Gallery of Ontario's Art for the Nation Exhibit, Toronto.' *Art Papers* 21 (May/June 1997): 92

Grier, Edmund Wyly, and A.Y. Jackson. 'Two Views of Canadian Art: Addresses by Mr Wyly Grier, R.C.A., O.S.A. and A.Y. Jackson, R.C.A., O.S.A. before the Empire Club of Toronto, February 26, 1925.' In *Empire Club of Canada Addresses,* 97–113

Harris, Lawren S. 'The Group of Seven in Canadian History.' In *Canadian Historical Association Annual Report 1948,* 28–38

Housser, F.B. 'The Group of Seven and Its Critics.' *Canadian Forum* 12, No. 137 (Feb 1932): 183–4

Jessup, Lynda. 'Art for a Nation?' *Fuse* 19, No. 4 (Summer 1996): 11–14

Lacroix, Laurier. 'Ombres portées: notes sur le paysage canadien avant le Groupe des sept. *Journal of Canadian Art History* 13, No. 1 (1990): 6–24

Lewis, Wyndham. 'Canadian Nature and Its Painters.' *Listener* 29 (Aug 1946). Reprint, *Delta* 26 (Oct 1966): 9–12

MacCallum, H.R. 'The Group of Seven: A Retrospect.' *Queen's Quarterly* 40, No. 2 (May 1933): 242–52

McInnes, G. Campbell. 'Upstart Crows.' *Canadian Forum* 16, No. 184 (May 1936): 14, 16

MacTavish, Newton. Chapter on Thomson and the Group of Seven. In *The Fine Arts in Canada.* Toronto: Macmillan Company of Canada, 1925. Reprint, Macmillan, 1950. Reprint, Toronto: Coles, 1973

Martinsen, Hanna E.H. *The Scandinavian Artists' Influence on the Canadian Painters in the Group of Seven.* Stockholm: Stockholms Universitet, 1980

Mellen, Peter. 'Canada's Group of Seven.' *Américas* 31, No. 10 (Oct 1979): 38–44

Pantazzi, Sybille. 'Group of Seven: Early Magazine Drawings.' *Canadian Antiques Collector* 4, No. 2 (Feb 1969): 22–3

Richmond, Leonard. 'A Portfolio of Drawings by Members of the Canadian Group of Seven.' *Studio* 91, No. 397 (April 1926): 244–7

Ridley, Hilda. 'Art and Canadian Life.' *Dalhousie Review* 14, No. 2 (1934–5): 214–20

Smith, George L. *Norman Gurd and the Group of 7: A History of the Sarnia Art Movement.* Brights Grove, Ont.: George L. Smith, 1974

Stillman, Terry. 'Book Illustrations by the Group of Seven.' *Antiques and Art* 6, No. 5 (June–July 1980): 32–6

Trepanier, Esther. 'Nationalisme et modernité: la reception critique du Groupe des sept dans la presse montréalaise francophone des années vingt.' *Journal of Canadian Art History* 17, No. 2 (1996): 28–57

Walton, Paul. H. 'The Group of Seven and Northern Development.' *RACAR* [*Revue d'art canadienne/Canadian Art Review*] 17, No. 2 (1990): 171–9

Webb, Ken. 'The Group of Seven.' *North/Nord* 23, No. 2 (March–April 1976): 2–5; French summary, 5

Exhibition Catalogues

Art Gallery of Toronto. *B. Brooker, Frank Carmichael, A.J. Casson, L.A.C. Panton.* Exhibition catalogue. Toronto, 1940

———. *Catalogue of an Exhibition of Contemporary British Water Colours, Wood Engravings by Clare Leighton, A.R.E., Arctic Sketches by Lawren Harris and A.Y. Jackson, R.C.A: May, 1931.* Toronto, 1931

Art Museum of Toronto. *Catalogue of Three Exhibitions: The Society of Canadian Painter-Etchers; J.E.H. MacDonald, A.R.C.A., Lawren Harris and Frank H. Johnston; and William Cruikshank, R.C.A.* Part-title for second exhibition: 'Algoma Sketches and Pictures by J.E.H. MacDonald, A.R.C.A., Lawren Harris and Frank H. Johnston.' Toronto, 1919

Art Museum of Toronto, later Art Gallery of Toronto. Publications for eight Group of Seven exhibitions: 7–27 May 1920, *Exhibition of Paintings,* pamphlet produced by the Group; 7–29 May 1921, broadsheet by the Group; 5–29 May 1922, pamphlet by the Group; 9 Jan–2 Feb 1925, list by the Group; 7–31 May 1926, gallery catalogue, including arts from French Canada; Feb 1928, gallery catalogue, including etchings by R.F. Logan; April 1930, gallery catalogue, including Canadian Society of Painter-Etchers and Toronto Camera Club; Dec 1931, gallery catalogue, including show of seascapes and waterfronts

Brandon University, Brandon, Man. *Doig Collection of Canadian Paintings, Featuring the Group of Seven.* Exhibition catalogue. Brandon, 1968

Canada House Gallery, London, England. *Group of Seven, Canadian Landscape Painters: A Travelling Exhibition from the McMichael Canadian Collection, Kleinburg, Ontario/Groupe des sept: peintres canadiens de paysages: une exposition itinérante de la collection canadienne McMichael, de Kleinburg, Ontario.* Exhibition catalogue. 1977

Canadian Masters from the Collection of Power Corporation of Canada, 1850–1950. [Quebec:] Musée du Séminaire de Québec, 1990

Dalhousie Art Gallery, Halifax. *Selections from the Sobey Collections, Part III, Tom Thomson, J.E.H. MacDonald, A.Y. Jackson and Frank H. Johnston, 16 December, 1983–29 January, 1984.* Exhibition catalogue. Halifax, 1983

Galleries of J. Merritt Maloney, Toronto. *Exhibition of Paintings: A.Y. Jackson, Fred S. Haines, Frank Carmichael, A.J. Casson.* Exhibition catalogue. Toronto, 1935

Hill, Charles C. *The Group of Seven: Art for a Nation.* Exhibition catalogue for National Gallery of Canada. Toronto: McClelland and Stewart, 1995. Also video recording of same title, based on the research of Charles C. Hill, presented by National Gallery of Canada, produced in association with Bravo!FACT, narrated by Gordon Pinsent, 1995

Kelly, Gemey. *Selections from the Sobey Collections, Part II, Lawren Harris, F.H. Varley, and Franklin Carmichael.* Exhibition catalogue. Halifax: Dalhousie Art Gallery, Dalhousie University, 1983

Mappin Art Gallery, Sheffield, England. *Our Home and Native Land: Sheffield's Canadian Artists: Arthur Lismer, Elizabeth Nutt, Stanley Royle, Frederick H. Varley and Their Contemporaries, 1991.* Sheffield: MAG, 1991

Mellors Galleries, Toronto. *Exhibition of the Work of Tom Thomson and J.E.H. MacDonald.* Exhibition catalogue. Toronto, 1939

National Gallery of Canada, Ottawa. *Catalogue of Arctic Sketches by A.Y. Jackson, R.C.A. and Lawren Harris.* Exhibition catalogue; 4 pp. Ottawa, 1930

———. *Retrospective Exhibition of Painting by Members of the Group of Seven 1919–1933.* Exhibition catalogue. Ottawa, 1936

Pattison, Jeanne L. *Group of Seven: Canadian Landscape Painters, from the McMichael Canadian Collection.* Catalogue for exhibition at Phillips Collection, Washington, D.C., 1977

Percival, Robert. *A Selection of Works by the Group of Seven.* Exhibition catalogue. Saint John, N.B.: New Brunswick Museum, Art Department, 1976

Reid, Dennis. *The Group of Seven.* Exhibition catalogue. Ottawa: National Gallery of Canada, 1970

Residenz, Munich, West Germany. *Group of Seven: Kanadische Landschafts-Maler: Eine Wanderausstellung der McMichael Canadian Collection, Kleinburg, Ontario, Kanada: unter der Schirmherrschaft des 'Department of External Affairs of Canada' und des 'Government of the Province of Ontario.'* Exhibition catalogue. 1977

Stacey, Robert, and Barbara Volkmann, with Rose-France Raddatz. *OKanada: Ausstellungen und Veranstaltungen der Akademie der Kunste, Berlin, und des Canadian Department of External Affairs in Zusammenarbeit mit Canada Council vom 5. Dezember 1982 bis 30. Januar 1983.* Exhibition catalogue. Akademie-Katalog 136. Berlin: Akademie der Kunste, [1982]

Tom Thomson Memorial Art Gallery, Owen Sound, Ont. *Tom Thomson and the Group of Seven: Opening Exhibition, May 27 to June 11, 1967.* Exhibition catalogue. Owen Sound, 1967

Vancouver Art Gallery, Vancouver, B.C. *Group of Seven.* Exhibition catalogue. Includes 'The Story of the Group of 7' by Lawren Harris and 'The National Movement in Canadian Painting' by Robert H. Hubbard. Vancouver, 1954

Public Collection Catalogues

Adamson, Jeremy. *The Hart House Collection of Canadian Painting.* [Toronto:] Published in association with the Art Committee of Hart House by University of Toronto Press, 1969

Art Gallery of Ontario, Toronto. *Art Gallery of Ontario: The Canadian Collection.* Toronto: McGraw-Hill, 1970

———. *Art Gallery of Ontario: Selected Works.* Toronto: 1990

Blodgett, Jean, Megan Bice, David Wistow, and Lee-Ann Martin. *The McMichael Canadian Art Collection.* Kleinburg, Ont.: McMichael Canadian Art Collection; Toronto: McGraw-Hill Ryerson, 1989. French-language ed., *La Collection McMichael d'art canadien*

Fox, Ross, and Grace Inglis. *The Art Gallery of Hamilton: Seventy-five Years (1914–1989).* Hamilton, Ont: Art Gallery of Hamilton, 1989

The Montreal Museum of Fine Arts. Foreword by Guy Cogeval; text by Nathalie Bondil, et al.; translation of French text by Margaret Clarke. Paris: Fondation BNP PARIBAS, Réunion des musées nationaux; Montreal: Montreal Museum of Fine Arts, 2001. French-language ed., *Le Musée des beaux-arts, Montréal*

Smart, Tom. *The Collection, London, Canada.* [London, Ont.:] London Regional Art and Historical Museums, 1990

The View from Here: Selections from the Canadian Historical Collection. Essay by Mary Jo Hughes. Issued in conjunction with an exhibition at the Winnipeg Art Gallery, 28 May–31 December 2000. Winnipeg: Winnipeg Art Gallery, 2000

Motion Pictures and Video Recordings

The Group of Seven – In Celebration. Contains three National Film Board films: *Canadian Landscape: An Intimate Portrait of Group of Seven Painter A.Y. Jackson,* directed by Radford Crawley, produced in 1941; *Lismer,* directed by Allan Wargon, produced in 1952; *Varley,* directed by Allan Wargon, produced in 1953. Video recording, VHS, 53 mins, 21 secs. Montreal: National Film Board of Canada, 1995

Images d'une rive nord: chefs-d'oeuvre du Groupe des sept et de Tom Thomson. Video recording, VHS, 28 mins. Toronto: Art Gallery of Ontario, 1990

The Passionate Canadians: Tom Thomson and the Group of Seven, 1910–1920. CBC production; produced and directed by Nancy Ryley; narration and personal commentary by Harry Adaskin. Video recording, VHS, 57 mins. [Toronto:] CBC Enterprises, 1977

Frank Carmichael

Art Gallery of Toronto. *Franklin Carmichael Memorial Exhibition.* Introduction by F.S. Haines. Toronto, 1947

Bice, Megan. *Light and Shadow: The Work of Franklin Carmichael.* With an essay by Mary Carmichael Mastin. Exhibition catalogue. Kleinburg, Ont.: McMichael Canadian Art Collection, 1990

Carmichael, Franklin. *A Portfolio of Drawings.* Hearst, Ont.: University College of Hearst, 1978

Franklin Carmichael: October Gold. Essay by Catharine Mastin. Landmarks/Oeuvres marquantes series. 1 folded sheet. Kleinburg, Ont.: McMichael Canadian Art Collection, 1987

McMichael Canadian Art Collection, Kleinburg, Ont. *Franklin Carmichael: Prints/gravures.* Kleinburg, 1984

Mastin, Catharine M. *Franklin Carmichael.* New Views on Canadian Art series. Kingston, Ont.: Quarry Press, 1995

———. *Portrait of a Spiritualist: Franklin Carmichael and the National Gallery of Canada Collection.* Exhibition catalogue; 20 pp. Ottawa: National Gallery of Canada, 2001. French-language ed., *Portrait d'un spiritualiste*

———. *Thorn-Apple Tree: Book Illustrations by Franklin Carmichael.* Exhibition catalogue; 1 folded sheet. Windsor, Ont.: Art Gallery of Windsor, 1992

Milroy, Sarah. 'A Portrait of Two Artists in One: Both Facets of Franklin Carmichael's Work – Commercial Design and Painting – Are Juxtaposed in a Current Show.' Review of exhibition at National Gallery of Canada. *Globe and Mail,* 12 January 2002, p. R5

Thom, Ian M. *Franklin Carmichael Watercolours.* Exhibition catalogue. Victoria, B.C.: Art Gallery of Greater Victoria, 1981

A.J. Casson

A.J. Casson: October, North Shore/Le rive nord en octobre. Essay by Susan Chykaliuk. Landmarks/Oeuvres marquantes series. 1 folded sheet. Kleinburg, Ont.: McMichael Canadian Art Collection, 1987

Casson, A.J. *My Favourite Watercolours, 1919–1957.* Foreword by Paul Duval. Toronto: Cerebrus, Prentice-Hall, 1982

Duval, Paul. *A.J. Casson.* Toronto: Roberts Gallery, 1975

———. *A.J. Casson, His Life and Works: A Tribute.* Toronto: Cerebrus, Prentice-Hall, 1980

———. *Alfred Joseph Casson: President, Royal Canadian Academy.* Canadian Art Series. Toronto: Ryerson Press, 1951

Gray, Margaret, Margaret Rand, and Lois Steen. *A.J. Casson.* Canadian Artists 1. Agincourt, Ont.: Gage, 1976

Jackson, Christopher E. *A.J. Casson: An Artist's Life.* Exhibition catalogue. Kleinburg, Ont.: McMichael Canadian Art Collection, 1998

McMaster University, Hamilton, Ont. *A.J. Casson: Retrospective.* Exhibition catalogue. Hamilton, 1971

The McMichael, Kleinburg, Ont. *A.J. Casson: From the McMichael Canadian Collection, Kleinburg, Ontario.* Exhibition catalogue; 1 folded sheet; for exhibition at the Brockville Civic Auditorium. Kleinburg, 1977

Murray, Joan. *A.J. Casson.* Exhibition catalogue. Windsor, Ont.: Art Gallery of Windsor, 1978

National Film Board of Canada. *A.J. Casson: The Only Critic Is Time.* Video recording (VHS), 28 mins; director, Michael Morningstar; producers, Michael Morningstar and Don Haig. Toronto: Film Arts, c1981

Thom, Ian M. *A.J. Casson: Early Works in the McMichael Canadian Collection/Premières oeuvres à la Collection McMichael d'art canadien.* Kleinburg, Ont.: McMichael Canadian Art Collection, 1984

———. *Casson's Cassons/Les Casson de Casson.* Exhibition catalogue. Kleinburg, Ont.: McMichael Canadian Art Collection, 1988

LeMoine FitzGerald

Ayre, Robert. 'Painter of the Prairies.' *Weekend Magazine* 8, No. 12 (22 March 1958)

Barwick, Frances Duncan. *Pictures from the Douglas M. Duncan Collection.* Toronto: University of Toronto Press, 1975

Bovey, Patricia E. *Lionel LeMoine FitzGerald, Bertram Brooker: Their Drawings.* Exhibition catalogue. Winnipeg: Winnipeg Art Gallery, 1975. 2nd ed., 1976. French-language ed., *Dessins de Lionel LeMoine FitzGerald et Bertram Brooker*

Bovey, Patricia E., and Ann Davis. *Lionel LeMoine FitzGerald (1890–1956): The Development of an Artist.* Exhibition catalogue. Winnipeg: Winnipeg Art Gallery, 1978. French-language ed., *Lionel LeMoine FitzGerald (1890–1956): l'évolution d'un artiste*

Coy, Helen. *FitzGerald as Printmaker: A Catalogue Raisonné of the First Complete Exhibition of His Printed Works.* Winnipeg: University of Manitoba Press, 1982

Davis, Ann. 'Living Harmony, British Columbia Landscapes: Vancouver Art Gallery; Exhibit.' *Canadian Art* 10 (Winter, 1993): 15

Eckhardt, Ferdinand. *L.L. FitzGerald, 1890–1956: A Memorial Exhibition 1958.* Exhibition catalogue. Winnipeg: Winnipeg Art Gallery, 1958

——. *Painting at Stratford, 1962: Nine Prairie Province Painters.* Includes section on FitzGerald. Exhibition catalogue. Stratford, Ont.: Stratford Festival, 1962

——. 'The Technique of L.L. FitzGerald.' *Canadian Art* 15, No. 2 (April 1958): 114–19, 149; French summary, 163–4

FitzGerald, Lionel LeMoine. *The Fitzgerald Alphabet.* 29 sheets in box. Norfolk, Va: Corinthian Publications, [1990?]

Foss, Brian. 'In Seclusion with Nature: The Later Work of L. Lemoine Fitzgerald, 1942 to 1956.' *Journal of Canadian Art History* 12, No. 2 (1989): 203–7

Glover, Patricia E. 'Manitoba Art.' *Canadian Antiques Collector* 6, No. 8 (Nov–Dec 1971): 73–8

Harris, Lawren S. 'LeMoine FitzGerald: Western Artist.' *Canadian Art* 3, No. 1 (Oct–Nov 1945): 10–13

McDougall, Anne. 'La facture magistrale de FitzGerald/Lionel LeMoine FitzGerald: Master of the Brushstroke.' *Vie des arts* 24, No. 97 (hiver 1979–80): 56–8, 92–3

Parke-Taylor, Michael. *In Seclusion with Nature: The Later Work of L. LeMoine FitzGerald, 1942–1956.* Exhibition catalogue. Winnipeg: Winnipeg Art Gallery, 1989

Winnipeg Art Gallery. *A New FitzGerald.* Exhibition catalogue; 1 folded sheet. Winnipeg, 1963

——. *The Winnipeg Art Gallery, 1912–1962: An Introduction to the History, the Activities and Collection.* Winnipeg, 1962

Wylie, Elizabeth. 'The Development of Spirituality in the Work of Lionel LeMoine FitzGerald, 1890–1956.' MFA thesis. Montreal: Concordia University, 1981. Canadian Theses on Microfiche No. 52705

Lawren Harris

Adamson, Jeremy. *Lawren S. Harris: Urban Scenes and Wilderness Landscapes, 1906–1930.* Exhibition catalogue. Toronto: Art Gallery of Ontario, 1978

Art Gallery of Toronto. *Lawren Harris: Paintings 1910–1948.* Biographical sketch by A.Y. Jackson; essay by Sydney Key. Exhibition catalogue. Toronto, 1948

Fairley, Barker. 'Some Canadian Painters: Lawren Harris.' *Canadian Forum* 1, No. 9 (June 1921): 275–8

Bell, Andrew. 'Lawren Harris: A Retrospective Exhibition of His Painting, 1910–1948.' *Canadian Art* 6, No. 2 (Christmas 1948): 50–3

Boyanoski, Christine. 'Charles Comfort's Lake Superior Village and the Great Lakes Exhibition.' *Journal of Canadian Art History* 12, No. 2 (1989): 174–98

Carr, Angela K. 'Portrait of Dr. Salem Bland: Another Spiritual Journey for Lawren S. Harris?' *Journal of Canadian Art History* 19, No. 2 (1998): 6–27

Christensen, Lisa. *A Hiker's Guide to the Rocky Mountain Art of Lawren Harris.* Calgary: Fifth House Publishers, 2000

Dalhousie Art Gallery, Halifax. *Lawren P. Harris, 37/72.* Exhibition catalogue. Halifax, 1972

Duncan, Norman. *Going Down from Jerusalem: The Narrative of a Sentimental Traveller.* Illustrations by Harris. New York and London: Harper and Brothers, 1909

Foss, Brian. '"Synchronism" in Canada: Lawren Harris, Decorative Landscape, and Willard Huntington Wright, 1916–1917.' *Journal of Canadian Art History* 20, No. 1/2 (1999): 68–91

Frye, Northrop. 'The Pursuit of Form.' *Canadian Art* 6, No. 2 (Christmas 1948): 54–7

Harris, Bess, and R.G.P. Colgrove, editors. *Lawren Harris.* Introduction by Northrop Frye. Toronto: Macmillan of Canada, 1969

Harris, Lawren. *Abstract Painting: A Disquisition.* Toronto: Rous and Mann Press, 1954

——. *Contrasts: A Book of Verse.* Toronto: McClelland and Stewart, 1922

——. 'Creative Art and Canada.' In *Yearbook of the Arts in Canada, 1928–1929,* pp. 177–86. Edited by Bertram Brooker. Toronto: Macmillan Company of Canada, 1929. Reprinted from *McGill News* (Dec 1928)

——. 'Different Idioms in Creative Art.' *Canadian Comment* 2, No. 12 (Dec 1933): 5–6, 32

——. 'An Essay on Abstract Painting.' *Royal Architectural Institute of Canada Journal* 26, No. 1 (Jan 1949): 3–8

——. 'Modern Art and Aesthetic Reactions: An Appreciation.' *Canadian Forum* 7 (May 1927): 239–41

——. 'Revelation of Art in Canada.' *Canadian Theosophist* 7, No. 5 (July 1926): 85–8

——. 'Theosophy and Art.' *Canadian Theosophist* 14, No. 5/6 (15 July/15 Aug 1933): 129–32/161–6

Hunter, Andrew. *Lawren Stewart Harris: A Painter's Progress.* Exhibition catalogue. New York: Americas Society, 2000

Jackson, Christopher. *Lawren Harris: North by West: The Arctic and Rocky Mountain Paintings of Lawren Harris, 1924–1931/Lawren Harris: le Grand Nord via l'Ouest: les tableaux de l'Arctique et des Rocheuses peints par Lawren Harris de 1924 à 1931.* Exhibition catalogue. Calgary: Glenbow Museum, 1991

Larisey, Peter. *The Landscape Painting of Lawren Stewart Harris.* Ph.D. thesis. New York: Columbia University, 1982

——. *Light for a Cold Land: Lawren Harris's Work and Life – An Interpretation.* Toronto: Dundurn Press, 1993

——. 'Nationalist Aspects of Lawren S. Harris's Aesthetics.' *National Gallery of Canada Bulletin/Galerie nationale du Canada Bulletin* 23 (1974): 3–9. French summary

——. 'A Portfolio of Landscapes by Lawren S. Harris/Carton de paysages de Lawren S. Harris.' *National Gallery of Canada Bulletin/Galerie nationale du Canada Bulletin* 23 (1974): 10–16

Lauder, Brian. 'Two Radicals: Richard Maurice Bucke and Lawren Harris.' *Dalhousie Review* 56, No. 2 (Summer 1976): 307–18

Lawren S. Harris. Artists of Canada series. Filmstrip with manual produced for the National Gallery of Canada by the National Film Board. [Ottawa:] National Film Board of Canada, 1965. French-language ed., *Lawren S. Harris*

Lawren S. Harris: Pic Island/Ile Pic. Essay by Susan Chykaliuk. Landmarks/Oeuvres marquantes series. 1 folded sheet. Kleinburg, Ont.: McMichael Canadian Art Collection, 1986

Linsley, Robert. 'Landscapes in Motion: Lawren Harris, Emily Carr and the Heterogenous Modern Nation.' *Oxford Art Journal* 19, No. 1 (1996): 80–95

Mandel, Eli. 'The Inward, Northward Journey of Lawren Harris.' *Artscanada* 35, No. 3 (Oct–Nov 1978): 17–24

Murray, Joan, and Robert Fulford. *The Beginning of Vision: The Drawings of Lawren S. Harris.* Toronto: Douglas and McIntyre, 1982

National Gallery of Canada, Ottawa. *Lawren Harris: Retrospective Exhibition, 1963/ Lawren Harris: exposition rétrospective, 1963.* Exhibition catalogue. Ottawa, 1963

Pfaff, L.R. 'Portraits by Lawren Harris: Salem Bland and Others.' *RACAR* [*Revue d'art canadienne/Canadian Art Review*] 5, No. 1 (1978): 21–7

Reid, Dennis. *Atma Buddhi Manas: The Later Work of Lawren S. Harris.* Exhibition catalogue. Toronto: Art Gallery of Ontario, 1985

———. 'Lawren Harris.' *Artscanada* 25, No. 5 (Dec 1968): 9–16

Robins, John. 'Lawren Harris.' *Canadian Review of Music and Other Arts* 3, Nos 3 and 4 (April, May 1944): 13–14

Smith, Sydney. 'The Recent Abstract Work of Lawren Harris.' *Maritime Art* 2, No. 3 (Feb–March 1942): 79–81

Street, Linda Marjorie. *Emily Carr: Lawren Harris and Theosophy, 1927–1933.* Dissertation. Ottawa: Carleton University, 1980

Trainor, James. 'Facing North.' *Border Crossings* 20, No. 1 (Feb 2001): 61–3

'What B.C. Means to Nine of Its Best Artists.' *Maclean's* 71, No. 10 (10 May 1958): 27–33

Edwin Holgate

Ayre, Robert. *The Laurentians: Painters in a Landscape.* Exhibition catalogue. Toronto: Art Gallery of Ontario, 1977. French-language ed., *Les Laurentides: peintres et paysage*

Chauvin, Jean. *Ateliers: études sur vingt-deux peintres et sculpteurs canadiens.* Montreal: Louis Carrier, 1928

Haviland, Richard H. 'Canadian Art and Artists – Edwin Headley Holgate.' *Montreal Standard* 23 July 1938

Reid, Dennis. *Edwin Holgate.* Canadian Artists Series 4. Ottawa: National Gallery of Canada, 1976. French-language ed., *Edwin Holgate*

Thom, Ian M. *The Prints of Edwin Holgate/Les gravures d'Edwin Holgate.* Exhibition catalogue. Kleinburg, Ont.: McMichael Canadian Art Collection, 1989

A.Y. Jackson

'Adventure in Art.' [About Jackson's trip to the Arctic.] *Canadian Forum* 8, No. 86 (Nov 1927): 424

Art Gallery of Hamilton, Hamilton, Ont. *A.Y. Jackson: A Retrospective Exhibition, March–April 1960.* Exhibition catalogue; 8 pp. Hamilton, 1960

Art Gallery of Toronto. *A.Y. Jackson: Paintings, 1902–1953.* Exhibition catalogue. Toronto, 1953

A.Y. Jackson: Winter Morning at St Tite des Caps/Matin d'hiver à St-Tite des Caps. Essay by Susan Chykaliuk. Landmarks/Oeuvres marquantes series. 1 folded sheet. Kleinburg, Ont.: McMichael Canadian Collection, [1986]

Ayre, Robert. 'A.Y. Jackson – The Complete Canadian.' *Educational Record* 70, No. 2 (April–June 1954): 79–84

Barbeau, Marius. 'Père Raquette [i.e., A.Y. Jackson].' *Revue moderne* 21, No. 11 (March 1940): 13, 24–7

Bennett, W.J. *The Eldorado Collection of A.Y. Jackson Sketches.* [Ottawa?:] Eldorado Nuclear, 1988.

Beston, Henry. *The St Lawrence.* Illustrated by Jackson. New York and Toronto: Farrar and Rinehart, [1942]

Buchanan, Donald W. 'A.Y. Jackson, the Development of Nationalism in Canadian Painting.' *Canadian Geographical Journal* (June 1946): 248–85

Crawley, Radford, director. *Canadian Landscape: An Intimate Portrait of Group of Seven Painter A.Y. Jackson.* Video recording of 1941 production, 18 mins. Montreal: National Film Board of Canada, 1994.

Davidson, True. 'The Creative Artist: A.Y. Jackson.' In *The Golden Strings,* pp. 93–102. Toronto: Griffin House, 1973

Dominion Gallery, Montreal. *A.Y. Jackson: Thirty Years of Painting.* Exhibition catalogue; 10 pp. Montreal, 1946

Firestone, O.J. *The Other A.Y. Jackson: A Memoir.* Toronto: McClelland and Stewart, 1979

Fisher, John W. 'Homage to A.Y. Jackson.' *Empire Club of Canada Addresses* (1972–3): 20–32

Gagnon, François-Marc. 'A.Y. Jackson, régionaliste québécois?.' *RACAR* [*Revue d'art canadienne/Canadian Art Review*] 21, No. 1/2 (1994): 60–70

Groves, Naomi Jackson. *A.Y.'s Canada: Pencil Drawings by A.Y. Jackson.* Toronto: Clarke, Irwin, 1968

———. *One Summer in Quebec: A.Y. Jackson in 1925: A Family View.* Kapuskasing, Ont.: Penumbra Press, 1988. French-language ed., *Un été au Québec en 1925,* Pointe-Claire, [Que.]: Roussan, [1991?]

Jackson, A.Y. 'Artist in the Mountains.' *Canadian Forum* 5, No. 52 (Jan 1925): 112–13

———. 'Box-Car Days in Algoma, 1919–20.' *Canadian Art* 14, No. 4 (Summer 1957): 136–41

———. 'The Development of Canadian Art.' *Royal Society of Arts Journal* 97, No. 4786 (Jan 1949): 129–43

———. *The Far North: A Book of Drawings by A.Y. Jackson.* Toronto: Rous and Mann Press, 1927

———. *A Painter's Country: The Autobiography of A.Y. Jackson.* Toronto: Clarke, Irwin, 1958. Another ed., 1967

———. 'Recollections on My Seventieth Birthday.' *Canadian Art* 10/11, No. 3/1 (Spring/Autumn 1953): 94–9

———. 'A Record of Total War.' *Canadian Art* 3, No. 4 (July 1946): 150–5

———. 'Reminiscences of Army Life, 1914–1918.' *Canadian Art* 11, No. 1 (Autumn 1953): 6–10

———. 'Sketching on the Alaska Highway.' *Canadian Art* 1, No. 3 (Feb–March 1944): 88–92

———. 'Sketching in Algoma.' *Canadian Forum* 1, No. 6 (March 1921): 174–5

———. 'The War Memorials: A Challenge.' *Lamps* (Dec 1919): 75–8

Jackson, A.Y., and Leslie F. Hannon. 'A Self-Portrait: A.Y. Jackson.' *Mayfair* 28, No. 9 (Sept 1954): 27–9, 58, 61–4, 67

Lismer, Arthur. *A.Y. Jackson: Paintings, 1902–1953.* Exhibition catalogue. Toronto: Art Gallery of Toronto, 1953

Purdy, Alfred. *North of Summer: Poems from Baffin Island.* With oil sketches of the Arctic by Jackson. Toronto: McClelland and Stewart, [1967]

Purdy, A.W., P.B. Baird, and Naomi Jackson Groves. 'A Profile of A.Y. Jackson.' *Beaver* 297 (Spring 1967): 15–19

Robson, Albert H. *A.Y. Jackson.* Canadian Artists Series. Toronto: Ryerson Press, 1938

Sabbath, Lawrence. 'A.Y. Jackson.' *Canadian Art* 17, No. 4 (July 1960): 240–1, 243–4

Tovell, Rosemarie L. 'A.Y. Jackson in France, Belgium and Holland: A 1909 Sketchbook/A.Y. Jackson en France, en Belgique et en Hollande: carnet de croquis de 1909.' *National Gallery of Canada Annual Bulletin/Galerie nationale du Canada Bulletin annuel* 2 (1978–9): 31–51

Frank Johnston

Arbuckle, Mrs Franklin. 'At Home with an Artist.' *Mayfair* 29 (June 1955): 36–7

Champlain College, Trent University, Peterborough, Ont. *Rodrik/Johnston.* Exhibition catalogue. Peterborough, 1973

Rodrik, Paul. *Frank H. Johnston, A.R.C.A.: 'Western sketchbook – 1924.'* 8 leaves, 8 plates. White Briar Publications, 1970

———. 'The Resurgent – Franz Johnston.' *Canadian Antique Collector* 5, No. 10 (Nov 1970): 24–5

———. *Franz Johnston in Retrospect, 1888–1949.* Exhibition catalogue. Stratford, Ont.: Rothman's Art Gallery, 1970

Winnipeg Art Gallery. *Exhibition of Paintings and Sketches by Frank H. Johnston, A.R.C.A., O.S.A.* Exhibition catalogue. Winnipeg: The Gallery, 1922

Woods, Kay. *Franz Johnston, Frances-Anne Johnston, Paul Rodrik.* Exhibition catalogue. Oshawa, Ont.: Robert McLaughlin Gallery, 1972

Arthur Lismer

Arthur Lismer: Bright Land. Essay by Catharine M. Mastin. Landmarks/Oeuvres marquantes series. 1 folded sheet. Kleinburg, Ont.: McMichael Canadian Art Collection, 1987

Ayre, Robert. 'Arthur Lismer.' *Canadian Art* 4, No. 2 (Feb–March 1947): 48–51

Barbeau, Marius, Arthur Lismer, and Arthur Bourinot. *Come a Singing!: Canadian Folk-Songs.* National Museum of Canada Bulletin 107. Anthropological Series 26. Ottawa: Department of Mines and Resources, Mines and Geology Branch, E. Cloutier, Printer to the King, 1947

———. *Folk-Songs of Old Quebec.* Illustrations by Arthur Lismer. Ottawa: National Museum of Canada, 1935? 2nd ed., Ottawa: Queen's Printer, 1962

Bell, Andrew. 'Lismer's Painting from 1913 to 1949 in Review.' *Canadian Art* 7, No. 3 (Spring 1950): 91–3

Blakely, Phyllis. 'Key Roles Played by the Nova Scotia College of Art.' *Atlantic Advocate* 57, No. 9 (May 1967): 33–9

Bridges, Marjorie Lismer. *A Border of Beauty: Arthur Lismer's Pen and Pencil.* Toronto: Red Rock, 1977

Daly, Tom, producer; Allan Wargon, director. *Lismer.* Video recording, VHS, 19 mins. Originally produced as a motion picture in 1952 in the Canadian Artists Series; produced by the NFB in cooperation with the National Gallery of Canada and the Montreal Museum of Fine Arts. Montreal: National Film Board of Canada, 1995

Darroch, Lois. *Bright Land: A Warm Look at Arthur Lismer.* Introduction by Walter Klinkhoff. Toronto: Merritt, 1981

Frye, Helen. 'Arthur Lismer.' *Food for Thought* 9, No. 1 (Oct 1948): 5–8, 32

Galleries of J. Merritt Malloney, Toronto. *Exhibition of Paintings, Sketches and Drawings by Arthur Lismer.* Exhibition catalogue; 1 folded sheet. Toronto, 1935

Grant, Anita. 'Lismer in Sheffield: Arthur Lismer's Early Years in England.' *Journal of Canadian Art History* 17, No. 1 (1996): 36–49

Grigor, Angela Nairne. *Arthur Lismer, Artist-Educator: The Professor Was a Rebel.* Montreal: McGill-Queen's University Press, 2002

Hambleton, Josephine. 'Art, Society and the Montreal Student.' *Dalhousie Review* 27, No. 1 (April 1947): 64–8

Harris, Lawren S. *Arthur Lismer: Paintings, 1913–1949.* Exhibition catalogue. Toronto: Art Gallery of Toronto, 1950

Hinterreiter, Gilda. 'Arthur Lismer, Artist and Art-Educator: A Reflection on His Life, Work and Philosophy.' *School Arts* 66, No. 5 (Jan 1967): 21–8

Hunter, E.R. 'Arthur Lismer.' *Maritime Art* 3, No. 5 (July–Aug 1943): 137–41, 168–9

Jackson, A.Y. 'Arthur Lismer.' *Educational Record* 71, No. 1 (Jan–March 1955): 11–17

———. 'Arthur Lismer: His Contribution to Canadian Art.' *Canadian Art* 7, No. 3 (Spring 1950): 89–90

Johnstone, Ken. 'The Professor Is a Rebel.' *New Liberty* (May 1951): 32–3, 44, 46–52

Kelly, Gemey. *Arthur Lismer – Nova Scotia, 1916–1919.* Exhibition catalogue. Halifax: Dalhousie Art Gallery, Dalhousie University, 1982

——. *Selections from the Sobey Collections, Part IV, Arthur Lismer.* Exhibition catalogue; 4 pp. Halifax: Dalhousie Art Gallery, Dalhousie University, 1984

Lismer, Arthur. 'Art Education and Art Appreciation.' *Rebel* 3, No. 5 (Feb 1920): 208–11

——. 'Canadian Art.' *Canadian Theosophist* 5, No. 12 (Feb 1925): 177–9

——. 'The Canadian War Memorials.' *Rebel* 4, No. 1 (Oct 1919): 40–2

——. *Education through Art for Children and Adults at the Art Gallery of Toronto: Being an Account of Development, Experiments and Progress of Educational Activities at the Art Gallery of Toronto During the Last Seven Years.* Toronto: Art Gallery of Toronto, 1936

——. 'Mural Painting.' *Royal Architectural Institute of Canada Journal* 10, No. 7 (July 1933): 127–35

——. *A Short History of Painting with a Note on Canadian Art.* Compiled for the use of teachers of art history and art appreciation in the schools and for art students. Toronto: Andrews Bros., 1926

Lord, Barry. 'Georgian Bay and the Development of the September Gale Theme in Arthur Lismer's Painting, 1912–1921.' *National Gallery of Canada Bulletin/Galerie nationale du Canada Bulletin* 5, No. 1–2 (1967): 28–38; French summary, 49

McLeish, John A.B. *September Gale: A Study of Arthur Lismer of the Group of Seven.* Toronto: J.M. Dent and Sons, 1955. 2nd ed., Toronto: J.M. Dent and Sons (Canada), 1973

Martin, Carol. *Arthur Lismer.* New Views on Canadian Art series. Kingston, Ont.: Quarry Press, 1995

Ottawa Art Gallery, Ottawa, Ont. *Arthur Lismer: Later Landscapes/Ses derniers paysages.* Firestone Art Collection. Exhibition catalogue; 1 folded sheet. Ottawa, 1994

Tolmatch, Elaine. *L'esthétique du paysage chez Arthur Lismer.* 2 vols. Montreal: Université de Montréal, 1978

Yanover, Shirley. *The Gallery School, 1930–1980: A Celebration.* Toronto: Art Gallery of Ontario, 1980

J.E.H. MacDonald

Cooke, Britton B. 'The Spirit of Travel: The Second of Two Sketches of Travel across Canada.' Decorations by J.E.H. MacDonald. *Canadian Magazine* 42 (1913–14): 31–8

Carman, Bliss. *Later Poems.* Decorations by J.E.H. MacDonald. Toronto: McClelland and Stewart, 1921

Dominion Gallery, Montreal. *J.E.H. MacDonald, Memorial Exhibition.* Exhibition catalogue. Montreal, [1947]

Duval, Paul. *The Tangled Garden.* Toronto: Cerebrus, Prentice-Hall, 1978

Hunter, E.R. 'J.E.H. MacDonald.' *Educational Record* 70, No. 3 (July–Sept 1954): 157–62

——. *J.E.H. MacDonald: A Biography and Catalogue of His Work.* Toronto: Ryerson Press, 1940

Jackson, A.Y. 'J.E.H. MacDonald.' *Canadian Forum* 13 (Jan 1933): 136–8

J.E.H. MacDonald: Forest Wilderness/Forêt sauvage. Essay by Susan Chykaliuk. Landmarks/Oeuvres marquantes series. 1 folded sheet. Kleinburg, Ont.: McMichael Canadian Art Collection, 1986

Kelly, Gemey, and Scott Robson, co-researcher. *J.E.H. MacDonald, Lewis Smith, Edith Smith: Nova Scotia.* Exhibition catalogue. Halifax: Dalhousie University, Dalhousie Art Gallery, 1990. French-language ed., *J.E.H. MacDonald, Lewis Smith, Edith Smith: Nouvelle-Ecosse*

MacDonald, J.E.H. 'A.C.R. 10557.' *Lamps* (Dec 1919): 33–9

——. 'The Choir Invisible.' *Canadian Forum* 3, No. 28 (Jan 1923): 111–3

——. 'Interior Decoration of St Anne's Church, Toronto.' *Royal Architectural Institute of Canada Journal* 2, No. 3 (May–June 1925): 85–93

——. J.E.H. MacDonald's 'West Indian Journal.' Edited by Doris Huestis Speirs. *Artscanada* 29, No. 5 (Dec–Jan 1972–3): 17–36

——. *Sketchbook, 1915–1922.* Introduction by Hunter Bishop. Facsimile ed. Moonbeam, Ont.: Penumbra Press, 1979

——. 'The Terrier and the China Dog.' *Rebel* 3, No. 2 (Dec 1918): 55–60

——. *West by East and Other Poems.* With drawings by Thoreau MacDonald. Toronto: Ryerson Press, 1933

——. *A Word to Us All: Being a Message for Canadians Here Written and Illumined by James MacDonald, November, 1900.* Prefatory note by Thoreau MacDonald. Toronto: Ryerson Press, 1945. Another ed., note by Robert Stacey, Toronto: McBurnie-Cutler Editions, co-published by the Archives of Canadian Art, 1996

Mckay, Marylin. 'St. Anne's Anglican Church, Toronto: Byzantium versus Modernity.' *Journal of Canadian Art History* 18, No. 1 (1997): 6–24

Maclure, John. 'Hidden Treasures of a Shy Rebel.' *Maclean's* 78, No. 21 (1 Nov 1965): 23–6, 52, 54, 56

Mastin, Catharine M. *J.E.H. Macdonald, Logs on the Gatineau.* Exhibition catalogue; 1 folded sheet. Windsor, Ont.: Art Gallery of Windsor, 1991

Mellors Galleries, Toronto. *A Loan Exhibition of the Work of J.E.H. MacDonald, R.C.A.* Exhibition catalogue. Essay by Barker Fairley. Toronto, November 1937

Middleton, J.E. 'J.E.H. MacDonald, an Appreciation.' *Lamps* (Dec 1932): 1–4, supplement

National Gallery of Canada. *Annual Exhibition of Canadian Art 1933.* Exhibition catalogue. Includes selection of works by J.E.H. MacDonald, as a memoriam. Ottawa, 1933

——. *Exploring the Collections: Bouquets from a Tangled Garden.* Exhibition catalogue; 8 pp., by Charles C. Hill. Ottawa: National Gallery of Canada, 1975

Pierce, Lorne. *A Postscript on J.E.H. MacDonald, 1873–1932.* Toronto: Ryerson Press, 1940

Robertson, Nancy. *J.E.H. MacDonald, R.C.A., 1873–1932.* Exhibition catalogue. Toronto: Printed by Rous and Mann Press [for Art Gallery of Toronto, 1965]

Robson, Albert H. *J.E.H. MacDonald, R.C.A.* Toronto: Ryerson Press, 1937. Another ed., 1946

Stacey, Robert. *J.E.H. MacDonald, Designer: An Anthology of Graphic Design, Illustration and Lettering.* With research by Hunter Bishop. Ottawa: Archives of Canadian Art, 1996

Whiteman, Bruce. *J.E.H. MacDonald.* Kingston, Ont.: Quarry Press, 1995

Addison, Ottelyn, and Elizabeth Harwood. *Tom Thomson: The Algonquin Years.* Toronto: Ryerson Press, 1969

Art Gallery of Toronto. *Catalogue of a Memorial Exhibition of Paintings by Tom Thomson, and a Collection of Japanese Colour Prints Loaned by Sir Edmund Walker.* Toronto: Art Gallery of Toronto, 1920

Arts Club of Montreal. *Catalogue of an Exhibition of Paintings by the Late Tom Thomson, March 1 to March 21, 1919.* Foreword by A.Y. Jackson

Atherton, Ray. 'The Man in a Canoe.' *Canadian Art* 5, No. 2 (Christmas 1947): 56–8. Reprint, *Canadian Art* 15, No. 1 (Jan 1958): 20–1; French summary, 74–5

Betts, Jim. *Colours in the Storm: A Gallery of Scenes and Songs on the Life of Tom Thomson.* Play. 1st ed., Feb 2000. Toronto: Playwrights Canada Press, 2000, c1990

Buchanan, Donald W. 'Tom Thomson, Painter of the True North.' *Canadian Geographical Journal* 33, No. 2 (Aug 1946): 98–100

Colgate, William. *Two Letters of Tom Thomson, 1915 and 1916.* Weston, Ont.: Old Rectory Press, 1946. Originally published in *Saturday Night* 62 (9 Nov 1946): 20

Davies, Blodwen. *Paddle and Palette: The Story of Tom Thomson.* Notes for the pictures by Arthur Lismer. Toronto: Ryerson Press, 1930

——. *A Study of Tom Thomson: The Story of a Man Who Looked for Beauty and for Truth in the Wilderness.* Foreword by A.Y. Jackson; sketches by Arthur Lismer. Toronto: Discus Press, 1935. Another ed., retitled *Tom Thomson: The Story of a Man Who Looked for Beauty and for Truth in the Wilderness,* Vancouver, B.C.: Mitchell Press, 1967

Fairley, Barker. 'Tom Thomson and Others.' *Rebel* 3, No. 6 (March 1920): 244–8

Frayne, Trent. 'The Rebel Painter of the Pine Woods.' *Maclean's* 66, No. 13 (1 July 1953): 16–17, 30–3

Frye, Northrop. 'Canadian and Colonial Painting.' *Canadian Forum* 20, No. 242 (March 1941): 377–8. Reprinted in *The Bush Garden: Essays on the Canadian Imagination,* Toronto: Anansi, 1971, 199–202

Hubbard, R.H. *Tom Thomson.* Toronto: Society for Art Publications, and McClelland and Stewart, 1962

Hunter, Andrew. *Stand by Your Man, or, Annie Crawford Hurn: My Life with Tom Thomson.* Published in conjunction with an exhibition produced by the Edmonton Art Gallery, in partnership with the Art Gallery of Hamilton. Edmonton: Edmonton Art Gallery, [2001]

——. *Up North: A Northern Ontario Tragedy.* Published in conjunction with an exhibition held at Tom Thomson Memorial Art Gallery, Owen Sound, 1997. Owen Sound, Ont.: Thomson Books, 1997

Kitchener-Waterloo Art Gallery. *Tom Thomson Exhibition, 1877–1917: Opening Exhibition, September–October 1956.* 8 pp. Kitchener, 1956

Lamb, H. Mortimer. 'Studio-Talk: Tom Thomson.' *Studio* 77, No. 317 (Aug 1919): 119–26. Reprint, *International Studio* 68, No. 271 (Sept 1919): 119–26

Lismer, Arthur. *Outline for Picture Study: Spring Ice by Tom Thomson.* 3 pp. Ottawa: National Gallery of Canada, [196-?]

——. 'Tom Thomson (1877–1917): Canadian Painter.' *Educational Record* 70, No. 3 (July–Sept 1954): 170–5

——. 'Tom Thomson, 1877–1917: A Tribute to a Canadian Painter.' *Canadian Art* 5, No. 2 (Christmas 1947): 59–62

——. 'The West Wind.' *McMaster Monthly* 43, No. 4 (Jan 1934): 162–4

Little, R.P. 'Some Recollections of Tom Thomson and Canoe Lake.' *Culture* 16, No. 2 (June 1955): 200–8

Little, William T. *The Tom Thomson Mystery.* Toronto: McGraw-Hill, 1970. Another ed., 1973

MacCallum, James M. 'Tom Thomson: Painter of the North.' *Canadian Magazine* 50, No. 5 (March 1918): 375–85

MacDonald, J.E.H. 'A Landmark of Canadian Art.' *Rebel* 2, No. 2 (Nov 1917): 45–50

MacGregor, Roy. *Shorelines, a Novel.* Toronto: McClelland and Stewart, 1980

McInnes, Graham, producer and director. *West Wind.* Video recording, VHS, of a 1944 production. Montreal: National Film Board of Canada, 1995. French-language ed., *Bourrasque*

Mellors Galleries, Toronto. *Loan Exhibition of Works by Tom Thomson.* Introduction by J.M. MacCallum. Exhibition catalogue. Toronto, 1937

Murray, Joan. *The Art of Tom Thomson.* Exhibition catalogue. Toronto: Art Gallery of Ontario, 1971. French-language ed., *L'art de Tom Thomson*

——. *The Best of Tom Thomson.* Edmonton: Hurtig, 1986

——. *Tom Thomson: Design for a Canadian Hero.* Toronto: Dundurn Press, 1998

——. *Tom Thomson: The Last Spring.* Toronto: Dundurn Press, 1994

——. *Tom Thomson.* New Views on Canadian Art series. Kingston, Ont.: Quarry Press, 1996

——. *Tom Thomson: A Sketchbook.* Toronto: Golden Press, 1996

——. *Tom Thomson: Trees.* Toronto: McArthur and Co., 1999

Musée du Jeu de paume, Paris, France. *Exposition d'art canadien.* Exhibition catalogue; includes retrospective of paintings by Tom Thomson. Organized by National Gallery of Canada, 1927

National Gallery of Canada, Ottawa, Extension Services. *Tom Thomson: Sketches/Esquisses.* Exhibition catalogue; 1 folded sheet. Ottawa, 1966

Ontario Agricultural College, Guelph, Ont. *Unveiling of 'The Drive,' a Northern Ontario Landscape Painting by Tom Thomson in the War Memorial Hall, Friday Evening, January 8th, 1926.* 4 pp. Guelph, 1926.

Pringle, Gertrude. 'Tom Thomson, the Man, Painter of the Wilds Was a Very Unique Individuality.' *Saturday Night* 41, No. 21 (10 April 1926): 5

Reid, Dennis. 'Photographs by Tom Thomson.' *National Gallery of Canada Bulletin/Galerie nationale du Canada Bulletin* 16 (1970): 2–36

——. *Tom Thomson: 'The Jack Pine'/Tom Thomson: 'Le pin.'* Masterpieces in the National Gallery of Canada series. Ottawa: National Gallery of Canada, 1975

Robson, Albert H. *Tom Thomson.* Canadian Artists Series. Toronto: Ryerson Press, 1937

Sharpe, Dr Noble. 'The Canoe Lake Mystery.' *Canadian Society of Forensic Science Journal* 3, No. 2 (June 1970): 34–40

Silcox, David P., and Harold Town. *Tom Thomson, the Silence and the Storm.* Toronto: McClelland and Stewart, 1977. French-language ed., *Tom Thomson, le calme et la tempête,* Laprairie, Que.: Éditions Marcel Broquet, 1983. 4th English ed., with new preface, Firefly Books, 2001

Thomas John (Tom) Thomson: Six Sketches/Six croquis. Essay by Megan Bice. Landmarks/Oeuvres marquantes series. 1 folded sheet. Kleinburg, Ont.: McMichael Canadian Art Collection, 1988

Tom Thomson Memorial Art Gallery, Owen Sound, Ont. *Algonquin Memories: Tom Thomson in Algonquin Park.* Essay by Laura Millard. Catalogue for exhibition organized by the Tom Thomson Memorial Art Gallery for the Algonquin Gallery. Owen Sound, Ont.: Thomson Books, 1998

——. *Paintings by Tom Thomson: The Second Anniversary Exhibition, May 23 to June 15, 1969.* Owen Sound, 1969

Tom Thomson Memorial Gallery and Museum of Fine Art, Owen Sound, Ont. *The Tom Thomson Memorial Exhibition.* Exhibition catalogue. Owen Sound, 1977

Town, Harold. 'The Pathfinder.' In *Great Canadians: A Century of Achievement,* selected by Vincent Massey, et al., pp. 108–10. Canadian Centennial Library. [Toronto: Canadian Centennial Publishing Co., 1965].

Vancouver Art Gallery. *Tom Thomson.* Exhibition catalogue; 8 pp. Essay by Ian M. Thom. Vancouver, 1990

Willistead Art Gallery, Windsor, Ont. *Tom Thomson, 1877–1917: October 6– November 2, 1957.* Exhibition catalogue. Windsor, 1957

F.H. Varley

Brown, Jeremy. 'Varley and Shortt: Their Voyage on the 'Nascopie' in 1938.' *Beaver* 309, No. 2 (Autumn 1978): 54–7

Buchanan, Donald W. 'The Paintings and Drawings of F.H. Varley.' *Canadian Art* 7, No. 1 (Oct 1949): 2–5

Burnaby Art Gallery, Burnaby, B.C. *Varley: The Middle Years.* Exhibition catalogue; 20 pp. Burnaby, 1974

Carpenter, Edmund. *Eskimo.* Sketches and paintings by Varley and illustrations of Robert Flaherty's collection of Eskimo carvings. Toronto: University of Toronto Press, 1959

Elliott, George. 'F.H. Varley – Fifty Years of His Art.' *Canadian Art* 12, No. 1 (Autumn 1954): 2–8

Fairley, Barker. 'Canadian War Pictures.' *Canadian Magazine* 54, No. 1 (Nov 1919): 3–11

——. 'F.H. Varley.' *In Our Living Tradition: Second and Third Series,* pp. 151–69. Edited by Robert L. McDougall. Toronto: University of Toronto Press, 1959

F.H. Varley: Early Morning, Sphinx Mountain/Tôt le matin, montagne du Sphinx. Essay by Megan Bice. Landmarks/Oeuvres marquantes series. 1 folded sheet. Kleinburg, Ont.: McMichael Canadian Art Collection, 1988

Hubbard, R.H. *F.H. Varley: Paintings, 1915–1954.* Exhibition catalogue. Toronto: Art Gallery of Toronto, 1954

MacDonald, Wilson Pugsley. *The Miracle Songs of Jesus.* Illustrations on end-papers by Varley. [2d ed.] Toronto: Ryerson Press, [1923?, c1921]

MacInnes, Thomas Robert Edward. *Complete Poems of Tom MacInnes.* Title-page and lining papers illustrated by Varley. Toronto: Ryerson Press, [1923]

——. *In the Old of My Age: A New Book of Rhymes.* Title-page and jacket by Varley and Thoreau MacDonald. Toronto: Ryerson Press, 1947

Milroy, Sarah. 'Varley in Paradise.' *Canadian Art* 17, No. 1 (Spring 2000): 76–81

Morris Gallery, Toronto. *Frederick Varley: Works on Paper.* Exhibition catalogue; 8 pp. Toronto, 1973

Porter, McKenzie. 'Varley.' *Maclean's* 72, No. 23 (7 Nov 1959): 30–3, 62, 64, 66, 71

Pratt, E.J. *Newfoundland Verse.* Decorations by Varley. Toronto: Ryerson Press, 1923

Stacey, Robert. 'Fall Fruit: Frederick Varley's Painting Trip to Algonquin Park, Ontario.' *Canadian Art* 14 (Spring 1997): 86

Stacey, Robert, and Sharon Gaum-Kuchar. *Varley: A Celebration.* Exhibition catalogue. Markham, Ont.: Frederick Horsman Varley Art Gallery of Markham, 1997

Tippett, Maria. *Stormy Weather: F.H. Varley, a Biography.* Toronto: McClelland and Stewart, 1998

Tooby, Michael. *Frederick Varley.* New Views on Canadian Art series. Kingston, Ont.: Quarry Press, 1995

Varley, Christopher. *F.H. Varley.* Canadian Artists Series 6. Ottawa: National Gallery of Canada, 1979. French-language ed., *F.H. Varley*

——. *F.H. Varley: A Centennial Exhibition/F.H. Varley: une exposition centenaire.* Exhibition catalogue. Edmonton: Edmonton Art Gallery, 1981

Varley, Peter. *Frederick H. Varley.* Preface by Jean Sutherland Boggs. Introduction by Joyce Zemans. Toronto: Key Porter Books, 1983

Willistead Art Gallery, Windsor, Ont. *F.H. Varley Retrospective 1964.* Exhibition catalogue; 16 pp. Windsor, 1964

LIST OF WORKS REPRODUCED

2 Tom Thomson, *The West Wind*, 1916–1917.
Oil on canvas; 120.7 × 137.9 cm; Art Gallery of
Ontario, Toronto. Gift of the Canadian Club
of Toronto, 1926. 784.
Photo: Carlo Catenazzi/AGO.

3 Tom Thomson, *The Jack Pine*, 1916–1917.
Oil on canvas; 127.9 × 139.8 cm;
National Gallery of Canada, Ottawa.
Purchased 1918. 1519.

4 F.H. Varley, *Squally Weather, Georgian Bay*, 1920.
Oil on wood; 30.0 × 40.9 cm; National Gallery
of Canada, Ottawa. Gift of Mrs. S.J. Williams,
Mrs. Harvey Sims, Mrs. T.M. Cram, and Miss
Geneva Jackson, Kitchener, 1943. 4582.
© 2003 Estate of Kathleen G. McKay.

8 Luncheon at the Arts and Letters Club,
Toronto, c. 1920.
Gelatin Silver print (vintage) on paper; 9.0
× 12.2 cm; Art Gallery of Ontario, Toronto.
Transferred from the E.P. Taylor Research
Library and Archives, Art Gallery of Ontario,
1996. 96/59.

10 Tom Thomson, c. 1905.
Photo: McMichael Canadian Art Collection
Archives, Kleinburg.

F.H. Varley at the Doon Summer School of
Fine Arts, Doon, Ontario, c. 1949.
Photo: The Frederick Varley fonds, Edward P.
Taylor Research Library and Archives,
Art Gallery of Ontario, Toronto. Gift of Mrs.
Donald McKay PH-643. © 2003 Estate of
Kathleen G. McKay.

Lawren Harris, c. 1920
Photo: Courtesy The Edward P. Taylor
Research Library and Archives, Art Gallery
of Ontario, Toronto. PH-683.

Arthur Lismer sketching in the bush,
Lake Temagami, August, 1944.
Photo: Courtesy Marjorie Lismer Bridges and
Art Gallery of Ontario, Toronto. PH-261 #1.

A.Y. Jackson preparing to leave the Studio
Building, Toronto, January, 1955.
Photo: WEEKEND staff photo by Jock Carroll.
Courtesy Naomi Jackson Groves and Art
Gallery of Ontario, Toronto. PH-173
Reproduction courtesy the Carroll family.

J.E.H. MacDonald, c. 1911.
Photo: Courtesy the Arts and Letters Club,
Toronto.

12 Edwin Holgate, n.d.
Photo: Courtesy the Holgate Estate and David
Rittenhouse.

Franklin Carmichael, c. 1912.
Photo: Courtesy Art Gallery of Ontario,
Toronto. PH-596 #1.

A.J. Casson, n.d.
Photo: Courtesy The Edward P. Taylor
Research Library and Archives, Art Gallery of
Ontario, Toronto. PH-389.

LeMoine Fitzgerald, n.d.
Photo: Courtesy The Edward P. Taylor
Research Library and Archives, Art Gallery of
Ontario, Toronto. Digital file A-08185.

Frank Johnston, c. 1925.
Photo: Courtesy the Arts and Letters Club,
Toronto.

24 Lawren Harris, four black and white prints
created for a portfolio published in 1925 by
Rous and Mann, Toronto in an edition of 100.
Each print was reproduced on a single sheet.

28 A.Y. Jackson, four black and white prints
created for a portfolio published in 1925 by
Rous and Mann, Toronto in an edition of 100.
Each print was reproduced on a single sheet.

32 Arthur Lismer, four black and white prints
created for a portfolio published in 1925 by
Rous and Mann, Toronto in an edition of 100.
Each print was reproduced on a single sheet.

36 J.E.H. MacDonald, four black and white prints
created for a portfolio published in 1925 by
Rous and Mann, Toronto in an edition of 100.
Each print was reproduced on a single sheet.

40 F.H. Varley, four black and white prints
created for a portfolio published in 1925 by
Rous and Mann, Toronto in an edition of 100.
Each print was reproduced on a single sheet.
© 2003 Estate of Kathleen G. McKay.

52 Tom Thomson, *Study for Northern River*,
1914–1915.
Ink and gouache on wove paper;
29.9 × 26.5 cm; Art Gallery of Ontario, Toronto.
Purchased 1982. 82/176.
Photo: Larry Ostrom/AGO.

53 Tom Thomson, *Moccasin Flower (Orchid,
Algonquin Park)*, c 1915.
Oil on panel; 26.7 × 21.6 cm;
Private Collection.

54 Lawren Harris, *Return from Church*, c. 1919.
Oil on panel; 26.6 × 32.4 cm;
Private Collection. Photo: Christine Guest.

55 Lawren Harris, *Isolation Peak*, c. 1930. Oil on canvas; 104.2 × 124.5 cm; Hart House Permanent Collection, University of Toronto. Purchased with income from the Harold and Murray Wrong Memorial Fund, 1946. Photo: Thomas Moore.

56 A.Y. Jackson, *The Winter Road*, 1921. Oil on canvas; 53.3 × 63.5 cm; Private Collection. Photo: Nancy Rahija.

57 A.Y. Jackson, *The Red Maple*, 1914. Oil on canvas; 82.0 × 99.5 cm; National Gallery of Canada, Ottawa. Purchased 1914. 1038.

58 J.E.H. MacDonald, *October Shower Gleam*, 1922. Oil on canvas; 105.4 × 120.7 cm; Hart House Permanent Collection, University of Toronto. Purchased with income from the Harold and Murray Wrong Memorial Fund, 1933. Photo: Thomas Moore.

59 J.E.H. MacDonald, *The Tangled Garden*, 1916. Oil on beaverboard; 121.4 × 152.4 cm; National Gallery of Canada, Ottawa. Gift of W.M. Southam, F.N. Southam, and H.S. Southam, 1937, in memory of their brother, Richard Southam. 4291.

60 Arthur Lismer, *The Guide's Home, Algonquin*, 1914. Oil on canvas; 102.6 × 114.4 cm; National Gallery of Canada, Ottawa. Purchased 1915. 1155.

61 Arthur Lismer, *Isles of Spruce*, 1922. Oil on canvas; 114.3 × 133.3 cm; Hart House Permanent Collection, University of Toronto. Purchased 1928.

62 Frank Carmichael, *Grace Lake*, 1931. Oil on canvas; 101.6 × 122.0 cm; University College Art Collection, University of Toronto Art Centre. Photo: Nancy Rahija.

63 Frank Carmichael, *Autumn Hillside*, 1920. Oil on canvas; 76.0 × 91.4 cm; Art Gallery of Ontario, Toronto. Gift from the J.S. McLean Collection, Toronto, 1969; donated by the Ontario Heritage Foundation, 1988. L69.16. Photo: Larry Ostrom/AGO.

64 F.H. Varley, *Vera*, 1931. Oil on canvas; 61.0 × 50.6 cm; National Gallery of Canada, Ottawa. Vincent Massey Bequest, 1968. 15559. © 2003 Estate of Kathleen G. McKay.

65 F.H. Varley, *Open Window*, c. 1933. Oil on canvas; 102.3 × 87.0 cm; Hart House Permanent Collection, University of Toronto. Purchased with income from the Harold and Murray Wrong Memorial Fund, 1944. © 2003 Estate of Kathleen G. McKay.

66 Edwin Holgate, *Totem Poles, Gitsegiuklas*, 1927. Oil on canvas; 80.9 × 81.1 cm; National Gallery of Canada, Ottawa. Purchased 1939. 4426.

67 Edwin Holgate, *Ludivine*, 1930. Oil on canvas; 76.3 × 63.9 cm; National Gallery of Canada, Ottawa. Vincent Massey Bequest, 1968. 15478.

68 LeMoine FitzGerald, *The Pool*, 1934. Oil on canvas, mounted on masonite; 36.2 × 43.7 cm; National Gallery of Canada, Ottawa. Purchased 1973. 17612.

69 LeMoine FitzGerald, *Doc Snyder's House*, 1931. Oil on canvas; 74.9 × 85.1 cm; National Gallery of Canada, Ottawa. Gift of P.D. Ross, Ottawa, 1932. 3993.

70 A.J. Casson, *Old Store at Salem*, 1931. Oil on canvas; 76.7 × 91.5 cm; Art Gallery of Ontario, Toronto. Gift from the J.S. McLean Collection, by Canada Packers Inc., Toronto, 1990. 89/785. (CP 141) Photo: Carlo Catenazzi/AGO.

71 A.J. Casson, *House Tops in the Ward*, 1924. Oil on canvas; 113.0 × 93.0 cm; The Thomson Collection, The Hudson's Bay Company Gallery.

72 Frank Johnston, *Fire-swept, Algoma*, 1920. Oil on canvas; 127.5 × 167.5 cm; National Gallery of Canada, Ottawa. Purchased 1920. 1694.

73 Frank Johnston, *Beamsville*, 1918–1919. Oil and charcoal on canvas; 182.8 × 137.1 cm; Canadian War Museum, War Art Collection, Ottawa. 19710261-0243.

77 A.Y. Jackson, *Blue Gentians*, 1913. Oil on canvas; 53.0 × 48.3 cm; McMichael Canadian Art Collection, Kleinburg. Gift of Miss D.E. Williams. 1975.1.1.

78 (upper) Arthur Lismer, *Poppies, Bedford Park Avenue*, 1924. Oil on panel; 30.5 × 39.7 cm; The Thomson Collection, The Hudson's Bay Company Gallery. Photo: Nancy Rahija.

78 (lower) Frank Johnston, *Near the Berry Patch*, c. 1920. Oil on paperboard; 26.9 × 33.2 cm; National Gallery of Canada, Ottawa. Purchased 1958. 6940.

79 (upper) Frank Carmichael, *Wild Cherry Blossoms*, c. 1932. Oil on board; 25.4 × 30.5 cm; The Thomson Collection, The Hudson's Bay Company Gallery. Photo: Nancy Rahija.

79 (lower) J.E.H. MacDonald, *Flower Border, Usher's Farm, York Mills*, 1918. Oil on panel; 21.6 × 26.7 cm; The Thomson Collection, The Hudson's Bay Company Gallery. Photo: Nancy Rahija.

80 J.E.H. MacDonald, *Asters and Apples*, 1917. Oil on beaverboard; 53.4 × 66.1 cm; National Gallery of Canada, Ottawa. Purchased 1917. 1427.

81 Arthur Lismer, *Lilies and Apples*, 1931.
Oil on cardboard; 30.7 × 40.5 cm;
National Gallery of Canada, Ottawa.
Purchased 1947. 4892.

82 Tom Thomson, *Wild Flowers*, 1916.
Oil on board; 15 × 25 cm; Collection of Tom
Thomson Memorial Art Gallery, Owen Sound.
Gift of Mrs. J.G. Henry, sister of the artist.

83 Tom Thomson, *Marguerites, Wood Lilies and
Vetch*, 1915.
Oil on wood panel; 21.4 × 26.8 cm; Art Gallery
of Ontario, Toronto. Gift from the Albert H.
Robson Memorial Subscription Fund, 1941. 2563.

84 LeMoine FitzGerald, *Interior*, c. 1948.
Oil on canvas; 75.0 × 69.4 cm; Collection
of Power Corporation of Canada/Collection
Power Corporation du Canada, Montreal.
Photo: Joyner Fine Art.

85 LeMoine FitzGerald, *The Little Plant*, 1947.
Oil on canvas; 60.5 × 45.7 cm; McMichael
Canadian Art Collection, Kleinburg.
Gift of Mr. R.A. Laidlaw. 1969.2.4.

86 (upper) Edwin Holgate, *Nude*, 1930.
Oil on canvas; 64.8 × 73.6 cm; Art Gallery
of Ontario, Toronto. Gift from Friends of
Canadian Art Fund, 1930. 1326. Photo: Larry
Ostrom/AGO.

86 (lower) Edwin Holgate, *Nude in a Landscape*,
c. 1930.
Oil on canvas; 73.1 × 92.3 cm; National Gallery
of Canada, Ottawa. Purchased 1930. 3702.

87 Edwin Holgate, *Interior*, c. 1933.
Oil on canvas; 76.2 × 63.5 cm; Art Gallery
of Ontario, Toronto. Purchased, 1933. 2155.
Photo: Larry Ostrom/AGO.

88 F.H. Varley, *Self-portrait*, 1919.
Oil on canvas; 60.5 × 51.0 cm; National Gallery
of Canada, Ottawa. Purchased 1936. 4272.
© 2003 Estate of Kathleen G. McKay.

89 F.H. Varley, *Self-portrait*, 1945.
Oil on canvas; 49.5 × 40.7 cm; Hart House
Permanent Collection, University of Toronto.
Purchased 1949. © 2003 Estate of Kathleen
G. McKay.

90 F.H. Varley, *Mrs. E.*, 1921.
Oil on canvas; 103.2 × 86.4 cm; Art Gallery of
Ontario, Toronto. Gift of Mrs. E.F. Ely, Toronto,
1946. 2852. ©2003 Estate of Kathleen G. McKay.

91 F.H. Varley, *Jess*, 1950.
Oil on canvas; 55.9 × 40.7 cm;
Private Collection. © 2003 Estate of Kathleen
G. McKay. Photo: Nancy Rahija.

92 F.H. Varley, *Girl in Red*, c. 1921.
Oil on canvas; 53.2 × 51.6 cm; McMichael
Canadian Art Collection, Kleinburg.
In memory of H. Laurence Rous. 1968.15.
© 2003 Estate of Kathleen G. McKay.

93 F.H. Varley, *Sunflowers*, c. 1921.
Oil on canvas; 61.0 × 50.8 cm; Private
Collection. © 2003 Estate of Kathleen
G. McKay. Photo: Nancy Rahija.

94 Lawren Harris, *Bess*, 1920.
Oil on canvas; 112.5 × 92.2 cm; Art Gallery of
Ontario, Toronto. Gift of L.S.H. Holdings Ltd.,
Vancouver, 1989. 89/113.
Photo: Carlo Catenazzi/AGO.

95 Lawren Harris, *Dr. Salem Bland*, 1925.
Oil on canvas; 103.5 × 91.4 cm; Art Gallery of
Ontario, Toronto. Gift of the Toronto Daily Star,
1929. 1320-A. Photo: Carlo Catenazzi/AGO.

96 (upper) Frank Carmichael, *Woman in a Black
Hat*, 1939.
Oil on canvas; 51.0 × 41.2 cm: Confederation
Centre of the Arts, Charlottetown.

96 (lower) Lawren Harris, *Mrs. Oscar Taylor*, 1920.
Oil on canvas; 96.8 × 112.2 cm; National Gallery
of Canada, Ottawa. Purchased 1964. 14668.

97 F.H. Varley, *Alice Massey*, c. 1924–1925.
Oil on canvas; 82.0 × 61.7 cm;
National Gallery of Canada, Ottawa.
Vincent Massey Bequest, 1968. 15558.
© 2003 Estate of Kathleen G. McKay.

98 F.H. Varley, *Study of Joan (Fairley)*, c. 1923.
Oil on canvas; 43.2 × 33.0 cm; The Thomson
Collection, The Hudson's Bay Company Gallery.
© 2003 Estate of Kathleen G. McKay.
Photo: Nancy Rahija.

99 F.H. Varley, *Rocky Shore*, 1921.
Oil on board; 56.8 × 40.0 cm;
Private Collection. © 2003 Estate of Kathleen
G. McKay. Photo: Nancy Rahija.

100 (upper left) Edwin Holgate, *Fire Ranger*,
1925–1926.
Oil on canvas; 54.0 × 45.7 cm; Hart House
Permanent Collection, University of Toronto.
Purchased 1926.

100 (upper right) Edwin Holgate, *Forest Ranger*,
c. 1926.
Charcoal on paper; 67.8 × 50.9 cm; Collection of
the Mendel Art Gallery, Saskatoon. 1987.6.7.

100 (lower left) Edwin Holgate, *Paul, Trapper*,
c. 1929.
Oil on canvas; 65.2 × 55.3 cm;
Musée du Québec, Quebec City. 38.14.

100 (lower right) Edwin Holgate, *The Lumberjack*,
1924.
Oil on canvas; 64.8 × 56.6 cm;
Gallery Lambton, Sarnia. Gift of Sarnia
Women's Conservation Art Association, 1956.

101 (upper left) Edwin Holgate, *The Naturalist*, 1941.
Oil on canvas; 64.7 × 54.5 cm;
Musée du Québec, Quebec City. 46.160.
Photo: Patrick Altman.

101 (upper right) Edwin Holgate, *The Skier (Portrait of Herman "Jackrabbit" Johannsen)*, c. 1935. Oil on canvas; 66.5 × 56.6 cm; The Montreal Museum of Fine Arts Collection. Arthur M. Terroux Bequest. 1980.9. Photo: Brian Merrett/MMFA.

101 (lower left) Edwin Holgate, *Chief Tsimshian Jim Larahnitz*, 1926. Charcoal and brown chalk on paper; 58.5 × 47.1 cm; Musée du Québec, Quebec City. Purchased 1935. 35.01. Photo: Jean-Guy Kérouac.

101 (lower right) Edwin Holgate, *Portrait of Stephen Leacock*, 1943. Oil on canvas; 76.3 × 63.8 cm; National Gallery of Canada, Ottawa. Purchased 1948. 4881.

102 Edwin Holgate, *Lady by the Window*, c. 1946. Oil on masonite; 46.0 × 48.7 cm; Collection of Power Corporation of Canada/Collection Power Corporation du Canada, Montreal.

103 Edwin Holgate, *The Cellist*, 1923. Oil on canvas; 128.0 × 97.5 cm; McMichael Canadian Art Collection, Kleinburg. Gift of the Founders, Robert and Signe McMichael. 1972.18.2.

104 (upper) Arthur Lismer, *Severn River*, 1925. Oil on board; 30.5 × 40.0 cm; Private Collection. Photo: Sotheby's.

104 (lower) Arthur Lismer, *My Wife, Sackville River, Nova Scotia*, 1918. Oil on panel; 22.7 × 30.6 cm; Art Gallery of Ontario, Toronto. Gift of the artist, Montreal, 1951. 50/48. Photo: Carlo Catenazzi/AGO.

111 (upper) A.Y. Jackson, *The Old Gun, Halifax*, 1919. Oil on canvas; 54.2 × 65.4 cm; Art Gallery of Hamilton. Gift of the artist, 1954.

111 (lower) A.Y. Jackson, *The Entrance to Halifax Harbour*, 1919. Oil on canvas; 64.8 × 80.6 cm; Tate Gallery, London, England. Purchased 1924. N3967.

112 (upper) Arthur Lismer, *Halifax Harbour, Time of War*, 1918. Oil on canvas; 102.5 × 130.0 cm; Dalhousie Art Gallery, Halifax. Gift of the artist, 1954.

112 (lower) Arthur Lismer, *Winter Camouflage*, 1918. Oil on canvas; 71.5 × 91.6 cm; National Gallery of Canada, Ottawa. Purchased 1918. 1488.

113 (upper) Arthur Lismer, *Convoy at Sea*, 1920. Oil on canvas; 163.2 × 213.3 cm; MacKenzie Art Gallery, Regina, University of Regina Collection. Gift of Regina Boat Club. Photo: Don Hall.

113 (lower) A.Y. Jackson, *The Convoy*, 1919. Oil on canvas; 61.4 × 92.5 cm; National Gallery of Canada, Ottawa. Royal Canadian Academy of Arts diploma work, deposited by the artist, Toronto, 1921. 1817.

114 F.H. Varley, *Gas Chamber at Seaford*, 1918. Oil on canvas; 111.7 × 142.1 cm; Canadian War Museum, War Art Collection, Ottawa. 19710261-0772. © 2003 Estate of Kathleen G. McKay.

115 A.Y. Jackson, *Camouflaged Huts, Villers-au-Bois*, 1917. Oil on canvas; 88.1 × 111.7 cm; Canadian War Museum, War Art Collection, Ottawa. 19710261.0166.

116 A.Y. Jackson, *A Copse, Evening*, 1918. Oil on canvas; 86.4 × 111.8 cm; Canadian War Museum, War Art Collection, Ottawa. 19710261-0186.

117 A.Y. Jackson, *Springtime in Picardy*, 1919. Oil on canvas; 65.1 × 77.5 cm; Art Gallery of Ontario, Toronto. Gift from the Albert H. Robson Memorial Subscription Fund, 1940. 2544. Photo: Larry Ostrom/AGO.

118 F.H. Varley, *For What?*, 1918. Oil on canvas; 147.4 × 180.6 cm; Canadian War Museum, War Art Collection, Ottawa. 19710261-0770. © 2003 Estate of Kathleen G. McKay.

119 F.H. Varley, *The Sunken Road*, 1918. Oil on canvas; 132.7 × 162.7 cm; Canadian War Museum, War Art Collection, Ottawa. 19710261-0771. © 2003 Estate of Kathleen G. McKay. Photo: William Kent.

120 F.H. Varley, *Burnt-out Tank*, 1918. Oil on wood; 21.4 × 26.9 cm; National Gallery of Canada, Ottawa. Purchased 1978. 18945. © 2003 Estate of Kathleen G. McKay.

121 F.H. Varley, *German Prisoners*, 1918. Oil on canvas; 127.0 × 183.8 cm; Canadian War Museum, War Art Collection, Ottawa. 19710261-0807. © 2003 Estate of Kathleen G. McKay.

122 Frank Johnston, *Looking into the Blue*, 1919. Watercolour on board; 57.5 × 72.1 cm; Canadian War Museum, War Art Collection, Ottawa. 19710261-0252.

129 (upper) A.Y. Jackson, *Smoke Fantasy*, 1932. Oil on canvas; 81.3 × 101.6 cm; Magna International. Photo: Sotheby's.

129 (lower) Lawren Harris, *Building the Ice House, Hamilton*, c. 1912. Oil on panel; 26.7 × 32.4 cm; Private Collection.

130 J.E.H. MacDonald, *Tracks and Traffic*, 1912. Oil on canvas; 71.1 × 101.6 cm; Art Gallery of Ontario, Toronto. Gift of Walter C. Laidlaw, Toronto, 1937. 2435. Photo: Carlo Catenazzi/AGO.

131 Lawren Harris, *The Gas Works*, 1911–1912. Oil on canvas; 58.6 × 56.4 cm; Art Gallery of Ontario, Toronto. Gift from the McLean Foundation, 1959. 58/22. Photo: Carlo Catenazzi/AGO.

132 Lawren Harris, *The Eaton Manufacturing Building*, 1911. Oil on canvas; 76.2 × 75.0 cm; Private Collection. Photo: Nancy Rahija.

133 Lawren Harris, *Billboard (Jazz)*, 1920. Oil on canvas; 108.0 × 127.6 cm; Imperial Oil Limited. Photo: Peter Ure.

134 Lawren Harris, *Old Houses, Toronto, Winter*, 1919. Oil on canvas; 82.6 × 98.1 cm; Art Gallery of Ontario, Toronto. Gift of the Canadian National Exhibition Association, Toronto, 1965. 2590.

135 Lawren Harris, *Red Sleigh, House, Winter*, 1919. Oil on canvas; 116.8 × 132.1 cm; Sidney Dawes Collection, McGill University, Montreal.

136 Lawren Harris, *The Corner Store*, 1912. Oil on canvas; 88.5 × 66.2 cm; Art Gallery of Ontario, Toronto. Bequest of Mary Gordon Nesbitt, Toronto, 1992. 92/113. Photo: Carlo Catenazzi/AGO.

137 (upper) Lawren Harris, *Toronto Street, Winter Morning*, 1920. Oil on canvas; 97.5 × 112.2 cm; National Gallery of Canada, Ottawa. Gift of the artist, Vancouver, 1960. 5010.

137 (lower) Lawren Harris, *Houses on Wellington Street*, 1910. Oil on canvas; 63.5 × 76.2 cm; Private Collection. Photo: Christine Guest.

138 Lawren Harris, *Toronto, Old Houses*, 1911. Oil on canvas; 38.1 × 38.1 cm; Alan O. Gibbons. Photo: Harquail Photography, Ottawa.

139 Lawren Harris, *Houses, Richmond Street*, 1911. Oil on canvas; 76.2 × 81.3 cm; The Thomson Collection, The Hudson's Bay Company Gallery. Photo: Nancy Rahija.

140 A.J. Casson, *Winter House*, c. 1942. Oil on board; 21.0 × 25.4 cm; Private Collection. Photo: Sotheby's.

141 Lawren Harris, *Winter Afternoon, City Street, Toronto*, 1918. Oil on canvas; 102.9 × 114.3 cm; The Thomson Collection, The Hudson's Bay Company Gallery.

142 (upper left) LeMoine FitzGerald, *Pritchard's Fence*, c. 1928. Oil on canvas; 71.6 × 76.5 cm; Art Gallery of Ontario, Toronto. Bequest of Isabel E.G. Lyle, 1951. 51/19. Photo: Carlo Catenazzi/AGO.

142 (upper right) LeMoine FitzGerald, *Williamson's Garage*, 1927. Oil on canvas; 55.9 × 45.7 cm; National Gallery of Canada, Ottawa. Purchased 1929. 3682.

142 (lower) LeMoine FitzGerald, *Fort Garry Store*, c. 1929. Oil on canvas; 101.6 × 152.4 cm; Private Collection. Photo: Sotheby's.

143 LeMoine FitzGerald, *From an Upstairs Window, Winter*, c. 1950–1951. Oil on canvas; 61.0 × 45.7 cm; National Gallery of Canada, Ottawa. Purchased 1951. 5800.

144 Lawren Harris, *Pine Tree and Red House*, c. 1920. Oil on canvas; 81.3 × 96.5 cm; Alan O. Gibbons. Photo: Harquail Photography, Ottawa.

145 Lawren Harris, *Red House, Winter*, c. 1925. Oil on canvas; 84.5 × 97.5 cm; Hart House Permanent Collection, University of Toronto. Gift of the graduating class of 1932.

146 Arthur Lismer, *Springtime on the Farm*, 1917. Oil on canvas; 66.1 × 81.3 cm; The Montreal Museum of Fine Arts Collection. Purchase: A. Sidney Dawes Fund. 1956.1124. Photo: Brian Merrett/MMFA.

147 Lawren Harris, *Hurdy Gurdy*, 1913. Oil on canvas; 75.8 × 86.6 cm; Art Gallery of Hamilton. Gift of Roy G. Cole, 1992.

148 Lawren Harris, *Chestnut Tree, House, Barrie*, 1916–1917. Oil on canvas; 113.0 × 101.6 cm; Sidney Dawes Collection, McGill University, Montreal. Photo: Christine Guest.

149 F.H. Varley, *The Wonder Tree* (also known as *Magic Tree*), 1924. Oil on canvas mounted on panel; 52.7 × 52.7 cm; Hart House Permanent Collection, University of Toronto. Purchased 1925. © 2003 Estate of Kathleen G. McKay. Photo: Thomas Moore.

150 (upper) LeMoine FitzGerald, *At Silver Heights*, 1931. Oil on canvas on board; 35.8 × 40.2 cm; Art Gallery of Ontario, Toronto. Purchased 1981. 81/7. Photo: Larry Ostrom/AGO.

150 (lower) LeMoine FitzGerald, *Untitled (Poplar Woods; Poplars)*, 1929. Oil on canvas; 71.8 × 91.5 cm; Collection of The Winnipeg Art Gallery. Acquired in memory of Mr. and Mrs. Arnold O. Brigden. G-75-66. Photo: Ernest Mayer, The Winnipeg Art Gallery.

151 (left) LeMoine FitzGerald, *Untitled (Tree Study II)*, 1949. Oil on canvas; 43.6 × 24.5 cm; Collection of The Winnipeg Art Gallery. Gift from the Estate of Arnold O. Brigden. G-73-325. Photo: Ernest Mayer, The Winnipeg Art Gallery.

151 (upper right) A.J. Casson, *First Snow, Grenadier Pond*, 1921. Oil on board; 23.5 × 28.5 cm; Art Gallery of Windsor Collection. Gift of Louis L. and Patricia Odette, Edmond G. and Gloria Odette, 1978. 1978.002.

151 (lower right) A.J. Casson, *Hillside Village*, 1927. Watercolour and black chalk on wove paper; 55.6 × 47.6 cm; Art Gallery of Ontario, Toronto. Gift from the Reuben and Kate Leonard Canadian Fund, 1928. 1283. Photo: Larry Ostrom/AGO.

152 (upper) A.J. Casson, *Anglican Church at Magnetawan*, 1933. Oil on canvas; 94.2 × 115.0 cm; National Gallery of Canada, Ottawa. Purchased 1939. 4270.

152 (lower) A.J. Casson, *Thunderstorm*, 1933.
Oil on canvas; 76.2 × 91.5 cm;
Private Collection. Photo: Nancy Rahija.

153 (upper) A.J. Casson, *Credit Forks*, c. 1930.
Graphite and watercolour on wove paper;
46.6 × 56.8 cm; Art Gallery of Ontario, Toronto.
Gift from Friends of Canadian Art Fund, 1930.
1327. Photo: Larry Ostrom/AGO.

153 (lower) A.J. Casson, *Mill Houses*, 1928.
Oil on canvas; 76.2 × 92.2 cm; Collection of
Agnes Etherington Art Centre, Queen's
University, Kingston. Presented by Mr. and
Mrs. Duncan K. MacTavish, 1955.
Photo: Larry Ostrom.

154 (upper) J.E.H. MacDonald, *Spring Breezes,
High Park*, 1912.
Oil on canvas; 71.1 × 92.2 cm; National Gallery
of Canada, Ottawa. Purchased 1948. 4874.

154 (lower) J.E.H. MacDonald, *Sleeping Fields*, 1915.
Oil on canvas; 40.6 × 50.8 cm;
Private Collection. Photo: Sotheby's.

155 J.E.H. MacDonald, *Cattle by the Creek*, 1918.
Oil on canvas; 65.6 × 82.3 cm; National Gallery
of Canada, Ottawa. Purchased 1918. 1489.

156 LeMoine FitzGerald, *Farmyard*, 1931.
Oil on canvas; 34.9 × 42.6 cm; National Gallery
of Canada, Ottawa. Vincent Massey Bequest,
1968. 15474.

157 J.E.H. MacDonald, *Pump and Pumpkins*, 1916.
Oil on canvas; 53.3 × 66.0 cm; Collection of
Power Corporation of Canada/Collection Power
Corporation du Canada, Montreal.

158 Lawren Harris, *Untitled (Lake Simcoe Summer)*,
1918.
Oil on board; 26.8 × 32.1 cm; Collection of The
Winnipeg Art Gallery. Gift from the Estate of
Arnold O. Brigden. G-73-269. Photo: Ernest
Mayer, The Winnipeg Art Gallery.

159 Lawren Harris, *Summer Houses, Grimsby*, c. 1926.
Oil on canvas; 91.4 × 101.6 cm;
Private Collection. Photo: Joyner Fine Art.

160 Lawren Harris, *Winter Landscape with Pink House*,
1918.
Oil on canvas; 119.4 × 126.4 cm;
Collection of Toronto Dominion Bank
Financial Group.

165 Arthur Lismer, *Seal Cove, Grand Manan*, 1931.
Oil on canvas; 91.4 × 101.6 cm;
Sidney Dawes Collection, McGill University,
Montreal. Photo: Christine Guest.

166 (upper) J.E.H. MacDonald, *Seashore, Nova Scotia*,
1923.
Oil on canvas; 71.7 × 91.7 cm; National Gallery
of Canada, Ottawa. Purchased 1923. 2914.

166 (lower) Arthur Lismer, *Fishing Village, New
Brunswick*, 1929.
Oil on wood; 29.8. × 40.4 cm; National Gallery
of Canada, Ottawa. Purchased 1958. 6950.

167 (upper) J.E.H. MacDonald, *Old Dock, Petite
Rivière, Nova Scotia*, 1922.
Oil on cardboard; 21.4 × 26.4 cm;
National Gallery of Canada, Ottawa.
Purchased 1936. 4534.

167 (lower) A.Y. Jackson, *Herring Cove, Nova Scotia*,
1919.
Oil on canvas; 63.9 × 76.7 cm;
Private Collection.

168 (upper) Edwin Holgate, *Fishermen's Houses*,
c. 1933.
Oil on canvas; 50.7 × 61.1 cm; McMichael
Canadian Art Collection, Kleinburg. Gift of Mr.
A.B. Gill in memory of Arthur B. Gill. 1977.36.

168 (lower) Arthur Lismer, *Cape Breton Island Beach*,
1924.
Oil on canvas; 60.0 × 75.0 cm;
Private Collection. Photo: Joyner Fine Art.

169 A.Y. Jackson, *Gaspé Landscape*, c. 1938.
Oil on canvas; 63.8 × 82.4 cm; Art Gallery of
Ontario, Toronto. Gift from the J.S. McLean
Collection, by Canada Packers Inc., 1990.
89/841. (CP236) Photo: Larry Ostrom/AGO.

170 (upper) Arthur Lismer, *Nova Scotia Fishing
Village*, 1930.
Oil on canvas; 92.5 × 107.4 cm;
National Gallery of Canada, Ottawa.
Purchased 1936. 4280.

170 (lower) J.E.H. MacDonald, *Nova Scotia Coastal
Scene*, 1922.
Oil on panel; 21.6 × 26.7 cm; The Thomson
Collection, The Hudson's Bay Company Gallery.
Photo: Nancy Rahija.

171 (upper) J.E.H. MacDonald, *Bridge at Petite
Rivière, Nova Scotia*, 1922.
Oil on cardboard; 21.4 × 26.3 cm;
National Gallery of Canada, Ottawa.
Purchased 1939. 4522.

171 (lower) J.E.H. MacDonald, *Nova Scotia Barn*,
c. 1922.
Oil on board; 10.8 × 12.7 cm; McMichael
Canadian Art Collection, Kleinburg. Gift of
the Founders, Robert and Signe McMichael.
1966.16.53.

172 Lawren Harris, *Black Court, Halifax*, 1921.
Oil on canvas; 97.1 × 112.0 cm;
National Gallery of Canada, Ottawa.
Gift of the artist, Vancouver, 1960. 5007.

173 Lawren Harris, *Elevator Court, Halifax*, 1921.
Oil on canvas; 96.5 × 112.1 cm; Art Gallery of
Ontario, Toronto. Gift from the Albert H.
Robson Memorial Subscription Fund, 1941.
2570. Photo: Carlo Catenazzi/AGO.

174 Lawren Harris, *Morning*, c. 1921.
Oil on canvas; 97.2 × 112.4 cm;
The Beaverbrook Art Gallery, Fredericton.
Gift of the W. Garfield Weston Foundation.

175 Lawren Harris, *Miners' Houses, Glace Bay*, c. 1925. Oil on canvas; 107.3 × 127.0 cm; Art Gallery of Ontario, Toronto. Bequest of Charles S. Band, Toronto, 1970. 69/122.

176 (upper) A.Y. Jackson, *St. John's Harbour, Newfoundland*, 1951. Oil on panel; 26.2 × 34.1 cm; McCord Museum, Montreal. Photo: Christine Guest.

176 (lower) A.Y. Jackson, *A Lake in Labrador*, 1930. Oil on canvas; 81.3 × 101.6 cm; Art Gallery of Newfoundland and Labrador Permanent Collection, St. John's. Gift of Celanese Canada. Photo: Ned Pratt.

177 (upper) Lawren Harris, *Newfoundland Sketch*, 1921. Oil on panel; 25.7 × 34.0 cm; Hart House Permanent Collection, University of Toronto. Purchased 1924. Photo: Thomas Moore.

177 (lower) Lawren Harris, *Fish Stage, Quidi Vidi, Newfoundland*, 1921. Oil on beaverboard; 26.6 × 35.0 cm; National Gallery of Canada, Ottawa. Gift of Leanora D. McCarney, Hull, Quebec, 1988, in memory of her parents Ethel and Frank De Rice. 30151.

178 A.Y. Jackson, *Labrador Coast*, 1931. Oil on canvas; 125.7 × 152.4 cm; Hart House Permanent Collection, University of Toronto. Purchased with income from the Harold and Murray Wrong Memorial Fund, 1942. Photo: Thomas Moore.

185 Lawren Harris, *Lighthouse, Father Point*, 1930. Oil on canvas; 107.9 × 128.1 cm; National Gallery of Canada, Ottawa. Gift of the artist, Vancouver, 1960. 5011.

186 A.Y. Jackson, *Spring, Lower Canada*, 1915. Oil on canvas, mounted on board; 63.5 × 81.3 cm; Gallery Lambton, Sarnia. Gift of the Sarnia Women's Conservation Association, 1956. Photo: Michael Cullen.

187 A.Y. Jackson, *The Edge of the Maple Wood*, 1910. Oil on canvas; 54.6 × 65.4 cm; National Gallery of Canada, Ottawa. Purchased 1937. 4298.

188 (upper) J.E.H. MacDonald, *Laurentian Village, October*, 1916. Oil on panel; 69.2 × 88.9 cm; Hart House Permanent Collection, University of Toronto. Gift of the Graduating Class of 1925. Photo: Thomas Moore.

188 (lower) J.E.H. MacDonald, *Laurentian Hillside, October*, 1914. Oil on canvas; 76.2 × 101.6 cm; Private Collection.

189 Edwin Holgate, *Baie St. Paul*, 1924. Oil on canvas; 50.8 × 55.9 cm; Private Collection. Photo: John Dean.

190 (upper) Edwin Holgate, *Laurentian Cemetery*, 1948. Oil on panel; 21.6 × 26.7 cm; Art Gallery of Ontario, Toronto. Purchase, 1957. 56/34. Photo: Carlo Catenazzi/AGO.

190 (lower) Edwin Holgate, *Ski Tracks*, c. 1935. Oil on canvas; 46.0 × 55.0 cm; Art Gallery of Hamilton.

191 Edwin Holgate, *Frances' Tree*, c. 1950. Oil on wood; 46.0 × 46.0 cm; Collection David Rittenhouse. Photo: Christine Guest.

192 A.Y. Jackson, *St. Lawrence in Winter*, n.d. Oil on canvas; 54.6 × 66.0 cm; Private Collection. Photo: Sotheby's.

193 A.Y. Jackson, *Afternoon, St. Hilarion*, n.d. Oil on panel; 21.0 × 26.7 cm. Private Collection. Photo: Sotheby's.

194 J.E.H. MacDonald, *Rain, Laurentians*, 1913. Oil on cardboard; 20.4 × 25.3 cm; National Gallery of Canada, Ottawa. Gift of an anonymous donor, 1999. 39999.

195 Arthur Lismer, *Baie St. Paul*, 1931. Oil on canvas; 61.1 × 76.4 cm; Collection of Power Corporation of Canada/Collection Power Corporation du Canada, Montreal.

196 (above) A.Y. Jackson, *St. Fidèle*, c. 1930. Oil on canvas; 63.8 × 81.9 cm; Private Collection. Photo: Christine Guest.

196 (right) A.Y. Jackson, *The St. Lawrence at St. Fidèle*, c. 1928. Oil on panel; 21.6 × 26.7 cm; The Thomson Collection, The Hudson's Bay Company Gallery. Photo: Nancy Rahija.

198 Arthur Lismer, *Quebec Village*, 1926. Oil on canvas; 132.8 × 162.6 cm; Collection of Agnes Etherington Art Centre, Queen's University, Kingston. Gift of Dr. H.S. Southam of Ottawa, 1949.

199 A.Y. Jackson, *Saint-Hilarion*, 1926. Oil on wood; 21.1 × 26.8 cm; National Gallery of Canada, Ottawa. Vincent Massey Bequest, 1968. 15487.

200 (upper) A.Y. Jackson, *A Quebec Farm*, c. 1930. Oil on canvas; 82.0 × 102.3 cm; National Gallery of Canada, Ottawa. Vincent Massey Bequest, 1968. 15481.

200 (lower) A.Y. Jackson, *Barns*, c. 1926. Oil on canvas; 81.6 × 102.1 cm; Art Gallery of Ontario, Toronto. Gift from the Reuben and Kate Leonard Canadian Fund, 1926. 846.

201 (upper) A.Y. Jackson, *Red Barn, Petite Rivière*, c. 1930. Oil on canvas; 63.5 × 81.3 cm; The Thomson Collection, The Hudson's Bay Company Gallery. Photo: Nancy Rahija.

201 (lower) A.Y. Jackson, *Hillside, St.-Tite-des-Caps*, 1937. Oil on canvas; 63.4 × 81.2 cm; Musée du Québec, Quebec City. Photo: Jean-Guy Kérouac.

202 (upper) A.Y. Jackson, *Early Spring, Quebec*, 1927. Oil on canvas; 53.3 × 66.0 cm; Art Gallery of Ontario, Toronto. Gift of the Canadian National Exhibition Association, Toronto, 1965. 135. Photo: Carlo Catenazzi/AGO.

202 (lower) A.Y. Jackson, *A Street in Murray Bay*, c. 1926. Oil on panel; 21.6 × 21.7 cm; The Thomson Collection, The Hudson's Bay Company Gallery. Photo: Nancy Rahija.

203 (upper) A.Y. Jackson, *Winter: L'Islet, Quebec*, 1940. Oil on canvas; 53.3 × 66.0 cm; Collection of Agnes Etherington Art Centre, Queen's University, Kingston. Gift of Mrs. Frederick Etherington, 1944. Photo: Cheryl O'Brien.

203 (lower) A.Y. Jackson, *March Day, Laurentians*, c. 1933. Oil on canvas; 54.0 × 66.9 cm; McMichael Canadian Art Collection, Kleinburg. Gift of Mrs. H.P. de Pencier. 1966.2.6.

204 A.Y. Jackson, *Grey Day, Laurentians*, c. 1930–1931. Oil on canvas; 63.5 × 81.6 cm; The Montreal Museum of Fine Arts Collection. Purchase, A. Sidney Dawes Fund and Dr. Francis J. Shepherd Fund. 1945.944. Photo: Brian Merrett/MMFA.

205 A.Y. Jackson, *Winter, Charlevoix County*, 1932–1933. Oil on canvas; 63.5 × 81.3 cm; Art Gallery of Ontario, Toronto. Purchased 1933. 2156. Photo: Larry Ostrom/AGO.

206 A.Y. Jackson, *Île aux Coudres*, c. 1926. Oil on canvas; 53.0 × 66.4 cm; The Edmonton Art Gallery Collection. 26.2. Photo: H. Korol.

215 Arthur Lismer, *Georgian Bay, Spring*, 1917. Oil on canvas; 91.5 × 70.8 cm; National Gallery of Canada, Ottawa. Bequest of Dr. J.M. MacCallum, Toronto, 1944. 4733.

216 (upper) A.J. Casson, *White Pine*, c. 1957. Oil on canvas; 76.0 × 101.3 cm; McMichael Canadian Art Collection, Kleinburg. Gift of the Founders, Robert and Signe McMichael. 1966.16.119.

216 (lower) Lawren Harris, *Island in the Lake, Algonquin Park*, 1916. Oil on board; 30.5 × 38.1 cm; Private Collection. Photo: Sotheby's.

217 (upper) Tom Thomson, *Split Rock Gap, Georgian Bay*, 1914. Oil on panel; 21.3 × 26.3 cm; Private Collection. Photo: Joyner Fine Art.

217 (lower) F.H. Varley, *Sun and Wind, Georgian Bay*, c. 1915. Oil on panel, mounted on plywood; 31.1 × 41.2 cm; Private Collection. © 2003 Estate of Kathleen G. McKay. Photo: Nancy Rahija.

218 Frank Carmichael, *Clouds, Georgian Bay*, 1919. Oil on canvas; 51.9 × 55.8 cm; Private Collection. Photo: Trevor Mills.

219 Lawren Harris, *Joe Lake, Algonquin Park*, c. 1914. Oil on board; 40.0 × 50.0 cm; Private Collection. Photo: Joyner Fine Art.

220 Arthur Lismer, *A September Gale, Georgian Bay*, 1921. Oil on canvas; 122.4 × 163.0 cm; National Gallery of Canada, Ottawa. Purchased 1926. 3360.

221 Arthur Lismer, *Bright Land*, 1938. Oil on canvas; 81.1 × 101.5 cm; McMichael Canadian Art Collection, Kleinburg. Gift of Col. R.S. McLaughlin. 1968.7.9.

222 Arthur Lismer, *Autumn, Bon Echo*, 1923. Oil on canvas; 106.0 × 132.9 cm; Collection of the Mendel Art Gallery, Saskatoon. Gift of the Mendel Family, 1965.

223 Arthur Lismer, *Sunglow*, 1915. Oil on canvas; 50.3 × 46.5 cm; Art Gallery of Nova Scotia, Halifax. 1919.1.

224 A.Y. Jackson, *Night, Pine Island*, 1924. Oil on canvas; 64.2 × 81.5 cm; National Gallery of Canada, Ottawa. Bequest of Dorothy Lampman McCurry, 1974, in memory of her husband, Harry O. McCurry, Director of the National Gallery of Canada, 1939–1955. 18124.

225 Tom Thomson, *Petawawa Gorges, Night*, c. 1916–1917. Oil on wood; 21.1 × 26.7 cm; National Gallery of Canada, Ottawa. Vincent Massey Bequest, 1968. 15548.

226 (upper) Tom Thomson, *Petawawa Gorges*, c. 1916. Oil on panel; 21.6 × 26.7 cm; Private Collection. Photo: Nancy Rahija.

226 (lower) Tom Thomson, *Open Water, Joe Creek*, c. 1914. Oil on panel; 21.6 × 26.7 cm; The Thomson Collection, The Hudson's Bay Company Gallery. Photo: Nancy Rahija.

227 (upper) Tom Thomson, *Lake and Red Tree*, c. 1916. Oil on panel; 21.6 × 26.3 cm; The Thomson Collection, The Hudson's Bay Company Gallery. Photo: Nancy Rahija.

227 (lower) Tom Thomson, *Sandbank with Logs*, 1916. Oil on panel; 21.3 × 26.3 cm; The Thomson Collection, The Hudson's Bay Company Gallery. Photo: Nancy Rahija.

228 Arthur Lismer, *The Happy Isles*, 1924. Oil on canvas; 93.5 × 113.5 cm; Kenderdine Art Gallery, University of Saskatchewan, Permanent Art Collection.

229 Arthur Lismer, *Pine Tree and Rocks*, 1921. Oil on canvas; 81.3 × 101.6 cm; Museum London, F.B. Housser Memorial Collection, 1945. Photo: William Kuryluk.

230 Lawren Harris, *Spring on the Oxtongue River*, 1924.
Oil on canvas; 82.2 × 102.2 cm; Gallery Lambton, Sarnia.

231 Lawren Harris, *Pines, Kempenfelt Bay*, n.d. Oil on canvas; 71.0 × 91.1 cm; University of Guelph Collection at Macdonald Stewart Art Centre, Guelph. Macdonald Institute Purchase, 1953. UG900.048.

232 Tom Thomson, *Larry Dickson's Cabin*, 1917. Oil on wood; 21.3 × 26.6 cm; National Gallery of Canada, Ottawa. Purchased 1918. 1528.

233 A.Y. Jackson, *Frozen Lake, Early Spring, Algonquin Park*, 1914. Oil on canvas; 81.4 × 99.4 cm; National Gallery of Canada, Ottawa. Bequest of Dr. J.M. MacCallum, Toronto, 1944. 4732.

234 (above) A.Y. Jackson, *Early Spring, Georgian Bay*, 1920. Oil on canvas; 54.0 × 65.8 cm; National Gallery of Canada, Ottawa. Purchased 1921. 1813.

234 (right) A.Y. Jackson, *Lake Cognaschene*, 1920. Oil on canvas; 63.5 × 81.3 cm; Art Gallery of Windsor Collection. Gift of Edmond G. and Gloria Odette, 1976. 76:11.

236 A.Y. Jackson, *Birches in Winter, Algonquin Park*, 1914. Oil on canvas; 63.5 × 81.2 cm; Private Collection. Photo: Trevor Mills.

237 Tom Thomson, *White Birch Grove*, c. 1917. Oil on canvas; 63.5 × 53.3 cm; Private Collection.

238 Tom Thomson, *Spring Ice*, 1916. Oil on canvas; 72.0 × 102.3 cm; National Gallery of Canada, Ottawa. Purchased 1916. 1195.

239 A.Y. Jackson, *March Storm, Georgian Bay*, 1920. Oil on canvas; 63.5 × 81.3 cm; National Gallery of Canada, Ottawa. Bequest of Dr. J.M. MacCallum, Toronto, 1944. 5051.

240 Lawren Harris, *Shimmering Water, Algonquin Park*, 1922. Oil on canvas; 82.3 × 102.0 cm; McMichael Canadian Art Collection, Kleinburg. Gift of the Founders, Robert and Signe McMichael. 1966.16.87.

241 Frank Carmichael, *Mirror Lake*, 1929. Watercolour over graphite paper; 51.0 × 68.7 cm; McMichael Canadian Art Collection, Kleinburg. Gift of Mrs. R.G. Mastin. 1976.8.

243 J.E.H. MacDonald, *Fine Weather, Georgian Bay*, 1913. Oil on canvas; 96.5 × 142.2 cm; The Thomson Collection, The Hudson's Bay Company Gallery. Photo: Nancy Rahija.

244 (upper) A.J. Casson, *Lake Kushog*, 1925. Oil on panel; 24.8 × 29.9 cm; Private Collection. Photo: Sotheby's.

244 (lower) J.E.H. MacDonald, *Logs Coming Down the Narrows, Turtle Lake*, n.d. Oil on board; 21.0 × 25.4 cm; Private Collection. Photo: Sotheby's.

245 Lawren Harris, *Sunset, Kempenfelt Bay*, 1921. Oil on canvas; 82.0 × 102.0 cm; Collection of Power Corporation of Canada/Collection Power Corporation du Canada, Montreal.

246 Tom Thomson, *Pine Trees at Sunset*, c. 1915–1916. Oil on panel; 26.7 × 21.6 cm; Private Collection.

247 Tom Thomson, *Sunset*, 1915. Oil on grey wood-pulp board; 21.6 × 26.7 cm; National Gallery of Canada, Ottawa. Bequest of Dr. J.M. MacCallum, Toronto, 1944. 4701.

248 Tom Thomson, *Hot Summer Moonlight*, c. 1915. Oil on wood; 21.4 × 26.7 cm; National Gallery of Canada, Ottawa. Bequest of Dr. J.M. MacCallum, Toronto, 1944. 4648.

249 Tom Thomson, *The Lily Pond*, 1914. Oil on wood; 21.5 × 26.7 cm; National Gallery of Canada, Ottawa. Bequest of Dr. J.M. MacCallum, Toronto, 1944. 4691.

250 Frank Johnston, *Woodland Tapestry,* 1919. Tempera on cardboard; 35.6 × 24.8 cm; The Thomson Collection, The Hudson's Bay Company Gallery.

251 Frank Johnston, *The Dark Woods, Interior*, c. 1921. Gouache on masonite; 55.9 × 46.7 cm; Art Gallery of Ontario, Toronto. Gift from the Reproduction Fund, 1954. 54/2. Photo: Larry Ostrom/AGO.

252 Lawren Harris, *Algonquin Park*, c. 1917. Oil on board; 35.4 × 27.0 cm; McMichael Canadian Art Collection, Kleinburg. Gift of Mr. R.A. Laidlaw. 1969.15.3.

253 Tom Thomson, *Pink Birches*, 1915. Oil on panel; 26.9 × 21.7 cm; The Thomson Collection, The Hudson's Bay Company Gallery. Photo: Nancy Rahija.

254 (upper) Tom Thomson, *Lumber Dam*, 1915. Oil on wood-pulp board; 21.6 × 26.7 cm; National Gallery of Canada, Ottawa. Purchased 1958. 6946.

254 (lower) Tom Thomson, *Bateaux*, 1916. Oil on wood panel; 21.5 × 26.8 cm; Art Gallery of Ontario, Toronto. Gift from the Reuben and Kate Leonard Canadian Fund, 1927. 853. Photo: Carlo Catenazzi/AGO.

255 Tom Thomson, *The Drive*, c. 1916. Oil on canvas; 120.0 × 137.5 cm; University of Guelph Collection at Macdonald Stewart Art Centre, Guelph. Ontario Agricultural College purchase with funds raised by students, faculty and staff, 1926.

256 J.E.H. MacDonald, *Logs on the Gatineau*, 1915. Oil on canvas; 87.4 × 115.3 cm; Collection of the Mendel Art Gallery, Saskatoon. Gift of the Mendel Family, 1965.

257 Tom Thomson, *Autumn Birches*, c. 1916.
Oil on panel; 21.6 × 26.7 cm; McMichael
Canadian Art Collection, Kleinburg.
Gift of Mrs. H.P. de Pencier. 1966.2.3.

258 (upper) Frank Carmichael, *Light and Shadow*,
1937.
Oil on board; 97.0 × 122.0 cm; The Thomson
Collection, The Hudson's Bay Company Gallery.
Photo: Nancy Rahija.

258 (lower) A.Y. Jackson, *Precambrian Hills*, 1939.
Oil on canvas; 71.5 × 91.4 cm; Art Gallery of
Ontario, Toronto. Purchase, 1946. 2829.
Photo: Carlo Catenazzi/AGO.

259 J.E.H. MacDonald, *A Northern Home*, 1915.
Oil on pressed board; 54.0 × 44.8 cm;
MacKenzie Art Gallery, Regina, University of
Regina Collection, purchased with funds from
the Brown estate. Photo: Don Hall.

261 (left) Frank Carmichael, *A Northern Silver Mine*,
1930.
Oil on canvas; 101.5 × 121.2 cm;
McMichael Canadian Art Collection, Kleinburg.
Gift of Mrs. A.J. Latner. 1971.9

261 (above) Frank Carmichael, *Jackfish Village*, 1926.
Watercolour and graphite on paper;
50.8 × 56.7 cm; Art Gallery of Ontario, Toronto.
Gift of the Canadian National Exhibition
Association, 1965. 305.
Photo: Carlo Catenazzi/AGO.

262 Frank Carmichael, *The Nickel Belt*, 1928.
Oil on canvas; 101.8 × 122.0 cm; Firestone Art
Collection: The Ottawa Art Gallery. Donated by
the Ontario Heritage Foundation to the City of
Ottawa. Photo: Tim Wickens.

263 (upper) Frank Carmichael, *Untitled (Industrial
Building)*, c. 1934–1937.
Oil on beaverboard; 25.4 × 30.3 cm;
National Gallery of Canada, Ottawa.
Gift of Mary Mastin, Toronto, 1996. 38416.

263 (lower) A.J. Casson, *Old Lime Kilns*, c. 1925.
Watercolour and pencil on paper;
35.6 × 40.7 cm; Glenbow Museum, Calgary.
R856.66.

264 Frank Carmichael, *La Cloche Mountain and Lake*,
c. 1940.
Oil on plywood panel; 29.9 × 40.4 cm;
Art Gallery of Ontario, Toronto. Gift from the
J.S. McLean Collection, by Canada Packers Inc.,
1990. 89/776. (CP132)
Photo: Carlo Catenazzi/AGO.

265 Frank Carmichael, *Bay of Islands*, 1930.
Watercolour on paper; 51.3 × 64.4 cm;
Art Gallery of Ontario, Toronto. Gift from
Friends of Canadian Art Fund, 1930. 1328.
Photo: Larry Ostrom/AGO.

266 Tom Thomson, *Autumn Foliage*, 1915.
Oil on wood panel; 21.6 × 26.8 cm; Art Gallery
of Ontario, Toronto. Gift from the Reuben
and Kate Leonard Canadian Fund, 1927. 852.

267 Tom Thomson, *Autumn Foliage*, 1916.
Oil on wood; 26.7 × 21.5 cm; National Gallery
of Canada, Ottawa. Purchased 1918. 1544.

268 Tom Thomson, *In the Northland*, 1915.
Oil on canvas; 101.7 × 114.5 cm; The Montreal
Museum of Fine Arts Collection. Gift of the
Friends of the Montreal Museum of Fine Arts.
1922.179. Photo: Denis Farley/MMFA.

269 Tom Thomson, *Autumn's Garland*, 1915–1916.
Oil on canvas; 122.5 × 132.2 cm;
National Gallery of Canada, Ottawa.
Purchased 1918. 1520.

270 (upper) Frank Carmichael, *The Hilltop*, 1921.
Oil on canvas; 76.9 × 92.0 cm; National Gallery
of Canada, Ottawa. Purchased 1921. 1811.

270 (lower) Frank Carmichael, *Red Maples*, 1922.
Oil on board; 24.6 × 30.2 cm; McMichael
Canadian Art Collection, Kleinburg. Gift of
the Founders, Robert and Signe McMichael.
1966.16.10.

271 Frank Carmichael, *October Gold*, 1922.
Oil on canvas; 119.5 × 98.0 cm; McMichael
Canadian Art Collection, Kleinburg. Gift of
the Founders, Robert and Signe McMichael.
1966.16.1.

272 (upper) Frank Carmichael, *Fanciful Autumn* (also
known as *The Glade*), 1922.
Oil on canvas; 63.0 × 75.5 cm; University College
Art Collection, University of Toronto Art Centre.

272 (lower) Frank Carmichael, *Autumn Splendour*,
1921.
Oil on panel; 25.4 × 30.5 cm; The Thomson
Collection, The Hudson's Bay Company Gallery.
Photo: Nancy Rahija.

273 Frank Carmichael, *Autumn: Orillia*, 1924.
Oil on canvas; 91.4 × 73.7 cm;
The Beaverbrook Art Gallery, Fredericton.
Gift of Lord Beaverbrook.

274 Frank Johnston, *The Fire Ranger*, 1921.
Oil on canvas; 123.0 × 153.2 cm;
National Gallery of Canada, Ottawa.
Purchased 1921. 1823.

275 Arthur Lismer, *The Big Rock, Bon Echo*, 1922.
Oil on canvas; 91.6 × 101.7 cm; National Gallery
of Canada, Ottawa. Purchased 1922. 2004.

276 Arthur Lismer, *September Sunlight, Georgian Bay*,
1933.
Oil on canvas; 81.3 × 101.5 cm; Art Gallery of
Ontario, Toronto. Gift from the J.S. McLean
Collection, Toronto; donated by the Ontario
Heritage Foundation, 1988. L69.27.
Photo: Carlo Catenazzi/AGO.

277 Arthur Lismer, *Sumach and Maple*, 1915.
Oil on canvas; 127.0 × 101.6 cm;
The Thomson Collection, The Hudson's Bay
Company Gallery.

278 Arthur Lismer, *A Westerly Gale, Georgian Bay*,
1916.
Oil on canvas; 63.7 × 79.9 cm; National Gallery
of Canada, Ottawa. Purchased 1916. 1369.

279 Arthur Lismer, *Evening Silhouette*, 1928.
Oil on canvas; 80.3 × 100.8 cm; University
College Art Collection, University of Toronto
Art Centre. Photo: Nancy Rahija.

280 Tom Thomson, *Tamarack*, 1916.
Oil on wood; 21.5 × 26.5 cm; National Gallery of
Canada, Ottawa. Vincent Massey Bequest, 1968.
15549.

281 Tom Thomson, *Tamarack*, 1916.
Oil on board or panel; 21.6 × 26.7 cm;
Private Collection. Photo: Michael Neill.

282 Frank Carmichael, *Wabajisik: Drowned Land*,
1929.
Watercolour and gouache over charcoal on
wove paper (watermark: "J. WHATMA[N]");
51.8 × 69.8 cm; National Gallery of Canada,
Ottawa. Purchased 1993. 37158.

283 A.J. Casson, *Autumn Evening* (originally
titled *October Evening* and also known as
Golden October), 1935.
Oil on canvas on board; 99.7 × 151.1 cm;
Hart House Permanent Collection, University
of Toronto. Purchased with income from the
Harold and Murray Wrong Memorial Fund,
1943.

284 (left) Tom Thomson, *Northern Lights*, c. 1916.
Oil on wood; 21.5 × 26.7 cm; National Gallery
of Canada, Ottawa. Bequest of Dr. J.M.
MacCallum, Toronto, 1944. 4677.

285 (upper) Tom Thomson, *Northern Lights*, 1916.
Oil on panel; 21.0 × 26.0 cm; Alan O. Gibbons.
Photo: Michael Neill.

285 (lower) Tom Thomson, *Moose at Night*, 1916.
Oil on wood; 20.9 × 26.9 cm; National Gallery
of Canada, Ottawa. Purchased 1918. 1545.

286 (upper) Tom Thomson, *Burnt Land*, c. 1915.
Oil on canvas; 54.6 × 66.7 cm; National Gallery
of Canada, Ottawa. Purchased 1937. 4299.

286 (lower) A.Y. Jackson, *November*, 1922.
Oil on canvas; 81.4 × 101.9 cm; National Gallery
of Canada, Ottawa. Purchased 1924. 3004.

287 Tom Thomson, *Fire-swept Hills*, 1915.
Oil on panel; 23.2 × 26.7 cm; The Thomson
Collection, The Hudson's Bay Company Gallery.

288 A.Y. Jackson, *Georgian Bay, November*, c. 1921.
Oil on canvas; 64.1 × 80.0 cm; Hart House
Permanent Collection, University of Toronto.
Purchased 1922. Photo: Thomas Moore.

289 (upper) A.Y. Jackson, *First Snow, Georgian Bay*,
c. 1920.
Oil on canvas; 53.8 × 66.7 cm; Art Gallery of
Ontario, Toronto. Gift from the J.S. McLean
Collection, by Canada Packers Inc., Toronto,
1990. 89/838. (CP233)
Photo: Carlo Catenazzi/AGO.

289 (lower) A.Y. Jackson, *Freddy Channel*, c. 1930.
Oil on canvas; 53.3 × 66.0 cm;
Private Collection. Photo: Nancy Rahija.

290 A.Y. Jackson, *Winter, Georgian Bay*, c. 1914.
Oil on canvas; 91.4 × 126.8 cm;
Private Collection. Photo: Joyner Fine Art.

291 Lawren Harris, *Winter Landscape*, c. 1916.
Oil on canvas; 120.7 × 127.0 cm;
Imperial Oil Limited. Photo: Peter Ure.

292 Lawren Harris, *Winter in the Northern Woods*,
c. 1915.
Oil on canvas; 139.5 × 182.6 cm;
Imperial Oil Limited. Photo: Peter Ure.

294 Lawren Harris, *Winter Sunrise*, 1918.
Oil on canvas; 127.0 × 120.7 cm;
MacKenzie Art Gallery, Regina, University
of Regina Collection. Photo: Don Hall.

295 Lawren Harris, *Snow II*, 1915.
Oil on canvas; 120.3 × 127.3 cm;
National Gallery of Canada, Ottawa.
Purchased 1916. 1193.

296 Tom Thomson, *In Algonquin Park*, 1914.
Oil on canvas; 63.2 × 81.1 cm; McMichael
Canadian Art Collection, Kleinburg. Gift of
the Founders, Robert and Signe McMichael,
in memory of Norman and Evelyn McMichael.
1966.16.76.

303 Lawren Harris, *North Shore, Lake Superior*, 1926.
Oil on canvas; 102.2 × 128.3 cm; National Gallery
of Canada, Ottawa. Purchased 1930. 3708.

304 Lawren Harris, *Northern Autumn*, 1922.
Oil on canvas; 81.3 × 97.2 cm; Museum London.

305 Frank Johnston, *Where the Eagles Soar*, c. 1920.
Oil on canvas; 101.6 × 81.3 cm; Art Gallery
of Ontario, Toronto. Gift of the Canadian
National Exhibition Association, Toronto, 1965.
134. Photo: Carlo Catenazzi/AGO.

306 Lawren Harris, *Autumn, Algoma*, 1920.
Oil on canvas; 101.6 × 127.0 cm;
Victoria College, University of Toronto.
Photo: Nancy Rahija.

307 Lawren Harris, *Waterfall, Algoma*, 1918.
Oil on canvas; 120.2 × 139.6 cm; Art Gallery of
Hamilton. Gift of the Women's Committee,
1957.

308 Lawren Harris, *Northern Lake*, c. 1923.
Oil on canvas; 82.5 × 102.8 cm; McMichael
Canadian Art Collection, Kleinburg.
Gift of Col. R.S. McLaughlin. 1968.7.5.

309 Lawren Harris, *Northern Lake II*, c. 1926.
Oil on canvas; 81.3 × 101.6 cm;
Private Collection. Photo: Nancy Rahija.

310 Lawren Harris, *Quiet Lake (Northern Painting 12)*,
c. 1923.
Oil on canvas; 86.4 × 101.6 cm;
Private Collection. Photo: Nancy Rahija.

311 Lawren Harris, *Northern Painting 25*, 1924.
Oil on canvas; 80.0 × 90.2 cm;
Private Collection. Photo: Sotheby's.

312 Lawren Harris, *Autumn, Batchewana*, 1918. Oil on board; 26.9 × 34.4 cm; Private Collection. Photo: Joyner Fine Art.

313 A.Y. Jackson, *Northern Landscape*, n.d. Oil on canvas; 104.1 × 125.7 cm; Private Collection. Photo: Sotheby's.

314 (upper) Frank Carmichael, *Lake Superior*, 1929. Oil on paperboard; 25.6 × 30.3 cm; National Gallery of Canada, Ottawa. Purchased 1957. 6665.

314 (lower) Arthur Lismer, *Untitled (Sombre Isle of Pic, Lake Superior)*, 1927. Oil on canvas; 87.5 × 110.3 cm; Collection of The Winnipeg Art Gallery. Gift of Mrs. R.A. Purves. G-52-174. Photo: Ernest Mayer, The Winnipeg Art Gallery.

315 (upper) Lawren Harris, *Pic Island*, c. 1924. Oil on canvas; 123.3 × 153.9 cm; McMichael Canadian Art Collection, Kleinburg. Gift of Col. R.S. McLaughlin. 1968.7.4.

315 (lower) Lawren Harris, *Pic Island*, c. 1923. Oil on panel; 30.5 × 38.1 cm; Art Gallery of Ontario, Toronto. Gift of Mrs. Doris Huestis Mills Speirs, Pickering, Ontario, 1971. 70/326. Photo: Carlo Catenazzi/AGO.

316 Frank Johnston, *Early Evening, Winter*, 1928. Gouache on paperboard; 74.2 × 48.8 cm; Collection of The Winnipeg Art Gallery. Gift of Mr. Peter Dobush. G-65-53. Photo: Ernest Mayer, The Winnipeg Art Gallery.

317 (upper) A.J. Casson, *Fog Lifting*, c. 1929. Watercolour on paper; 44.0 × 51.0 cm; McMichael Canadian Art Collection, Kleinburg. Gift of the Founders, Robert and Signe McMichael. 1966.16.128.

317 (lower) J.E.H. MacDonald, *Misty Morning, Algoma*, 1921. Oil on board; 21.3 × 26.3 cm; Private Collection. Photo: Joyner Fine Art.

318 J.E.H. MacDonald, *The Wild River*, 1919. Oil on canvas; 134.6 × 162.6 cm; Faculty Club, University of Toronto. Photo: Peter Ure.

319 J.E.H. MacDonald, *Falls, Montreal River*, 1920. Oil on canvas; 121.9 × 153.0 cm; Art Gallery of Ontario, Toronto. Purchased 1933. 2109. Photo: Larry Ostrom/AGO.

320 Arthur Lismer, *Sombre Hill, Algoma*, 1922. Oil on canvas; 101.6 × 114.3 cm; Art Gallery of Ontario, Toronto. Gift from the Fund of the T. Eaton Co. Ltd. for Canadian Works of Art, 1950. 49/58.

321 J.E.H. MacDonald, *The Solemn Land*, 1921. Oil on canvas; 122.5 × 153.5 cm; National Gallery of Ontario, Ottawa. Purchased 1921. 1785.

322 (upper) Arthur Lismer, *October on the North Shore, Lake Superior*, 1927. Oil on canvas; 122.4 × 163.3 cm; National Gallery of Canada, Ottawa. Purchased 1936. 4281.

322 (lower) A.J. Casson, *October*, 1928. Oil on canvas; 94.0 × 114.3 cm; University of Alberta Art and Artifact Collection, Museums and Collections Services. Presented to the Normal School, Edmonton, by the class of 1930–1931.

323 A.Y. Jackson, *Maple Woods, Algoma*, 1920. Oil on canvas; 63.5 × 81.5 cm; Art Gallery of Ontario, Toronto. Purchased 1981 with funds raised in 1977 by the Volunteer Committee (matched by Wintario) to celebrate the opening of the Canadian Wing. 81/15. Photo: Larry Ostrom/AGO.

324 Lawren Harris, *Lake Superior Hill*, 1925. Oil on canvas; 121.9 × 153.7 cm; Private Collection. Photo: Sotheby's.

325 Lawren Harris, *Algoma Hill*, 1920. Oil on canvas; 117.0 × 137.1 cm; University Health Network, Toronto.

326 A.Y. Jackson, *Algoma, November*, 1934. Oil on canvas; 81.3 × 102.1 cm; National Gallery of Canada, Ottawa. Gift of H.S. Southam, Ottawa, 1945. 4611.

327 A.Y. Jackson, *October Morning, Algoma*, 1920. Oil on canvas; 126.3 × 151.7 cm; Hart House Permanent Collection, University of Toronto. Purchased 1932.

328 (upper) Frank Carmichael, *Snow Clouds*, 1926. Oil on canvas; 100.3 × 121.3 cm; Hart House Permanent Collection, University of Toronto. Gift of the graduating class of 1926. Photo: Thomas Moore.

328 (lower) Lawren Harris, *Untitled (North Shore, Lake Superior)*, c. 1922. Oil on hardboard; 30.3 × 38.2 cm; Collection of The Winnipeg Art Gallery. Gift from the Estate of Arnold O. Brigden. G-73-270. Photo: Ernest Mayer, The Winnipeg Art Gallery.

329 Lawren Harris, *Beaver Swamp, Algoma*, 1920. Oil on canvas; 120.7 × 141.0 cm; Art Gallery of Ontario, Toronto. Gift of Ruth Massey Tovell, Toronto, in memory of Harold Murchison Tovell, 1953. 53/12. Photo: Carlo Catenazzi/AGO.

330 (above) Lawren Harris, *Lake Superior Painting 9*, 1923. Oil on canvas; 102.0 × 127.6 cm; Collection of Power Corporation of Canada/Collection Power Corporation du Canada, Montreal.

330 (right) Lawren Harris, *First Snow, North Shore of Lake Superior*, 1923. Oil on canvas; 123.0 × 153.3 cm; Vancouver Art Gallery. VAG 50.4. Photo: Trevor Mills/3757.

332 Frank Carmichael, *North Shore, Lake Superior*, 1927. Oil on canvas; 101.5 × 121.7 cm; The Montreal Museum of Fine Arts Collection. Purchase, Robert Lindsay Fund. 1959.1211. Photo: Brian Merrett/MMFA.

333 Lawren Harris, *Lake Superior*, c. 1928. Oil on canvas; 86.1 × 102.2 cm; National Gallery of Canada, Ottawa. Vincent Massey Bequest, 1968. 15477.

334 Lawren Harris, *Lake Superior*, c. 1924. Oil on canvas; 101.7 × 127.3 cm; Art Gallery of Ontario, Toronto. Bequest of Charles S. Band, Toronto, 1970. 69/121. Photo: Larry Ostrom/AGO.

335 Lawren Harris, *Above Lake Superior*, c. 1922. Oil on canvas; 121.9 × 152.4 cm; Art Gallery of Ontario, Toronto. Gift from the Reuben and Kate Leonard Canadian Fund, 1929. 1335. Photo: Carlo Catenazzi/AGO.

336 (upper) Lawren Harris, *Morning, Lake Superior*, c. 1921–1928. Oil on canvas; 86.3 × 101.6 cm; The Montreal Museum of Fine Arts Collection. Purchase, William Gilman Cheney Bequest. 1939.686. Photo: Brian Merrett/MMFA.

336 (lower) Lawren Harris, *Morning Light, Lake Superior*, c. 1927. Oil on canvas; 87.6 × 101.6 cm; University of Guelph Collection at Macdonald Stewart Art Centre. Gift of Frieda Helen Fraser, in memory of her friend Dr. Edith Bickerton Williams, OVC '41, 1988.

337 (upper) Lawren Harris, *Afternoon, Lake Superior* (*Sketch CXLIII*), c. 1924. Oil on board; 30.0 × 37.5 cm; Private Collection. Photo: Joyner Fine Art.

337 (lower) Lawren Harris, *Ice House, Coldwell, Lake Superior*, c. 1923. Oil on canvas; 94.0 × 114.3 cm; Art Gallery of Hamilton. Bequest of H.S. Southam, Esq., C.M.G., LL.D., 1966.

338 Lawren Harris, *From the North Shore of Lake Superior*, c. 1923. Oil on canvas; 121.9 × 152.4 cm; Museum London. Gift of H.S. Southam, Esq., Ottawa, 1940. 40.A.12. Photo: William Kuryluk.

339 Lawren Harris, *Untitled (Clouds, Lake Superior)*, 1923. Oil on canvas; 102.5 × 127.6 cm; Collection of The Winnipeg Art Gallery. Gift of Mr. John A. MacAulay, Q.C. G-56-16. Photo: Ernest Mayer, The Winnipeg Art Gallery.

340 A.J. Casson, *Approaching Storm, Lake Superior*, c. 1929–1930. Watercolour over graphite on wove paper; 46.9 × 57.0 cm; National Gallery of Canada, Ottawa. Purchased 1931. 3950.

341 J.E.H. MacDonald, *Mist Fantasy, Northland*, 1922. Oil on canvas; 53.7 × 66.7 cm; Art Gallery of Ontario, Toronto. Gift of Mrs. S.J. Williams, Toronto, in memory of F. Elinor Williams, 1927. 899. Photo: Larry Ostrom/AGO.

342 Lawren Harris, *Lake in Algoma*, c. 1925. Oil on canvas; 105.0 × 125.0 cm; Magna International. Photo: Joyner Fine Art.

343 A.Y. Jackson, *First Snow Algoma*, c. 1920. Oil on canvas; 107.1 × 127.7 cm; McMichael Canadian Art Collection, Kleinburg. In memory of Gertrude Wells Hilborn. 1966.7.

344 Lawren Harris, *Winter Comes from the Arctic to the Temperate Zone*, c. 1935. Oil on canvas; 74.1 × 91.2 cm; McMichael Canadian Art Collection, Kleinburg. 1994.13.

351 LeMoine FitzGerald, *Untitled (Summer Afternoon, The Prairie)*, 1921. Oil on canvas; 107.2 × 89.5 cm; Collection of The Winnipeg Art Gallery. L-90. Photo: Ernest Mayer, The Winnipeg Art Gallery.

352 LeMoine FitzGerald, *Pembina Valley*, 1923. Oil on canvas; 46.0 × 56.0 cm; Art Gallery of Windsor Collection. Given in memory of Richard A. Graybiel by his family, 1979.

353 LeMoine FitzGerald, *Potato Patch, Snowflake*, 1925. Oil on canvas on board; 43.4 × 52.2 cm; Collection of The Winnipeg Art Gallery. Gift of Dr. Bernhard Fast. G-98-279. Photo: Ernest Mayer, The Winnipeg Art Gallery.

354 A.Y. Jackson, *Elevator, Moonlight*, c. 1947. Oil on multi-ply paperboard; 26.4 × 34.2 cm; Art Gallery of Ontario, Toronto. Gift from the J.S. McLean Collection, by Canada Packers Inc., 1990. 89/835.

355 LeMoine FitzGerald, *The Harvester*, c. 1921. Oil on canvas; 66.8 × 59.5 cm; McMichael Canadian Art Collection, Kleinburg. Gift from the Douglas M. Duncan Collection. 1981.41.3.

356 A.Y. Jackson, *Blood Indian Reserve, Alberta*, 1937. Oil on canvas; 64.0 × 81.6 cm; Art Gallery of Ontario, Toronto. Purchased 1946. 2828.

357 (upper) A.Y. Jackson, *October, Twin Butte, Alberta*, 1951. Oil on canvas; 64.2 × 81.5 cm; National Gallery of Canada, Ottawa. Purchased 1956. 6456.

357 (lower) A.Y. Jackson, *Early Snow, Alberta*, 1937. Oil on canvas; 82.5 × 116.8 cm; Private Collection. Photo: Sotheby's.

358 (upper) F.H. Varley, *Reflections, Garibaldi Park*, 1927. Oil on canvas; 30.4 × 38.1 cm; Sidney Dawes Collection, McGill University, Montreal. © 2003 Estate of Kathleen G. McKay. Photo: McCord Museum.

358 (lower) Lawren Harris, *The Ramparts, Tonquin Valley*, c. 1924. Oil on panel; 26.4 × 34.6 cm; The Thomson Collection, The Hudson's Bay Company Gallery. Photo: Nancy Rahija.

359 (upper) Lawren Harris, *Athabaska Valley, Jasper Park*, n.d.
Oil on wood; 27.0 × 35.0 cm; Collection of Agnes Etherington Art Centre, Queen's University, Kingston. Gift of the Gertrude Matthewman Bequest, 1986.
Photo: Cheryl O'Brien.

359 (lower) Lawren Harris, *Mountain at Tonquin Valley, Jasper Park*, c. 1924.
Oil on panel; 26.7 × 35.6 cm;
Private Collection. Photo: Sotheby's.

360 Lawren Harris, *Mountains and Lake*, 1929.
Oil on canvas; 92.0 × 114.8 cm; McMichael Canadian Art Collection, Kleinburg.
Gift of Mr. R.A. Laidlaw. 1970.1.1.

361 Lawren Harris, *Maligne Lake, Jasper Park*, 1924.
Oil on canvas; 122.8 × 152.8 cm; National Gallery of Canada, Ottawa. Purchased 1928. 3541.

362 Lawren Harris, *Emerald Lake, Rocky Mountains*, c. 1925.
Oil on canvas; 30.5 × 38.1 cm; The Thomson Collection, The Hudson's Bay Company Gallery. Photo: Nancy Rahija.

363 Lawren Harris, *Lake McArthur, Rocky Mountains*, c. 1924–1928.
Oil on plywood; 30.0 × 38.1 cm; Collection of The Winnipeg Art Gallery. L-7. Photo: Ernest Mayer, The Winnipeg Art Gallery.

364 (upper) Lawren Harris, *Mountain Form*, c. 1925.
Oil on board; 30.5 × 40.6 cm;
Private Collection. Photo: Sotheby's.

364 (lower) Lawren Harris, *Untitled (Mountains near Jasper)*, 1934.
Oil on canvas; 143.8 × 168.5 cm; Collection of the Mendel Art Gallery, Saskatoon.
Gift of the Mendel family, 1965.
Photo: Grant Kernon, A.K. Photos.

365 (upper) Lawren Harris, *Lake and Mountains*, 1928.
Oil on canvas; 130.8 × 160.7 cm; Art Gallery of Ontario, Toronto. Gift from the Fund of the T. Eaton Co. Ltd. for Canadian Works of Art, 1948. 48/8. Photo: Carlo Catenazzi/AGO.

365 (lower) Lawren Harris, *Untitled (Mountain Sketch)*, c. 1924–1928
Oil on plywood on masonite; 30.8 × 37.9 cm; Collection of The Winnipeg Art Gallery. L-8. Photo: Ernest Mayer, The Winnipeg Art Gallery.

366 (upper) Arthur Lismer, *Cathedral Mountain*, 1928.
Oil on canvas; 122.0 × 142.5 cm;
The Montreal Museum of Fine Arts Collection. Gift of A. Sidney Dawes. 1959.1219.
Photo: Denis Farley/MMFA.

366 (lower) Arthur Lismer, *The Glacier*, 1928.
Oil on canvas; 101.5 × 126.7 cm; Art Gallery of Hamilton. Gift of the Women's Committee Fund, 1960. 60.77.J. Photo: Charles Hupé.

367 (upper) J.E.H. MacDonald, *Early Morning, Rocky Mountains*, 1928.
Oil on canvas; 76.2 × 89.2 cm; Art Gallery of Ontario, Toronto. Gift of Mrs. Jules Loeb, Toronto, 1977; donated by the Ontario Heritage Foundation, 1988. L76.1.
Photo: Carlo Catenazzi/AGO.

367 (lower) J.E.H. MacDonald, *Rain in the Mountains*, 1924.
Oil on canvas; 123.5 × 153.4 cm; Art Gallery of Hamilton. Bequest of H.L. Rinn, 1955.

368 J.E.H. MacDonald, *Lake McArthur, Yoho Park*, 1924.
Oil on cardboard; 21.4 × 26.6 cm;
National Gallery of Canada, Ottawa.
Vincent Massey Bequest, 1968. 15498.

369 F.H. Varley, *Evening after Rain*, n.d.
Oil on plywood; 30.2 × 37.8 cm;
National Gallery of Canada, Ottawa.
Purchased 1939. 4547.
© 2003 Estate of Kathleen G. McKay.

370 (upper) A.Y. Jackson, *Indian Home*, 1927.
Oil on canvas; 53.8 × 66.5 cm.
Robert McLaughlin Gallery, Oshawa.
Gift of Isabel McLaughlin, 1987.

370 (lower) A.Y. Jackson, *Totem Poles, Kitwanga*, c. 1927.
Oil on panel; 21.0 × 26.7 cm;
Private Collection. Photo: Nancy Rahija.

371 A.Y. Jackson, *Kispayaks Village*, 1927.
Oil on canvas; 64.1 × 82.1 cm; Collection of the Art Gallery of Greater Victoria. Gift of David N. Ker. AGGV 84.49. Photo: Bob Matheson.

372 (upper) F.H. Varley, *The Cloud, Red Mountain*, 1927–1928.
Oil on canvas; 87.0 × 102.2 cm;
Art Gallery of Ontario, Toronto. Bequest of Charles S. Band, Toronto, 1970. 69/127.
© 2003 Estate of Kathleen G. McKay.
Photo: Carlo Catenazzi/AGO.

372 (lower) F.H. Varley, *Sunrise, Sphinx Glacier, Garibaldi Park*, 1927.
Oil on panel; 30.5 × 38.1 cm; The Thomson Collection, The Hudson's Bay Company Gallery.
© 2003 Estate of Kathleen G. McKay.
Photo: Ritchie's Auctioneers.

373 F.H. Varley, *Night Ferry, Vancouver*, 1937.
Oil on canvas; 81.9 × 102.2 cm; McMichael Canadian Art Collection, Kleinburg.
Purchased 1983. 1983.10.
© 2003 Estate of Kathleen G. McKay.

374 F.H. Varley, *View from the Artist's Bedroom Window, Jericho Beach*, 1929.
Oil on canvas; 99.4 × 83.8 cm; Collection of The Winnipeg Art Gallery. Acquired with the assistance of the Women's Committee and the Woods-Harris Trust Fund No. 1. G-72-7.
© 2003 Estate of Kathleen G. McKay. Photo: Ernest Mayer, The Winnipeg Art Gallery.

381 A.Y. Jackson, *Terre Sauvage*, 1913.
Oil on canvas; 128.8 × 154.4 cm; National Gallery of Canada, Ottawa. Acquired 1936. 4351.

382 (upper) A.Y. Jackson, *Yellowknife Country, Northwest Territories*, 1929.
Oil on canvas; 81.2 × 101.6 cm; The Thomson Collection, The Hudson's Bay Company Gallery. Photo: Nancy Rahija.

382 (lower) A.Y. Jackson, *Northern Lake*, 1928.
Oil on canvas; 82.3 × 127.7 cm; National Gallery of Canada, Ottawa. Vincent Massey Bequest, 1968. 15480.

383 (upper) A.Y. Jackson, *Northern Landscape, Great Bear Lake*, c. 1938–1939.
Oil on canvas; 82.4 × 102.1 cm; Private Collection.

383 (lower) A.Y. Jackson, *Dawn in the Yukon*, 1943.
Oil on canvas; 81.3 × 101.6 cm; Sidney Dawes Collection, McGill University, Montreal. Photo: Christine Guest.

384 F.H. Varley, *Summer in the Arctic*, 1938.
Oil on canvas; 86.4 × 101.6 cm; The Thomson Collection, The Hudson's Bay Company Gallery. © 2003 Estate of Kathleen G. McKay. Photo: Nancy Rahija.

385 (upper) A.Y. Jackson, *Morning, Baffin Island*, 1930.
Oil on canvas; 64.1 × 81.9 cm; Private Collection. Photo: Sotheby's.

385 (lower) A.Y. Jackson, *Indian Homes, Fort Resolution*, 1928.
Oil on wood; 21.5 × 26.8 cm; National Gallery of Canada, Ottawa. Purchased 1958. 6960.

386 Lawren Harris, *Rice Strait, Ellesmere Island*, 1930.
Oil on panel; 29.2 × 36.8 cm; Private Collection. Photo: Nancy Rahija.

387 (upper) Lawren Harris, *Arctic Peaks, North Shore, Baffin Island*, 1930.
Oil on canvas; 82.6 × 106.7 cm; The Thomson Collection, The Hudson's Bay Company Gallery. Photo: Nancy Rahija.

387 (lower) Lawren Harris, *Ellesmere Island*, c. 1930.
Oil on panel; 30.4 × 37.7 cm; McMichael Canadian Art Collection, Kleinburg. Gift of Mrs. Chester Harris. 1981.40.2.

388 Lawren Harris, *Icebergs, Davis Strait*, 1930.
Oil on panel; 29.2 × 36.8 cm; Private Collection. Photo: Nancy Rahija.

389 Lawren Harris, *Icebergs, Davis Strait*, 1930.
Oil on canvas; 121.9 × 152.4 cm; McMichael Canadian Art Collection, Kleinburg. Gift of Mr. And Mrs. H. Spencer Clark. 1971.17.

390 (upper) A.Y. Jackson, *Iceberg*, 1930.
Oil on canvas; 63.5 × 82.5 cm; Private Collection. Photo: Nancy Rahija.

390 (lower) A.Y. Jackson, *Eastern Arctic*, 1965.
Oil on canvas; 51.0 × 66.0 cm; Imperial Oil Limited. Photo: Peter Ure.

391 A.Y. Jackson, *The "Beothic" at Bache Post, Ellesmere Island*, 1929.
Oil on canvas; 81.6 × 102.1 cm; National Gallery of Canada, Ottawa. Gift of the Honourable Charles Stewart, Minister of the Interior, 1930, to commemorate the establishment on 6 August 1926 of Bache Peninsula Post. 3711.

392 Lawren Harris, *North Shore, Baffin Island 1*, c. 1930.
Oil on canvas; 81.4 × 107.5 cm; National Gallery of Canada, Ottawa. Gift of the artist, Vancouver, 1960. 5008.

393 Lawren Harris, *Arctic Sketch XIII*, 1930.
Oil on composition board; 30.4 × 38.1 cm; Collection of Agnes Etherington Art Centre, Queen's University, Kingston. Gift of Mrs. Etherington, c. 1944. Photo: Cheryl O'Brien.

394 Lawren Harris, *Baffin Island*, 1930.
Oil on board; 30.5 × 38.1 cm; The Thomson Collection, The Hudson's Bay Company Gallery. Photo: Joyner Fine Art.

395 Lawren Harris, *North Shore, Baffin Island*, 1930.
Oil on beaverboard; 30.4 × 37.8 cm; National Gallery of Canada, Ottawa. Purchased 1942. 4561.

396 F.H. Varley, *Midnight Sun*, 1938.
Oil on panel; 36.8 × 29.2 cm; Private Collection. © 2003 Estate of Kathleen G. McKay. Photo: Peter Varley

398 (upper left) *Group of 7: Catalogue. Exhibition of Paintings. May 7th–May 27th, 1920.*
Catalogue cover of the first exhibition at the Art Museum of Toronto. Photo: Courtesy The Edward P. Taylor Research Library and Archives, Art Gallery of Ontario, Toronto. Digital file A-08186.

(lower left) *Group of Seven: Exhibition of Paintings at the Art Gallery of Toronto. Jan. 9th–Feb. 2nd, 1925.*
Catalogue cover of the fourth exhibition at Art Gallery of Toronto. Photo: Courtesy The Edward P. Taylor Research Library and Archives, Art Gallery of Ontario, Toronto. Digital file A-08189.

(right) *Exhibition of Paintings by The Group of 7, May 7–29, 1921.*
Catalogue cover of the second exhibition at Art Museum of Toronto. Photo: Courtesy The Edward P. Taylor Research Library and Archives, Art Gallery of Ontario, Toronto. Digital File A-08187.

GALLERY INDEX

Agnes Etherington Art Centre
University Avenue & Queen's Crescent
Queen's University
Kingston, ON K7L 3N6
Phone: (613) 533-2190
Website: www.queensu.ca/ageth

Art Gallery of Greater Victoria
1040 Moss Street
Victoria, BC V8V 4P1
Phone: (250) 384-4101
Website: www.aggv.bc.ca

Art Gallery of Hamilton
123 King Street West
Hamilton, ON L8P 4S8
Phone: (905) 527-6610
Website: www.artgalleryofhamilton.on.ca

Art Gallery of Newfoundland and Labrador
Arts & Culture Center
Allendale Road/Prince Philip Drive
St. John's, NF A1C 5S7
Phone: (709) 737-8209
Website: www.agnl.ca

Art Gallery of Nova Scotia
1723 Hollis Street
Halifax, NS B3J 3C8
Phone: (902) 424-5280
Website: www.agns.gov.ns.ca

Art Gallery of Ontario
317 Dundas Street West
Toronto, ON M5T 1G4
Phone: (416) 979-6648
Website: www.ago.net

Art Gallery of Windsor
401 Riverside Drive West
Windsor, ON N9A 7J1
Phone: (519) 977-0013
Web site: www.artgalleryofwindsor.com

The Beaverbrook Art Gallery
703 Queen Street
Fredericton, NB E3B 5A6
Phone: (506) 458-8545
Website: www.beaverbrookartgallery.org

Canadian War Museum
General Motors Court
330 Sussex Drive
Ottawa, ON K1A 0M8
Phone: (819) 776-8600
Website: www.warmuseum.ca

Confederation Centre of the Arts
145 Richmond Street
Charlottetown, PEI C1A 1J1
Phone: (902) 628-1864
Website: www.confederationcentre.com

Dalhousie Art Gallery
6101 University Avenue
Halifax, NS B3H 3J5
Phone: (902) 494-2403
Website: www.dal.ca/~gallery

The Edmonton Art Gallery
2 Sir Winston Churchill Square
Edmonton, AB T5J 2C1
Phone: (780) 422-6223
Website: www.edmontonartgallery.com

Gallery Lambton
Bayside Mall
150 North Christina Street
Sarnia, ON N7T 7W5
Phone: (519) 336-8127
Website: www.sarnia.com/groups/gallerylambton

Glenbow Museum
130-9th Avenue S.E.
Calgary, AB T2G 0P3
Phone: (403) 268-4100
Website: www.glenbow.org

Hart House Permanent Collection
University of Toronto
7 Hart House Circle
Toronto, ON M5S 3H3
Phone: (415) 978-8398
Website: www.utoronto.ca/gallery

The Hudson's Bay Company Gallery
(featuring The Thomson Collection)
401 Bay Street, 9th floor
Toronto, ON M5H 2Y4
Phone: (416) 861-4626

Kenderdine Art Gallery
51 Campus Drive (2nd level – Agricultural Building)
University of Saskatchewan
Saskatoon, SK S7N 5A8
Phone: (306) 966-6816
Website: www.usask.ca/kenderdine

Macdonald Stewart Art Centre
University of Guelph
358 Gordon Street
Guelph, ON N1G 1Y1
Phone: (519) 837-0010
Website: www.uoguelph.ca/msac

MacKenzie Art Gallery
T.C. Douglas Building
3475 Albert Street
Regina, SK S4S 6X6
Phone: (306) 584-4250
Website: www.mackenzieartgallery.sk.ca

McCord Museum of Canadian History
690 Sherbrooke Street West
Montreal, QC H3A 1E9
Phone: (514) 398-7100
Website: www.mccord-museum.qc.ca

McMichael Canadian Art Collection
10365 Islington Avenue,
Kleinburg, ON L0J 1C0
Phone: (905) 893-1121
Website: www.mcmichael.com

Mendel Art Gallery
950 Spadina Crescent East
Saskatoon, SK S7K 3L6
Phone: (306) 975-7610
Website: www.mendel.ca

The Montreal Museum of Fine Arts
1379-1380 Sherbrooke Street West
Montreal, QC
Phone: (514) 285-1600
Website: www.mmfa.qc.ca

Musée du Québec
Parc des Champs-de-Bataille
Québec, QC G1R 5H3
Phone: (418) 643-2150
Website: www.mdq.org

Museum London
421 Ridout St. N.,
London, ON N6A 5H4
Phone: (519) 661-0333
Website: www.museumlondon.ca

National Gallery of Canada
380 Sussex Drive
Ottawa, ON K1N 9N4
Phone: (613) 990-1985
Website: www.national.gallery.ca

The Ottawa Art Gallery
Firestone Collection of Canadian Art
2 Daly Avenue
Ottawa, ON K1N 6E2
Phone: (613) 233-8699
Website: www.ottawaartgallery.ca

The Robert McLaughlin Gallery
72 Queen Street
Civic Centre
Oshawa, ON L1H 3Z3
Phone: (905) 576-3000
Website: www.rmg.on.ca

Tate Gallery,
Millbank
London, England SW1P 4RG
Phone: 44 20 7887-8730/31/32
Website: www.tate.org.uk/britain

Tom Thomson Memorial Art Gallery
840 First Avenue West
Owen Sound ON N4K 4K4
Phone: (519) 376-1932
Website: www.tomthomson.org

University of Alberta Art and Artifact Collection
Department of Museums and Collections Services
Ring House 1 University of Alberta
Edmonton, AB T6G 2E1
Phone: (780) 492--5834
Website: www.museums.ualberta.ca

University College Art Collection,
University of Toronto Art Centre
15 King's College Circle
 (main floor of Laidlaw Wing)
Toronto, ON M5S 3H7
Phone: (416) 978-1838
Website: www.utoronto.ca/artcentre

Vancouver Art Gallery
750 Hornby Street
Vancouver, BC V6Z 2H7
Phone: (604) 662-4719
Website: www.vanartgallery.bc.ca

The Winnipeg Art Gallery
300 Memorial Boulevard
Winnipeg, MB R3C 1V1
Phone: (204) 786-6641
Website: www.wag.mb.ca

The publisher gratefully acknowledges the generous assistance provided by the dedicated staff members
of these galleries and collections, especially Felicia Cukier, Art Gallery of Ontario; Reina Lahtinen,
Canadian War Museum; Heather McMichael, Hudson's Bay Company Gallery
and Tanya Richard, National Gallery of Canada.

General Index

In January 1967 the graphic designer Carl Dair released Cartier, a calligraphic old-style face,
the first text typeface to be designed in Canada. Although the face was
well received at the time it failed to gain widespread use.
Believing that Dair's design was sound in concept, if not in execution, Toronto type designer
Rod McDonald reworked the original design in 2000 to make it a working type family.

CARTIER, CARL DAIR, 1967
CARTIER BOOK, ROD MCDONALD, 2000

Printed on 100 lb. Garda Silk, an archival paper
Separations by Quadratone Graphics, Toronto, Ontario
Printed and bound in Canada by Friesens, Altona, Manitoba